THE SCULPTURE OF JACQUES LIPCHITZ

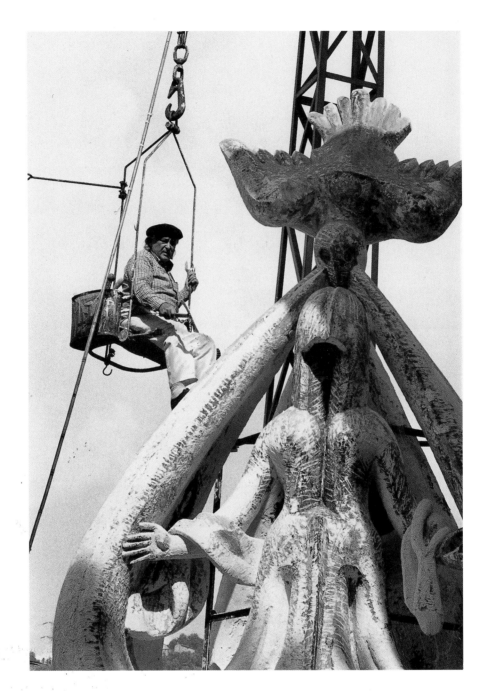

Lipchitz at work on plaster for *Peace on Earth* (No. 664), commissioned for The Music Center of Los Angeles County, Los Angeles, California. Photographed at Tommasi Foundry, Pietrasanta, Italy, September, 1967

THE SCULPTURE OF
JACQUES LIPCHITZ

A Catalogue Raisonné
Volume Two
The American Years
1941–1973

Alan G. Wilkinson

Thames & Hudson

In memory of Bob Hubbard,

my friend and mentor

First published in the United Kingdom in 2000 by Thames & Hudson Ltd., 181A High Holborn, London WCIV7QX
First published in the United States of America in 2000 by Thames & Hudson Inc., 500 Fifth Avenue, New York, New York 10110

©2000 Marlborough Gallery, Inc., New York
Preface and Catalogue text ©2000 Alan G. Wilkinson

All works of Jacques Lipchitz ©2000 the Estate of Jacques Lipchitz

Book design: Scott Marshall
Production assistance: Caitlin Shey, Hope Svenson
Publishing co-ordination: Paola Gribaudo, Studio Gribaudo, Torino, Italy
Duotone separations: Litho Art New, Torino, Italy
Printing and binding: Pozzo Gros Monti spa, Torino, Italy

British Library Cataloguing-in-Publication Data

A catalogue record for this book is available from the British Library

ISBN 0-500-09291-5

Library of Congress Catalog Card Number 96-60239

Printed and bound in Italy

CONTENTS

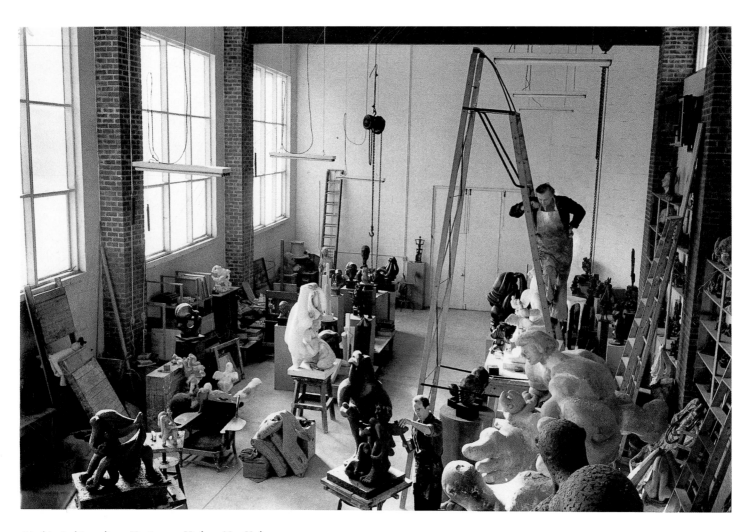

Lipchitz in his studio at Hastings-on-Hudson, New York

PREFACE, WITH NOTES ON CASTING

Alan G. Wilkinson

This is the second of the two-volume catalogue raisonné of the sculpture of Jacques Lipchitz. It documents the sculptures created during the second half (thirty-two years) of Lipchitz's working life, from his arrival in New York on June 13, 1941 until his death on the island of Capri on May 27, 1973. *Volume One: The Paris Years 1910-1940,* published in 1996, documented the sculptures created during the first half (thirty-one years) of Lipchitz's working life, from the 1910 *Seated Nude (No. 1)* to the 1940 *Flight* (No. 344). *Flight,* which was executed in Toulouse – where Lipchitz and his wife Berthe, anticipating the German occupation of Paris, had sought refuge in May, 1940 – was thought to have been the last sculpture from the Paris years. Recent research in the Lipchitz Archive at the Tate Gallery, London has brought to light a group of photographs of terracotta portraits dated "Toulouse 1940" and "Toulouse 1940-41" (see Nos. 344a to 344i in the Addendum to *Volume One: The Paris Years 1910-1940,* on pp. 23-24). Lipchitz mentioned these portraits in his autobiography, and they attest to the fact that he continued working on his sculpture in Toulouse in 1940, and during the winter months of 1941 before sailing to New York in early June of that year.[1] It is not known if any of these terracotta portraits have survived. They are reproduced here for the first time, and the originals will, perhaps, surface in the fullness of time.

Of the three hundred and forty-four sculptures documented in *Volume One: The Paris Years 1910-1940,* two bronzes, *Transparent,* 1930 (No. 245), and *Head and Hand* (also known as *Pastorale*), 1933 (No. 295) were incorrectly catalogued. They are now correctly catalogued in *Volume Two: The American Years 1941-1973,* as *Variation,* 1942 (No. 361), and *Pastorale* (also known as *Pastoral*), 1942 (No. 373). The Paris years now include three hundred and sixty-nine sculptures: three hundred and forty-two works now correctly catalogued in *Volume One,* and twenty-seven works which appear in the Addendum to *Volume One: The Paris Years 1910-1940,* on pp. 18-24.

Arrival, 1941 (No. 345), the first of the four hundred and three sculptures catalogued in *Volume Two,* was the companion piece to *Flight,* 1940 (No. 344). Lipchitz described *Flight* as being "very free and baroque in its organization, representing not only my emotions at this moment when I was fleeing with my family, but also a new and open expressionistic type of composition."[2] Of *Arrival,* which shares the same stylistic features, Lipchitz commented: "…the mother holds the child who is saved… there was the specific feeling of escape from the horror of the fascists to the refuge of the United States."[3] *Arrival,* with its dynamic gestures and powerful illusion of movement, embodies the most characteristic and consistent features which unite many of Lipchitz's sculptures from the American years: from the 1940s, *Prometheus Strangling the Vulture* (Nos. 380-381); from the 1950s, *The Spirit of Enterprise* (Nos. 493-500); from the 1960s, *Bellerophon Taming Pegasus* (Nos. 615-623); and from the late 1960s and early 1970s, the twenty-six variations on *The Rape of Europa* (Nos. 670-695).

Unexpectedly, the challenges of compiling *Volume Two: The American Years 1941-1973* of this catalogue raisonné of Lipchitz's sculpture have been more difficult and demanding than those encountered in documenting the work from the Paris years. During the 1920s and 30s there were relatively few publications on Lipchitz's sculpture. The most useful, contemporary sources were Maurice Raynal's *Lipchitz* (1920), the first monograph on the artist, Roger Vitrac's *Jacques Lipchitz* (1927), the list of works in *Cent Sculptures par Jacques Lipchitz*, Galerie de la Renaissance (Jean Boucher), Paris (1930), and various articles in periodicals such as *L'Amour de l'Art*, and *Cahiers d'Art*. Almost all the information on the sculptures executed between 1910 and 1940 was, however, obtained from the reasonably well documented books and exhibition catalogues of Lipchitz's work, most of which were published in the 1960s and 70s, and from photographs in the archives of the Marlborough Gallery, New York.

During the American years, the ever increasing flow of books and exhibition catalogues provided a far more detailed and comprehensive record of Lipchitz's sculptural output than had been available for the Paris years. However, many of these publications included lists of sculptures without photographs of all the works. For example, between 1942 and 1951, there were five exhibitions of Lipchitz's sculpture at Curt Valentin's Buchholz Gallery, 32 East 57th Street, New York. The small catalogues produced for each show are the most valuable sources of information for the work produced during these years. To cite one example, in the catalogue for the 1946 exhibition at the Buchholz Gallery, twenty-two sculptures are listed, with the title, date, medium and size of each work, but only twelve are illustrated. I have located photographs of all but one of the ten sculptures which are listed but not illustrated. I was unable to find a photograph of one of the two bronzes entitled *Sketch for Massacre,* 1945, cat. Nos. 14 and 15. In this instance, and in other cases when I have been unsuccessful in locating a photograph of a sculpture listed in a book or catalogue, the work has been included. It is now catalogued as *Sketch for Massacre: Maquette No. 2,* 1945 (No. 393), with the note: "Photograph unavailable. Catalogue No. 15 in: *Jacques Lipchitz,* Buchholz Gallery, New York, 1946." Another example is *Virgin in Flames II,* 1952 (No. 486), with the note (there were no catalogue numbers): "Listed in Henry R. Hope, *The Sculpture of Jacques Lipchitz,* The Museum of Modern Art, New York, 1954, p. 92".

The five Buchholz exhibition catalogues of 1942, 1943, 1946, 1948, and 1951 were obviously the most important documents for establishing the chronology of Lipchitz's sculpture produced between 1941 and 1951. The following dealer catalogues were invaluable in documenting much of the subsequent work, particularly the thematic "series" sculptures: *Jacques Lipchitz: Thirty-Three Semi-Automatics 1955-1956 and Earlier Works 1915-1928,* Fine Arts Associates, New York, 1957; *Jacques Lipchitz: Fourteen Recent Works 1958-1959 and Earlier Works 1949-1959,* Fine Arts Associates, New York, 1959; *Jacques Lipchitz: Images of Italy,* Marlborough-Gerson Gallery, New York, 1966; and *A Tribute to Jacques Lipchitz: Lipchitz in America 1941-1973,* Marlborough Gallery Inc., New York, 1973. Finding photographs of all the works in the "series" sculptures, such as the *Thirty-Three Semi-Automatics* of 1955-56 (Nos. 502-534), and the twenty-four *Images of Italy* of 1962-63 (Nos. 575-598), was akin to the pleasure one feels on completing a jigsaw puzzle. And one has the satisfaction of knowing that of the work produced during these periods of intense creativity, the catalogue is complete.

In establishing an accurate chronology of Lipchitz's sculpture from the American years, as for the work from the Paris years, *Jacques Lipchitz: Sketches in Bronze,* by H. H. Arnason (1969), and *My Life in Sculpture,* by Jacques Lipchitz, with H. H. Arnason (1972) were also indispensable. So were the many photographs in the archives of the Marlborough Gallery, New York, in the Lipchitz Archive at the Tate Gallery, London, and those which have been stored for many years at Lipchitz's studio at Hastings-on-Hudson, New York. Most of the photographs of the sculptures in the Addendum to *Volume One: The Paris Years 1910-1940* were found in the Tate Gallery's Lipchitz Archive, and among the photographs at the Hastings-on-Hudson studio. There is nothing more exciting than to discover photographs of hitherto unknown sculptures, such as the terracotta portraits of 1940 and 1940-41 (see Nos. 344a to 344i in the Addendum to *Volume One: The Paris Years 1910-1940,* on pp. 23-24). They fill unprecedented gaps in Lipchitz's work, while photographs of other unrecorded sculptures extend the scope of one's knowledge of existing themes and styles. As expected, photographs of the unique bronze casts of a number of the brilliantly innovative "transparents" of 1925-31 have surfaced, and are included in the Addendum to *Volume One,* Nos. 190a, 190b, 216a, 244a and 260a, on pp. 20-21. Prior to sifting through the hundreds of photographs which for many years had remained undisturbed in the Hastings-on-Hudson studio, I had managed to find photographs of only nineteen of the twenty-six *Variations on a Chisel* sculptures of 1951-52, which Lipchitz referred to in his autobiography.[4] I was both relieved and exhilarated to discover photographs of an additional ten chisel sculptures, bringing the total to twenty-nine. While the *Twelve Transparents* of 1942 (Nos. 361-372) were the first of the "series" sculptures from the American years, the *Variations on a Chisel* bronzes (Nos. 455-483) constituted a series in a quite different way, a way which was to become one of the defining characteristics of Lipchitz's sculpture during the remaining twenty years of his working life. With the *Transparents* of 1942, as with those of 1925-31, it is the open, lyrical construction of the forms, rather than the subject matter, that unifies the series. The *Variations on a Chisel* bronzes, on the other hand, are stylistically very closely related, in that each sculpture evolved from a wax, modeled in the form of a chisel without its handle, to which Lipchitz added figurative elements. And within the series, there are the closely related variations of the major themes: Hebrew objects, begging poets, dancers, and centaurs enmeshed. In some of the later "series" sculptures, such as three of the studies of 1963 for the monument for *Daniel Greysolen, Sieur du Luth* (Nos. 604-606), six of the studies of 1964 for *Bellerophon Taming Pegasus* (Nos. 615-620), and eleven of the series of twenty-six bronzes of 1969-72 on the theme of the *Rape of Europa* (Nos. 685-695), the variations are so similar that very careful scrutiny was required to distinguish one from another. There were no such difficulties in differentiating between closely related works from the Paris years.

In *Volume Two: The American Years,* the design of the book, and the cataloguing procedures remain unchanged from those of *Volume One: The Paris Years.* The catalogue of the sculpture includes four hundred and three works, Nos. 345 to 747. The plate section includes 129 full page illustrations of many of the most important works reproduced on a much smaller scale in the catalogue section. In assigning titles to the sculptures, I have followed those most frequently used in previous publications with which Lipchitz was involved. If a sculpture has been known by more than one title, the one less frequently used appears in brackets, as for example, *Theseus and the Minotaur*

(also known as *Theseus*), 1942 (No. 360). Where there are two or more preparatory studies for a larger sculpture, I have, in the interest of clarity, altered their original titles in the following ways. In the 1948 catalogue of the Lipchitz exhibition at the Buchholz Gallery, New York, Nos. 13 and 14 are both called *Rescue II (Study)*, 1947. Here they are catalogued as *Rescue II (Study): Maquette No. 1*, and *Rescue II (Study): Maquette No. 2* (Nos. 402-403). Lipchitz sometimes included roman numerals in the titles of sculptures to differentiate between several preparatory studies for a larger work, such as *Birth of the Muses I*, and *Birth of the Muses II* of 1944 (Nos. 382-383), or to differentiate between two versions of the same theme, such as *The Joy of Orpheus I*, 1945, and *The Joy of Orpheus II*, 1945-46 (Nos. 395-396). There was no reason to alter these titles. I have added roman numerals to the titles of certain groups of studies for larger works. For example, *Sketch for the Monument for du Luth I* of 1963 (No. 603), the first of five studies for the large monument for *Daniel Greysolon, Sieur du Luth*, is obviously more economical than *Sketch for the Monument for du Luth: Maquette No. 1*. This was not feasible with certain existing titles. For example, in the 1946 catalogue of the Lipchitz exhibition at the Buchholz Gallery, New York, Nos. 2 and 3 are both called *Sketch for Benediction I*, 1942. Here, the roman numeral I refers to the large bronze *Benediction I*, 1942-44 (No. 359). They have been catalogued as *Sketch for Benediction I: Maquette No. 1*, and *Sketch for Benediction I: Maquette No. 2* (Nos. 357-358). I have also added roman numerals to the titles of the series *Variations on a Chisel*, 1951-52 (Nos. 455-483), and to some of the groups of works within each of the three series *The Rape of Europa*, 1969-72 (670-695), *The Last Embrace*, 1970-72 (Nos. 696-711), and *A Partir de*, 1971 (Nos. 722-737).

Two problems remain unresolved in the documentation of the sculpture from the American years. As mentioned earlier, there are several works, such as *Virgin in Flames II*, 1952 (No. 486), listed but not illustrated in various publications, of which photographs have not been found. I expect that these photographs may surface in the future. More problematic are the nineteen photographs of two groups of sculptures, with no information as to the title, date or dimensions of the works. The five bronzes in the first group (Nos. 537-541) are, I believe, related to the series of *Thirty-Three Semi-Automatics* of 1955-56, Nos. 502-534, and to Nos. 535-536. I have assigned descriptive titles to each of the five bronzes, and dated them c. 1955-56. The second group comprises fourteen unidentified portraits (Nos. 630-643). As there are relatively few differences in style and technique between these portraits, the dated portraits of the early 1940s (Nos. 351-356), and those of the 1950s and 60s (Nos. 543-547, 567-569, 611-613, and 625-626), it would be a futile exercize to hazard a guess as to the various dates of these fourteen portraits. They have been catalogued as a group, immediately after the 1966 portraits of *Skira* and *Leidesdorf* (Nos. 625-626), and the undated portraits of *Cournant, Kaplan* and *Hamburger* (Nos. 627-629), in order to form a "problematic," portrait section, and because my intuition tells me that most of them were executed during the last few years of Lipchitz's working life. They are published here for the first time. The author would appreciate being notified, c/o the publisher, by anyone who is able to shed light on the identity of these portraits.

During the American years, Lipchitz preferred to model directly in clay, a practice which dates from his student years in Paris in 1909-10. "I have continued," he commented in later life, "to use this method ever since that time because I believe strongly that it is superior to all others.

With the small clay sketch it is possible to fix an idea immediately and to change it rapidly."[5] In the somewhat complex evolution of a sculptural idea, the first stage was the original clay or wax sketch. (The importance of modeling in wax during the American years will be discussed later.) These original clay sketches have not survived, since clay disintegrates unless it is kept damp. The exceptions are the terracottas, made with a special clay that can be fired in a kiln. In the second stage, the original clay model was translated by skilled craftsmen into plaster. Derek Pullen, in his informative article "A Note on Technique," published in the Tate Gallery's 1986 catalogue, *The Lipchitz Gift*, defines the primary plasters as having been "cast from moulds taken directly from the clay models."[6] In the third and final stage of the process, the bronze edition was cast from molds taken from the primary plaster. During the Paris years, many primary plasters of the cubist sculptures of 1915-25 were also translated by craftsmen into stone. Since the carving was based on a primary plaster from which the bronze edition was also cast, they are closely related. For example, the dimensions of *Sculpture,* 1915, stone (unique), No. 36 in *Volume One,* and *Sculpture,* 1915, bronze edition of 7, No. 37, are almost identical. Of the five known carvings from the American years, the granite *Return of the Child* of 1941-43 (No. 348) is the only sculpture with such close links, in terms of date and scale, with its bronze counterpart, the 1941 *Return of the Child* (No. 347).

Lipchitz had modeled directly in wax for the first time in the mid-1920s when he created the earliest of the series of "transparents" (see *Volume One* Nos. 185-197). Wax was an ideal material for modeling forms of extreme thinness, openness and delicacy, which characterized the "transparents" of 1925-31, and much of the post-1940 sculpture. During the American years, wax was used in creating the "originals" of what are to my mind among Lipchitz's most brilliant and innovative sculptures from this little understood, and little appreciated period of his career: *Twelve Transparents,* 1942 (Nos. 361-372); *Variations on a Chisel,* 1951-52 (Nos. 455-483); *Thirty-Three Semi-Automatics,* 1955-56 (Nos. 502-534); *A la Limite du Possible,* 1958-59 (Nos. 553-566), *Images of Italy,* 1962-63 (Nos. 575-598), and almost certainly *A Partir de,* 1971 (Nos. 722-737).

Lipchitz described the creative process involved in making the 1955-56 "semi-automatics" as follows: ". . . I would just splash or squeeze a piece of warm wax in my hands, put it in a basin of water without looking at it, and then let it harden in cold water. When I took it out and examined it, the lump suggested many different images to me. Automatically a particular image would emerge several times and this I would choose to develop and clarify."[7] *A la Limite du Possible,* 1958-59, the series of fourteen bronzes cast from the original waxes incorporating all sorts of found objects from driftwood to stuffed birds, were from a technical point of view, the most remarkable, and indeed miraculous bronze casts of Lipchitz's entire career, as the title of the series suggests. Of *Carnival* (No. 555), Lipchitz commented: "…I first designed it in water, then added the flowers; then put it in a mold and placed it in the oven to burn out the wax and the other objects."[8] Thus, the original wax was destroyed in the lost wax method of casting. There were no primary plasters cast from the original wax models, as there were from the original clay models. For this reason, only one, "unique" bronze was cast from each wax model, by pouring molten bronze into the mold to fill the hollow spaces left by the wax, which had burnt away completely. Each bronze in the series *Twelve Transparents,* 1942, *Variations on a Chisel,* 1951-52, *Thirty-Three Semi-Automatics,* 1955-56, *A la Limite du Possible,* 1958-59, and *A Partir de,* 1971, is a unique cast.

The importance of process, from sketch in clay or wax to bronze cast, cannot be overemphasized. For this reason, I have discussed in some detail the materials which Lipchitz used, and the stages involved in the collaborative venture between the sculptor and the bronze foundry. During the American years, clay remained, as it had been during the Paris years, Lipchitz's preferred medium. Modeling in wax, however, gained in importance during the second half of Lipchitz's working life. As far as I know, the unique bronze "transparents" of 1925-31 (some twenty-four works) were the only sculptures from the Paris years which were cast from wax models. I estimate that some one hundred and five unique bronzes catalogued in *Volume Two* were cast from original wax models. And finally, during the American years, Lipchitz and his assistants continued working in plaster to construct the medium-size and monumental sculptures, all of which evolved from preliminary studies in clay and plaster. *Bellerophon Taming Pegasus*, 1964-73 (No. 623), and *Peace on Earth*, 1967-69 (No. 664), are among the largest public sculptures in America. The sense of scale could not be better conveyed than in the photograph of the sculptor working on the twenty-nine foot high plaster for *Peace on Earth* at the Tommasi Foundry, Pietrasanta, Italy (see p. 2).

Volume Two is essentially a catalogue of the three hundred and ninety-two known bronzes created during the American years. Whereas stone carving was of vital importance during the great cubist years from 1915 to 1925, during the American years Lipchitz all but abandoned having his plasters translated into stone; only five carvings are known. There was a twenty-eight year gap between the time Lipchitz began work on the 1941-43 granite *Return of the Child* (No. 348) and the year he began the 1969-70 marble *Peace on Earth* (No. 665), the first of only four late carvings, executed between 1969 and 1971. (See also Nos. 668, 707 and 721.) This catalogue does not include sculptures in materials other than bronze and stone, with the following exceptions. The terracotta *Portrait of Barbara Rice Poe I*, 1941 (No. 352) is the only known example of one of the two portraits of Poe. There is no evidence that this terracotta was cast in bronze. The artificial stone *Dancer with Hood*, 1947 (No. 407) is a version, in a different material, of the 1947 bronze *Dancer with Hood* (No. 406). The 1947 cast stone *Cradle I* and *Cradle II* (Nos. 417 and 418) are the only known examples of these closely related works. *Study for Hagar: Maquette No. 2* (No. 435) and *Study for Hagar: Maquette No. 3* (No. 437) were each cast in an edition of ten, using a mixture of reinforced plaster and iron filings. They are the only known examples of editions cast in these materials. Both sculptures were also cast in bronze (Nos. 434 and 436).

This two-volume catalogue raisonné of the sculpture of Jacques Lipchitz comprises seven hundred and seventy-two works: three hundred and sixty-nine sculptures from the Paris years, and four hundred and three from the American years. As for those works missing from *Volume Two*, it will never be known how many sculptures were destroyed in the disastrous fire on January 5, 1952 at Lipchitz's 23rd Street studio in New York. Inevitably, works omitted from both volumes of this catalogue raisonné will surface. It is my hope that the lacunae will be few and that filling them will extend but not alter in any substantial way our knowledge of the scope of Lipchitz's achievement.

Notes on Casting of Works from the American Years, 1941-1973

Not long after his arrival in New York City on June 13, 1941, Lipchitz, on the advice of the dealer Joseph Brummer, began having his work cast at the Roman Bronze Foundry in Long Island City. In 1942 he switched to John Spring's Modern Art Foundry in Astoria, New York. Henceforth, according to Robert Spring, the present owner, all of Lipchitz's bronzes which were cast in the United States were done at the Modern Art Foundry with the following exceptions. The 1964 bronze *Sketch for John F. Kennedy* (No. 611) was cast in an edition of twenty-one by Joe Meisner, using the facilities of the Avnet Shaw Foundry, Plainview, Long Island. Meisner told me that he cast the editions of approximately five other works at the Avnet Shaw Foundry, but he could not remember which sculptures they were.

In the Notes on Casting of Works from the Paris Years, 1910-1940, on page 30 of *Volume One*, I stated that some of the bronzes which were cast in Paris during these years were inscribed with the date, such as the Albright-Knox Art Gallery's cast of the 1914 *Sailor with Guitar* (No. 21). I was mistaken when I added that "The American casts were never dated." I have discovered one cast inscribed with the date and there may well be a few sculptures from the 1940s. The bronze cast of *Arrival,* 1941 (No. 345, Lipchitz's first work from the American years) in the collection of the Minnesota Museum of American Art, St. Paul, is inscribed "J. Lipchitz 1941."

It was during the Paris years that Lipchitz made the decision to limit the bronze edition of any given work to seven casts. As far as I know, the only exception during the Paris years was the 1920 *Death Mask of Modigliani* (No. 116), which was cast in an edition of twelve. From the American years, I have found the following exceptions: the 1964 *Sketch for John F. Kennedy* (No. 611) edition of twenty-one; the 1967 *First Study for Peace on Earth* (No. 662) edition of fifteen; and the 1968 *Samson Fighting the Lion* (No. 666) edition of two hundred plus twelve artist's copies. To these I should add the twenty-four *Images of Italy* of 1962-63 (Nos. 575-598). The originals were made directly in wax, and from these the initial set of unnumbered lost wax bronzes was cast. From these unique bronzes, an edition of seven bronzes was cast of each sculpture, with the exception of No. 591, and numbered 1/7 through 7/7.

As mentioned in *Volume One* (p. 31), the casts all carry the artist's name or initials, and his thumbprint. Three bronzes from editions cast by the Modern Art Foundry illustrate the various inscriptions which appear on their casts. The 1941 *Return of the Child* (No. 347) includes at the back of the horizontal surface of the bronze base, the artist's thumbprint, the edition number 1/7, and the signature "J. Lipchitz" (fig. 1 on page 15). On the back, vertical surface of the bronze base of *Return of the Child* is the name of the foundry, "MODERN ART FDRY. N.Y." (fig. 2 of page 15). However, many of the bronzes cast by the Modern Art Foundry were not inscribed with the foundry's name. The 1951-52 *Variation on a Chisel XIX: Pas de Deux* (No. 473) is an example of a small bronze on which there was not enough space for the "J. Lipchitz" signature. The base of the sculpture includes the artist's thumbprint and the initials "J.L." (fig. 3 on page 15). As this bronze is a unique cast, there is no edition number inscribed on the base. As a general rule, when a bronze includes the artist's thumbprint and signature, but no edition number, as on the 1955-56 *Mother and Child on Sofa* (No. 523), one can assume that it is a unique cast (fig. 4 on page 15). There are,

however, certain unnumbered bronzes from the 1940s and 50s, such as the 1945 *Mother and Child* (No. 391), which may be unique, or which may have been cast in an edition of two or three. In such cases, I have stated in the caption, "edition unknown." The 1964 *Sketch for John F. Kennedy* (No. 611), which, as mentioned earlier, was cast at the Avnet Shaw Foundry, includes the edition number, 7/21, the artist's signature "J. Lipchitz," and the artist's thumbprint (fig. 5 on page 15).

In 1962, Lipchitz visited Italy for the first time, at the invitation of a friend who had told him about a very good bronze foundry at Pietrasanta near her home. This was the Tommasi Foundry, which was run by Vignalis and Gigi Tommasi. Lipchitz wrote, "I arrived at Pietrasanta on a Saturday and on Monday I was at the foundry, working."[9] He was so impressed with the working conditions, the technical skill of Vignalis Tommasi, and the fact that the foundry would be able to cast the very large commissions, that he decided to buy a Renaissance villa in the nearby town of Pieve di Camaiore. The first sculptures which Lipchitz created at the Tommasi Foundry were the *Images of Italy* (Nos. 575-598), of which nineteen in the series were executed during the summer of 1962, and five the following summer. From 1962 until his death in 1973, almost all of Lipchitz's works were cast at the Tommasi Foundry in Pietrasanta, including the following large commissions: *Daniel Greysolon, Sieur du Luth,* 1964-65 (No. 609); *Bellerophon Taming Pegasus,* 1964-73 (No. 623); *Government of the People,* 1967-70 (No. 661); and *Peace on Earth,* 1967-69 (No. 664). The inscriptions on the Tommasi casts included the artist's name "J. Lipchitz," or on very small bronzes, his initials "J.L.," the artist's thumbprint, and if a bronze was not a unique cast, the number from the edition of seven casts. Many of the Tommasi casts include the foundry stamp, which reads as follows: FONDERIA/ LUIGI TOMMASI/ PIETRASANTA (fig. 6, page 15).

All bronzes from the Paris years and from the American years were cast during Lipchitz's lifetime. Lipchitz provided in his Will that there were to be no posthumous bronze casts from the original plasters or terracottas.

* * *

Every effort has been made to make this catalogue raisonné of the American years as complete as possible. Inevitably, a number of sculptures whose whereabouts were unknown at the time of publication will surface in the future. The author would appreciate being notified, c/o the publisher, of any sculptures that have been omitted. Additional information regarding works in public collections would also be much appreciated.

A.G.W.

NOTES

1. Jacques Lipchitz and H. H. Arnason, *My Life in Sculpture,* New York, 1972, p. 143.
2. Ibid., p. 143.
3. Ibid., p. 143.
4. Ibid., p. 188.
5. Ibid., p. 4.
6. David Fraser Jenkins and Derek Pullen, *The Lipchitz Gift: Models for Sculpture,* London, 1986, p. 15.
7. *My Life in Sculpture,* pp. 193-194.
8. Ibid., p. 201.
9. Ibid., p. 209.

Fig. 1. The artist's thumbprint, edition number 1/7, and signature "J. Lipchitz" on *Return of the Child,* 1941 (No. 347).

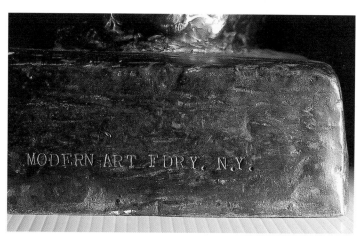

Fig. 2. Foundry stamp "MODERN ART FDRY. N.Y." on *Return of the Child,* 1941 (No. 347).

Fig. 3. The artist's thumbprint and initials "J.L." on *Variations on a Chisel XIX: Pas de Deux,* 1951-52 (No. 473).

Fig. 4. The artist's thumbprint and signature "J.Lipchitz" on *Mother and Child on Sofa,* 1955-56 (No. 523).

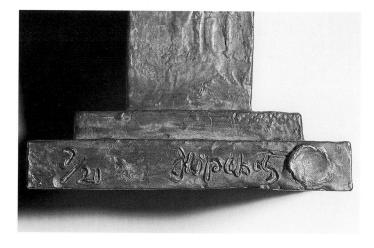

Fig. 5. Edition number 7/21, signature "J.Lipchitz," and the artist's thumbprint on *Sketch for John F. Kennedy,* 1964 (No. 611).

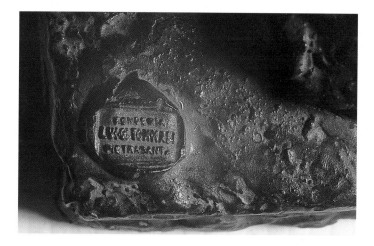

Fig. 6. Foundry stamp "FONDERIA/LUIGI TOMMASI/ PIETRASANTA" on *Variation on the Rape of Europa D,* 1969-70 (No. 673).

Acknowledgments

I am most grateful to Yulla Lipchitz for her confidence and support since the mid-1980s, when I began compiling this catalogue raisonné of the sculpture of Jacques Lipchitz. In particular, I thank Sir Alan Bowness for suggesting to Mrs. Lipchitz that I should be asked to undertake this project. I am greatly indebted to Pierre Levai, Director, Marlborough Gallery Inc., New York, and to Hanno Mott for their interest and generous support. I am most grateful to Cynthia Garvey, Archivist at the Marlborough Gallery, for her dedication and patience in helping me with my research, particularly in locating sculptures in public collections around the world. Joan Mercante and Sheri Pasquarella did admirable jobs in transferring my handwritten manuscript onto computer discs. Dr. Cathy Pütz, who recently completed her Ph.D thesis on the cubist sculpture of Lipchitz and Laurens, has given moral support and scholarly expertise to this project. She has been particularly helpful in tracking down and identifying sculptures omitted from *Volume One: The Paris Years 1910-1940,* and which appear in the Addendum on pp. 18-24. David Fraser Jenkins has always believed in the importance of this catalogue raisonné, and has given his support and scholarly advice on numerous occasions.

I would like to thank friends and colleagues who, in many different ways, have helped with the realization of *Volume Two: The American Years 1941-1973:* Dr. A.M.Beattie, His Grace The Duke of Beaufort, Alice Beckley, Barbara Boutin, Adrian Brink, Julia Brown, Phillip Bruno, Robert Buck, Paddy-Ann and Latham Burns, Georgiana Butler, Sir Anthony Caro, Janet Charlton, the late Bill Charlton, Geoffrey and Carolyn Chesler, Mary and Malcolm Cochrane, Harriet Cochrane, Dominic and Patzi Craven, Martin Davis, Caroline and Martin Davis, Edmund Davis, Ramsay Derry, L. A. B. Dodge, N. M. Dodge, R. G. L. Dodge, James and Sharon Edwards, Deborah Emont Scott, Gila Falkus, John Farnham, Antonia Fraser, Linda Frum, Dr. Murray Frum, George and Debby Gibbons, Dr. John Golding, Dr. Christopher Green, Kathleen Harleman, Patricia Jackson, John and Nicola Jennings, Dr. Dorothy Kosinski, Gilbert Lloyd, Nancy Lockhart, Anna and Francesco Macchi, Scott Marshall, Jennifer Marra, Donald Matthews, Robert and Renwick Matthews, Jane and John Lorn McDougall, Jenny McDougall, Fiona and Robert McElwain, Karen McKenzie, Jane and Michael Meredith, Peter and Sandy Merry, Herbert Michel, Iain Miller, Robert O'Rorke, Michael Parke-Taylor, Geoffrey Parton, Larry Pfaff, Harold Pinter, Franz and Maria Plutschow, Michael Plutschow, Judith Robertson, Tim and Leila Rose Price, Bill and Janet Rowley, Graham and Diana Rowley, Susan Sharratt, Charlie Simpson, Randall Speller, Robert Spring, Lisa Tankoos, Danielle Thornton, the late Betty Tinsley, Joy Tinsley, Alan Toff, Denzil Wadds, Hermione Waterfield, William Withrow, and Grace Zandarski.

A.G.W.

10a
Portrait of a Young Girl, c. 1912
Plaster
H. unknown
Whereabouts unknown

11a
Portrait of Mme. B., 1913
Plaster
H. unknown
Whereabouts unknown

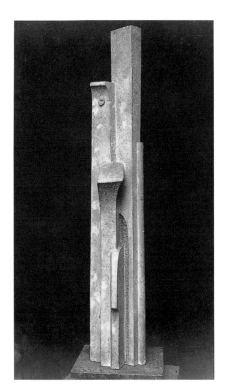

37a
Sculpture, 1915-16
Stone (unique)
H. 48 in. approx./122.0 cm
Whereabouts unknown
Former collection: Vicomte de Noailles

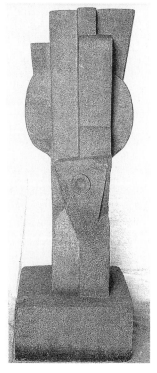

49a
Bather, c. 1916
Stone (unique)
H. 42.12 in/107.0 cm
Musée d'art et d'histoire du Judaïsme, Paris

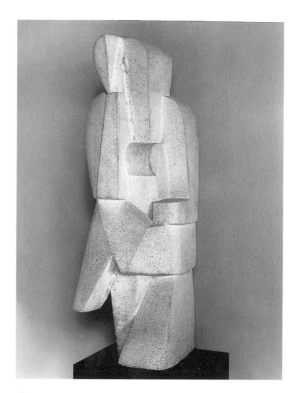

57a
Seated Bather, 1916-17
Stone (unique)
H. 33 in/83.8 cm
The David and Alfred Smart Museum of Art,
The University of Chicago

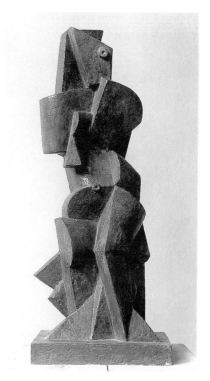

65a
Bather, 1917
Bronze, edition of 7
H. 34 in/86.36 cm
Museum Moderner Kunst
Stiftung Ludwig, Vienna

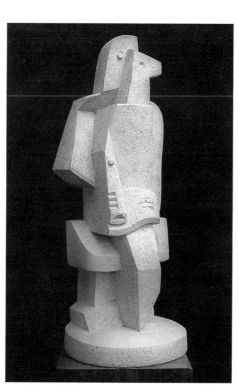

l04a
Seated Man with Clarinet I, 1919-20
Stone (unique)
H. 29 in approx./73.7 cm
Whereabouts unknown

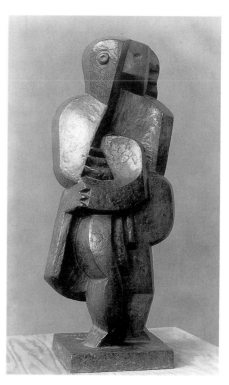

170a
Bather, 1924
Bronze, edition of 7
H. 25.5 in/63.5 cm

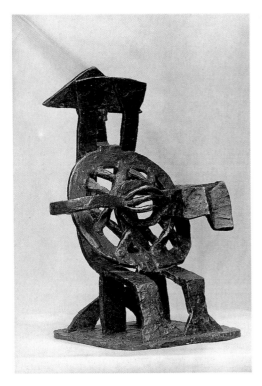

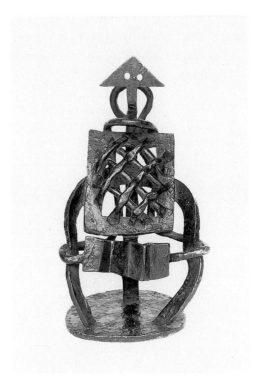

l90a
Seated Harlequin with Mandolin, 1926
Bronze (unique)
H. 8.26 in/21.0 cm
Whereabouts unknown

190b
Harlequin with Accordion (author's title), 1926
Bronze (unique)
H. 9.62 in/24.5 cm
Whereabouts unknown

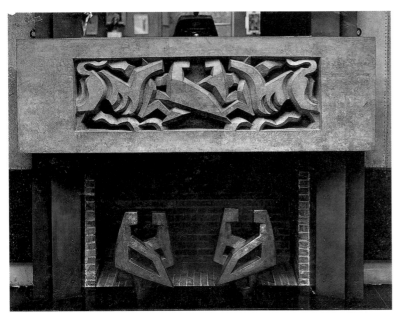

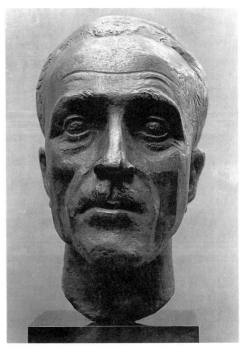

211a
Andirons and Fireplace Relief, 1927
Commissioned by Jacques Doucet
Bronze (andirons); stone ? (relief)
Dimensions unknown
Whereabouts unknown

212a
Portrait of Dr. Jacques Le Mée, 1928
Bronze, edition unknown
H. unknown

216a
Woman with Guitar, 1928
Bronze (unique)
H. 10.23 in/26.0 cm
Whereabouts unknown

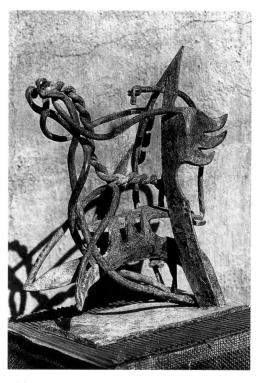

244a
Pierrot on Horseback, 1930
Bronze (unique)
H. unknown
Whereabouts unknown

245
Transparent, 1930
This unique bronze was incorrectly titled and
dated in *Volume One: The Paris Years.* It now
appears in *Volume Two, the American Years,*
No. 361, *Variation,* 1942.

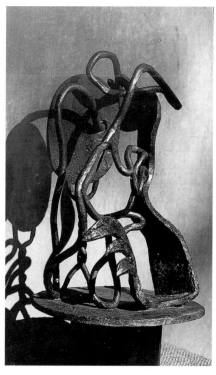

260a
Elle, 1931
Bronze (unique)
H. unknown
Whereabouts unknown

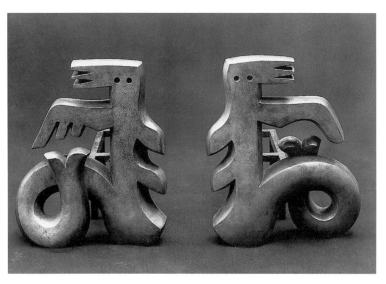

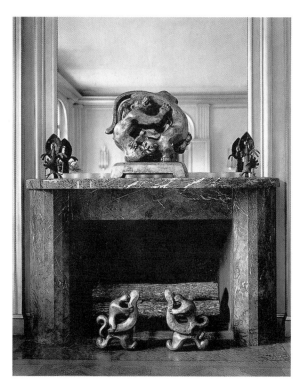

279a
Andirons, 1932
Commissioned by Pierre David-Weill
Bronze (unique)
Dimensions unknown
Whereabouts unknown

279b
Andirons and Mantlepiece Sculptures, c. 1932 (1936?)
Commissioned by Comte André de Fels
Bronze (unique)
Dimensions unknown
Whereabouts unknown

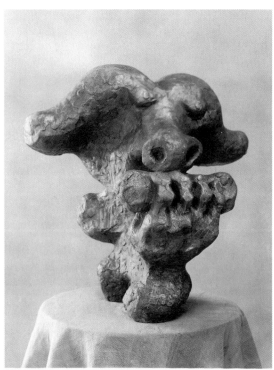

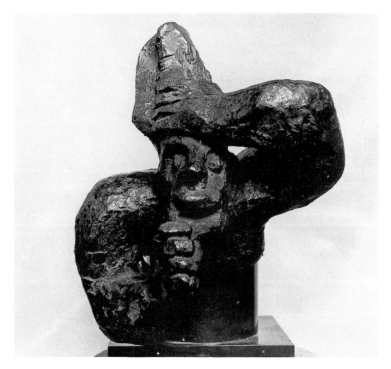

295
Head and Hand (also known as *Pastorale*), 1933
This bronze was incorrectly titled and dated in *Volume One: The Paris Years*. It now appears in *Volume Two: The American Years,* No. 373, *Pastorale* (also known as *Pastoral*), 1942.

337a
The Terrified One (author's title), c. 1936
Bronze, edition unknown
H. unknown

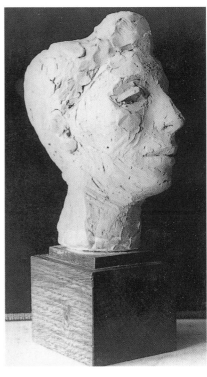
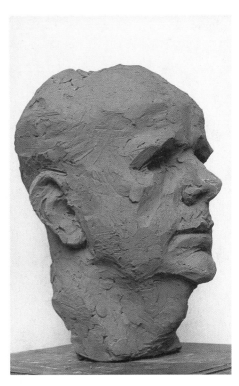
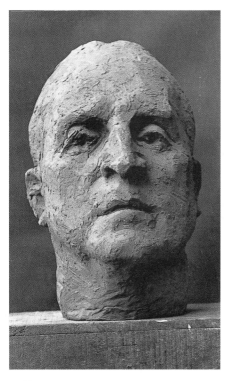

344a
Jenny Courtois de Viçose, 1940 (Toulouse)
Plaster?
H. unknown
Whereabouts unknown

344b
Prof. Louis Bugnard, 1940 (Toulouse)
Terracotta (unique)
H. unknown
Whereabouts unknown

344c
Prof. ?, 1940 (Toulouse)
Terracotta (unique)
H. unknown
Whereabouts unknown

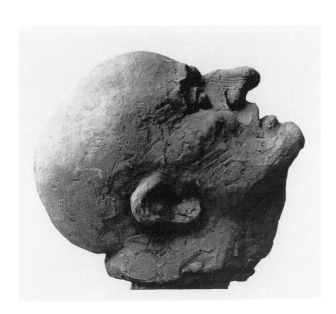
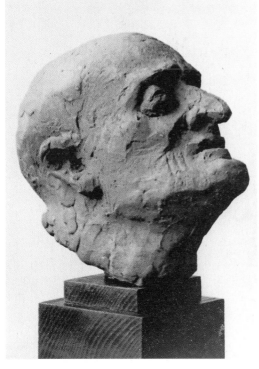

344d
*Study for the Portrait of Prof. Camille
Soula I,* 1940-41 (Toulouse)
Terracotta (unique)
H. unknown
Whereabouts unknown

344e
*Study for the Portrait of Prof. Camille
Soula II,* 1940-41 (Toulouse)
Terracotta (unique)
H. unknown
Whereabouts unknown

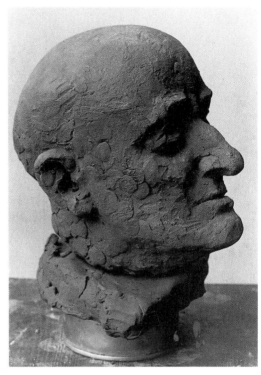

344f
*Study for the Portrait of Prof. Camille
Soula III,* 1940-41 (Toulouse)
Terracotta (unique)
H. unknown
Whereabouts unknown

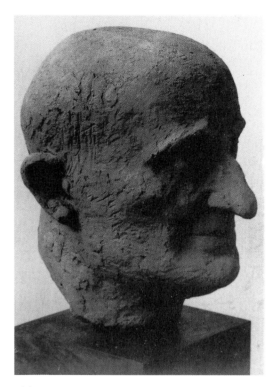

344g
*Study for the Portrait of Prof. Camille
Soula IV,* 1940-41 (Toulouse)
Terracotta (unique)
H. unknown
Whereabouts unknown

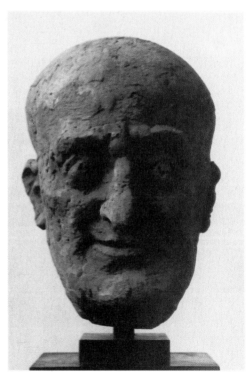

344h
*Study for the Portrait of Prof. Camille
Soula V,* 1940-41 (Toulouse)
Terracotta (unique)
H. unknown
Whereabouts unknown

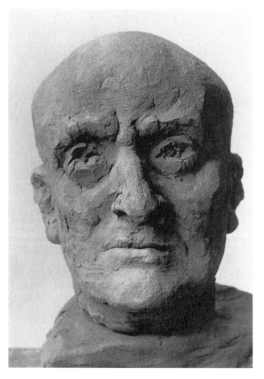

344i
*Study for the Portrait of Prof. Camille
Soula VI,* 1940-41 (Toulouse)
Terracotta (unique)
H. unknown
Whereabouts unknown

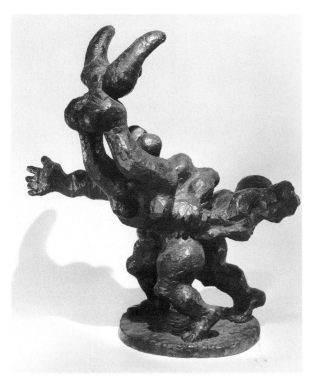

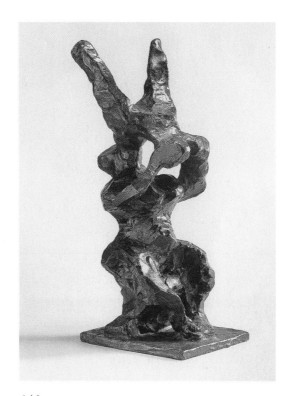

345
Arrival, 1941
Bronze, edition of 7
H. 21 in / 53.3 cm
Des Moines Art Center, Des Moines, Iowa; Minnesota Museum of
American Art, St. Paul, Minnesota

346
Study for Return of the Child, 1941
Bronze, edition of 7
H. 11.75 in / 29.9 cm
Israel Museum, Jerusalem

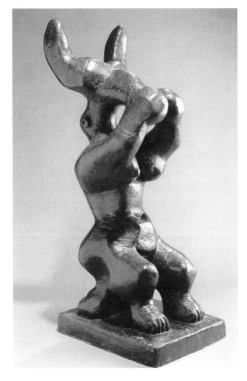

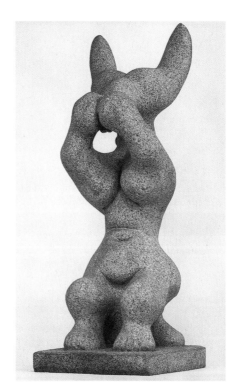

347
Return of the Child, 1941
Bronze, edition of 7
H. 45 in /114.3 cm

348
Return of the Child, 1941-43
Granite (unique)
H. 45.75 in /116.2 cm
Former collection: The Solomon R. Guggenheim Museum, New York

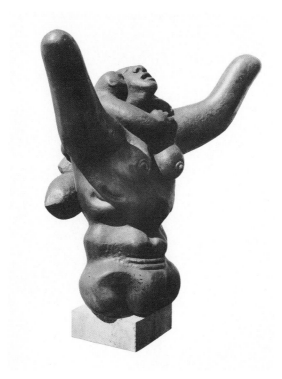

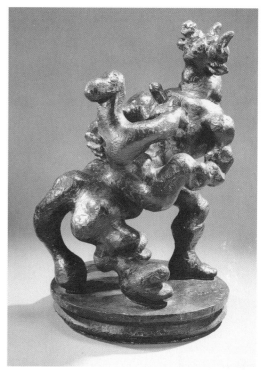

349
Mother and Child II, 1941
Bronze, edition of 7
H. 50 in/127.0 cm
Art Gallery of Ontario, Toronto; Baltimore Museum of Art; Israel Museum,
Jerusalem; The Museum of Modern Art, New York; Norman MacKenzie
Art Gallery, Regina, Saskatchewan; Philadelphia Museum of Art

350
Rape of Europa, 1941
Bronze, edition of 7
H. 33.5 in /85.1 cm

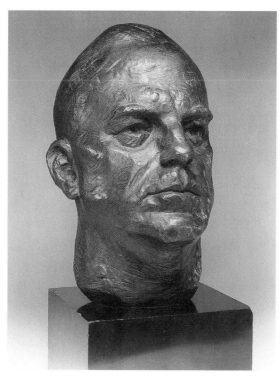

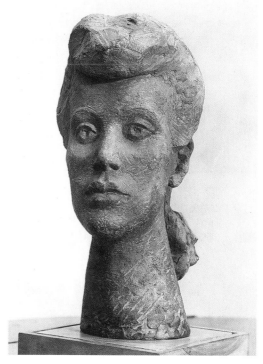

351
Portrait of T. Catesby Jones, 1941
Bronze, edition of 2 (?)
H. 16 in /40.6 cm
Virginia Museum of Fine Arts, Richmond

352
Portrait of Barbara Rice Poe I, 1941
Terracotta (unique)
H. 13 in /33.0 cm
Whereabouts unknown

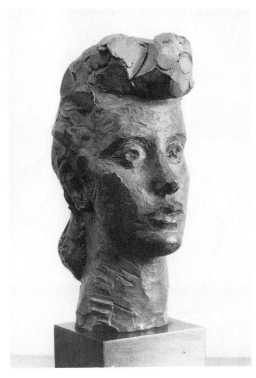

353
Portrait of Barbara Rice Poe II, 1941
Bronze, edition unknown
H. 13 in /33.0 cm

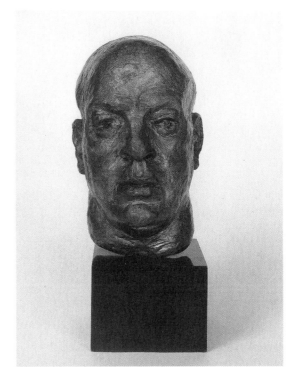

354
Portrait of Curt Valentin, 1941-42
Bronze (unique)
H. 15 in /38.0 cm
The Museum of Modern Art, New York

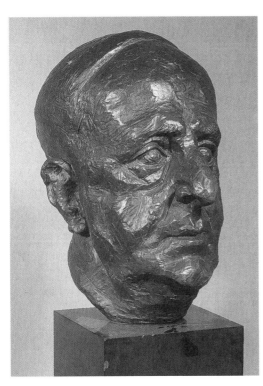

355
Portrait of Marsden Hartley, 1942
Bronze, edition of 7
H. 15 in /38.1 cm
Des Moines Art Center, Des Moines, Iowa; Hirshhorn Museum and
Sculpture Garden, Smithsonian Institution, Washington, D.C.

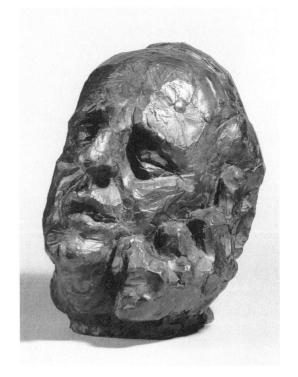

356
Marsden Hartley Sleeping, 1942
Bronze, edition of 7
H. 10.75 in /27.3 cm

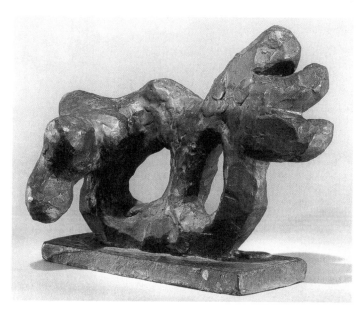

357
Sketch for Benediction I: Maquette No. 1, 1942
Bronze, edition of 7
L. 7.87 in /20.0 cm

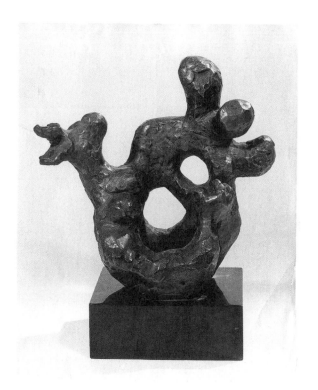

358
Sketch for Benediction I: Maquette No. 2, 1942
Bronze, edition of 7
L. 8.5 in /21.6 cm

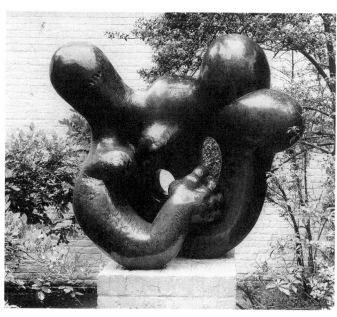

359
Benediction I, 1942-44
Bronze (unique)
H. 42 in /106.7 cm

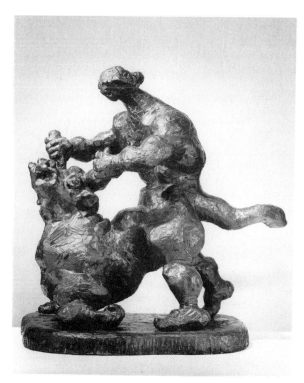

360
Theseus and the Minotaur (also known as *Theseus*), 1942
Bronze, edition of 7
L. 28.5 in /72.4 cm
Haags Gemeentemuseum, The Hague; Nelson-Atkins Museum of
Art, Kansas City, Missouri; Walker Art Center, Minneapolis,
Minnesota.

(This is the sequence in which the twelve bronzes were catalogued in: *Jacques Lipchitz,* Buchholz Gallery, New York, 1943)

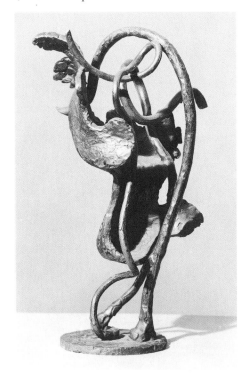

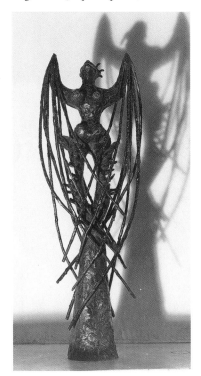

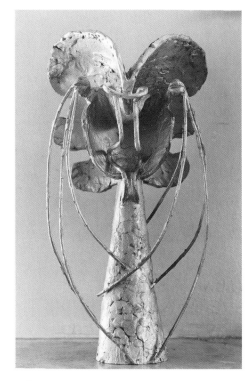

361
Variation, 1942
Bronze (unique)
H. 15 in /38.1 cm
This sculpture was incorrectly catalogued in *Volume One: The Paris Years,* No. 245, as *Transparent,* 1930.

362
The Promise, 1942
Bronze (unique)
H. 18 in /45.7 cm

363
Barbara, 1942
Bronze (unique)
H. 15.87 in /40.3 cm
Smith College Museum of Art, Northampton, Massachusetts

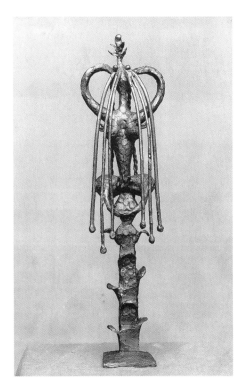

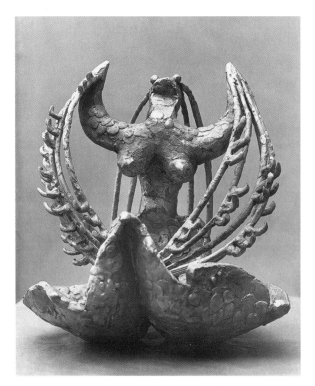

364
The Fiancée, 1942
Bronze (unique)
H. 21.5 in /54.2 cm

365
Yara I, 1942
Bronze (unique)
H. 22 in /55.9 cm

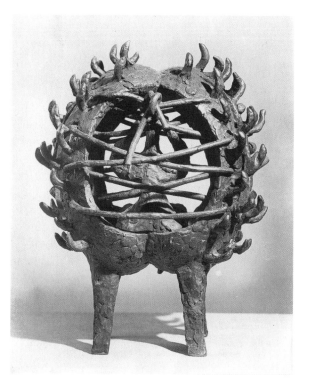

366
Spring, 1942
Bronze (unique)
H. 14 in /35.6 cm

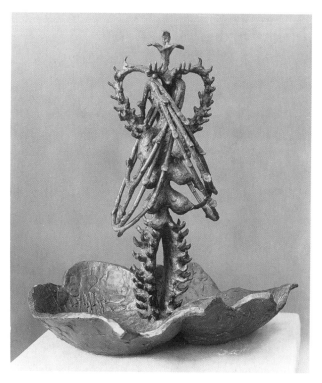

367
Yara II, 1942
Bronze (unique)
H. 22 in /55.9 cm

368
Album Page, 1942
Bronze (unique)
18 x 22.75 in /45.7 x 57.9 cm

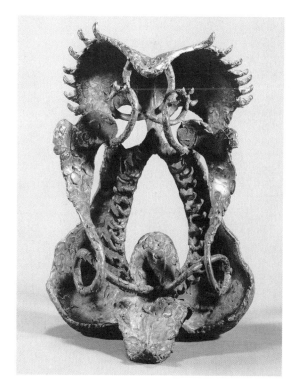

369
Myrrah, 1942
Bronze (unique)
H. 22.75 in /57.9 cm

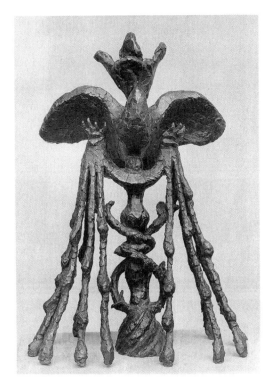

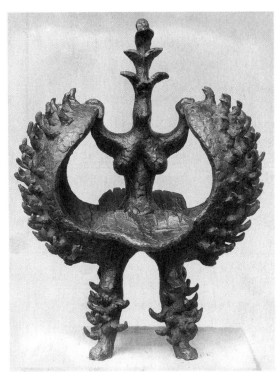

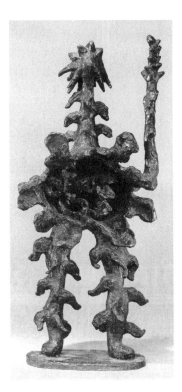

370
Innocent Victim, 1942
Bronze (unique)
H. 18 in /45.7 cm
The Harvard University Art Museums, Cambridge,
Massachusetts

371
Blossoming, 1942
Bronze (unique)
H. 21.5 in /54.6 cm
The Museum of Modern Art, New York

372
The Pilgrim, 1942
Bronze (unique)
H. 29.75 in /75.6 cm

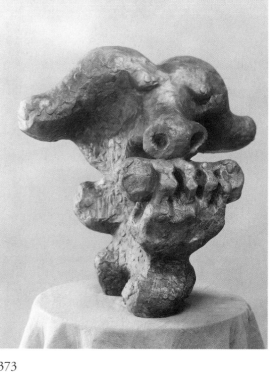

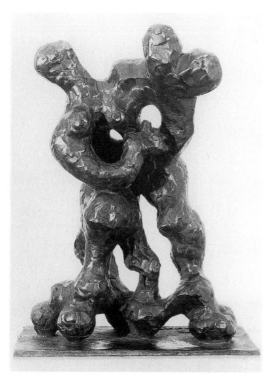

373
Pastorale (also known as *Pastoral*), 1942
Bronze, edition of 7, H. 22 in /55.9 cm
This sculpture, with the addition of a conical pedestal, was incorrectly catalogued in *Volume One: The Paris Years,* No. 295, as *Head and Hand* (also known as *Pastorale*), 1933, H. 30.62 in /77.8 cm

Photograph unavailable

374
The Betrothed, 1942
Bronze, edition unknown
H. 17.75 in /45.1 cm
Catalogue No. 76, in: *Sculpture by Jacques Lipchitz,* Tate Gallery, London, 1959.

375
Sketch for Benediction II, 1943
Bronze, edition of 7
H. 14.62 in /37.2 cm

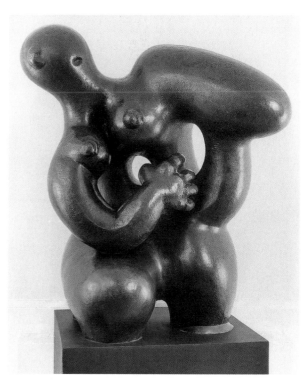

376
Benediction II, 1943-45
Bronze (unique)
H. 56.5 in /143.5 cm

377
The Prayer, 1943
Bronze (unique)
H. 42.5 in /108.0 cm
Philadelphia Museum of Art

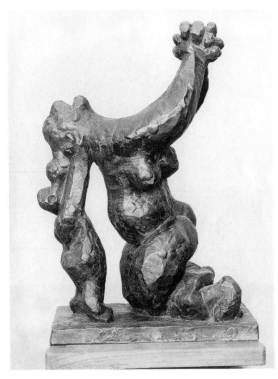

378
The Suppliant, 1943
Bronze, edition unknown
H. 17.5 in /44.5 cm
Musée d'art et d'histoire du Judaïsme, Paris

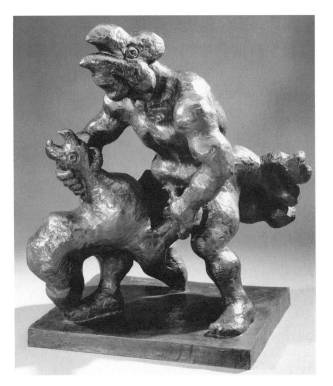

379
Prometheus Strangling the Vulture, 1943
Bronze, edition of 7
H. 37.5 in /95.3 cm
The Art Museum, Princeton University, Princeton, New Jersey

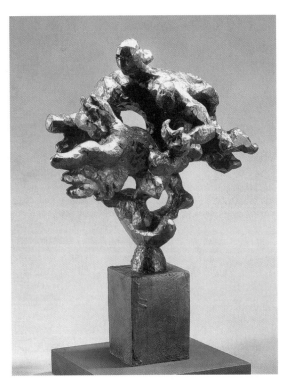

380
Prometheus Strangling the Vulture, 1943
Bronze, edition of 7, H. 16 to 20 in /40.1 to 50.8
cm, depending on height of pedestal
Portland Art Museum, Portland, Oregon; Worcester Art
Museum, Worcester, Massachusetts; Stedelijk Museum,
Amsterdam

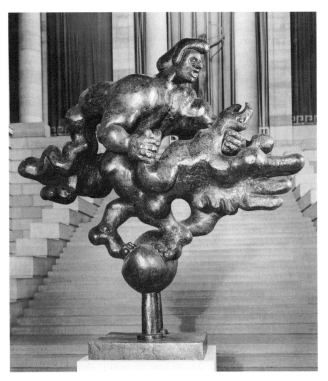

381
Prometheus Strangling the Vulture, 1944-53
Bronze, edition of 2
H. 7 ft 9 in /236.2 cm
Philadelphia Museum of Art; Walker Art Center, Minneapolis, Minnesota

34

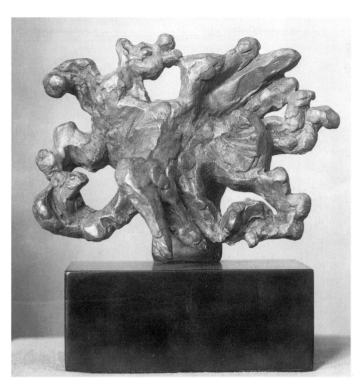

382
Birth of the Muses I, 1944
Bronze, edition of 7
H. 5 in /12.7 cm

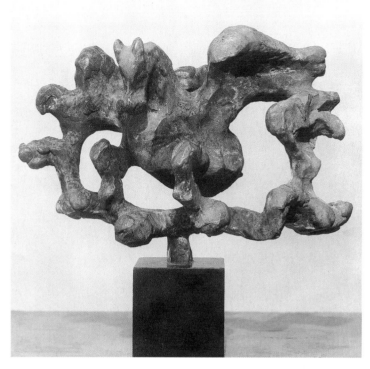

383
Birth of the Muses II, 1944
Bronze, edition unknown
L. 7.12 in /18.1 cm
Stedelijk Museum, Amsterdam

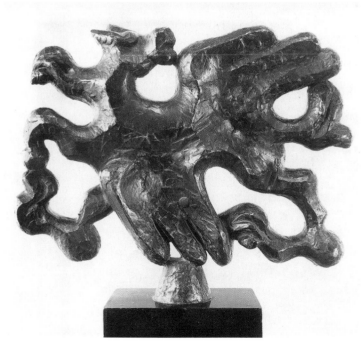

384
Pegasus (also known as Birth of the Muses), 1944
Bronze, edition of 7
L. 20.56 in /53.3 cm
Cincinnati Art Museum; Israel Museum, Jerusalem

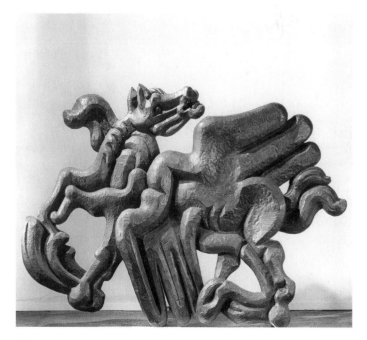

385
Birth of the Muses, 1944-50
Bronze, edition of 7
60.5 x 89 in /153.7 x 226.1 cm
Lincoln Center for the Performing Arts, New York; MIT List Visual Art Center,
Cambridge, Massachusetts; Syracuse University Art Collection, Syracuse, New York

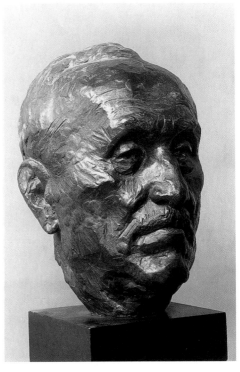

Photograph unavailable

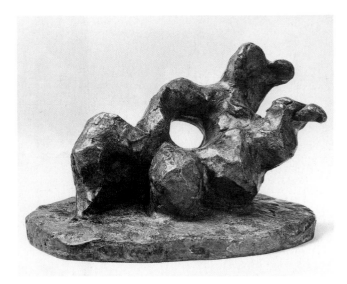

386
Portrait of the Poet Leib Jaffe, 1944
Bronze, edition of 7
H. 15 in /38.1 cm
Tel Aviv Museum of Art, Israel

387
Portrait of W. Oertly, 1944
Terracotta (unique)
H. 12.5 in /31.8 cm
Catalogue No. 9 with small illustration in: *Jacques Lipchitz,* Buchholz Gallery, New York, 1946.

388
Song of Songs: Maquette No. 1
(also known as *First Study for Song of Songs*), 1944
Bronze, edition of 7
L. 7 in /17.8 cm
Israel Museum, Jerusalem

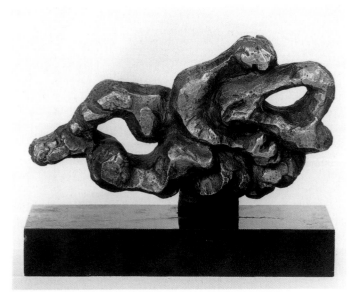

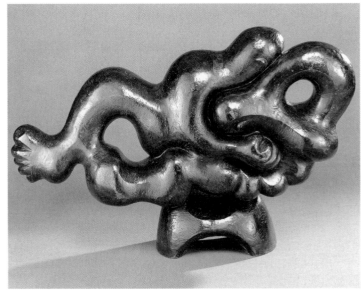

389
Song of Songs: Maquette No. 2
(also known as *Sketch for Song of Songs*), 1945
Bronze, edition unknown
L. 7.87 in /20.0 cm
Stedelijk Museum, Amsterdam

390
Song of Songs, 1945
Bronze, edition of 7
L. 36 in /91.5 cm
Indiana University Art Museum, Bloomington, Indiana; MIT List Visual Art Center, Cambridge, Massachusetts

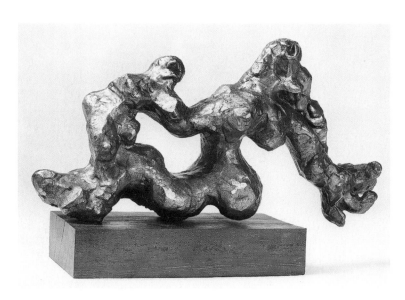

391
Mother and Child, 1945
Bronze, edition unknown
L. 11 in /27.9 cm
Israel Museum, Jerusalem

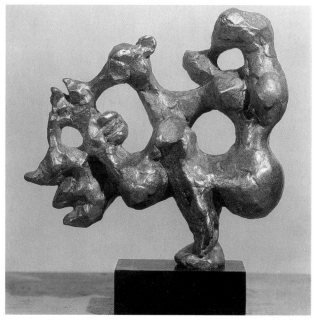

392
Sketch for Massacre: Maquette No. 1, 1945
Bronze, edition unknown
H. 5.75 in /14.6 cm

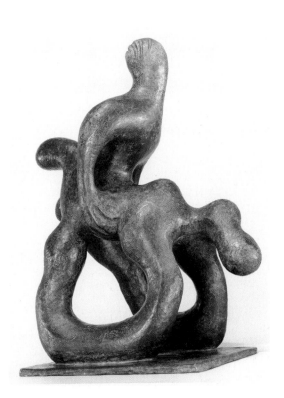

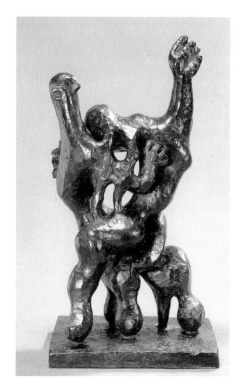

Photograph unavailable

393
Sketch for Massacre: Maquette No. 2, 1945
Bronze, edition unknown
H. 5.75 in /14.6 cm
Catalogue No. 15 in: *Jacques Lipchitz,* Buchholz Gallery, New York, 1946.

394
The Rescue, 1945
Bronze, edition of 7
H. 15.75 in /40.0 cm

395
The Joy of Orpheus I, 1945
Bronze, edition of 7, H. 18.5 in /47.0 cm
The Harvard University Art Museums, Cambridge, Massachusetts; Hirshhorn Museum and Sculpture Garden, Smithsonian Institution, Washington, D.C.; Washington University Gallery of Art, St. Louis, Missouri

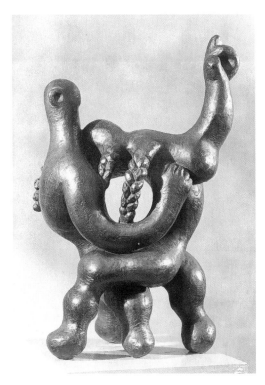

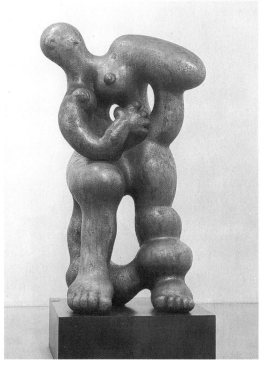

396
The Joy of Orpheus II, 1945-46
Bronze, edition of 7
H. 20 in /50.8 cm

397
Benediction, 1945
Bronze (unique)
H. 7 ft/213.4 cm

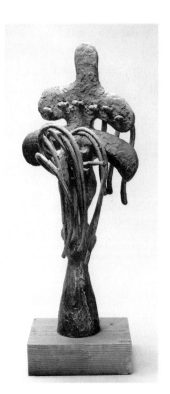

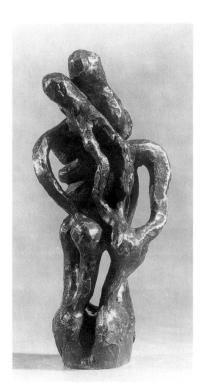

398
Trentina, 1946
Bronze (unique)
H. 20.56 in /52.2 cm
The Harvard University Art Museums, Cambridge,
Massachusetts

399
Aurelia, 1946
Bronze (unique)
H. 25.37 in /64.5 cm
Peggy Guggenheim Collection,
Venice, The Solomon R. Guggenheim
Foundation, New York

400
Happiness (Study), 1947
Bronze, edition unknown
H. 9.75 in /24.8 cm

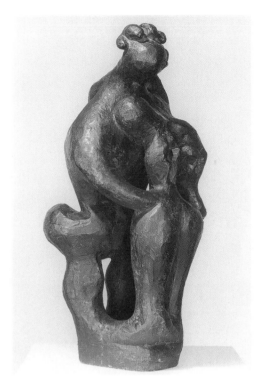

401
Happiness, 1947
Bronze, edition of 7
H. 19.25 in /48.9 cm
University of Michigan Museum of Art, Ann Arbor

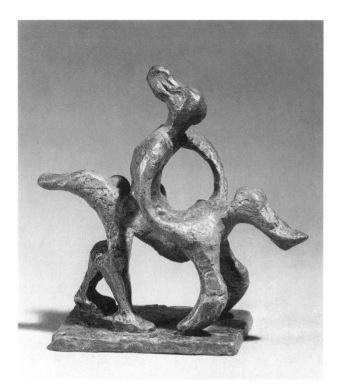

402
Rescue II (Study): Maquette No. 1, 1947
Bronze, edition of 1 or 2
H. 6 in /15.2 cm

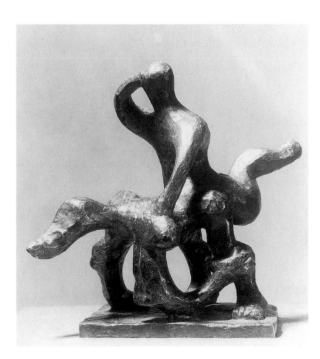

403
Rescue II (Study): Maquette No. 2, 1947
Bronze, edition unknown
H. 8 in /20.3 cm

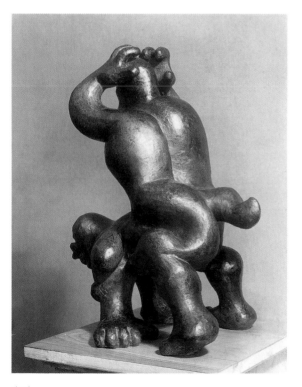

404
Rescue II, 1947
Bronze, edition of 7
H. 20 in /50.8 cm
Norton Museum of Art,
West Palm Beach, Florida

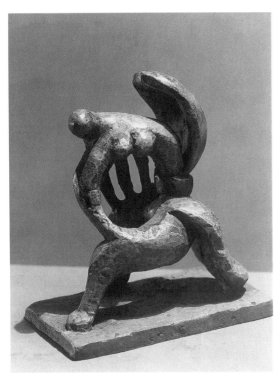

405
Dancer with Hood (Study)
(also known as *Danseuse au Capuchon (Study)*), 1947
Bronze, edition unknown
H. 9 in /22.8 cm

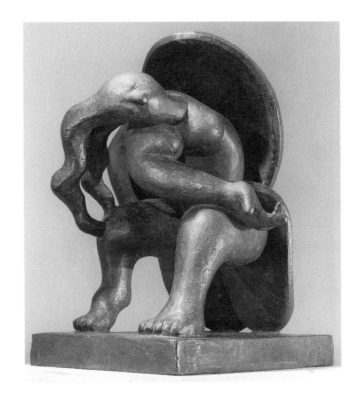

406
Dancer with Hood
(also known as *Danseuse au Capuchon*), 1947
Bronze, edition of 7
H. 21.12 in /53.7 cm
Niigata City Art Museum, Japan

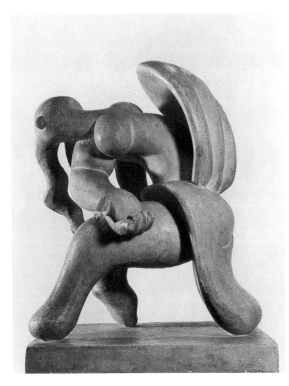

407
Dancer with Hood, 1947
Artificial stone
H. 20.87 in /53.0 cm
Tel Aviv Museum of Art, Israel

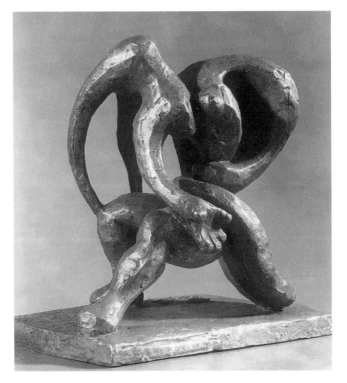

408
Dancer with Drapery
(also known as *Dancer*), 1947
Bronze, edition unknown
H. 8.25 in /21.0 cm

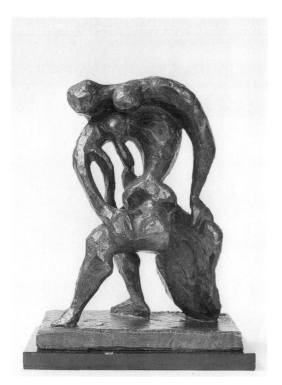

409
Dancer with Train
(also known as *Dancer with Veil,* and
Dancer), 1947
Bronze, edition unknown
H. 9.12 in /23.2 cm
Israel Museum, Jerusalem

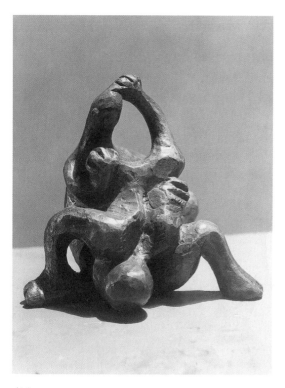

410
Couple I, 1947
Bronze, edition unknown
H. 5 in /12.7 cm
Israel Museum, Jerusalem

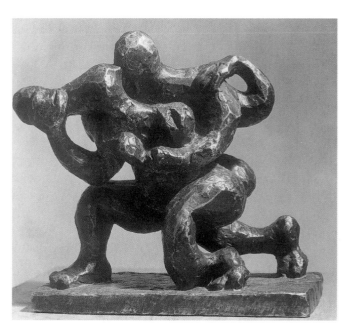

411
Couple II, 1947
Bronze, edition of 7
H. 8 in /20.3 cm

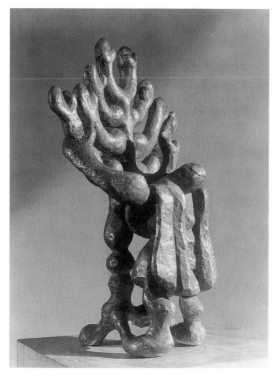

412
Miracle
(also known as *Miracle I*), 1947
Bronze, edition unknown
H. 14.25 in /36.2 cm

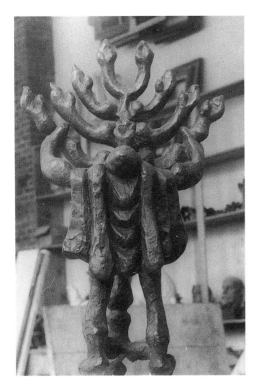

413
Miracle, 1947
Bronze, edition unknown
H. unknown
Photographed in Lipchitz's studio, Hastings-
on-Hudson, New York

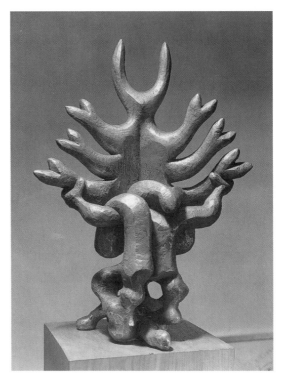

414
Exodus, 1947
Bronze, edition of 7
H. 22 in /55.9 cm

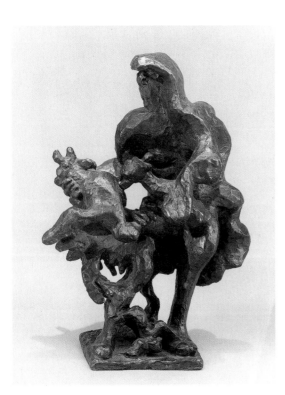

415
First Study for Sacrifice
(also known as *Sacrifice (Study)*), 1947
Bronze, edition of 7
H. 13.62 in /34.6 cm
Philadelphia Museum of Art

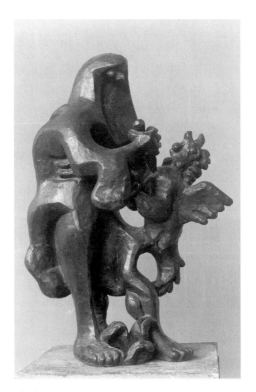

416
Second Study for Sacrifice (also known as
Sacrifice 1), 1947, Bronze, edition of 7
H. 19 in /48.3 cm
Herbert F. Johnson Museum of Art, Cornell University,
Ithaca, New York; Portland Art Museum, Portland,
Oregon; The David and Alfred Smart Museum of Art,
The University of Chicago; University of Iowa Museum
of Art, Iowa City, Iowa

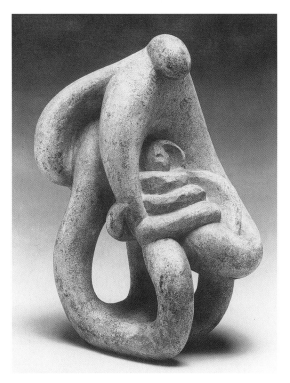

417
Cradle I, 1947
Cast stone (unique)
H. 12.25 in /31.1 cm

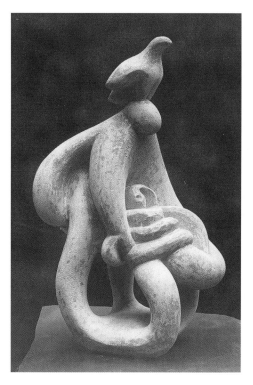

418
Cradle II, 1947
Cast stone (unique)
H. 15.25 in /38.7 cm

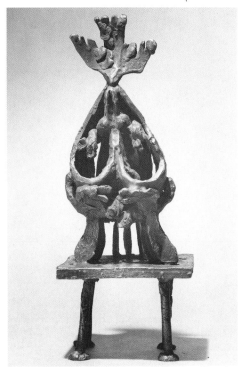

419
Notre Dame de Liesse:
Maquette No. 1, 1948
Bronze (unique)
H. 9.25 in /23.5 cm

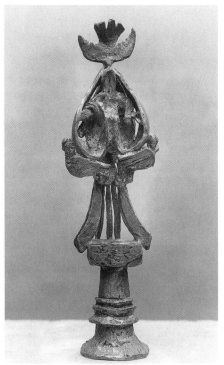

420
Notre Dame de Liesse:
Maquette No. 2, 1948
Bronze (unique)
H. 8.75 in /22.2 cm

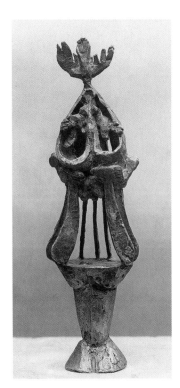

421
Notre Dame de Liesse:
Maquette No. 3, 1948
Bronze (unique)
H. 8.25 in /21.0 cm

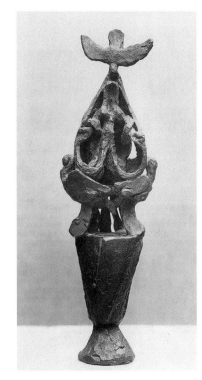

422
Notre Dame de Liesse:
Maquette No. 4, 1948
Bronze (unique)
H. 8.25 in /21.0 cm

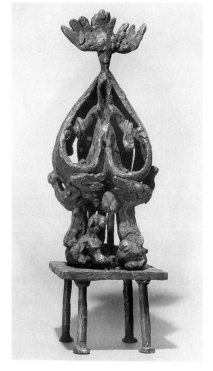

423
Notre Dame de Liesse:
Maquette No. 5, 1948
Bronze (unique)
H. 10 in /25.4 cm

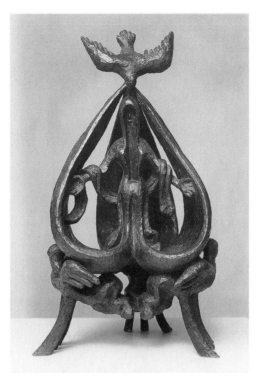

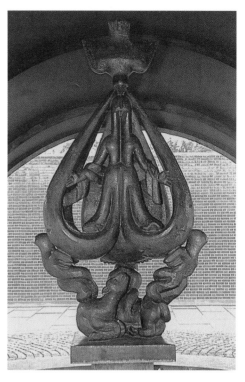

424
Study for Notre Dame de Liesse, 1948
Bronze, edition of 7
H. 33 in /83.8 cm
The David and Alfred Smart Museum of Art, The
University of Chicago

425
Notre Dame de Liesse, 1948-55
Bronze, edition of 3
H. 97 in /246.4 cm
The Abbey of Saint Columba, Iona, Argyll, Scotland;
Notre Dame de Toute Grâce, Assy, Haute-Savoie;
Roofless Church, New Harmony, Indiana

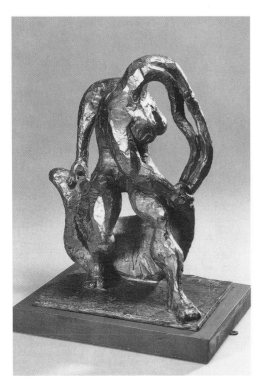

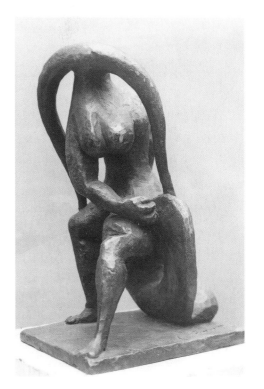

426
Dancer with Braids
(also known as *Study for Dancer with Braids*), 1948
Bronze, edition of 7
H. 13.25 in /33.7 cm
Baltimore Museum of Art

427
Dancer with Braids, 1948
Bronze, edition unknown
H. 14.25 in /36.2 cm

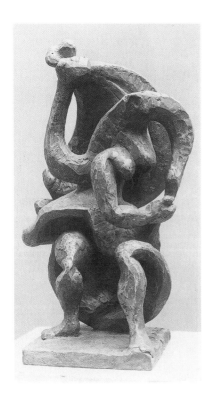

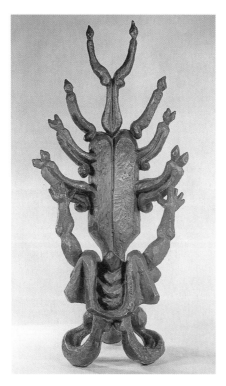

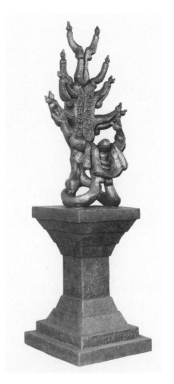

428
Dancer, 1948
Bronze, edition unknown
H. 13.75 in /35.0 cm

429
Miracle II, 1948
Bronze, edition of 7
H. 30 in /76.2 cm
The Harvard University Art Museums,
Cambridge, Massachusetts; The Jewish
Museum, New York

430
Miracle II, 1948
Bronze, edition of 7
H. 110 in./279.4 cm

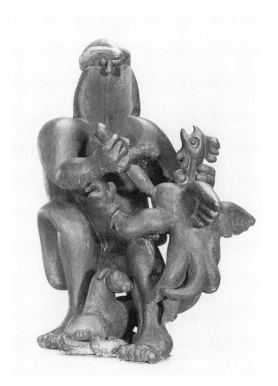

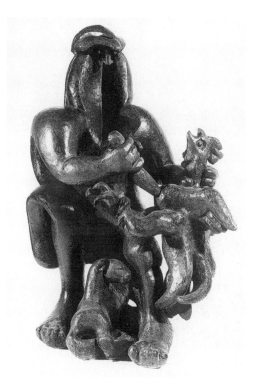

431
Sacrifice, 1948
Bronze (unique)
H. 48.75 in /123.9 cm
Albright-Knox Art Gallery, Buffalo, New York

432
Sacrifice II, 1948-52
Bronze (unique)
H. 49.25 in /125.1 cm
Whitney Museum of American Art, New York

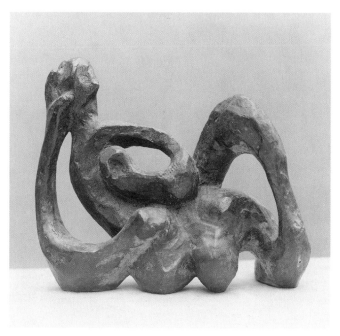

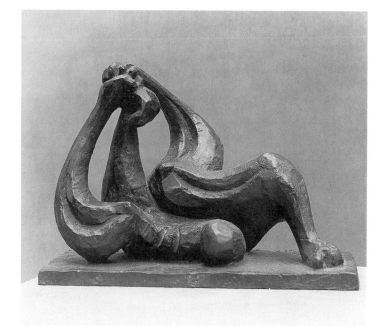

433
Study for Hagar: Maquette No. 1, 1948
Bronze, edition unknown
L. 8.5 in /21.6 cm
The David and Alfred Smart Museum of Art, The University of Chicago;
Philadelphia Museum of Art

434
Study for Hagar: Maquette No. 2, 1948
Bronze, edition unknown
L. 8.75 in /22.2 cm
The David and Alfred Smart Museum of Art, The University of Chicago

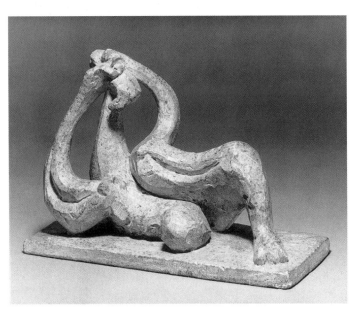

435
Study for Hagar: Maquette No. 2, 1948
Plaster and iron filings, edition of 10
L. 9 in /22.8 cm

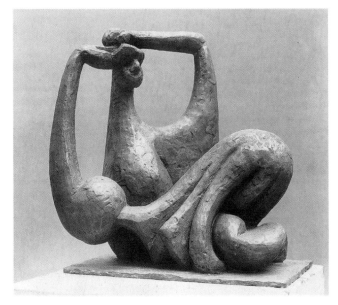

436
Study for Hagar: Maquette No. 3, 1948
Bronze, edition unknown
H. approx. 9.5 in /21.1 cm

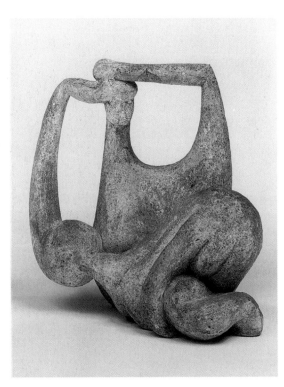

437
Study for Hagar: Maquette No. 3, 1948
Plaster and iron filings, edition of 10
H. 9.5 in /24.1 cm
Rijksmuseum Kröller-Müller, Otterlo, The Netherlands; The David
and Alfred Smart Museum of Art, The University of Chicago; Tate
Gallery, London

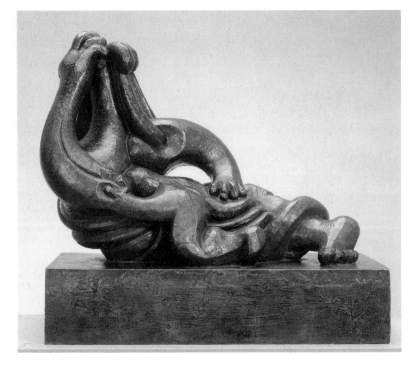

438
Hagar I, 1948
Bronze, edition of 7
L. 31.25 in /79.4 cm
Art Gallery of Ontario, Toronto

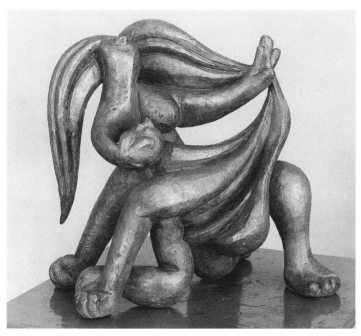

439
Hagar II
(also known as *Hagar*), 1949
Bronze, edition unknown
H. 13 in /33.0 cm
Los Angeles County Museum of Art, Los Angeles, California

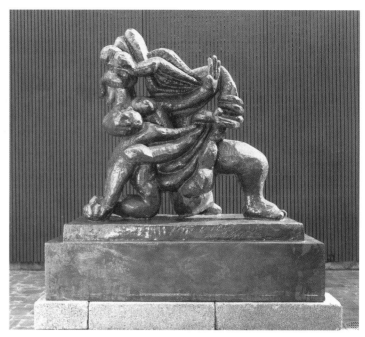

440
Hagar in the Desert (also known as *Hagar III*), 1949-57
Bronze, edition of 7
H. 39.5 in /100.4 cm
Von der Heydt-Museum Wuppertal, Germany;
MIT List Visual Art Center, Cambridge, Massachusetts

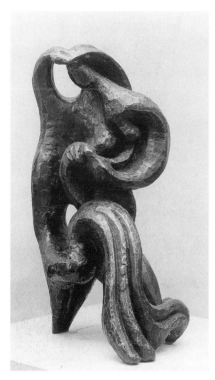

441
Mother and Child I, 1949
Bronze, edition of 7
H. 17.5 in /44.4 cm
The Jewish Museum, New York

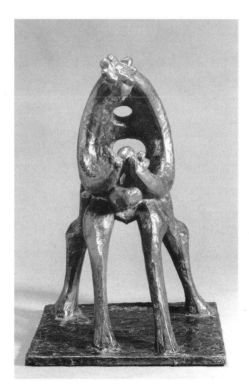

442
Mother and Child II, 1949
Bronze, edition of 7
H. 15.25 in /38.7 cm

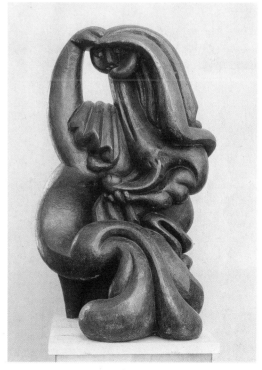

443
Mother and Child, 1949
Bronze, edition of 7
H. 48.5 in /123.3 cm
Washington University Gallery of Art, St. Louis, Missouri;
Wilhelm Lehmbruck Museum, Duisberg, Germany

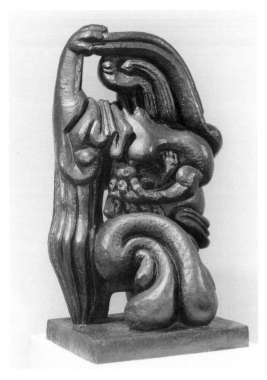

444
Mother and Child, 1949
Bronze, edition of 7
H. 57 in /144.8 cm
Birmingham Museum of Art, Birmingham, Alabama; Hood
Museum of Art, Dartmouth College, Hanover, New
Hampshire

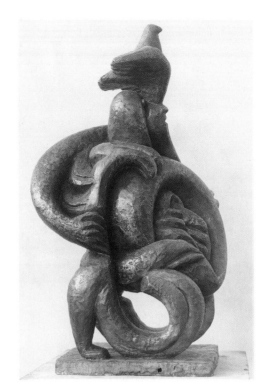

445
The Cradle, 1949-54
Bronze, edition unknown
H. 32.25 in /82 cm

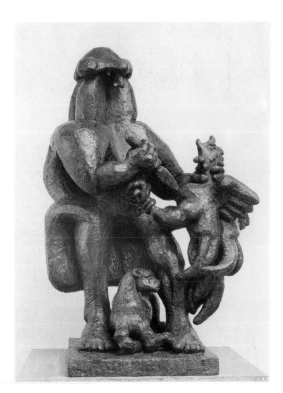

446
Sacrifice III (also known as *Sacrifice*), 1949-57
Bronze, edition of 7
H. 49.25 in /125.1 cm
Fundacion Museo de Bellas Artes de Caracas, Venezuela; Jewish
Museum, New York; MIT List Visual Art Center, Cambridge,
Massachusetts; Tel Aviv Museum of Art, Israel

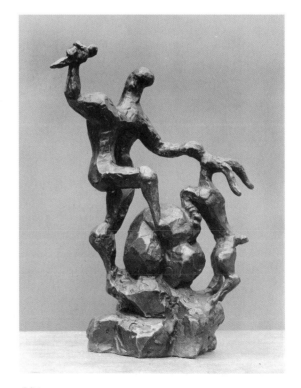

447
Biblical Scene I, 1950
Bronze, edition of 7
H. 12.37 in /31.4 cm

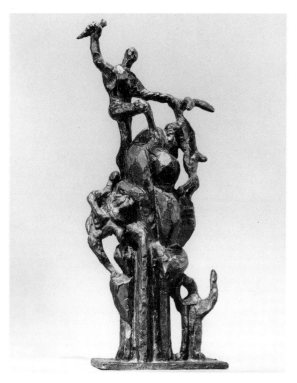

448
Biblical Scene II, 1950
Bronze, edition of 7
H. 20 in./50.8 cm
Des Moines Art Center, Des Moines, Iowa

449
Study for Birth of the Muses I
(also known as *Sketch for Pegasus*), 1950
Bronze, edition of 7
11 x 12.25 in /28.0 x 31.1 cm
Israel Museum, Jerusalem

450
Study for Birth of the Muses II, 1950
Bronze, edition unknown
Dimensions unknown

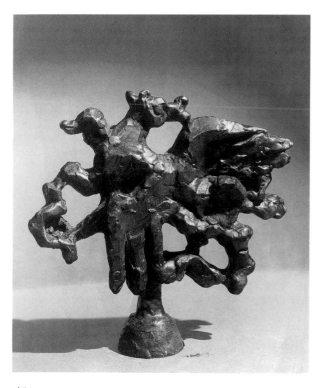

451
Study for Birth of the Muses III, 1950
Bronze, edition unknown
L. 9.5 in /21.1 cm

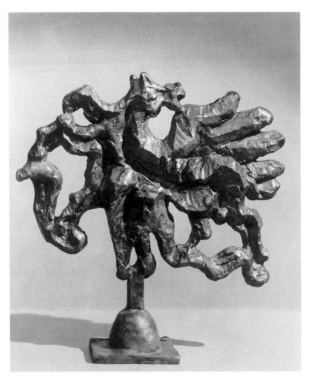

452
Study for Birth of the Muses IV
(also known as *Pegasus*), 1950
Bronze, edition of 7
L. 10.12 in /25.5 cm

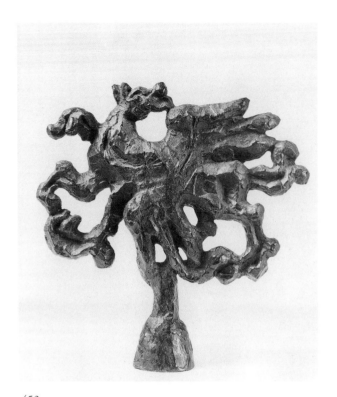

453
Study for Birth of the Muses V
(also known as *Pegasus*), 1950
Bronze, edition of 7
H. 9.84 in /25.0 cm
Israel Museum, Jerusalem

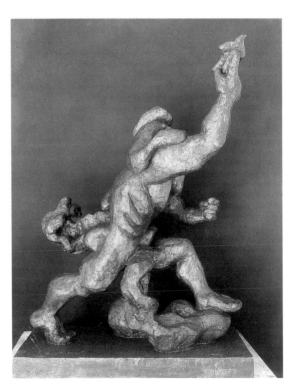

454
Study for a Monument (The Spirit of Enterprise), 1951
Bronze, edition of 7
H. 35.75 in /90.8 cm

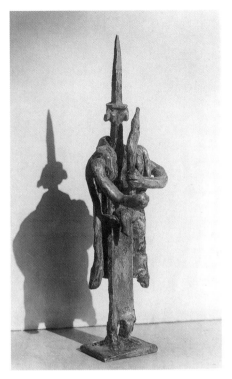

455
Variation on a Chisel I: Hebrew Object, Praying Man, 1951
Bronze (unique)
H. approx. 8.25 in /20.9 cm

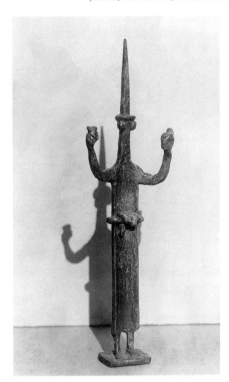

456
Variation on a Chisel II: Hebrew Object, Praying Man, 1951
Bronze (unique)
H. approx. 8.25 in /20.9 cm

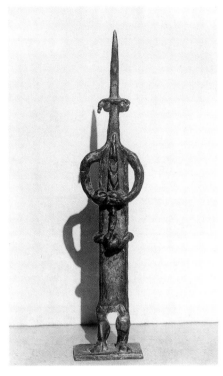

457
Variation on a Chisel III: Hebrew Object, 1951
Bronze (unique)
H. 8.75 in /22.2 cm

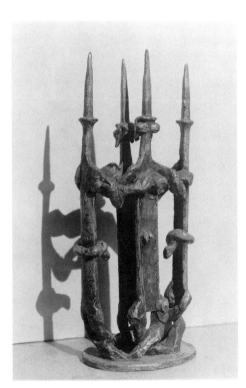

458
Variation on a Chisel IV: Hebrew Object, The Dance, 1951
Bronze (unique)
H. approx. 9 in /22.9 cm

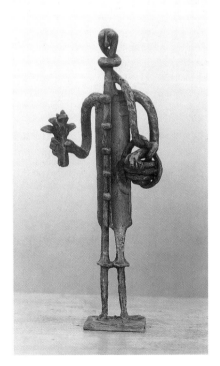

459
Variation on a Chisel V: Flower Vendor, 1951-52
Bronze (unique)
H. 9.5 in /24.1 cm

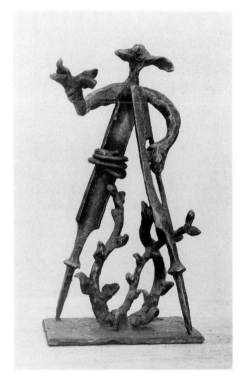

460
Variation on a Chisel VI: Begging Poet, 1951-52
Bronze (unique)
H. 8.5 in /21.6 cm

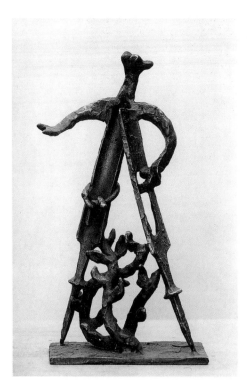

461
Variation on a Chisel VII: Begging Poet
(author's title), 1951-52
Bronze (unique)
H. approx. 9 in /22.9 cm

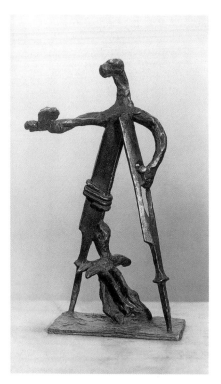

462
Variation on a Chisel VIII: Begging Poet (author's title), 1951-52
Bronze (unique)
H. 8.87 in /22.5 cm

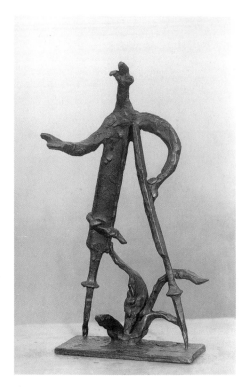

463
Variation on a Chisel IX: Begging Poet
(author's title), 1951-52
Bronze (unique)
H. 9 in /22.9 cm

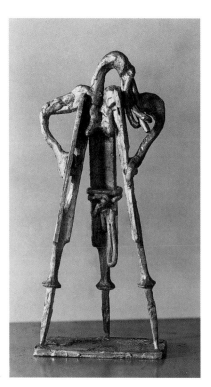

464
Variation on a Chisel X: Poet on Crutches, 1951-52
Bronze (unique)
H. 8.5 in /21.6 cm

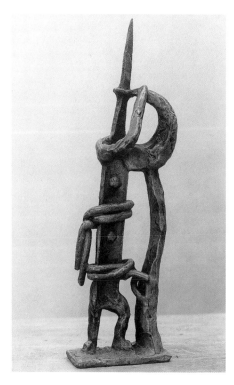

465
Variation on a Chisel XI, 1951-52
Bronze (unique)
H. 9.62 in /24.5 cm

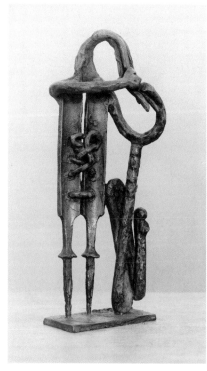

466
Variation on a Chisel XII: La Toilette, 1951-52
Bronze (unique)
H. 9.25 in /23.5 cm

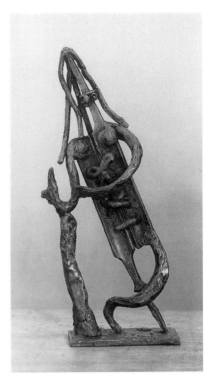

467
Variation on a Chisel XIII: Lady with Bird, 1951-52
Bronze (unique)
H. 9.62 in /24.4 cm

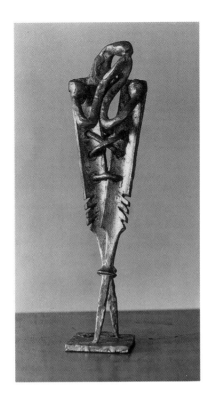

468
Variation on a Chisel XIV, 1951-52
Bronze (unique)
H. 8.5 in /21.6 cm

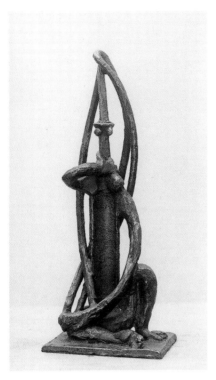

469
Variation on a Chisel XV, 1951-52
Bronze (unique)
H. approx. 9 in /22.9 cm

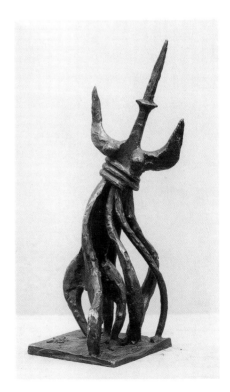

470
Variation on a Chisel XVI, 1951-52
Bronze (unique)
H. approx. 9 in /22.9 cm

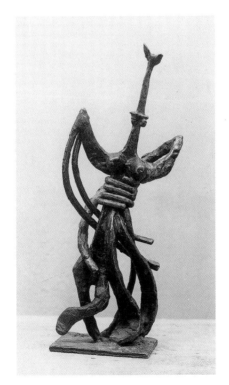

471
Variation on a Chisel XVII, 1951-52
Bronze (unique)
H. approx. 9 in /22.9 cm

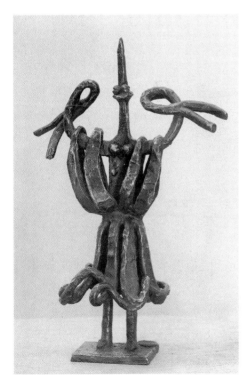

472
Variation on a Chisel XVIII, 1951-52
Bronze (unique)
H. approx. 9 in /22.9 cm

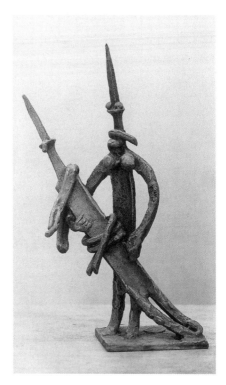

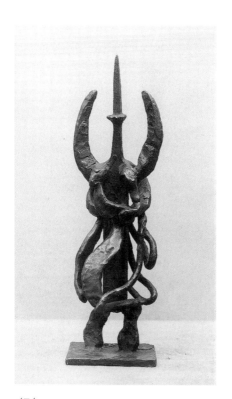

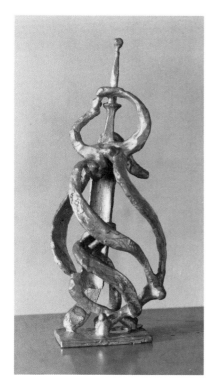

473
Variation on a Chisel XIX: Pas de Deux
(author's title), 1951-52
Bronze (unique)
H. 8.75 in /22.2 cm

474
Variation on a Chisel XX: Dancer,
1951-52
Bronze (unique)
H. 8.5 in /21.6 cm

475
Variation on a Chisel XXI: Danseuse à
la violette, 1951-52
Bronze (unique)
H. 9.12 in /23.2 cm

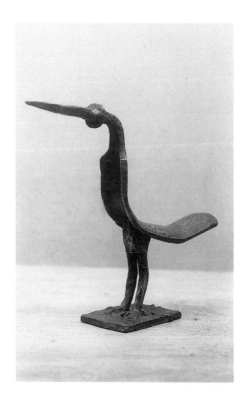

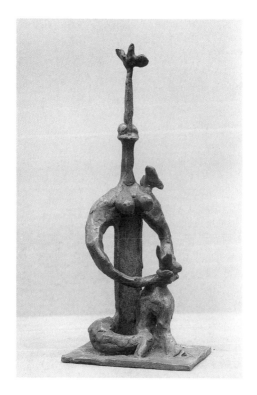

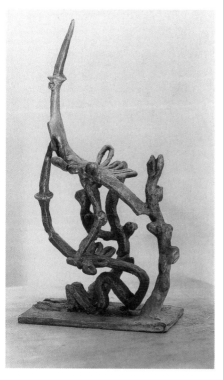

476
Variation on a Chisel XXII: Bird (author's
title), 1951-52
Bronze (unique)
H. approx. 9 in /22.9 cm

477
Variation on a Chisel XXIII, 1951-52
Bronze (unique)
H. approx. 9 in /22.9 cm

478
Variation on a Chisel XXIV:
Storks, 1951-52
Bronze (unique)
H. 8.75 in /22.2 cm

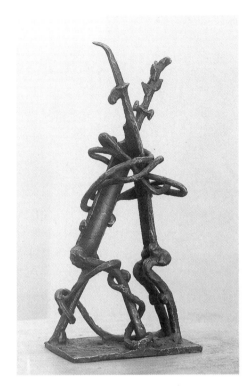

479
Variation on a Chisel XXV: Combat, 1951-52
Bronze (unique)
H. 10 in /25.4 cm

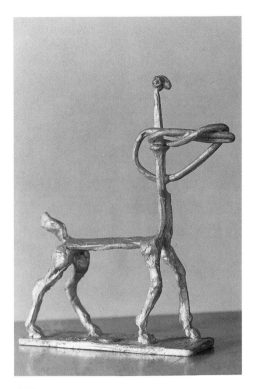

480
Variation on a Chisel XXVI: Centaur, 1951-52
Bronze (unique)
H. 7 in /17.8 cm

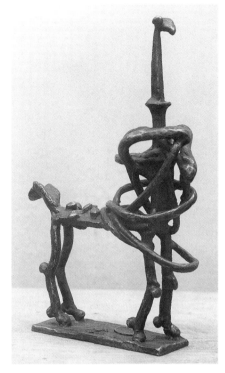

481
Variation on a Chisel XXVII: Centaur Enmeshed I, 1951-52
Bronze (unique)
H. approx. 9 in /22.9 cm

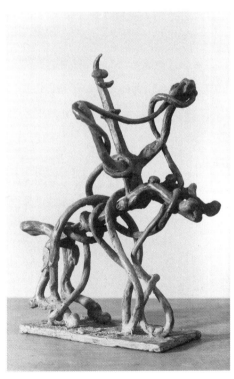

482
Variation on a Chisel XXVIII: Centaur Enmeshed II, 1951-52
Bronze (unique)
H. 7.5 in /19.1 cm

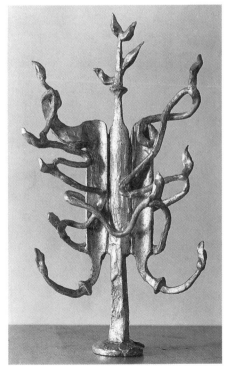

483
Variation on a Chisel XXIX: Menorah, 1951-52
Bronze (unique)
H. approx. 9 in /22.9 cm

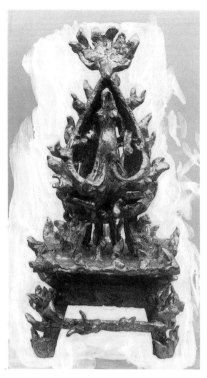

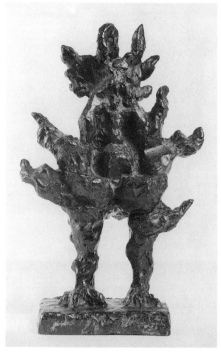

Photograph unavailable

Photograph unavailable

484
Oriental Dancer, 1952
Bronze, edition unknown
H. 9 in /22.9 cm.
Listed in: Henry R. Hope, *The Sculpture of Jacques Lipchitz,* The Museum of Modern Art, New York, 1954, p. 92.

485
Virgin in Flames I, 1952
Bronze (unique)
H. 13.5 in /34.3 cm

486
Virgin in Flames II, 1952
Bronze, edition unknown
H. 20 in /50.8 cm.
Listed in: Henry R. Hope, *The Sculpture of Jacques Lipchitz,* The Museum of Modern Art, New York, 1954, p. 92.

487
Lesson of a Disaster, 1952 (1956?)
Bronze, edition of 7
H. 10.25 in /26.0 cm
Israel Museum, Jerusalem

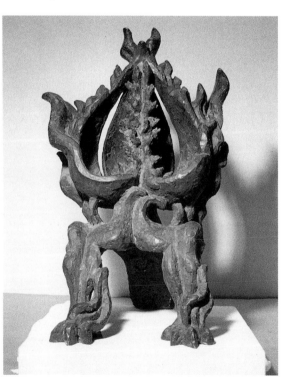

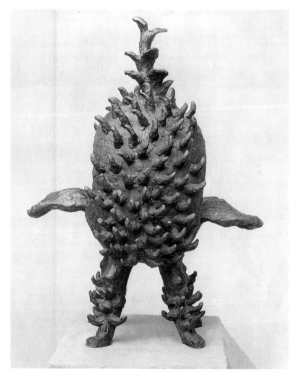

488
Lesson of a Disaster, 1952
Bronze (unique)
H. 25.25 in /64.1 cm

489
Figure (author's title), c. 1952
Bronze, edition unknown
H. unknown
There is no information on the back of this photograph.

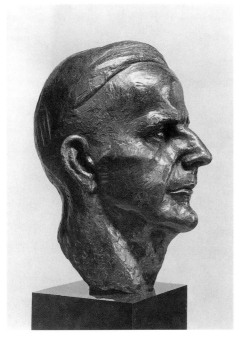

490
Portrait of Otto Spaeth, 1952
Bronze, edition unknown
H. 14.5 in /36.8 cm

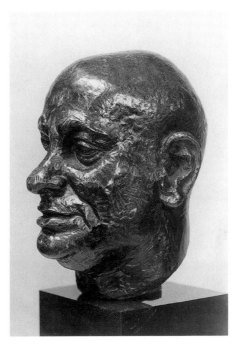

491
Portrait of Henry Pearlman, 1952
Bronze, edition unknown
H. 16.5 in /41.9 cm

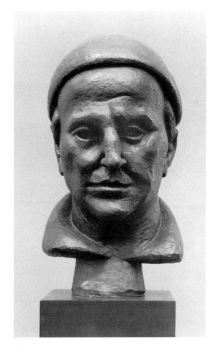

492
Portrait of Gertrude Stein, 1953
Bronze, edition unknown
H. 20 in /50.8 cm

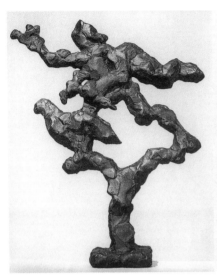

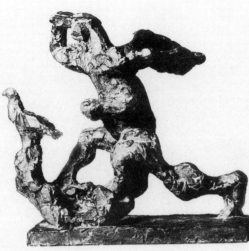

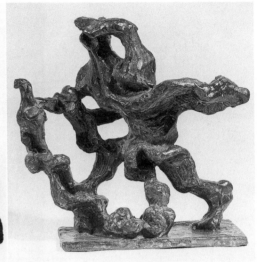

493
Sketch for the Spirit of Enterprise I, 1953
Bronze, edition of 7
H. 9.75 in /24.8 cm
Dallas Museum of Art

494
Sketch for the Spirit of Enterprise II, 1953
Bronze, edition of 7
H. 9.12 in /23.2 cm

495
Sketch for the Spirit of Enterprise III, 1953
Bronze, edition of 7
L. 10.25 in /26.0 cm
Israel Museum, Jerusalem

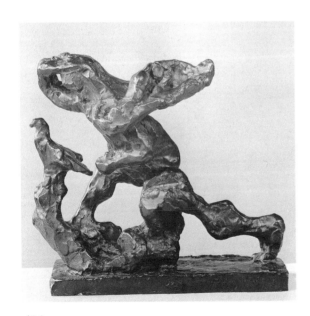

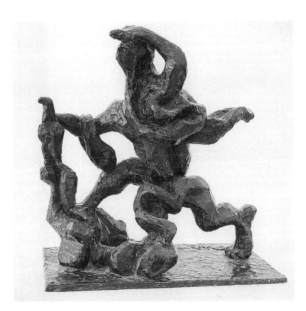

496
Sketch for the Spirit of Enterprise IV, 1953
Bronze, edition of 7
L. 12.12 in /30.8 cm

497
Sketch for the Spirit of Enterprise V, 1953
Bronze, edition of 7
L. 17.25 in /43.8 cm
Israel Museum, Jerusalem

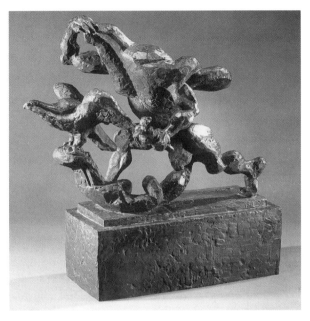

498
Study for the Spirit of Enterprise, 1953
Bronze, edition of 7
H. 31.62 in /80.3 cm
Tate Gallery, London

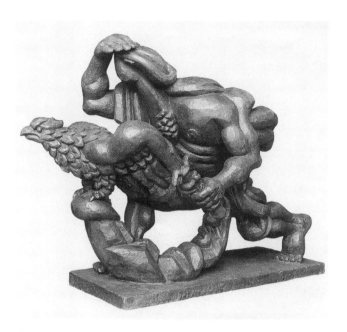

499
Working Model for the Spirit of Enterprise, 1953
Bronze (unique)
H. 45 in /114.3 cm

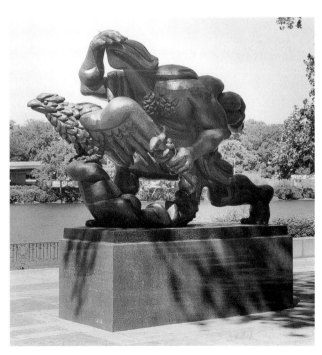

500
The Spirit of Enterprise, 1953-54
Bronze (unique)
H. 137 in /347.98 cm
Fairmount Park Art Association, Philadelphia, Pennsylvania

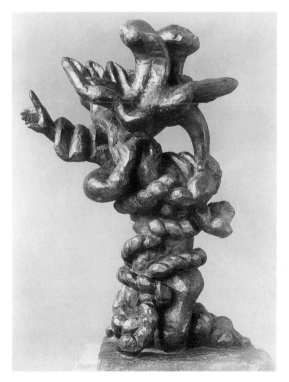

501
Inspiration, 1955
Bronze, edition of 7
H. 29.25 in /74.3 cm
Stedelijk Museum, Amsterdam

THIRTY-THREE SEMI-AUTOMATICS, 1955-56

(This is the sequence in which the thirty-three bronzes were catalogued in: *Jacques Lipchitz: Thirty-Three Semi-Automatics 1955-1956 and Earlier Works 1915-1928,* Fine Arts Associates, New York, 1957).

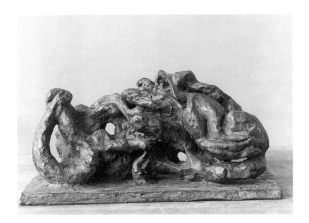

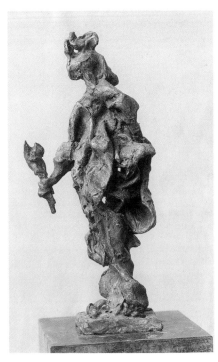

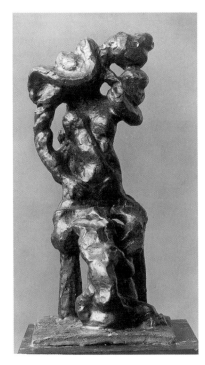

502
Reclining Figure, 1955-56
Bronze (unique)
L. 9.75 in /24.8 cm

503
The Prophet, 1955-56
Bronze (unique)
H. 10 in /25.4 cm

504
Mother and Child (Standing),
1955-56
Bronze (unique)
H. 11.5 in /29.2 cm

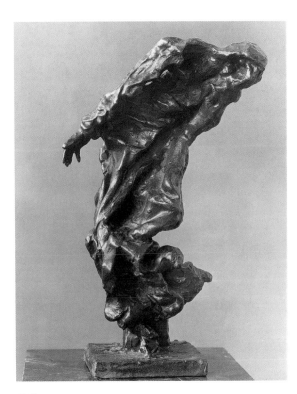

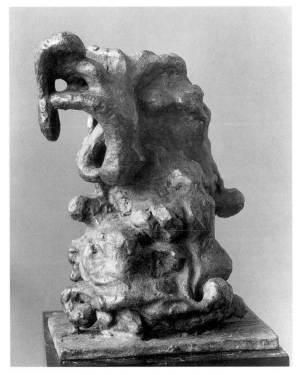

505
Mater Dolorosa, 1955-56
Bronze (unique)
H. 12.25 in /31.1 cm

506
Mother and Child, 1955-56
Bronze (unique)
H. 8 in /20.3 cm

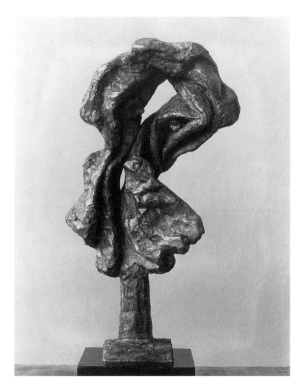

507
Head of an Old Man, 1955-56
Bronze (unique)
H. 13.5 in /34.3 cm

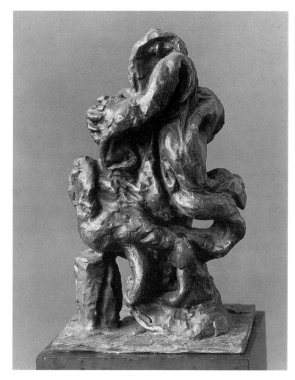

508
Consolation, 1955-56
Bronze (unique)
H. 9 in /22.9 cm

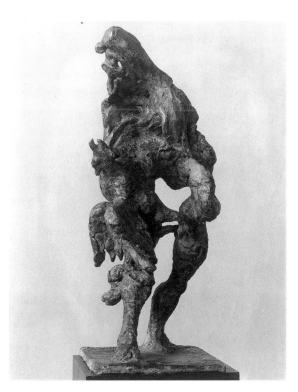

509
Man with Rooster, 1955-56
Bronze (unique)
H. 13.5 in /34.3 cm

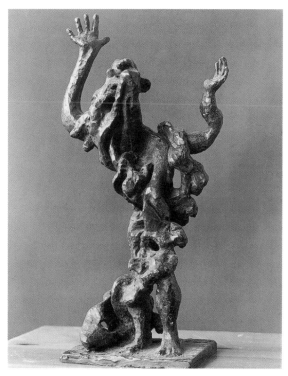

510
Imploration, 1955-56
Bronze (unique)
H. 18.5 in /47.0 cm

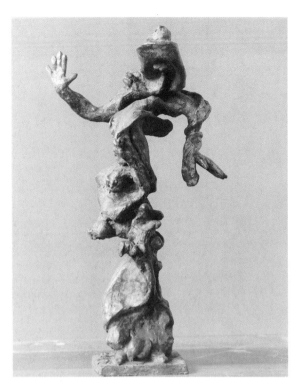

511
Geisha, 1955-56
Bronze (unique)
H. 15.5 in /39.4 cm

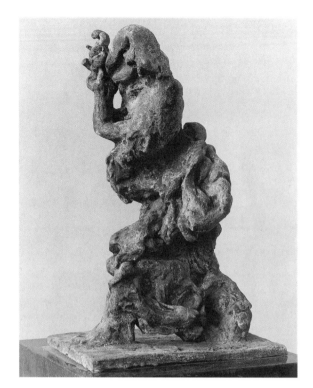

512
Bouquet, 1955-56
Bronze (unique)
H. 11.25 in /28.6 cm

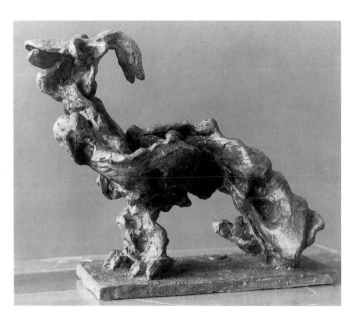

513
Animal-Bird, 1955-56
Bronze (unique)
L. 12 in /30.5 cm

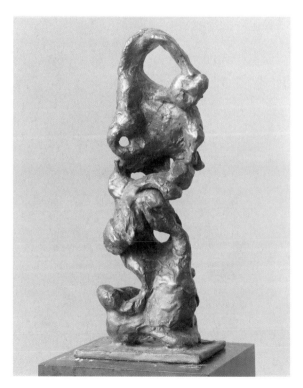

514
Gypsy Dancer, 1955-56
Bronze (unique)
H. 11.25 in /28.6 cm

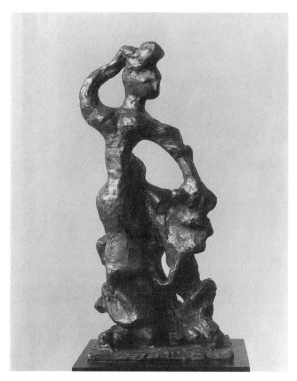

515
Rêve de Valse, 1955-56
Bronze (unique)
H. 11 in /27.9 cm

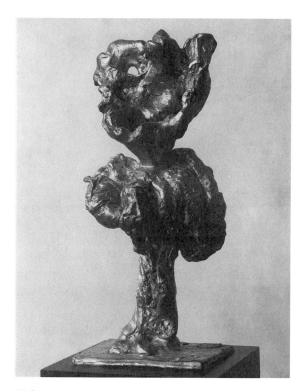

516
Woman-Flower, 1955-56
Bronze (unique)
H. 11.12 in /28.3 cm

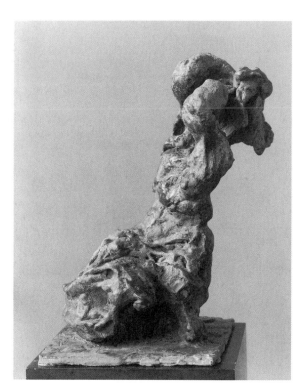

517
Awakening, 1955-56
Bronze (unique)
H. 8.87 in /22.5 cm

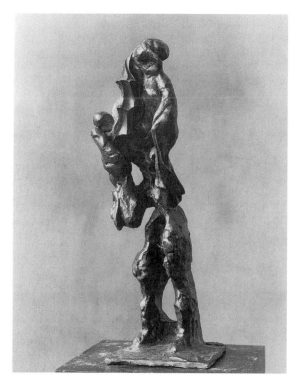

518
Precious Bundle, 1955-56
Bronze (unique)
H. 11.75 in /29.9 cm

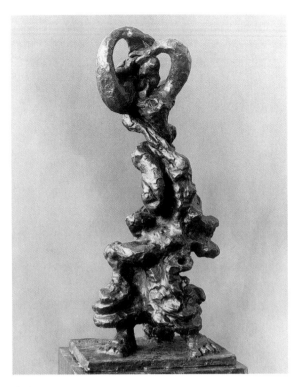

519
Dancer, 1955-56
Bronze (unique)
H. 16.25 in /41.3 cm

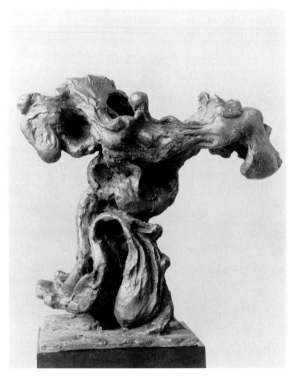

520
Remembrance of Loie Fuller, 1955-56
Bronze (unique)
H. 10 in /25.4 cm

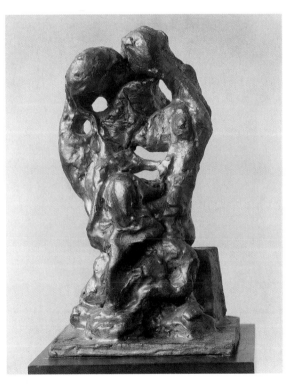

521
Two Sisters, 1955-56
Bronze (unique)
H. 9 in /22.9 cm

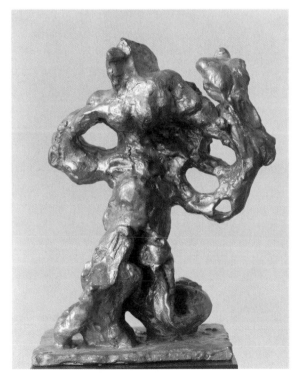

522
Exotic Dancer, 1955-56
Bronze (unique)
H. 9.5 in /24.1 cm

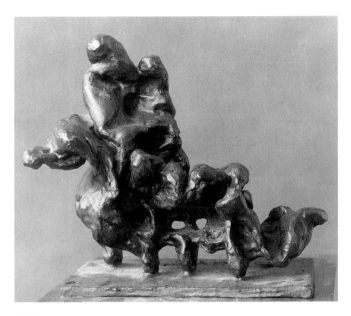

523
Mother and Child on Sofa, 1955-56
Bronze (unique)
L. 8.75 in /22.2 cm

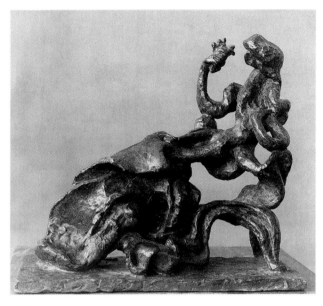

524
The Lady with Camellias, 1955-56
Bronze (unique)
H. 13 in /33.0 cm

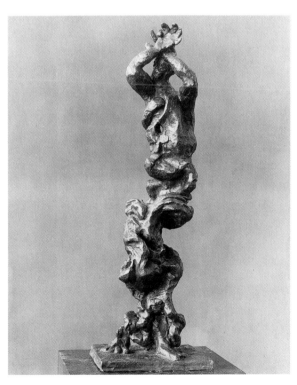

525
Dervish, 1955-56
Bronze (unique)
H. 16.75 in /42.6 cm

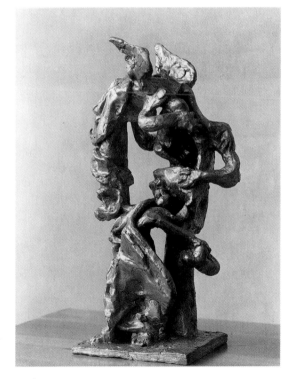

526
Hagar and the Angel, 1955-56
Bronze (unique)
H. 14.5 in /36.8 cm

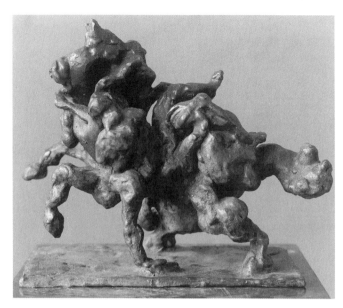

527
Only Inspiration, 1955-56
Bronze (unique)
L. 9 in /22.9 cm

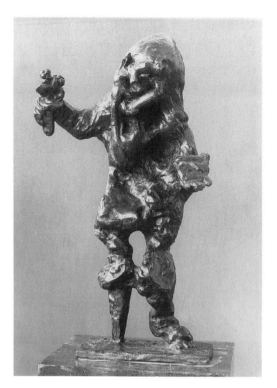

528
Beggar Selling Flowers, 1955-56
Bronze (unique)
H. 14.5 in /36.8 cm
Hirshhorn Museum and Sculpture Garden, Smithsonian Institution,
Washington, D.C.

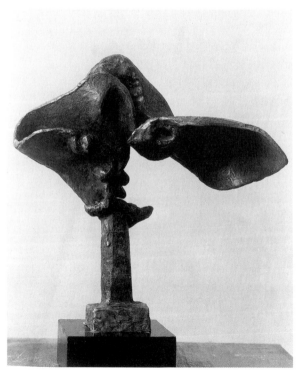

529
Head of Harlequin, 1955-56
Bronze (unique)
H. 12 in /30.5 cm

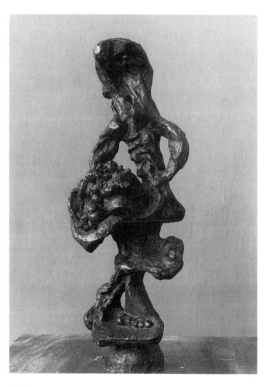

530
Here are the Fruits and the Flowers, 1955-56
Bronze (unique)
H. 16.75 in /42.5 cm

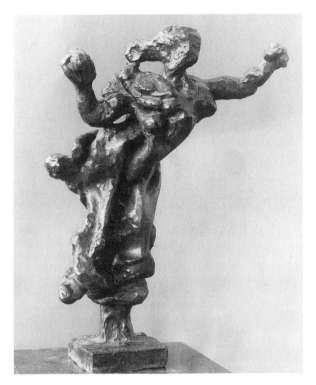

531
Defense, 1955-56
Bronze (unique)
H. 13 in /33.0 cm

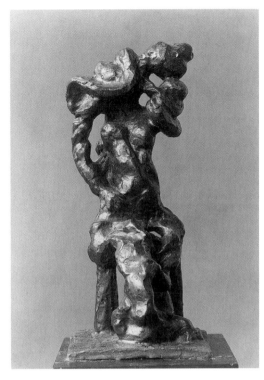

532
Mother and Child, 1955-56
Bronze (unique)
H. 11.75 in /29.9 cm

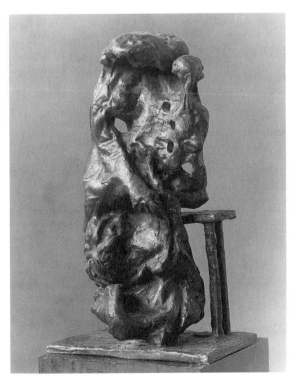

533
Mother and Child on Bench, 1955-56
Bronze (unique)
H. 10.75 in /27.3 cm

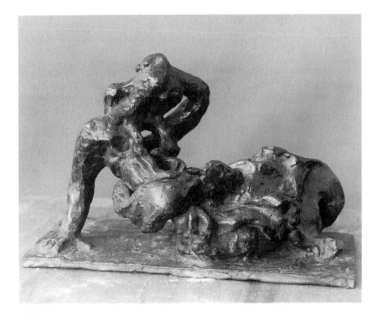

534
Reclining Figure, 1955-56
Bronze (unique)
L. 11.25 in /28.6 cm

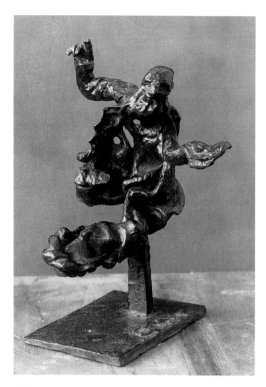

535
The Prophet, c. 1955-56
Bronze (unique)
H. 12.5 in /31.8 cm

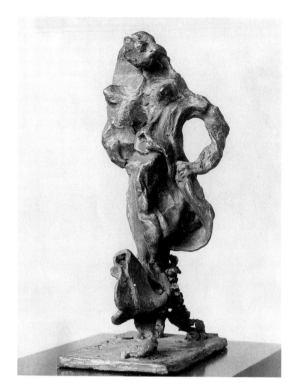

536
Woman with Swirling Robes (author's title), c. 1955-56
Bronze (unique)
H. 11 in /27.9 cm

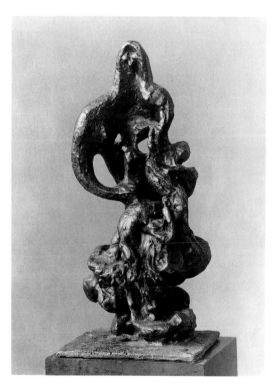

537
Standing Figure (author's title), c. 1955-56
Bronze (unique)
H. unknown
There is no information on the back of this photograph.

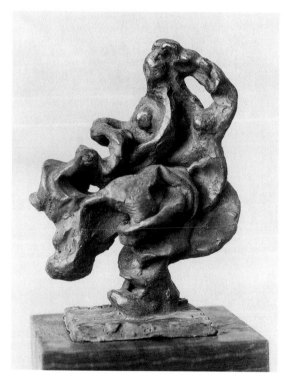

538
Figure with Drapery (author's title), c. 1955-56
Bronze (unique)
H. unknown
There is no information on the back of this photograph.

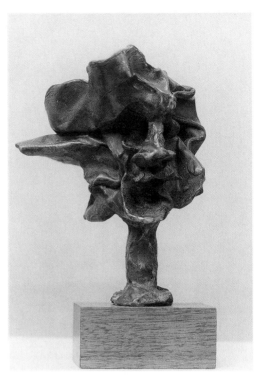

539
Head (author's title), c. 1955-56
Bronze (unique)
H. unknown
There is no information on the back of this
photograph.

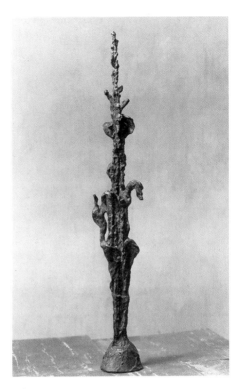

540
Upright Form I (author's title), c. 1955-56
Bronze (probably unique)
H. 19.62 in /49.9 cm
There is no information on the back of this
photograph. The author measured this unidentified
bronze cast.

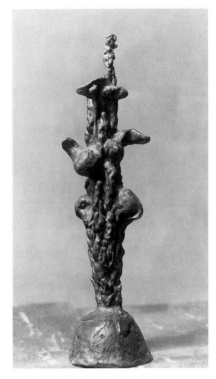

541
Upright Form II (author's title),
c. 1955-56
Bronze (probably unique)
H. unknown
There is no information on the back of this
photograph.

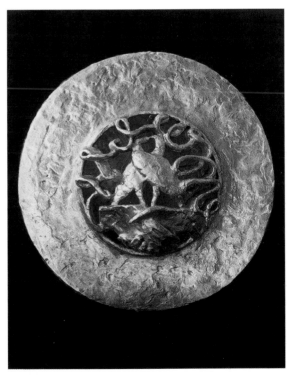

542
The Lock: Design for Yale Locksmiths, n.d.
Bronze, edition unknown
Dimensions unknown

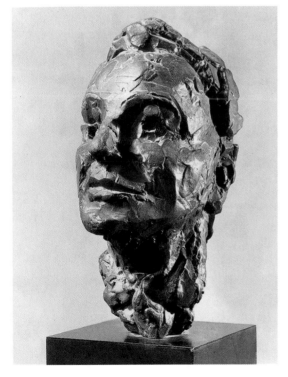

543
Sketch of Mrs. John Cowles, 1956
Bronze, edition unknown
H. 13 in /33.0 cm

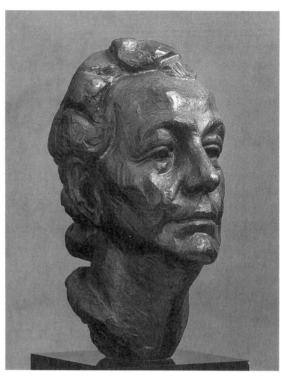

544
Head of Mrs. John Cowles, 1956
Bronze, edition of 5
H. 17 in /43.2 cm
Des Moines Art Center, Des Moines, Iowa; Minneapolis Institute of Arts,
Minneapolis, Minnesota; Smith College Museum of Art, Northampton,
Massachusetts

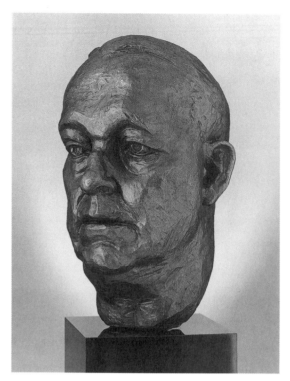

545
Head of Mr. John Cowles, 1956
Bronze, edition of 5
H. 17 in /43.2 cm
Des Moines Art Center, Des Moines, Iowa; Minneapolis Institute of Arts,
Minneapolis, Minnesota

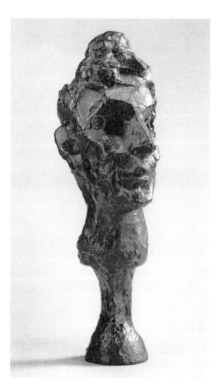

546
Sketch for Yulla Lipchitz, 1956
Bronze, edition of 7
H. 12.12 in /30.8 cm

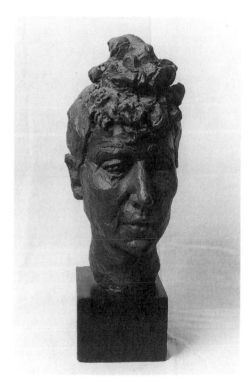

547
Portrait of Yulla Lipchitz, c. 1956
Bronze, edition unknown
H. 14.75 in /37.5 cm

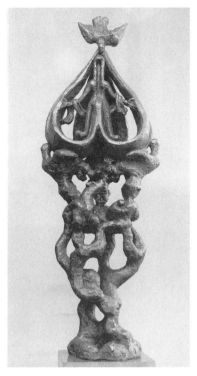

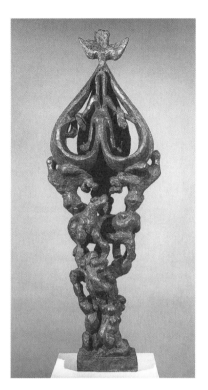

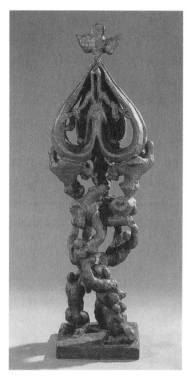

548
Between Heaven and Earth I, 1958
Bronze, edition of 3
H. 46 in /116.8 cm

549
Between Heaven and Earth II, 1958
Bronze, edition of 3
H. 45 in /114.3 cm

550
Between Heaven and Earth III,
1958
Bronze, edition of 3
H. 46 in /116.8 cm

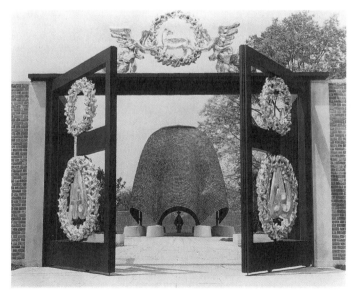

551
Sketch for the Gates of the Roofless Church, 1958
Bronze (unique)
17 x 20.75 in /43.2 x 52.7 cm

552
Gates Leading to Philip Johnson's Roofless Church, 1958
Bronze (unique)
New Harmony, Indiana

A LA LIMITE DU POSSIBLE, 1958-59

(This is the sequence in which the fourteen bronzes were catalogued in: *Jacques Lipchitz: Fourteen Recent Works, 1958-1959, and Earlier Works, 1949-1959,* Fine Arts Associates, New York, 1959).

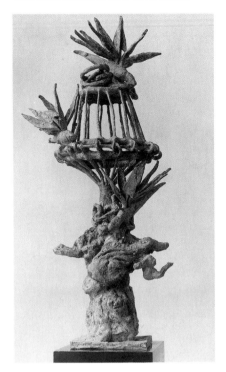

553
Freedom, 1958
Bronze (unique)
H. 26 in /66.0 cm

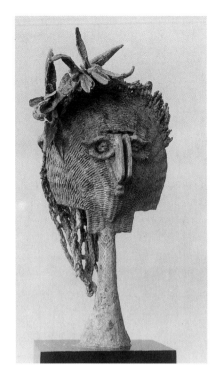

554
Japanese Basket, 1958
Bronze (unique)
H. 20 in /50.8 cm
Art Gallery of Ontario, Toronto

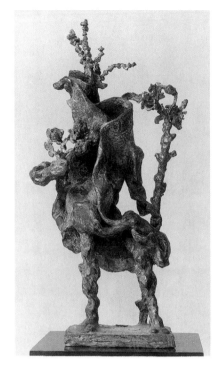

555
Carnival, 1958
Bronze (unique)
H. 17.75 in /45.1 cm

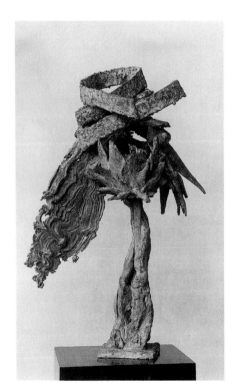

556
The Artichokes, 1958
Bronze (unique)
H. 19.5 in /49.5 cm

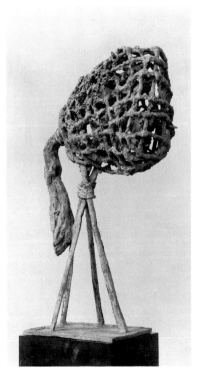

557
Miraculous Catch, 1958
Bronze (unique)
H. 22 in /55.9

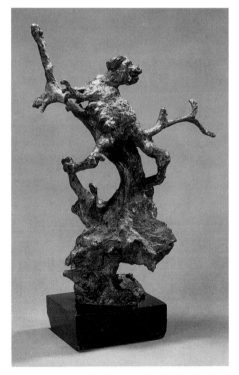

558
Galapagos I, 1958
Bronze (unique)
H. 19.5 in./49.5 cm

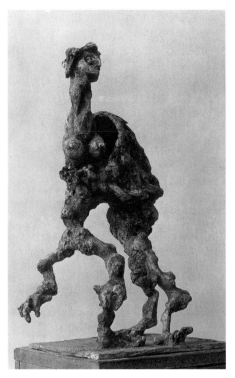

559
Galapagos II, 1958
Bronze (unique)
H. 19.5 in /49.5 cm

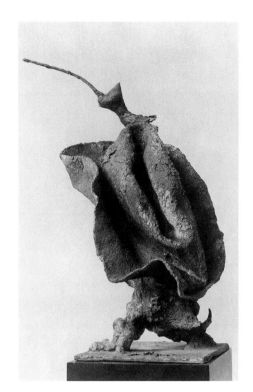

560
Galapagos III, 1958
Bronze (unique)
H. 16.87 in /42.9 cm

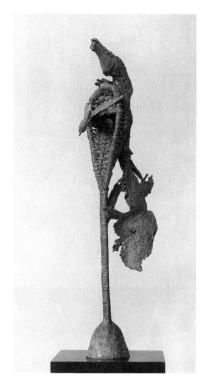

561
Oceanide, 1958
Bronze (unique)
H. 25 in /63.5 cm

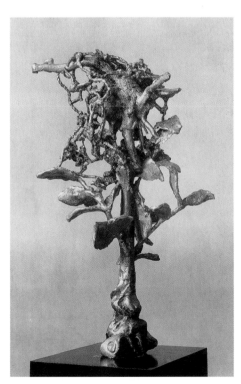

562
Marvelous Capture, 1958
Bronze (unique)
H. 18 in /45.7 cm

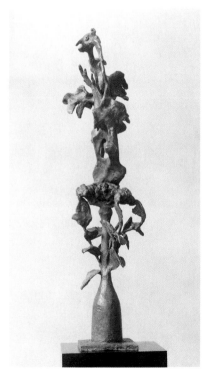

563
The Nest, 1958
Bronze (unique)
H. 27 in /68.6 cm

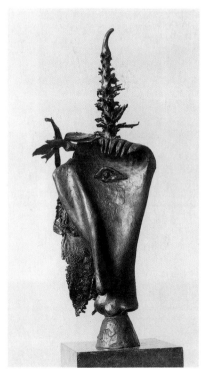

564
The Bone, 1958-59
Bronze (unique)
H. 26 in /66.0 cm

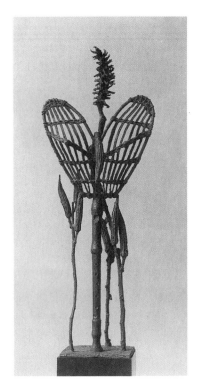

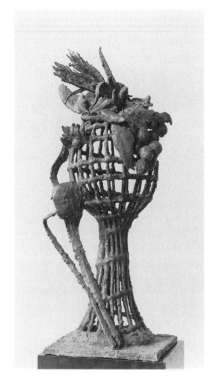

565
Enchanted Flute, 1959
Bronze (unique)
H. 35 in /88.9 cm

566
Abundance, 1959
Bronze (unique)
H. 20.5 in /52.1 cm

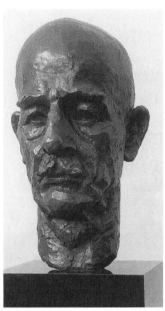

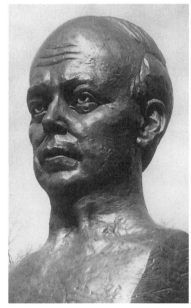

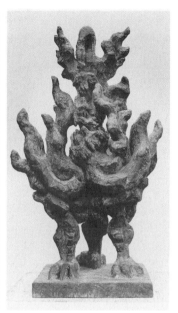

567
Portrait of Zalman Schocken,
c. 1959 Bronze, edition unknown
H. 14.56 in /37.50 cm

568
Portrait of R. Sturgis Ingersoll,
1960 Bronze, edition
unknown
H. 17 in /43.2 cm
Philadelphia Museum of Art

569
*Memorial Bust of Senator Robert
Alphonso Taft,* c. 1961
Bronze (unique), H. approx. 4 ft
/121.9 cm Cincinnati Art Museum,
Cincinnati, Ohio. Lent by the Thomas M.
Emery Memorial Foundation

570
Study for Lesson of a Disaster,
1961 Bronze, edition
unknown
H. 26.5 in /67.3 cm

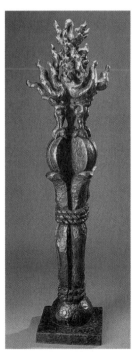

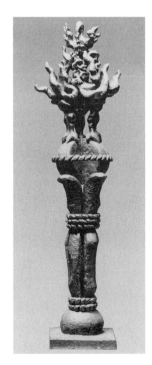

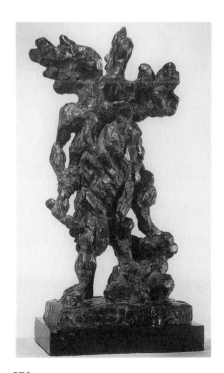

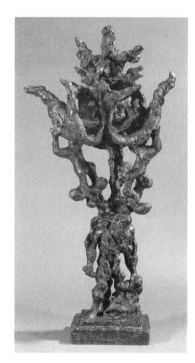

571
*Working Model for
Lesson of a Disaster,*
1961-70 Bronze,
edition of 7
H. 71 in /180.3 cm

572
Lesson of a Disaster,
1961-70 Bronze,
edition of 7
H. 139 in./353.3 cm
The University of Arizona
Museum of Art, Tucson

573
Study for Our Tree of Life
(also known as *The Sacrifice of
Abraham*), 1962
Bronze, edition of 7
H. 15.62 in /39.0 cm
Israel Museum, Jerusalem

574
Study for Our Tree of Life, 1962
Bronze, edition of 7
H. 33.5 in /85.1 cm

IMAGES OF ITALY, 1962-63

The *Images of Italy* series, first exhibited in 1966 at the
Marlborough-Gerson Gallery, New York, included
twenty-five bronzes. Twenty-four of these, executed
during the summers of 1962 and 1963, are catalogued
below, Nos. 575 to 598, in the sequence in which they
appeared in the Marlborough-Gerson catalogue. The
Sword of du Luth, 1964, No. 25 in the 1966
Marlborough-Gerson catalogue, which has, Lipchitz
pointed out, nothing to do with the *Images of Italy*, is
catalogued, No. 610, immediately after the monumental
bronze *Daniel Greysolon, Sieur du Luth*. Lipchitz made
the *Images of Italy* sculptures directly in wax. From
these, the initial set of lost wax bronzes was cast, each of
which is signed, includes the artist's thumbprint, but is
not numbered. From these unique bronzes, an edition
of seven bronzes was cast of each sculpture (with the
exception of No. 591), and numbered 1/7 through 7/7.
Of these editions, Lipchitz commented: "While
retouching the waxes, I let myself go; so they [the
bronzes in each edition] are not completely identical."

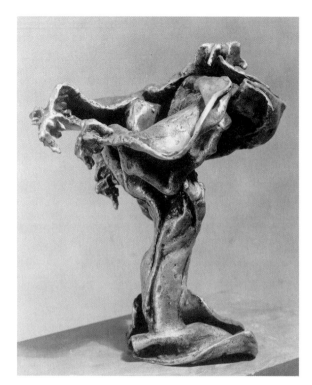

575
The Cup of Atonement, 1962
Bronze, edition of 7 + 1
H. 11.87 in /30.2 cm

576
The Day After Viareggio, 1962
Bronze, edition of 7 + 1
H. 6.87 in /17.5 cm

577
The Olive Branch, 1962
Bronze, edition of 7 + 1
H. 8.62 in /21.9 cm

578
Memory of Barga, 1962
Bronze, edition of 7 + 1
L. 8.75 in, included base/22.2 cm

579
The Tower and its Shadow, 1962
Bronze, edition of 7 + 1
H. 11.25 in /28.6 cm

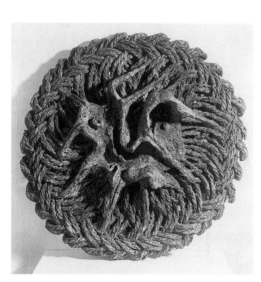

580
Homage to Etruria, 1962
Bronze, edition of 7 + 1
Diameter 21 in /53.3 cm

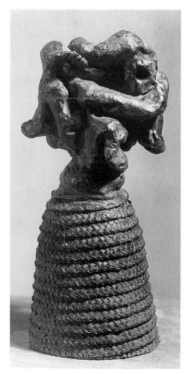

581
Head, 1962
Bronze, edition of 7 + 1
H. 8.75 in /22.2 cm

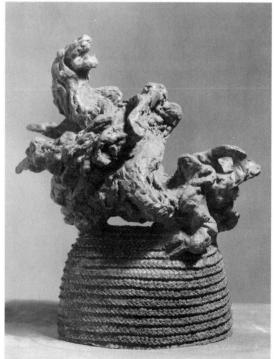

582
Fountain of the Dragon, 1962
Bronze, edition of 7 + 1
H. 10.75 in /27.3 cm

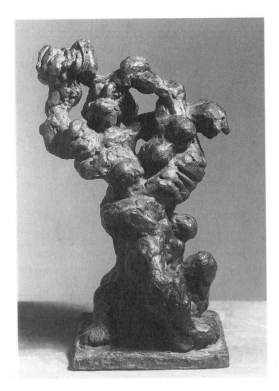

583
Homage to the Renaissance, 1962
Bronze, edition of 7 + 1
H. 8.75 in /22.2 cm

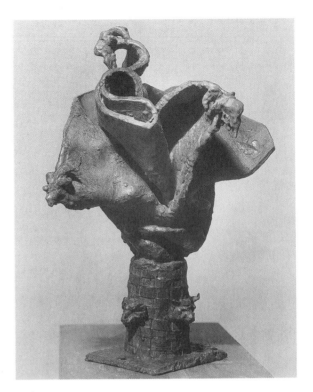

584
Fountain, 1962
Bronze, edition of 7 + 1
H. 14.75 in /37.5 cm

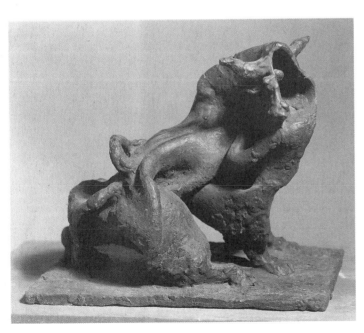

585
The Bull, 1962
Bronze, edition of 7 + 1
L. 9.75 in /24.8 cm

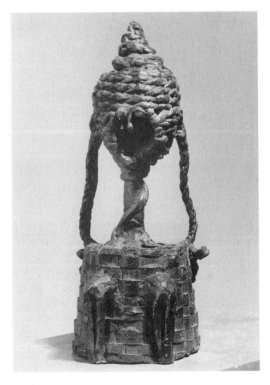

586
The Beautiful One, 1962
Bronze, edition of 7 + 1
H. 12.5 in /31.7 cm

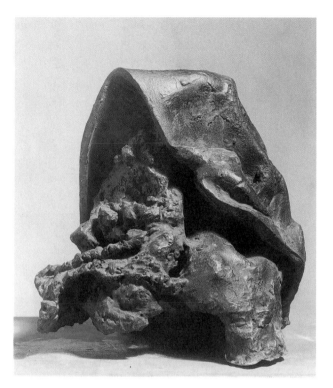

587
Head of an Old Man, 1962
Bronze, edition of 7 + 1
H. 9.5 in /24.1 cm

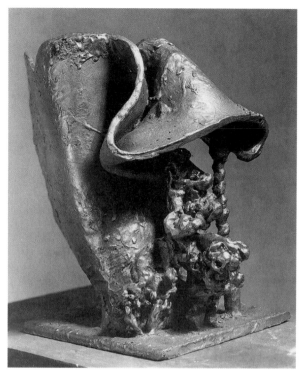

588
Chapel in the Mountains, 1962
Bronze, edition of 7 + 1
H. 9.25 in /23.5 cm

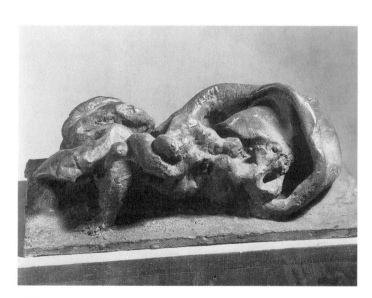

589
On the Beach, 1962
Bronze, edition of 7 + 1
L. 14.5 in /36.8 cm

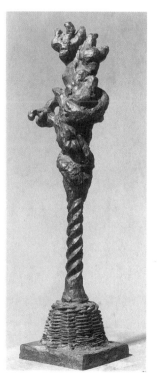

590
The Flame, 1962
Bronze, edition of 7 + 1
H. 16.75 in /42.6 cm

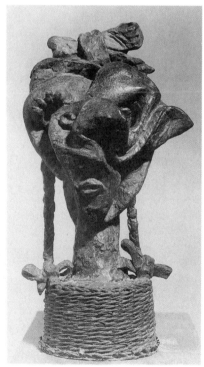

591
Happy Birthday, 1962
Bronze, probably unique
H. 16 in /40.6 cm

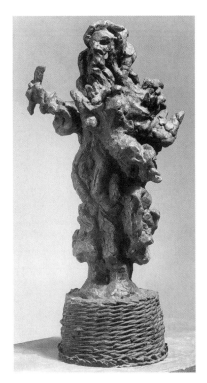

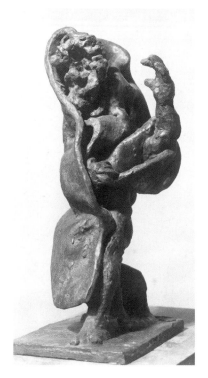

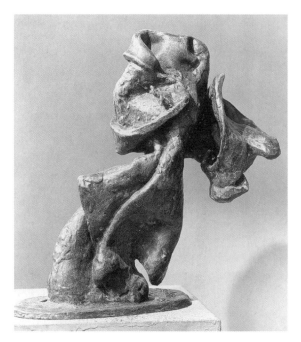

592
The Schechoth, 1962
Bronze, edition of 7 + 1
H. 14.5 in /36.8 cm

593
The Prophet, 1962
Bronze, edition of 7 + 1
H. 14.5 in /36.8 cm

594
Memory of Rabat, 1963
Bronze, edition of 7 + 1
H. 14.5 in /36.8 cm

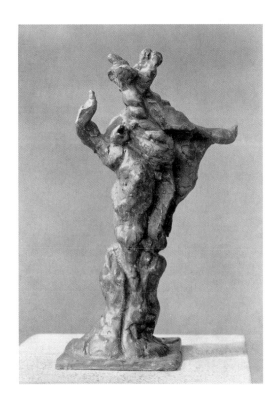

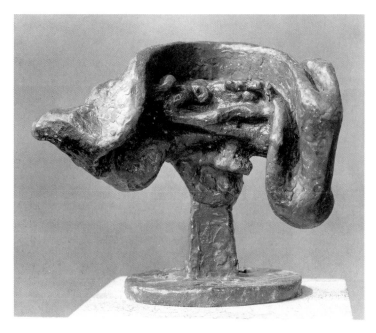

595
The Geisha, 1963
Bronze, edition of 7 + 1
H. 13.5 in /34.3 cm

596
Head of Harlequin, 1963
Bronze, edition of 7 + 1
H. 10.75 in /27.3 cm

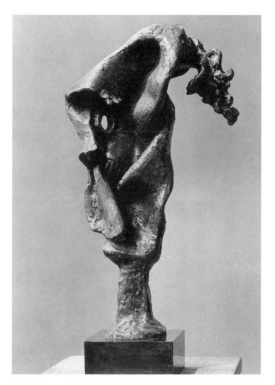

597
Head of a Woman, 1963
Bronze, edition of 7 + 1
H. 17.75 in /45.1 cm

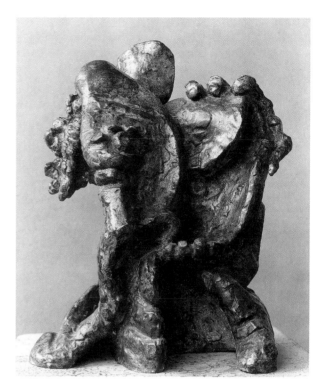

598
Woman with Comb, 1963
Bronze, edition of 7 + 1
H. 11.62 in /29.5 cm

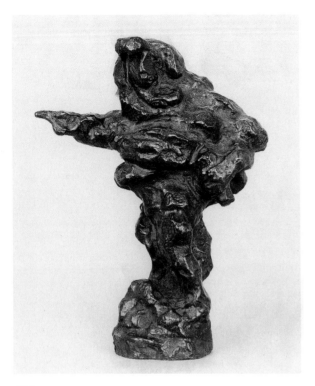

599
Variation on the Schechoth, c. 1963
Bronze, edition unknown
H. 8.25 in /21.0 cm

600
Variation on the Beautiful One, c. 1963
Bronze, probably unique
H. 11 in /21.0 cm

601
Variation on Chapel in the Mountains, c. 1963
Bronze, edition of 7
H. 9.37 in./23.8 cm

602
Portrait of Jules Stein, 1963
Bronze, edition unknown
H. unknown

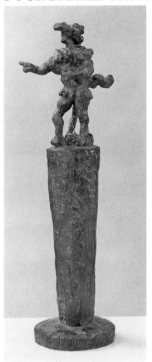

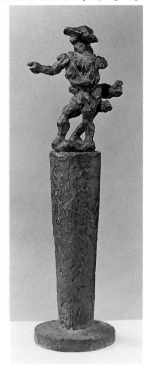

603
Sketch for the Monument for du Luth I, 1963
Bronze, edition of 7
H. 15.5 in /39.4 cm
Tweed Museum of Art, University of Minnesota, Duluth

604
Sketch for the Monument for du Luth II, 1963
Bronze, edition of 7
H. 22.32 in /56.8 cm

605
Sketch for the Monument for du Luth III, 1963
Bronze, edition of 7
H. 22.62 in /57.5 cm

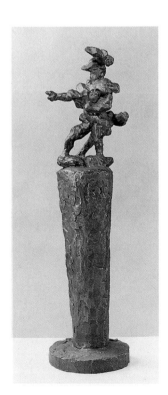

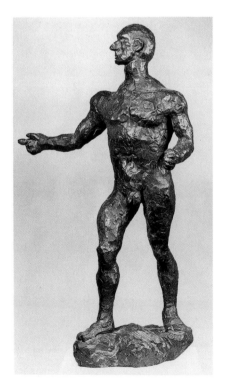

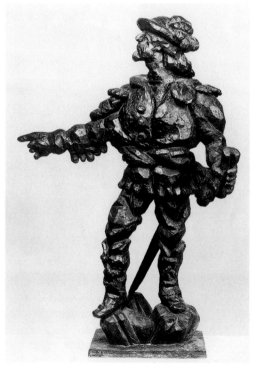

606
Sketch for the Monument for du Luth IV, 1963
Bronze, edition of 7
H. 22.62 in /57.5 cm

607
Sketch for the Monument for du Luth V (Giuliano), 1963
Bronze, edition of 7
H. 28.25 in /71.8 cm

608
Working Model for the Monument for du Luth, 1963, Bronze, edition of 7
H. 33 in /83.8 cm
Tweed Museum of Art, University of Minnesota, Duluth

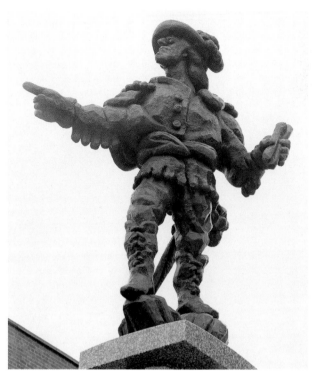

609
Daniel Greysolon, Sieur du Luth, 1964-65
Bronze (unique)
H. 9 ft/2.7 m
Tweed Museum of Art, University of Minnesota, Duluth

610
Sword of du Luth, 1964
Bronze, edition of 7
H. 42.5 in /107.9 cm
Museo de Arte Contemporáneo de Caracas,
Venezuela

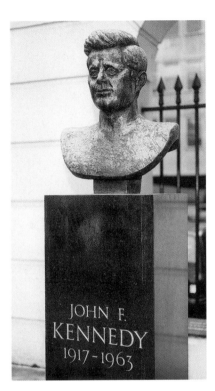

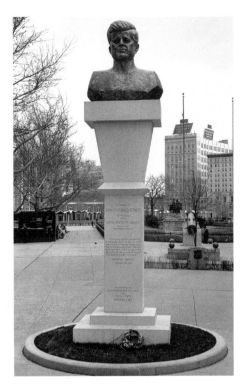

611
Sketch for John F. Kennedy, 1964
Bronze, edition of 21
H. 17.75 in /45.1 cm

612
John F. Kennedy, 1964-65
Bronze (unique)
H. 31 in /78.8 cm
International Students' House, London

613
John F. Kennedy, 1964-65
Bronze (unique)
H. approx. 30 in /76 cm
Military Park, Newark, New Jersey

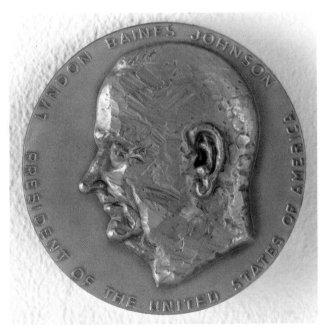

614
President Lyndon Baines Johnson
Award Medal, c. 1964
Bronze, Diameter 3.5 in /8.8 cm

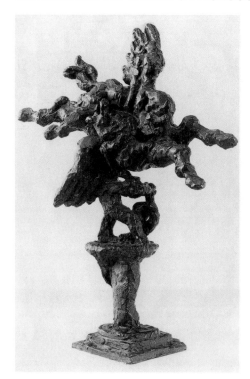

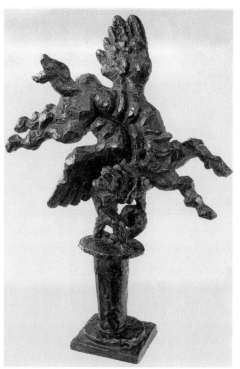

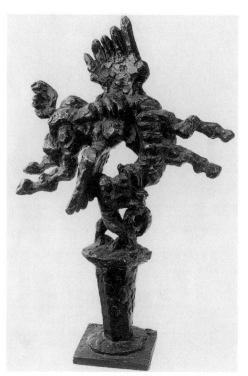

615
Sketch for Bellerophon Taming Pegasus I,
1964
Bronze, edition of 7
H. 19.5 in /49.5 cm

616
Sketch for Bellerophon Taming Pegasus II,
1964
Bronze, edition of 7
H. 20 in /50.8 cm

617
Sketch for Bellerophon Taming Pegasus III,
1964
Bronze, edition of 7
H. 19.75 in /50.2 cm

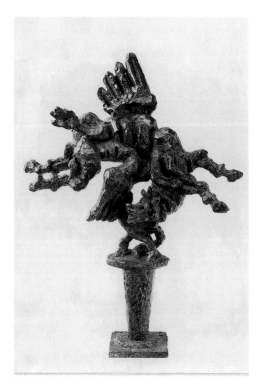

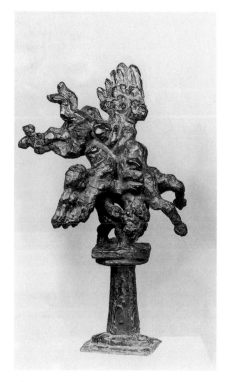

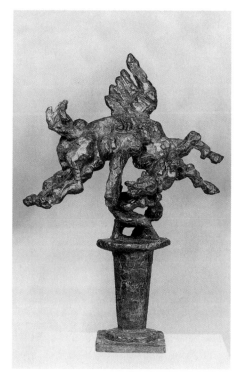

618
Sketch for Bellerophon Taming Pegasus IV, 1964
Bronze, edition of 7
H. 20.5 in /52.1 cm

619
Sketch for Bellerophon Taming Pegasus V,
1964
Bronze, edition of 7
H. 19.25 in /48.9 cm

620
Sketch for Bellerophon Taming Pegasus VI,
1964
Bronze, edition of 7
H. 19.25 in /48.9 cm

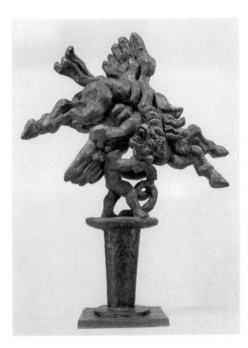

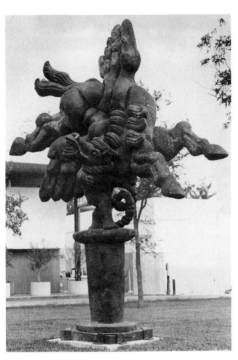

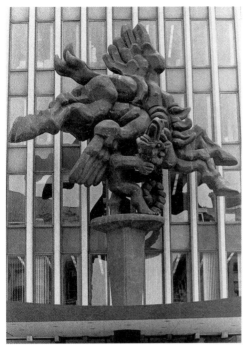

621
Study for Bellerophon Taming Pegasus, 1964
Bronze, edition of 7
H. 59 in /149.8 cm

622
Bellerophon Taming Pegasus: Large Version,
1964-66
Bronze, edition of 2
H. approx. 12 ft /365.76 cm

623
Bellerophon Taming Pegasus, 1964-73
Bronze (unique)
H. approx. 38 ft /11.4 m
Columbia University in the City of New York. Gift of the
Alumni to the Law School. Cast assembled after
Lipchitz's death. Installed 1977.

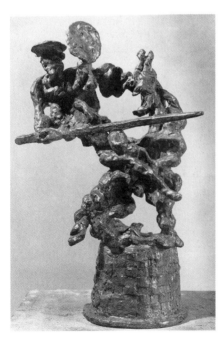

624
Don Quixote, 1966
Bronze, probably unique
H. 15.5 in /39.4 cm

PORTRAITS

Of these nineteen portraits, the identity of only five of the subjects is known, and of these only the portraits of Skira and Leidesdorf have been dated. As no information is available as to the subject or dates of the other portraits, they have been catalogued below, following the undated portraits of Cournant, Kaplan and Hamburger.

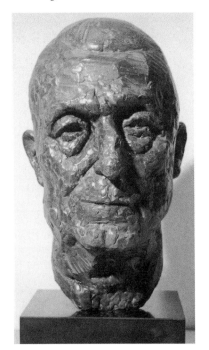

625
Portrait of Albert Skira, 1966
Bronze, edition of 7
H. 16.12 in /41.0 cm

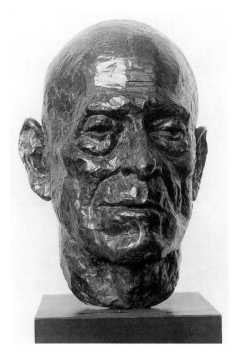

626
Portrait of Samuel D. Leidesdorf, 1966
Bronze, edition unknown
H. 15 in /38.1 cm

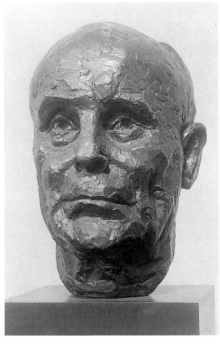

627
Portrait of Dr. A. Cournant, n.d.
Bronze, edition unknown
H. 14.5 in /36.8 cm

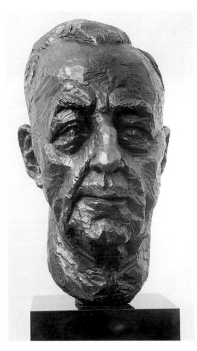

628
Portrait of J. Kaplan, n.d.
Bronze, edition unknown
H. unknown

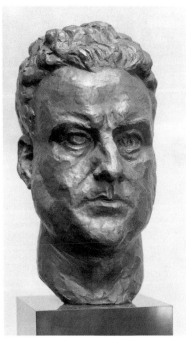

629
Portrait of Freddy Hamburger, n.d.
Bronze, edition unknown
H. unknown

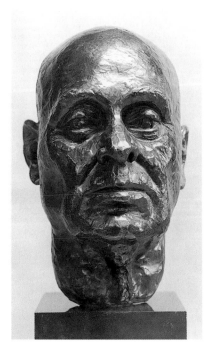

630
Head of a Man I, n.d.
Bronze, edition unknown
H. unknown

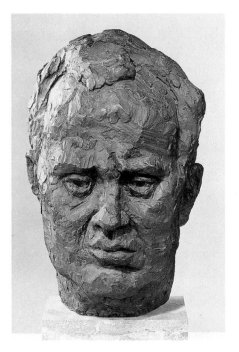

631
Head of a Man II, n.d.
Bronze, edition of 7
H. 15.25 in /38.7 cm

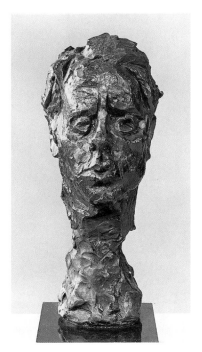

632
Head of a Man III, n.d.
Bronze, edition of 7
H. 14.25 in /36.2 cm

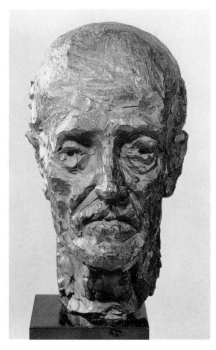

633
Head of a Man IV, n.d.
Bronze, edition unknown
H. 13.62 in /34.6 cm

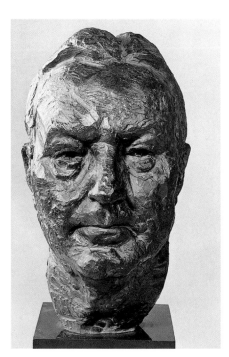

634
Head of a Man V, n.d.
Bronze, edition unknown
H. 14.37 in /36.5 cm

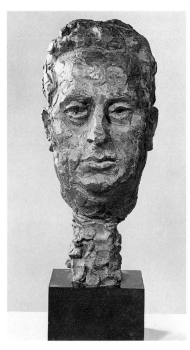

635
Head of a Man VI, n.d.
Bronze, edition unknown
H. 18.5 in /47.0 cm

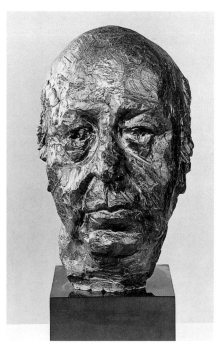

636
Head of a Man VII, n.d.
Bronze, edition unknown
H. 16.37 in /41.6 cm

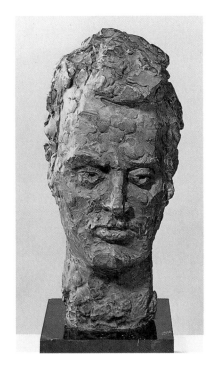

637
Head of a Man VIII, n.d.
Bronze, edition unknown
H. 13 in /33.0 cm

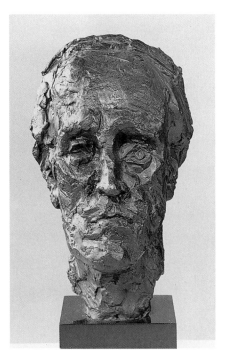

638
Head of a Man IX, n.d.
Bronze, edition unknown
H. 12 in /30.5 cm

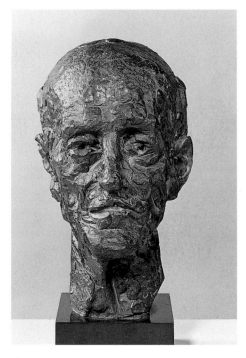

639
Head of a Man X, n.d.
Bronze, edition unknown
H. 11.25 in /28.6 cm

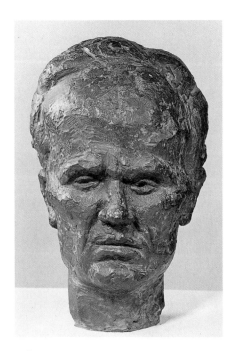

640
Head of a Man XI, n.d.
Bronze, edition of 2 (?)
H. 13.56 in /34.5 cm

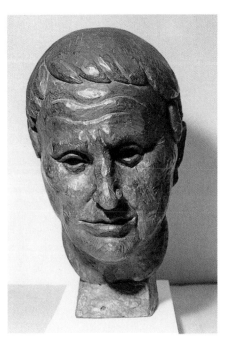

641
Head of a Man XII, n.d.
Bronze, edition unknown
H. 18.5 in /47.0 cm

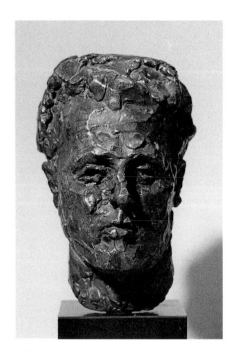

642
Head of a Man XIII, n.d.
Bronze, edition unknown
H. 12 in /30.5 cm

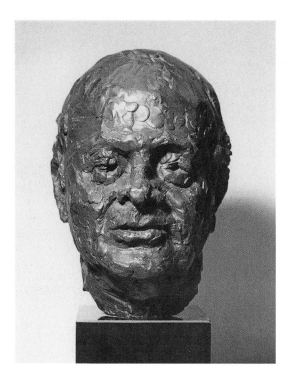

643
Head of a Man XIV, n.d.
Bronze, edition unknown
H. 12 in /30.5 cm

644
Negev Sponsor Pin, 1967
Metal with turquoise stone
2 x 2 in /5.1 x 5.1 cm
Jewish Museum, New York

645
Chai Sponsor Pin, 1967
Metal with diamond-like stone
2 x 2 in /5.1 x 5.1 cm
Jewish Museum, New York

646
Sponsor Pin, 1968
Metal
1.87 x 2 in /4.8 x 5.1 cm
Jewish Museum, New York

647
Negev Sponsor Pin, 1968
Metal with turquoise stone
1.87 x 2 in /4.8 x 5.1 cm
Jewish Museum, New York

648
20th Anniversary Sponsor Pin, 1968
Metal with diamond-like stone
1.87 x 2 in /4.8 x 5.1 cm
Jewish Museum, New York

649
Sponsor Pin, 1970
Metal
2.75 x 2.25 in /7.0 x 5.7 cm
Jewish Museum, New York

650
Jerusalem Sponsor Pin, 1970
Metal with diamond-like stone
2.75 x 2.25 in /7.0 x 5.7 cm
Jewish Museum, New York

651
Sponsor Pin, 1971
Metal
2.25 x 2 in /5.7 x 5.1 cm
Jewish Museum, New York

652
Jerusalem Sponsor Pin, 1971
Metal with diamond-like stone
2.25 x 2 in /5.7 x 5.1 cm
Jewish Museum, New York

653
Golden Sponsor Pin, 1971
Metal with three ruby-like stones
2.25 x 2 in /5.7 x 5.1 cm
Jewish Museum, New York

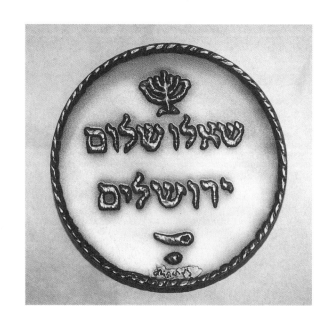

654
Jerusalem Foundation Award Medal, n.d.
Bronze
Diameter 3.5 in /8.8 cm
Jewish Museum, New York

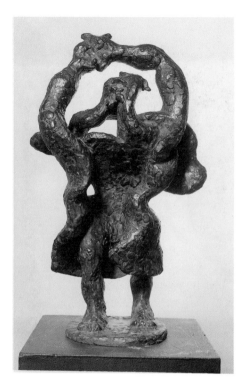

655
Lamentation, 1967
Bronze, edition of 7
H. 20.25 in /51.4 cm

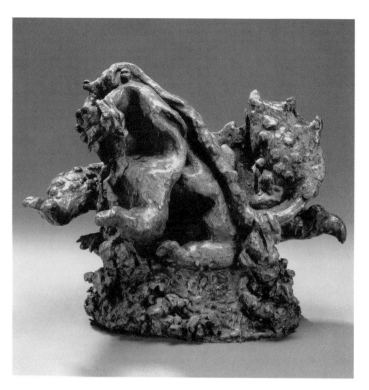

656
L'Arno Furioso, 1967
Bronze, edition of 7
H. 11 in /27.9 cm

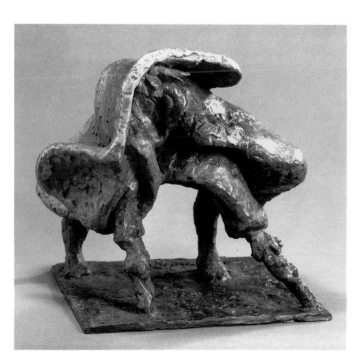

657
Il Ponte Vecchio, 1967
Bronze, edition of 7
H. 12 in /30.5 cm

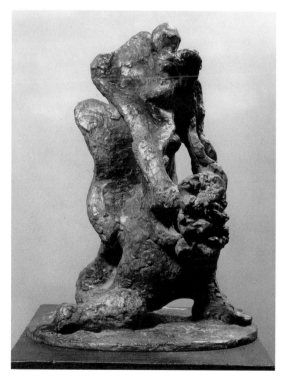

658
Fleur pour Florence douloureuse, 1967
Bronze, edition of 7
H. 16.25 in /41.3 cm

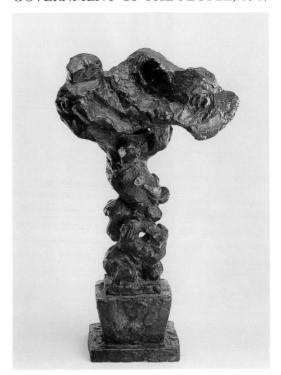

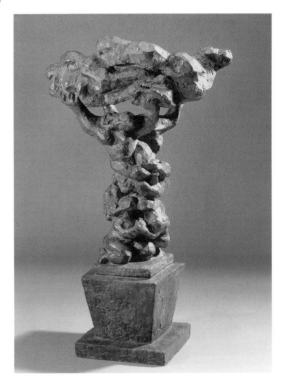

659
First Study for Government of the People,
1967
Bronze, edition of 7
H. 16.5 in /41.9 cm
Philadelphia Museum of Art

660
Working Model for Government of the
People, 1967
Bronze, edition of 7
H. 48.5 in /123.2 cm

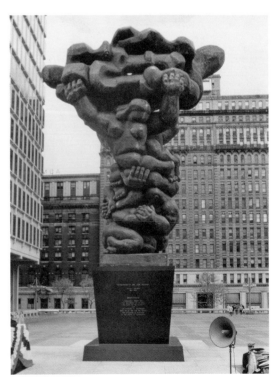

661
Government of the People, 1967-70
Bronze (unique)
H. 35 ft/10.5 m
Municipal Plaza, Philadelphia

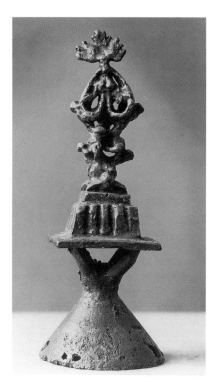

662
First Study for Peace on Earth,
1967
Bronze, edition of 15
H. 10.25 in /26.0 cm
Israel Museum, Jerusalem

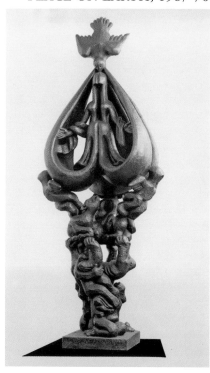

663
Peace on Earth, 1967-69
Bronze, edition of 7
H. 135 in /360.0 cm
Hastings-on-Hudson, New York; The
Nelson-Atkins Museum of Art, Kansas
City, Missouri

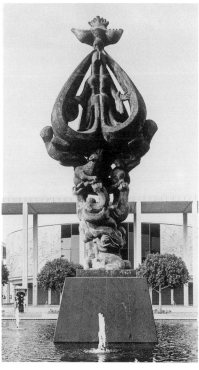

664
Peace on Earth, 1967-69
Bronze (unique)
H. approx. 29 ft/8.7 m
The Music Center of Los Angeles County,
Los Angeles, California

Photograph unavailable

665
Peace on Earth, 1969-70
Marble (unique)
H. 169.25 in /430.0 cm
Galerie Nazionale d'Arte Moderna e
Contemporaneo di Roma

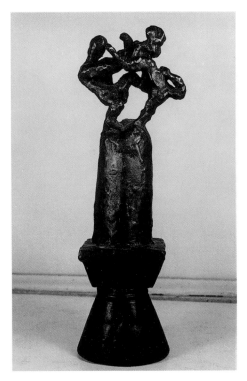

666
Samson Fighting the Lion, 1968
Bronze, edition of 200 + 12 artist's
copies numbered in Roman numerals
H. 8.5 in /21.6 cm

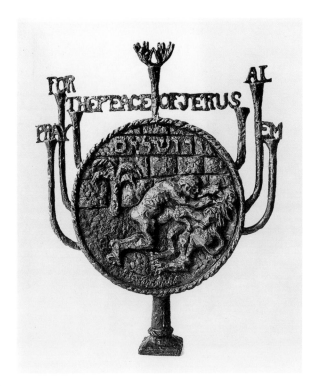

667
*Remembrance Medal (Prayer for the Peace
of Jerusalem)*, 1969
Bronze (unique)
20.87 x 16.5 in /53.0 x 42.0 cm

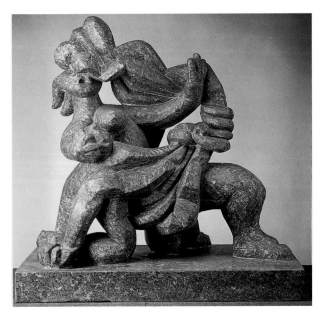

668
Hagar, 1969
Marble (unique)
H. 36.25 in /92.1 cm

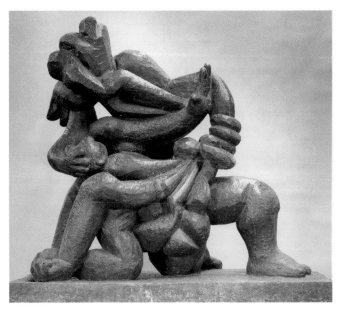

669
Hagar in the Desert, 1969
Bronze, edition of 7
L. 70.5 in /179.0 cm
Jewish Museum San Francisco, California; Tel Aviv Museum of Art, Israel

THE RAPE OF EUROPA, 1969-72

The twenty-six sculptures on the theme of the Rape of Europa, executed between 1969 and 1972, have been divided into three groups. In Group A, the vertical compositions and the closely related figurative style of Europa and the bull form an obvious series. Group B includes the small bronze showing Europa riding on the back of the bull, No. 680, and the three closely related studies of the Rape of Europa, two of which are mounted on a column. The twelve bronzes in Group C represent the most closely related series of bronzes of Lipchitz's entire career.

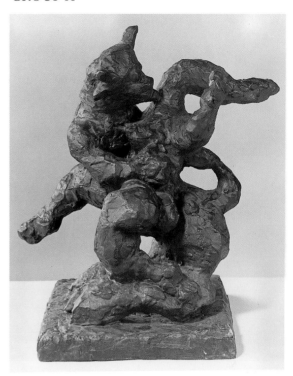

670
Variation of the Rape of Europa A, 1969-70
Bronze, edition of 7
H. 15.75 in /40.0 cm

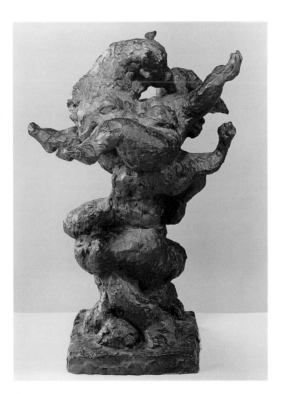

671
Variation of the Rape of Europa B, 1969-70
Bronze, edition of 7
H. 20.68 in /52.5 cm

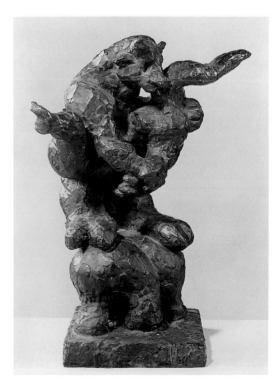

672
Variation of the Rape of Europa C, 1969-70
Bronze, edition of 7
H. 17.87 in /45.5 cm

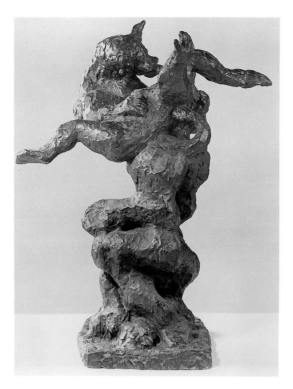

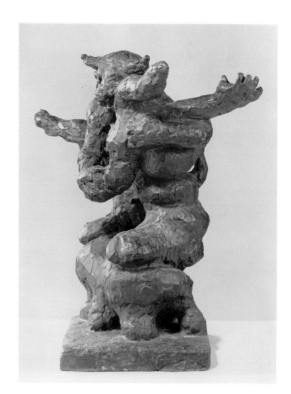

673
Variation of the Rape of Europa D, 1969-70
Bronze, edition of 7
H. 13.62 in /34.5 cm

674
Variation of the Rape of Europa E, 1969-70
Bronze, edition of 7
H. 18.5 in /47.0 cm

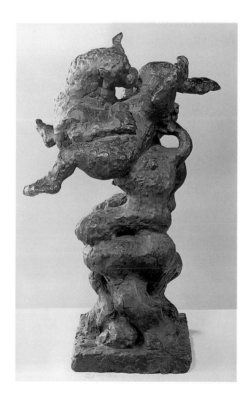

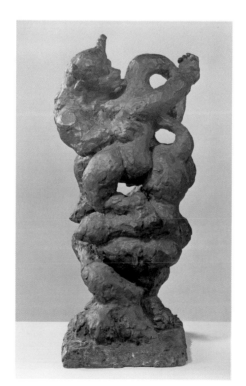

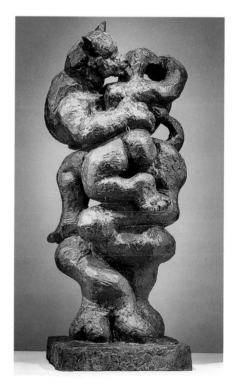

675
Variation of the Rape of Europa F, 1969-70
Bronze, edition of 7
H. 18.5 in /47.0 cm

676
Variation of the Rape of Europa G, 1969-70
Bronze, edition of 7
H. 19.31 in /49.0 cm

677
Rape of Europa, 1969-70
Bronze, edition of 7
H. 38.75 in /98.4 cm

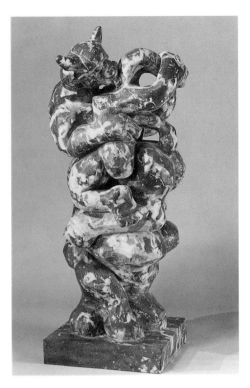

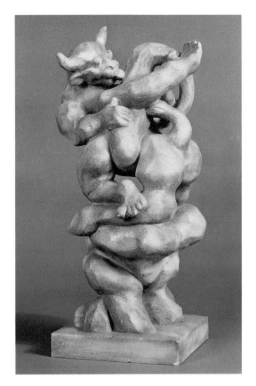

678
Rape of Europa, 1969-70
Marble (unique)
H. 41 in /104.1 cm

679
Rape of Europa, 1969-70
Marble (unique)
H. 20 in /50.8 cm

GROUP B

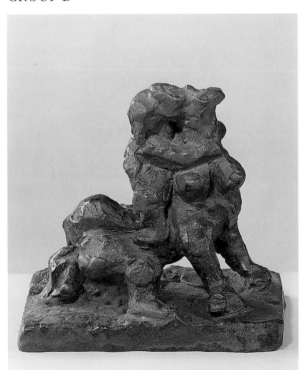

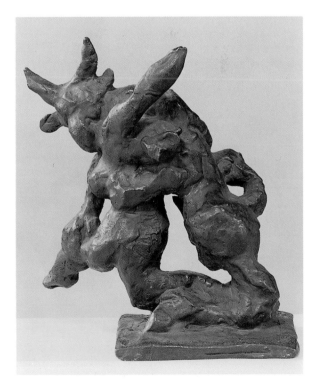

680
Small Study for the Rape of Europa, 1969-70
Bronze, edition of 7
L. 4.25 in /10.8 cm

681
Small Study for the Rape of Europa, 1969-70
Bronze, edition of 7
H. 4.87 in /12.4 cm

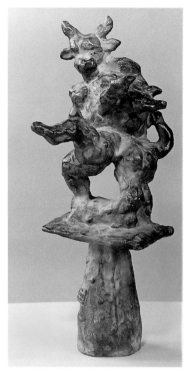

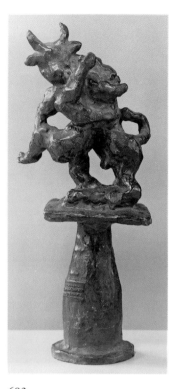

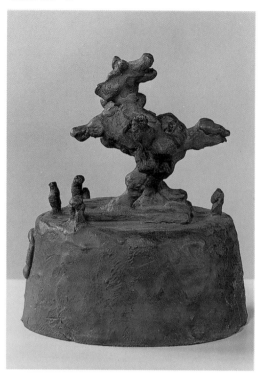

682
*Small Study for the Rape of
Europa on Column I,* 1969-70
Bronze, edition of 7
H. 8.25 in /20.9 cm

683
*Small Study for the Rape of
Europa on Column II,* 1969-70
Bronze, edition of 7
H. 8.87 in /22.5 cm

684
Variation on the Theme of the Rape of Europa I,
1969-72
Bronze, edition of 7
H. 4.31 in /11 cm

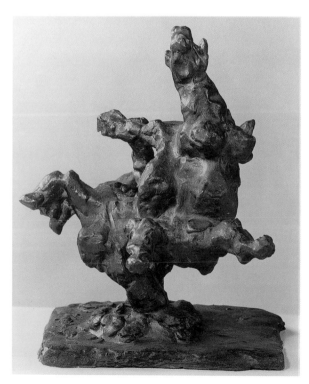

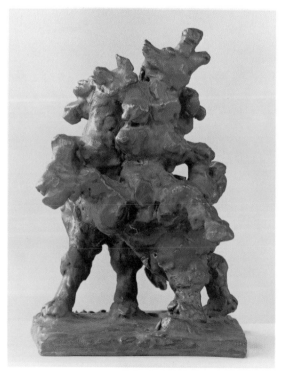

685
Variation on the Theme of the Rape of Europa II, 1969-72
Bronze, edition of 7
H. 6.5 in /16.5 cm

686
Variation on the Theme of the Rape of Europa III, 1969-72
Bronze, edition unknown
H. 7.5 in /19.0 cm

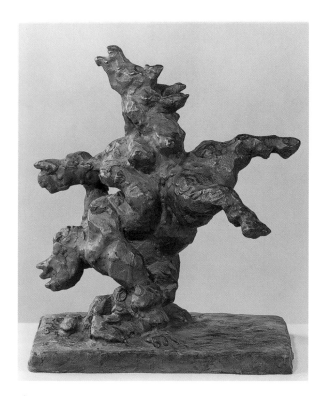

687
Variation on the Theme of the Rape of Europa IV, 1969-72
Bronze, edition of 7
H. 8.87 in /22.5 cm

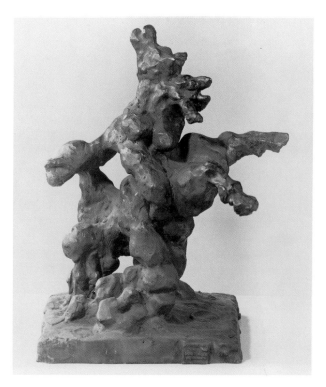

688
Variation on the Theme of the Rape of Europa V, 1969-72
Bronze, edition of 7
H. 8.93 in /22.7 cm

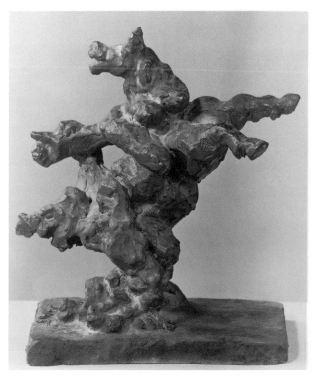

689
Variation on the Theme of the Rape of Europa VI, 1969-72
Bronze, edition of 7
H. 8.93 in /22.7 cm

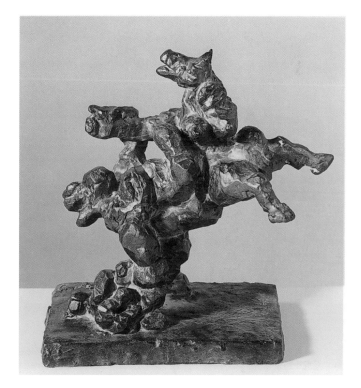

690
Variation on the Theme of the Rape of Europa VII, 1969-72
Bronze, edition of 7
H. 9.06 in /23.0 cm

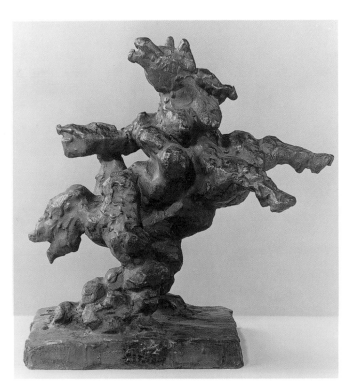

691
Variation on the Theme of the Rape of Europa VIII, 1969-72
Bronze, edition of 7
H. 9.12 in /23.2 cm

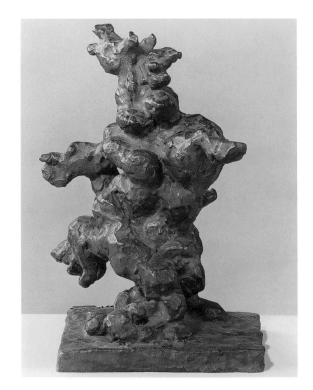

692
Variation on the Theme of the Rape of Europa IX,
1969-72
Bronze, edition of 7
H. 9.31 in /23.7 cm

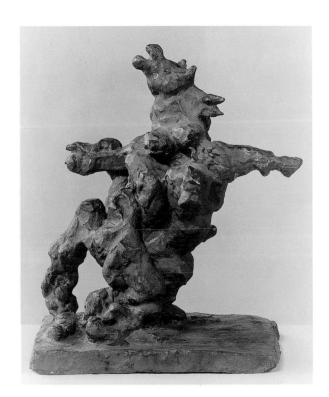

693
Variation on the Theme of the Rape of Europa X, 1969-72
Bronze, edition of 7
H. 9.43 in /24.0 cm

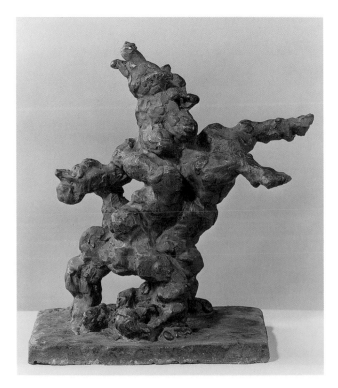

694
Variation on the Theme of the Rape of Europa XI, 1969-72
Bronze, edition of 7
H. 9.56 in /24.2 cm

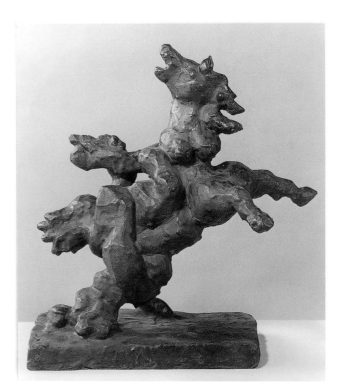

695
Variation on the Theme of the Rape of Europa XII, 1969-72
Bronze, edition of 7
H. 10.06 in /25.5 cm

THE LAST EMBRACE, 1970-72

The sixteen sculptures on the theme of the last embrace, executed between 1970 and 1972, have been divided into three groups. In Group A, Nos. 696-698 are three disparate studies of which there are no variations. Nos. 699-700 are so closely related that the easiest way to differentiate between them is by the irregular shapes of the bronze bases. Nos. 701 and 702, which are untitled, would appear to belong to the series, although this is by no means certain. In Group B, the four bronzes, Nos. 703-706, and the marble carving, No. 707, are closely related versions of an embracing couple. In this group, Lipchitz included the Italian *Salvataggio* (the rescue) in the titles. In Group C, the three maquettes, Nos. 708-710, are studies for the large bronze, *The Last Embrace,* No. 711.

GROUP A

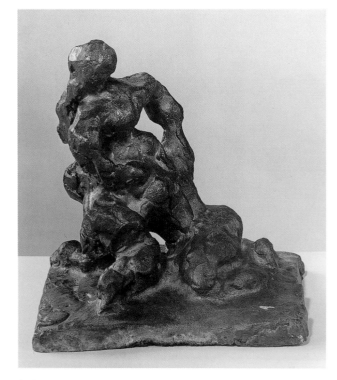

696
Variation on the Theme of the Last Embrace I, 1970-72
Bronze, edition of 7
L. 4.5 in /11.4 cm

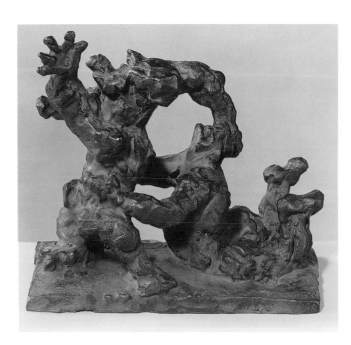

697
Variation on the Theme of the Last Embrace II, 1970-72
Bronze, edition of 7
L. 6.68 in /17.0 cm

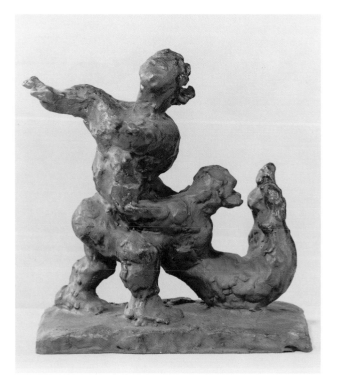

698
Variation on the Theme of the Last Embrace III, 1970-72
Bronze, edition of 7
L. 7.93 in /19.9 cm

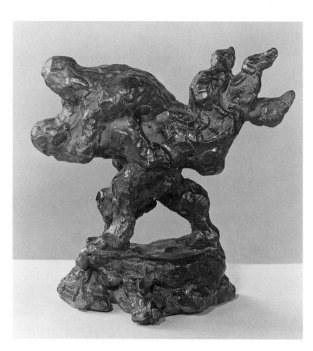

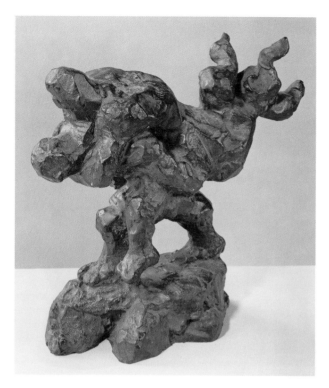

699
Variation on the Theme of the Last Embrace IV, 1970-72
Bronze, edition of 7
L. 7.25 in /18.4 cm

700
Variation on the Theme of the Last Embrace V, 1970-72
Bronze, edition of 7
L. 7.25 in /18.4 cm

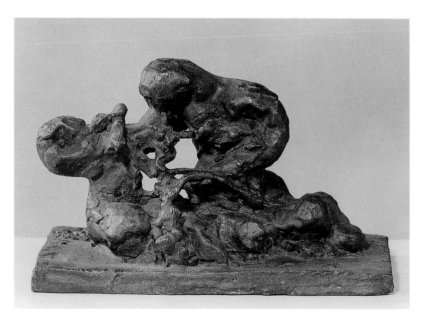

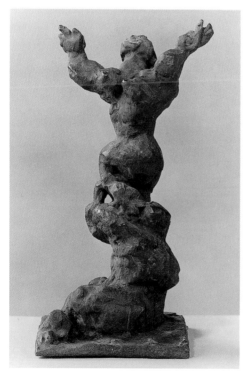

701
Untitled (Variation on the Theme of the Last Embrace?), c. 1970-72
Bronze, edition of 7
L. 6.37 in /16.2 cm

702
*Untitled (Variation on the Theme of the Last
Embrace?),*
c. 1970-72
Bronze, edition unknown
H. 8.43 in /21.5 cm

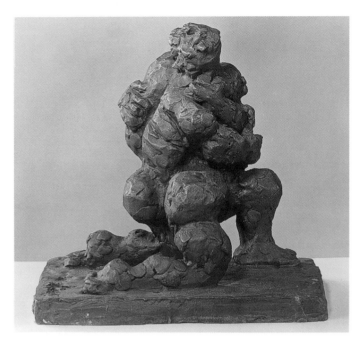

703
Variation on the Theme of the Last Embrace (Salvataggio) I, 1970-72
Bronze, edition unknown
L. 9.87 in /25.0 cm

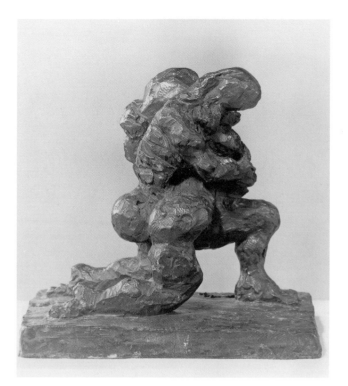

704
Variation on the Theme of the Last Embrace (Salvataggio) II,
1970-72
Bronze, edition of 7
L. 10.5 in (with base)/26.7 cm

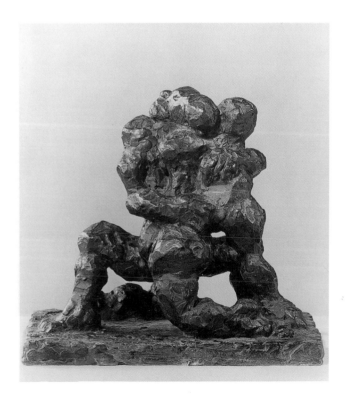

705
Variation on the Theme of the Last Embrace (Salvataggio) III,
1970-72
Bronze, edition of 7
L. 11.81 in (with base)/30.0 cm

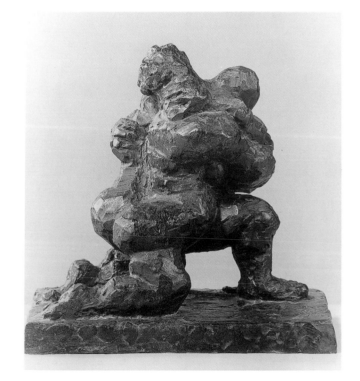

706
Variation on the Theme of the Last Embrace (Salvataggio) IV,
1970-72
Bronze, edition of 7
L. 12 in (with base)/30.5 cm

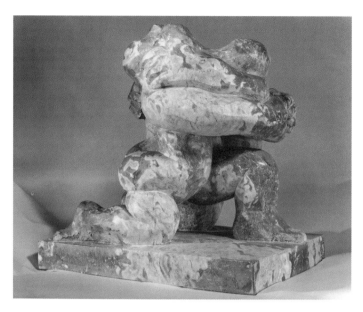

707
The Last Embrace (Salvataggio), 1971
Marble (unique)
H. 26 in /66.0 cm

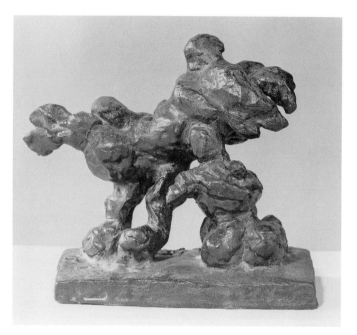

708
Study for the Last Embrace: Maquette No. 1, 1970-72
Bronze, edition of 7
L. 5.87 in /15.0 cm

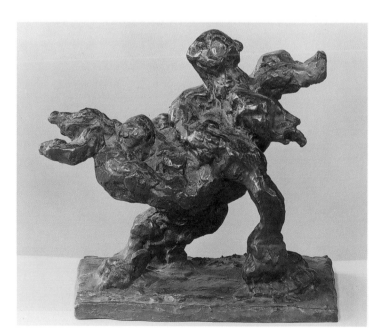

709
Study for the Last Embrace: Maquette No. 2, 1970-72
Bronze, edition of 7
L. 8.25 in /21.0 cm

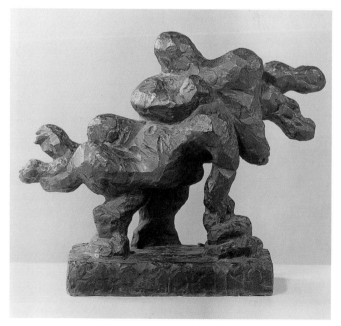

710
Study for the Last Embrace: Maquette No. 3, 1970-72
Bronze, edition of 7
L. 15.5 in /39.4 cm

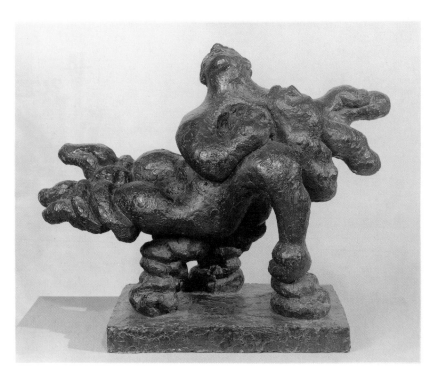

711
The Last Embrace, 1970-71
Bronze, edition of 7
L. 41 in /104.1 cm

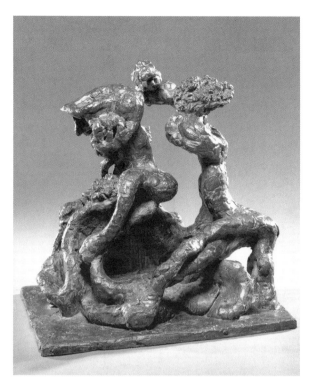

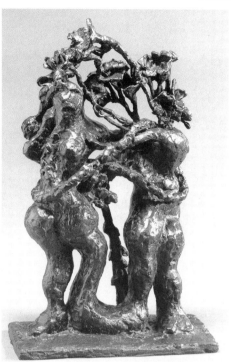

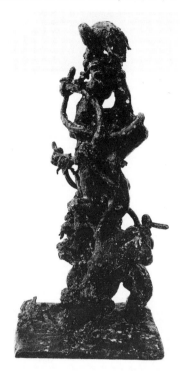

712
Homage to Dürer, 1970
Bronze, edition of 7
L. 16 in /40.6 cm

713
La première rencontre, 1970-71
Bronze, edition of 7
H. 17.5 in /44.5 cm

714
L'emmelé, 1970-71
Bronze, edition of 7
H. 15.5 in /39.4 cm

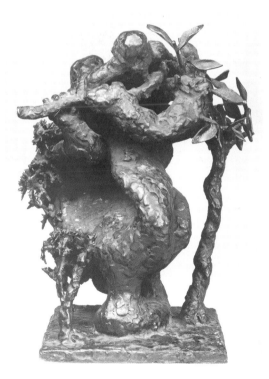

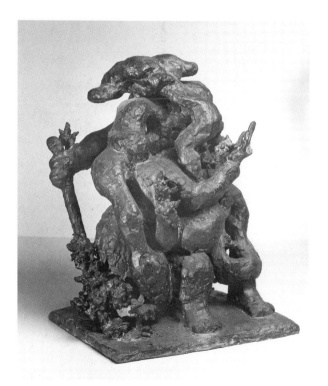

715
Pierrot, 1970-71
Bronze, edition of 7
H. 14.75 in /37.5 cm

716
La rencontre, 1970-71
Bronze, edition of 7
H. 16.56 in /42.0 cm

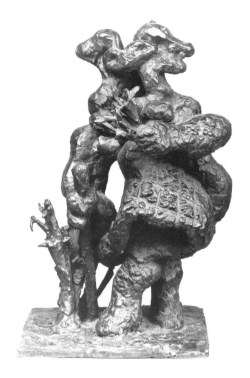

717
Harlequin, 1970-71
Bronze, edition of 7
H. 15.37 in /39.1 cm

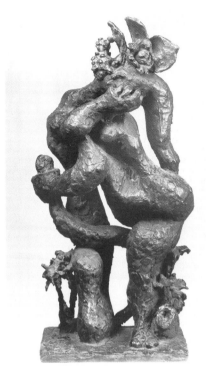

718
Columbine, 1971
Bronze, edition of 7
H. 20.37 in /51.8 cm

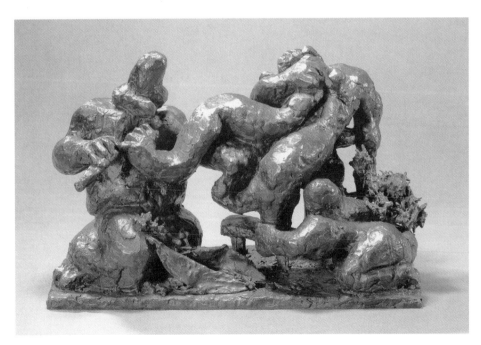

719
La mort de Harlequin, 1971
Bronze, edition of 7
L. 17.75 in /45.1 cm

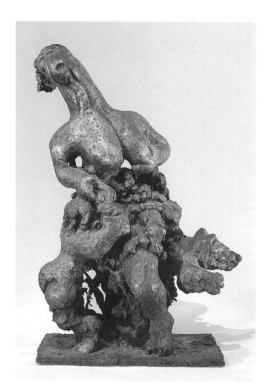

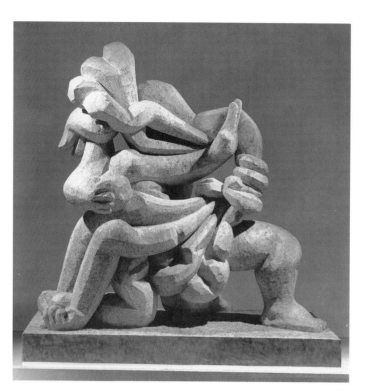

720
Untitled, c. 1970-71
Bronze, edition unknown
H. 24.5 in /62.2 cm

721
Hagar, 1971
Stone (unique)
H. 72 in /182.9 cm

722
Homage to Arcimboldo, 1971
Bronze (unique)
H. 21.5 in /54.6 cm

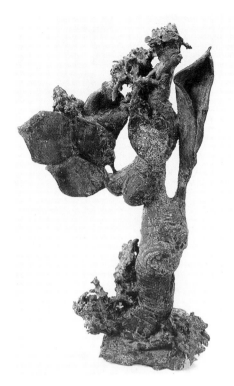

723
Fleur solitaire, 1971
Bronze (unique)
H. 11.87 in /30.2 cm

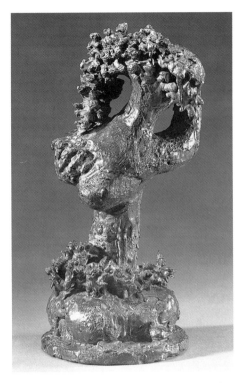

724
La belle I, 1971
Bronze (unique)
H. 12.25 in /31.1 cm

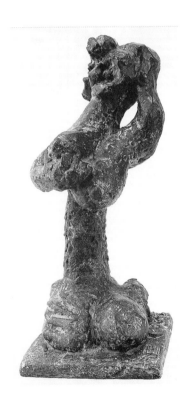

725
La belle II, 1971
Bronze (unique)
H. 12.5 in /31.8 cm

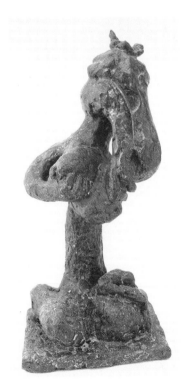

726
La belle III, 1971
Bronze (unique)
H. 12.12 in /30.8 cm

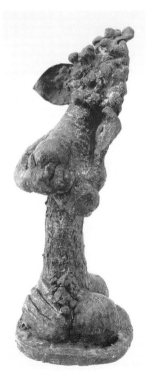

727
La belle IV, 1971
Bronze (unique)
H. 11.62 in /29.5 cm

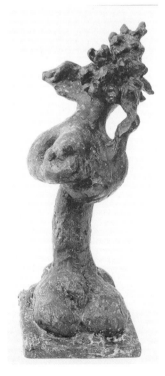

728
La belle V, 1971
Bronze (unique)
H. 11.62 in /29.5 cm

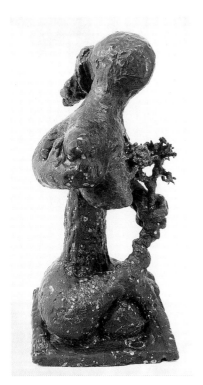

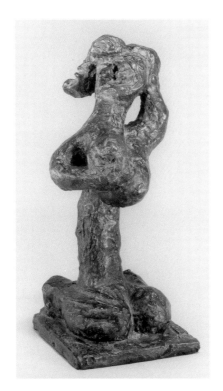

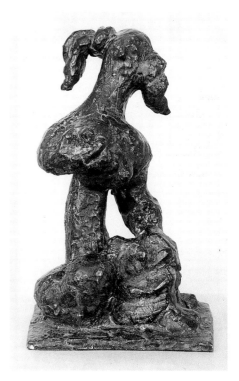

729
La belle VI, 1971
Bronze (unique)
H. 10.5 in /26.7 cm

730
La belle VII, 1971
Bronze (unique)
H. 11.5 in /29.2 cm

731
La belle VIII, 1971
Bronze (unique)
H. 11.75 in /29.8 cm

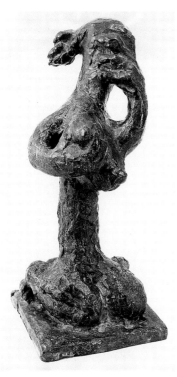

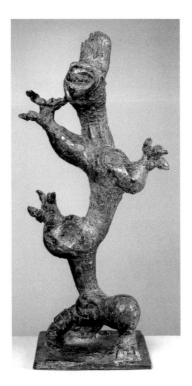

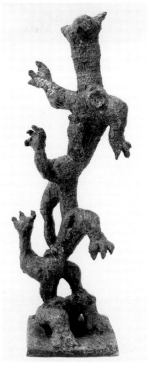

732
La belle IX, 1971
Bronze (unique)
H. 12.25 in /31.1 cm

733
La danse érotique, 1971
Bronze (unique)
H. 17.75 in /45.1 cm

734
Le grand tumulte, 1971
Bronze (unique)
H. 20.75 in /52.7 cm

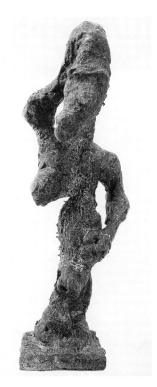

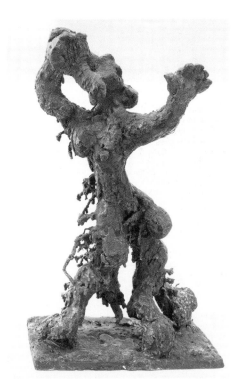

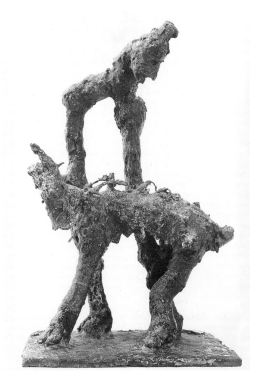

735
La sauvageonne, 1971
Bronze (unique)
H. 14.37 in /36.5 cm

736
L'Amazone, 1971
Bronze (unique)
H. 12.75 in /32.4 cm

737
Le bon pasteur, 1971
Bronze (unique)
H. 11.75 in /29.8 cm

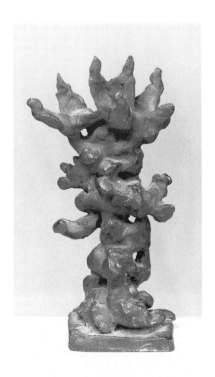

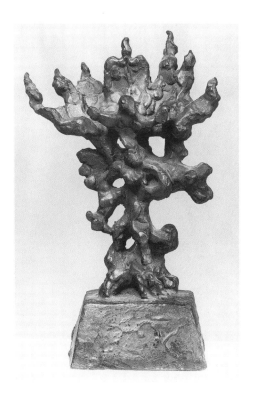

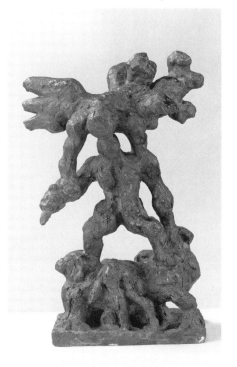

738
Sketch for Our Tree of Life I, 1971-72
Bronze, edition of 7
H. 4.5 in /11.5 cm

739
Sketch for Our Tree of Life II, 1971-72
Bronze, edition of 7
H. 9.25 in /23.5 cm

740
Sketch for Our Tree of Life III, 1971-72
Bronze, edition of 7
H. 11.75 in /29.9 cm

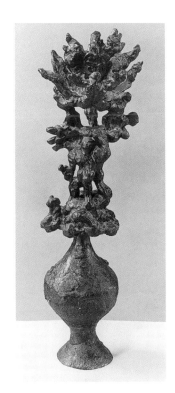

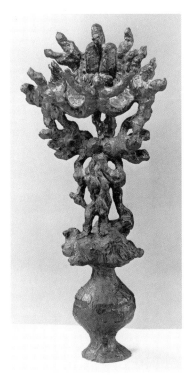

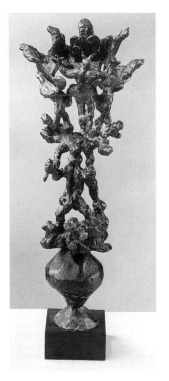

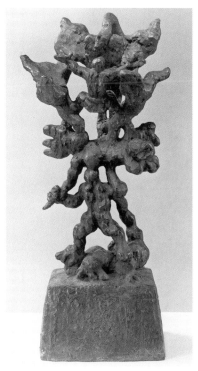

741
Sketch for Our Tree of Life IV,
1971-72
Bronze, edition of 7
H. 18.5 in /47.0 cm

742
Sketch for Our Tree of Life V,
1971-72
Bronze, edition of 7
H. 20.5 in /52.1 cm

743
Sketch for Our Tree of Life VI,
1971-72
Bronze, edition of 7
H. 23 in /58.4 cm

744
Sketch for Our Tree of Life VII,
1971-72
Bronze, edition of 7
H. 21.37 in /54.3 cm

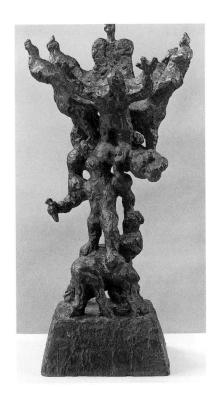

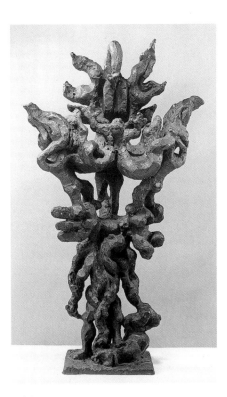

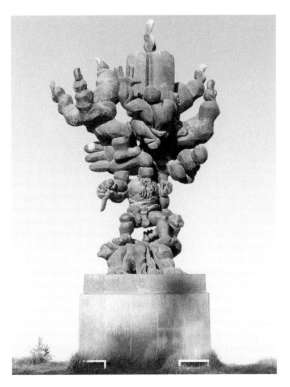

745
Sketch for Our Tree of Life VIII, 1971-72
Bronze, edition of 7
H. 25.87 in /65.7 cm

746
Sketch for Our Tree of Life IX, 1971-72
Bronze, edition of 7
H. 31.5 in /80.0 cm

747
Our Tree of Life, 1973-78, Bronze (unique)
H. 20 ft/6 m.
Hadassah University Hospital, Mount Scopus, Jerusalem.

Yulla Lipchitz, the sculptor's widow, enlarged this sculpture,
based on the definitive plaster study for *Our Tree of Life,* which
Lipchitz completed shortly before his death on May 27, 1973.
The sculpture was installed on Mount Scopus in 1978.

PLATES

Each bronze is from an edition of 7 unless otherwise indicated

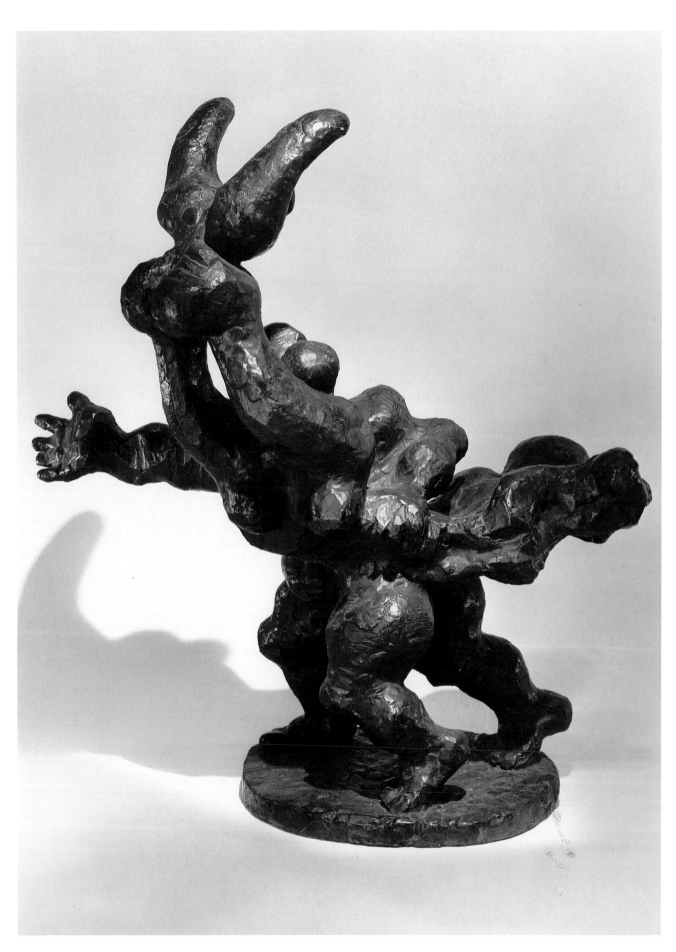

345 *Arrival*, 1941 Bronze, H. 21 in / 53.3 cm

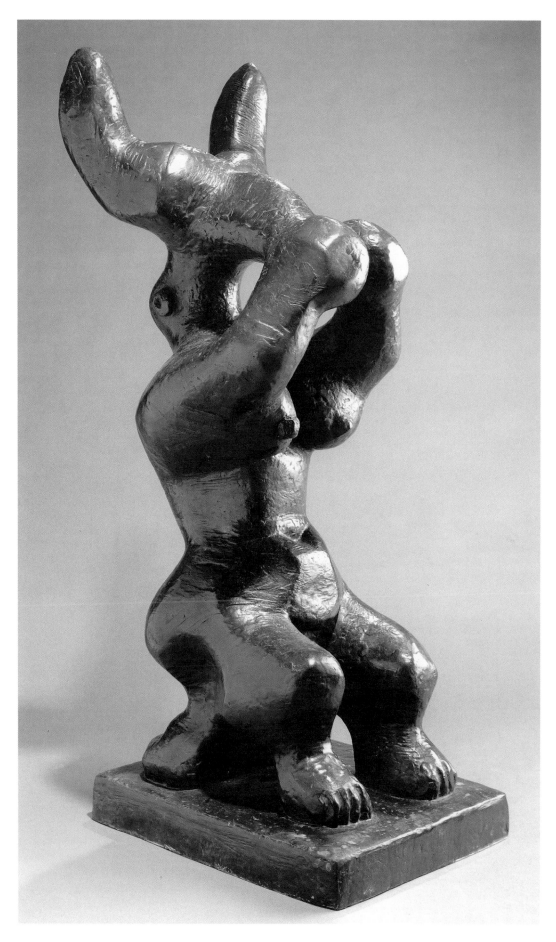

347 *Return of the Child,* 1941, Bronze, H. 45 in /114.3 cm

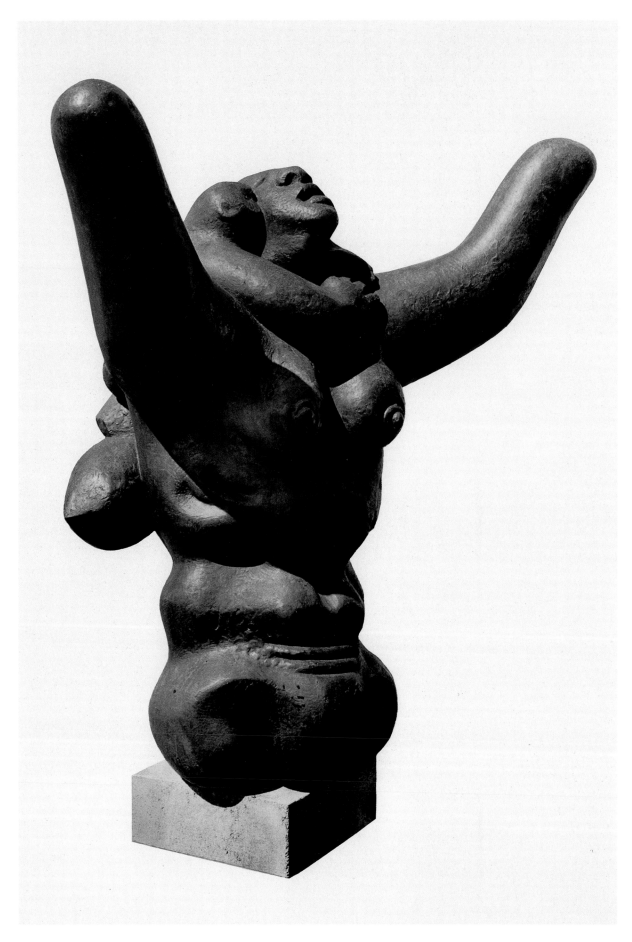

349 *Mother and Child II*, 1941, Bronze, H. 50 in/127.0 cm

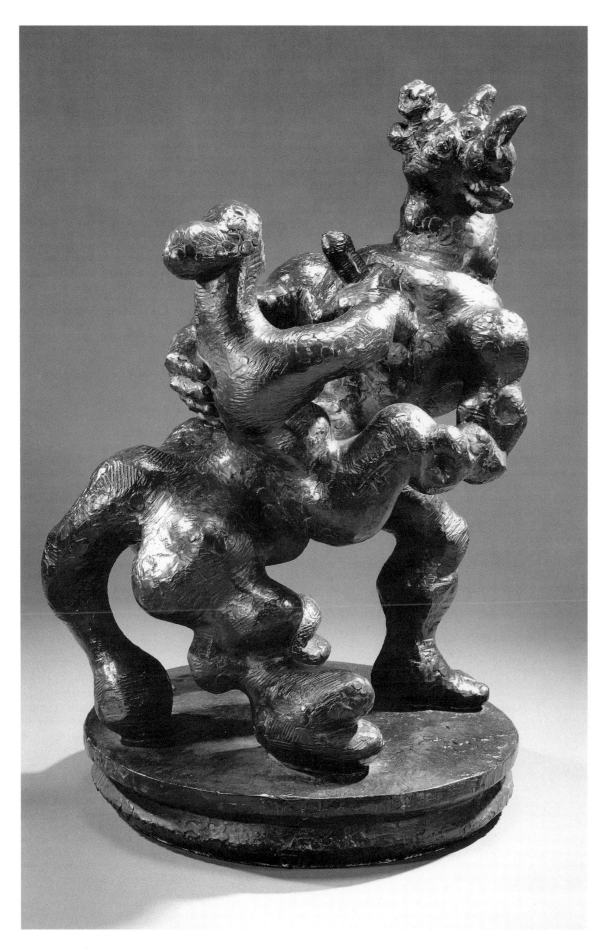

350 *Rape of Europa,* 1941, Bronze, 3.5 in /85.1 cm

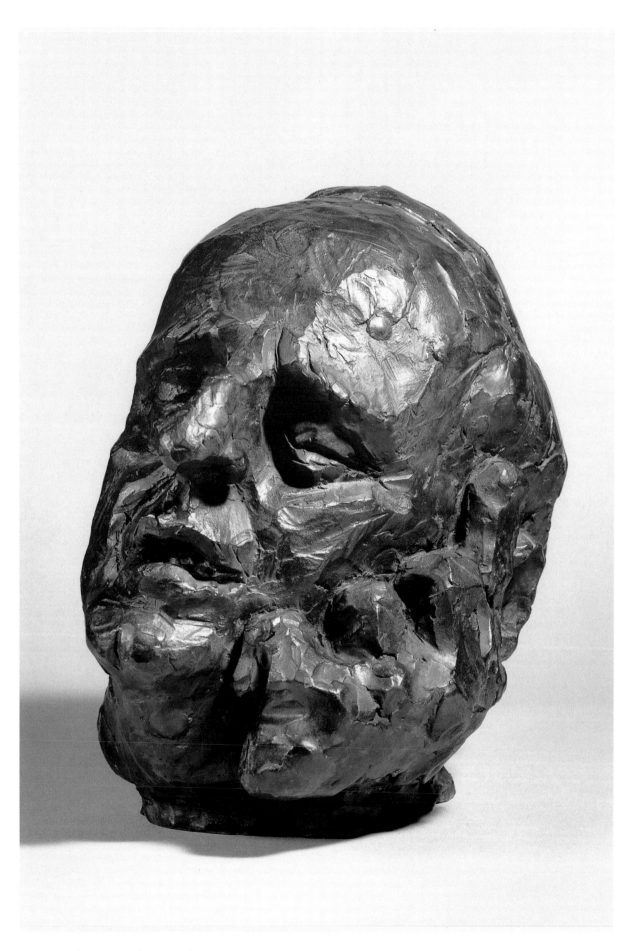

356 *Marsden Hartley Sleeping*, 1942, Bronze, H. 10.75 in /27.3 cm

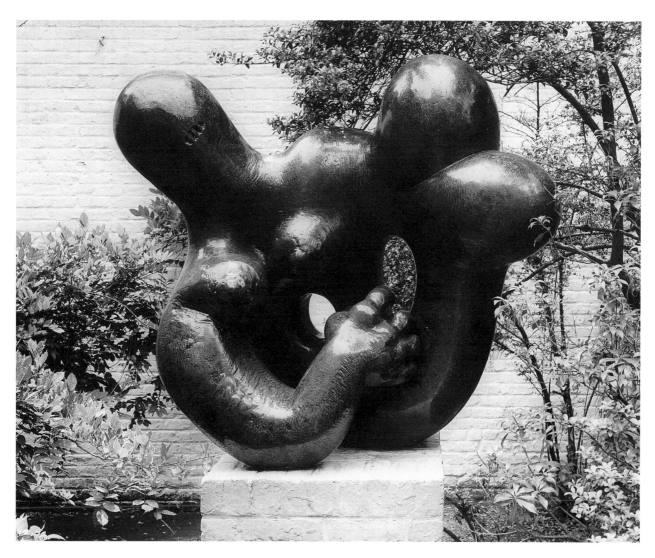

359 *Benediction I*, 1942-44, Bronze (unique), H. 42 in /106.7 cm

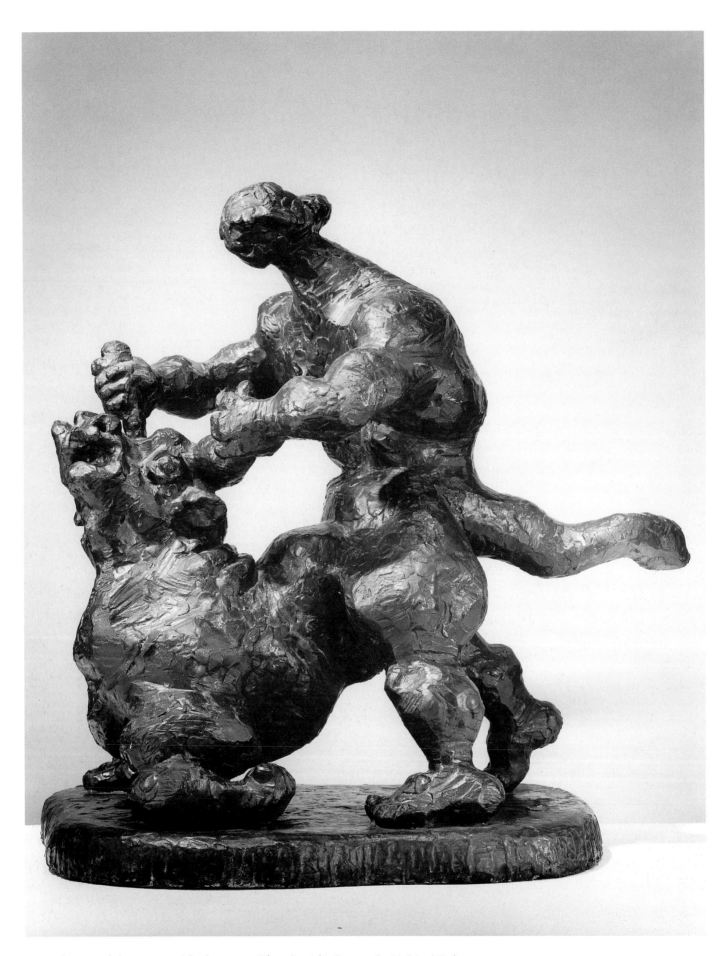

360 *Theseus and the Minotaur* (also known as *Theseus*), 1942, Bronze, L. 28.5 in /72.4 cm

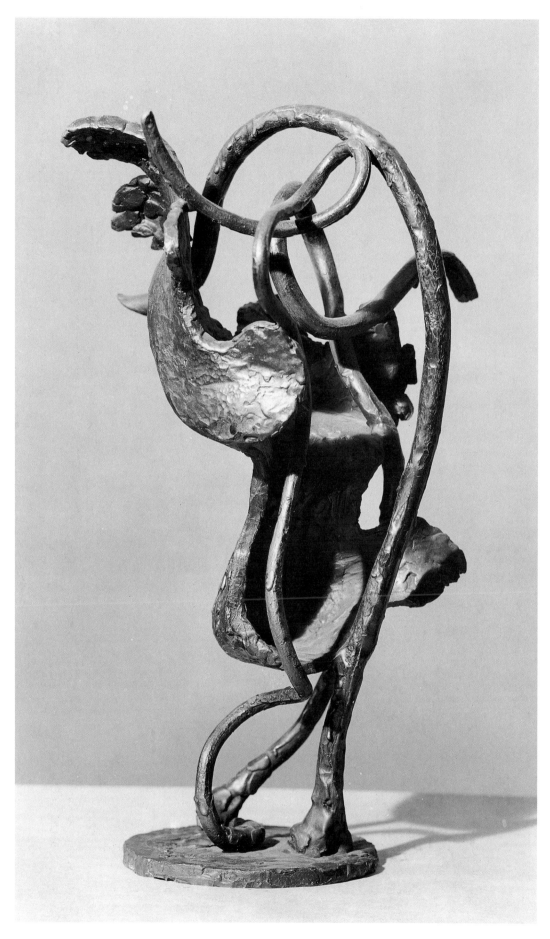

361 *Variation,* 1942, Bronze (unique), H. 15 in /38.1 cm

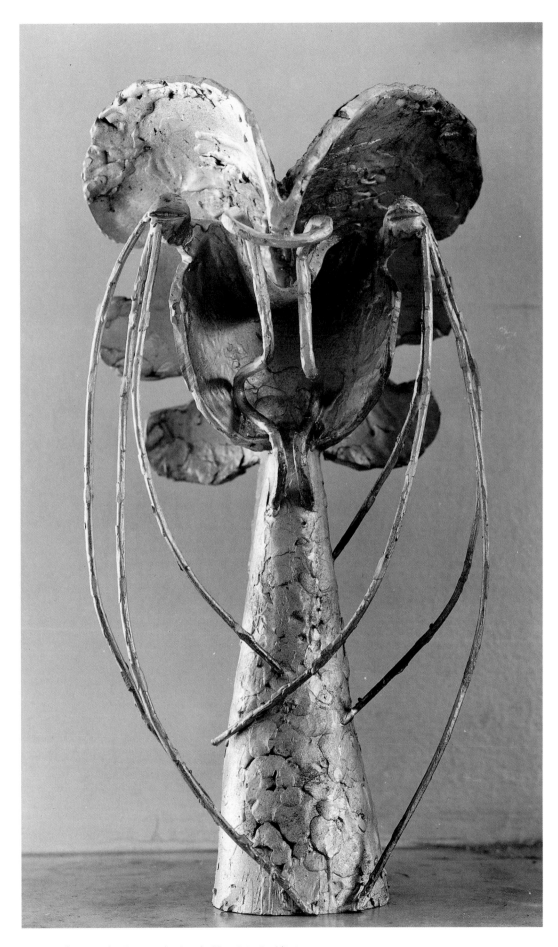

363 *Barbara,* 1942, Bronze (unique), H. 15.87 in /40.3 cm

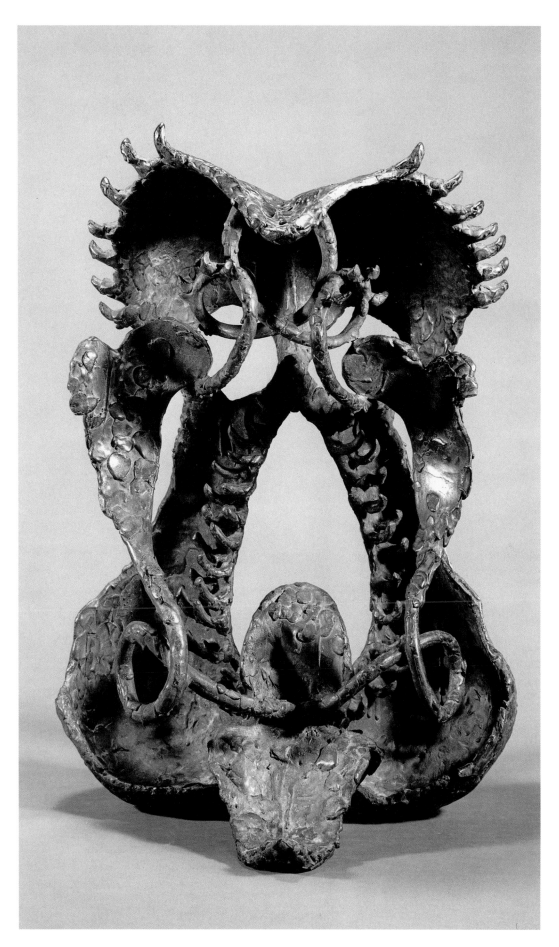

369 *Myrrah,* 1942, Bronze (unique), H. 22.75 in /57.9 cm

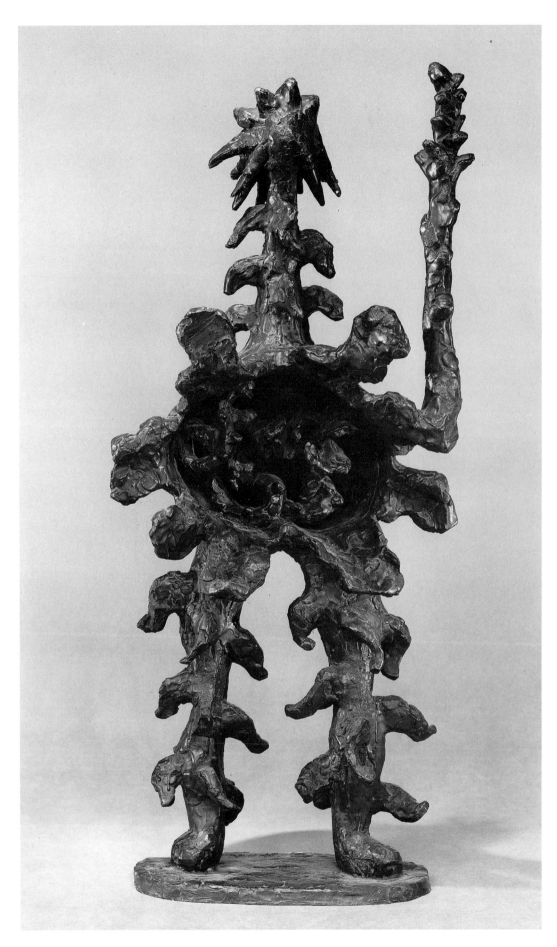

372 *The Pilgrim*, 1942, Bronze (unique), H. 29.75 in /75.6 cm

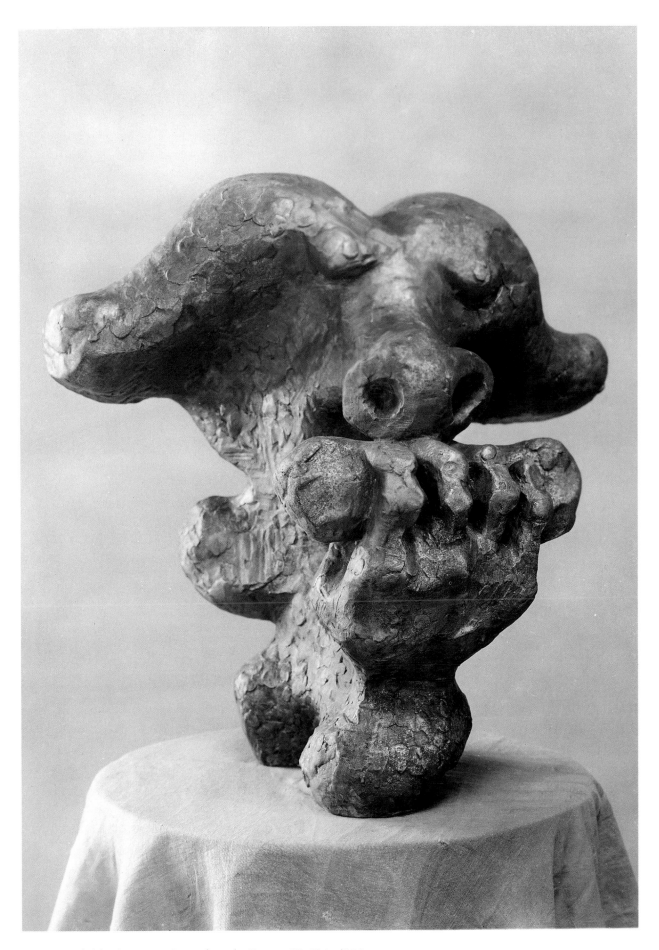

373 *Pastorale* (also known as *Pastoral*), 1942, Bronze, H. 22 in /55.9 cm

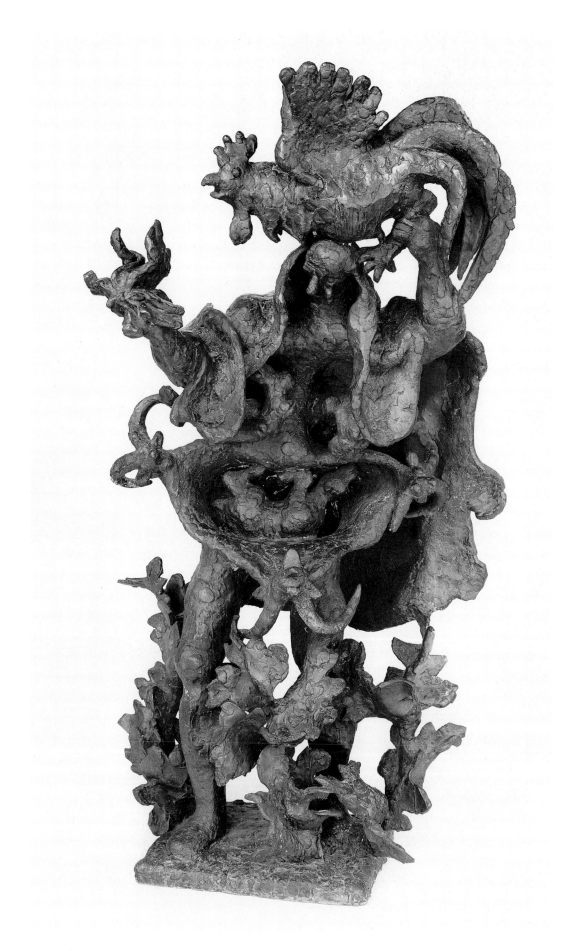

377 *The Prayer,* 1943, Bronze (unique), H. 42.5 in /108.0 cm

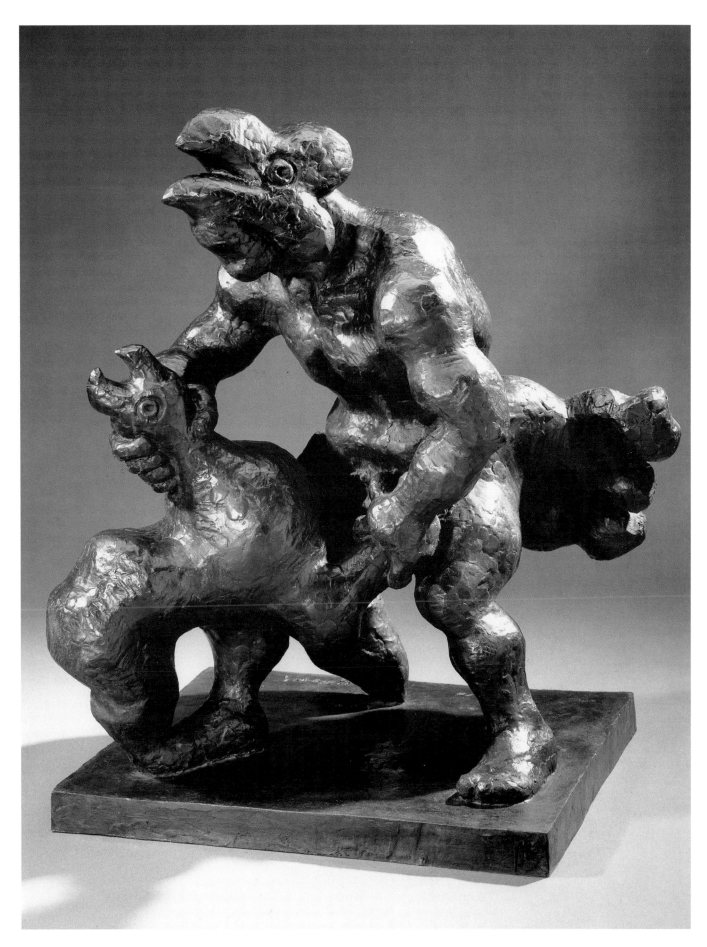

379 *Prometheus Strangling the Vulture*, 1943, Bronze, H. 37.5 in /95.3 cm

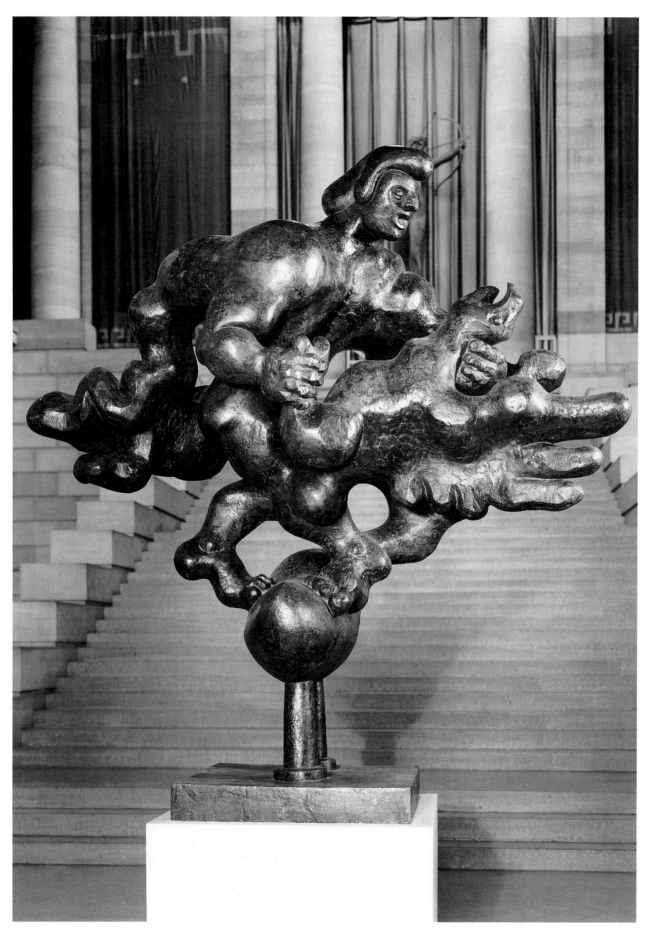

381 *Prometheus Strangling the Vulture*, 1944-53, Bronze, edition of 2, H. 7 ft 9 in /236.2 cm

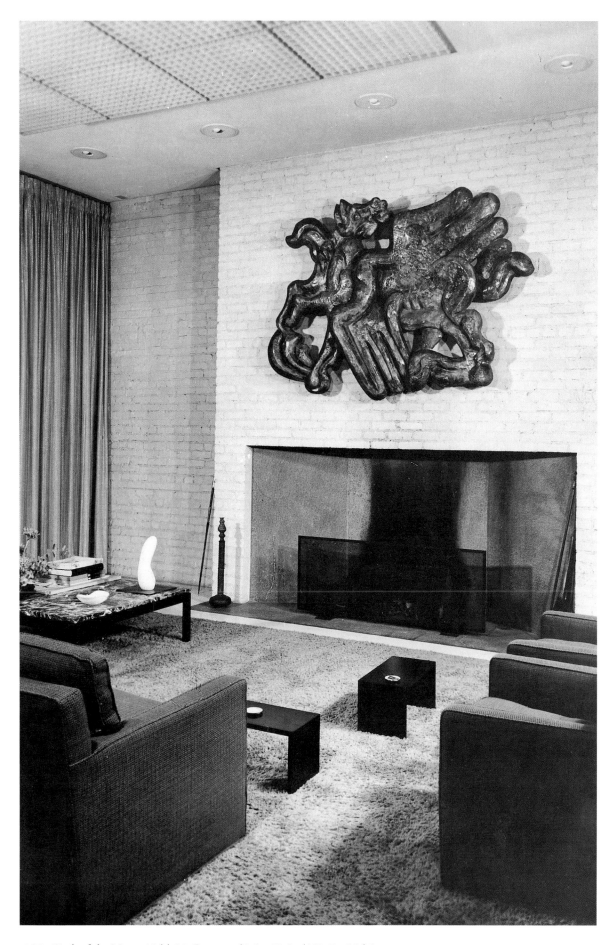

385 *Birth of the Muses,* 1944-50, Bronze, 60.5 x 89 in /153.7 x 226.1 cm

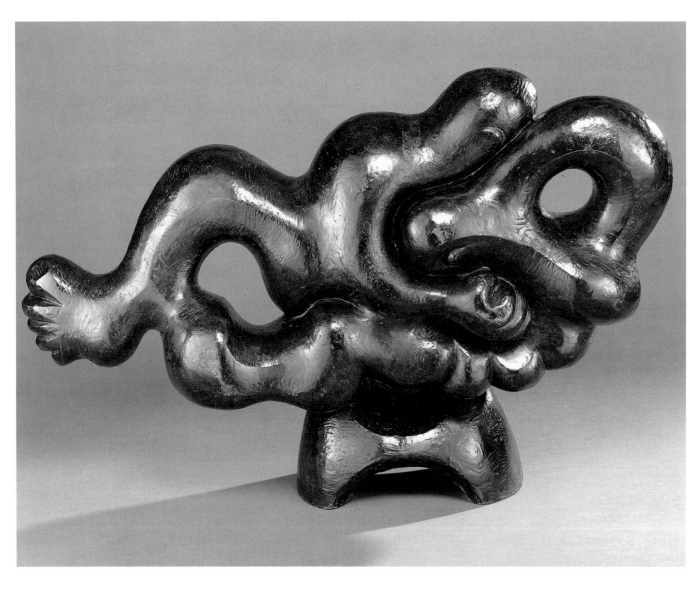

390 *Song of Songs,* 1945, Bronze, L. 36 in /91.5 cm

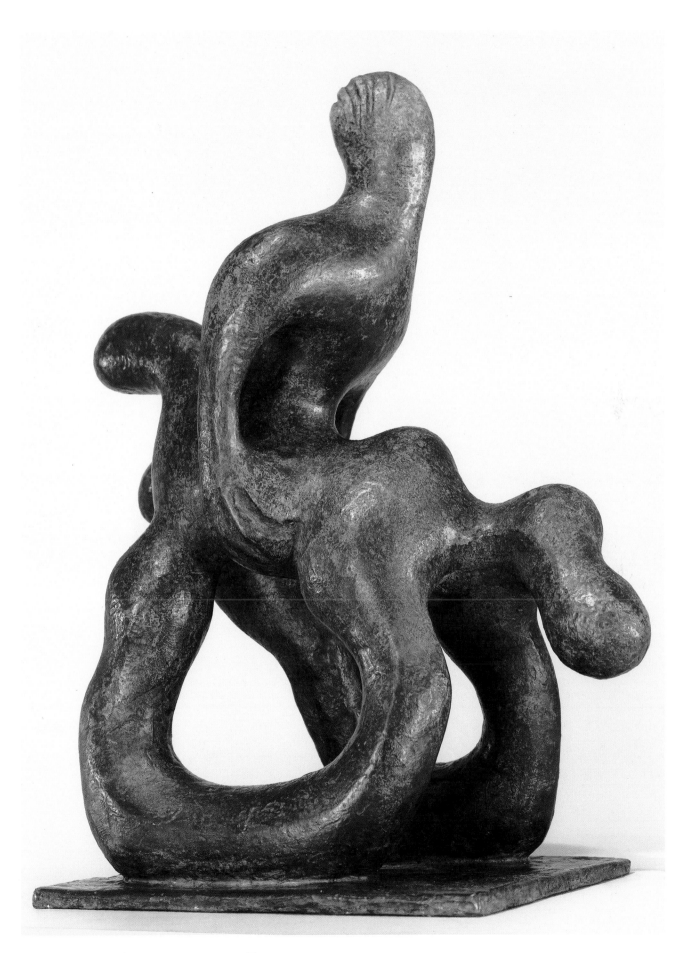

394 *The Rescue,* 1945, Bronze, H. 15.75 in /40.0 cm

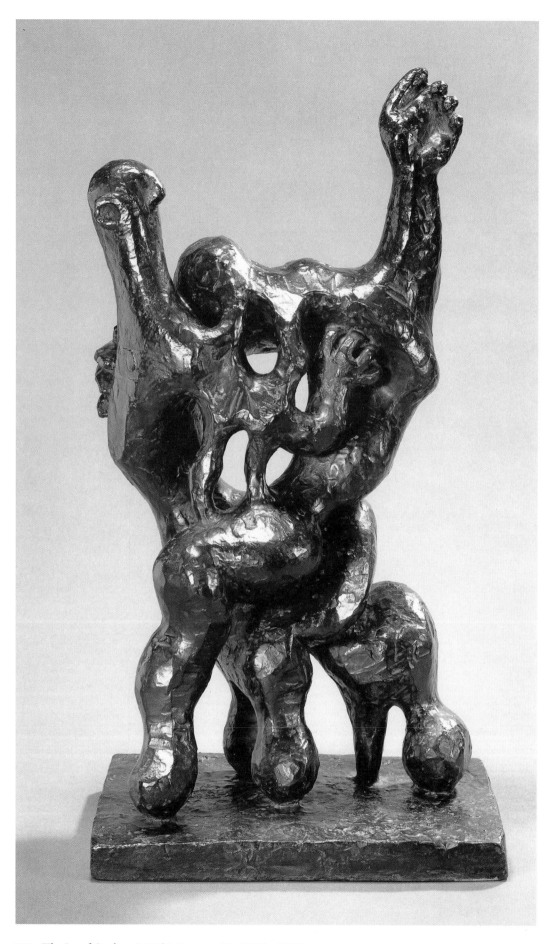

395 *The Joy of Orpheus I,* 1945, Bronze, H. 18.5 in /47.0 cm

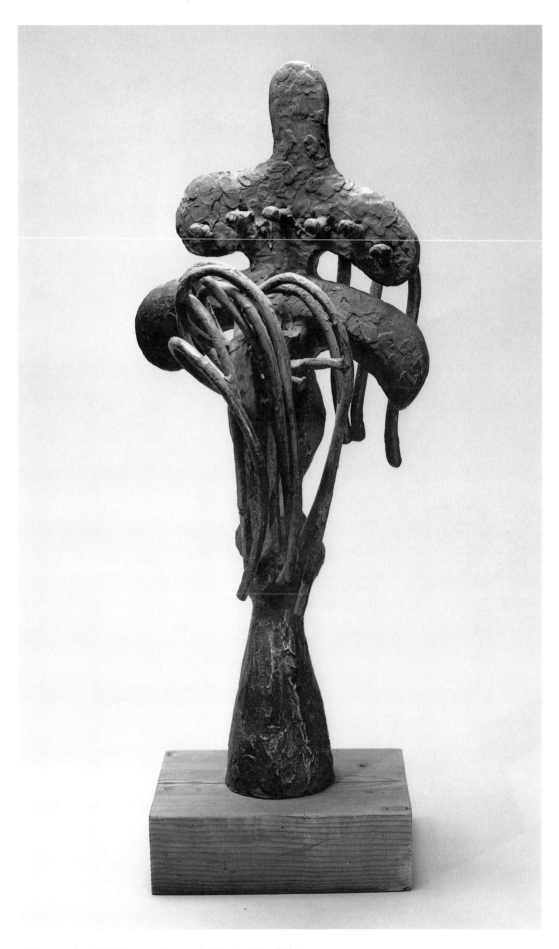

399 *Aurelia,* 1946, Bronze (unique), H. 25.37 in /64.5 cm

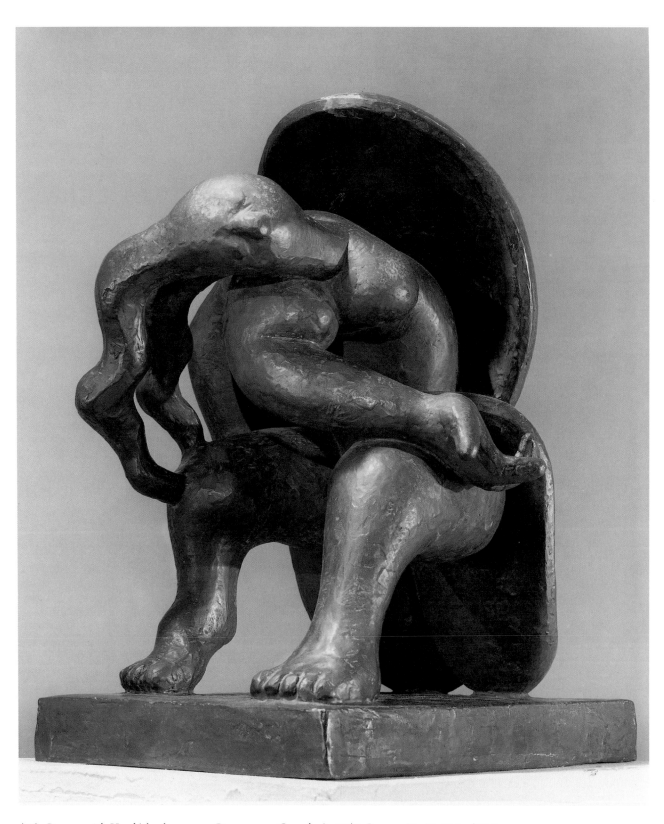

406 *Dancer with Hood* (also known as *Danseuse au Capuchon*), 1947, Bronze, H. 21.12 in /53.7 cm

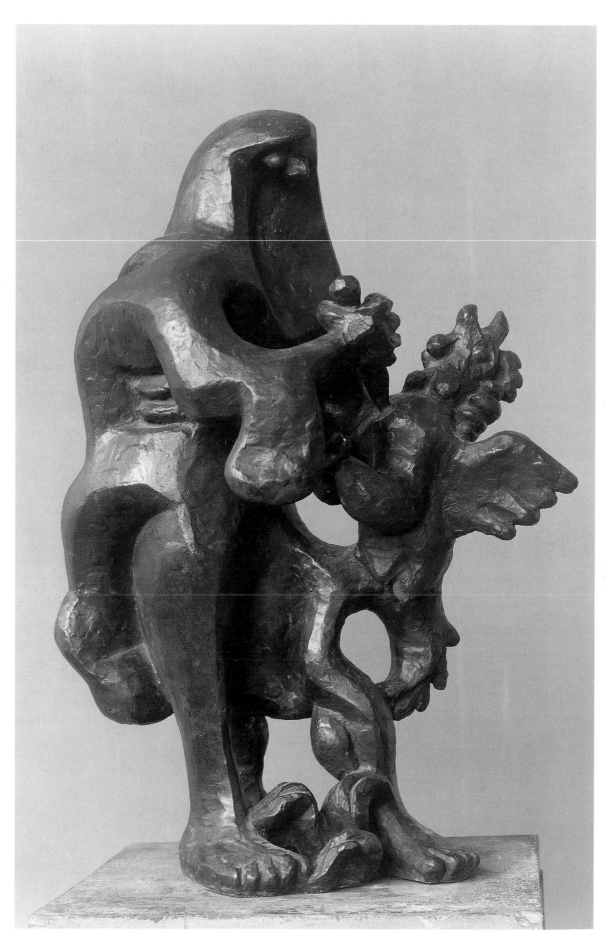

416 *Second Study for Sacrifice* (also known as *Sacrifice 1*), 1947, Bronze, H. 19 in /48.3 cm

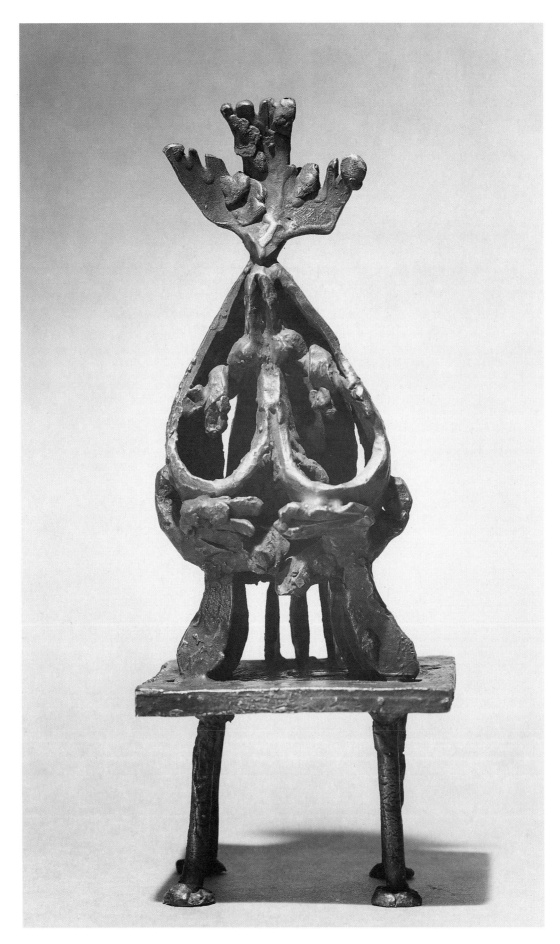

419 *Notre Dame de Liesse: Maquette No. 1,* 1948, Bronze (unique), H. 9.25 in /23.5 cm

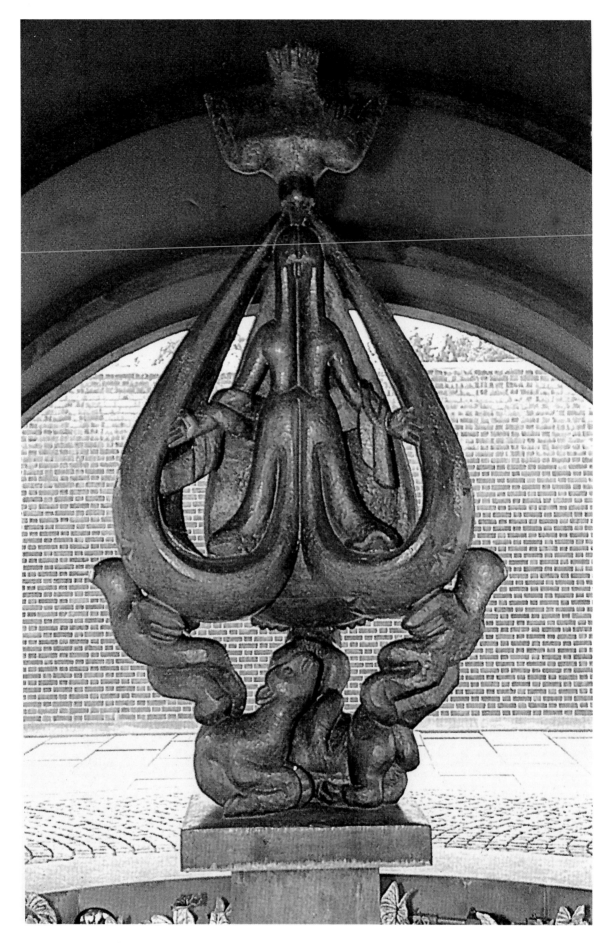

425 *Notre Dame de Liesse,* 1948-55, Bronze, edition of 3, H. 97 in /246.4 cm

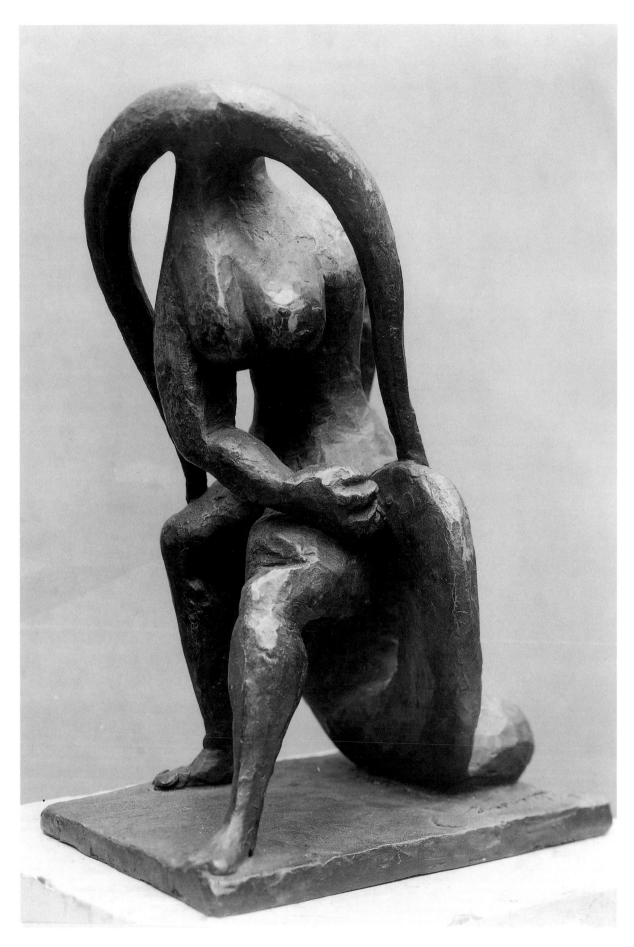

427 *Dancer with Braids,* 1948, Bronze, edition unknown, H. 14.25 in /36.2

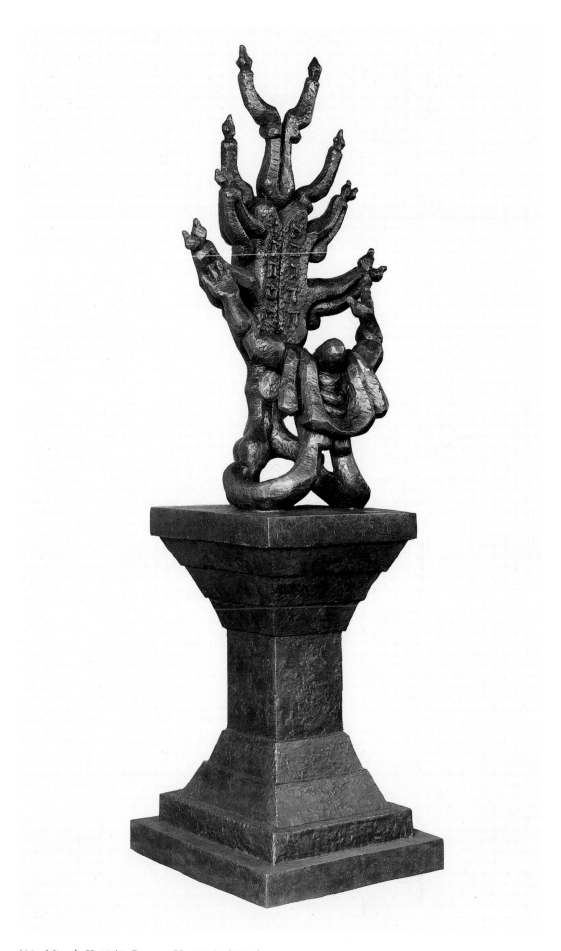

430 *Miracle II,* 1948, Bronze, H. 110 in./279.4 cm

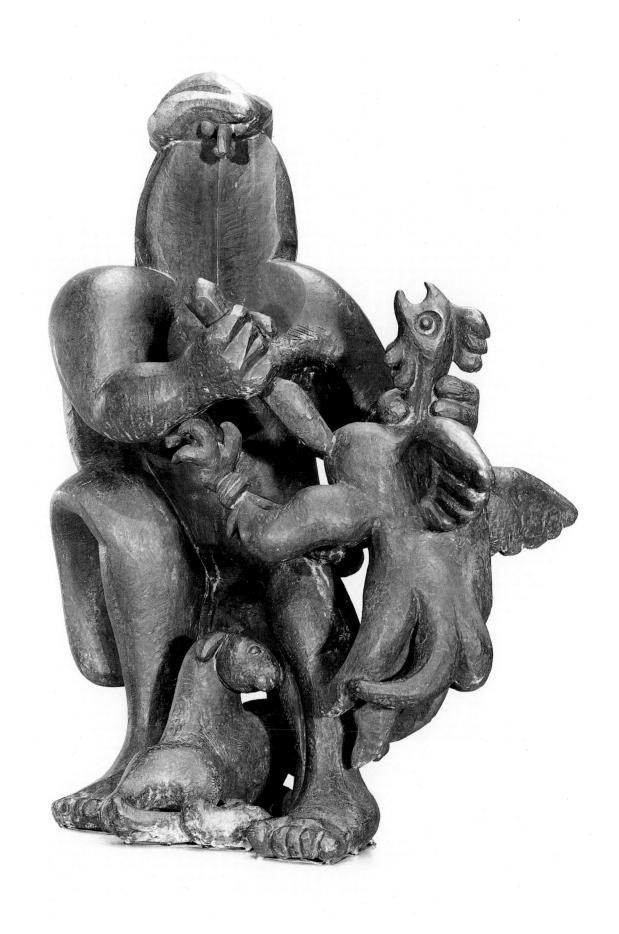

431 *Sacrifice,* 1948, Bronze (unique), H. 48.75 in /123.9 cm

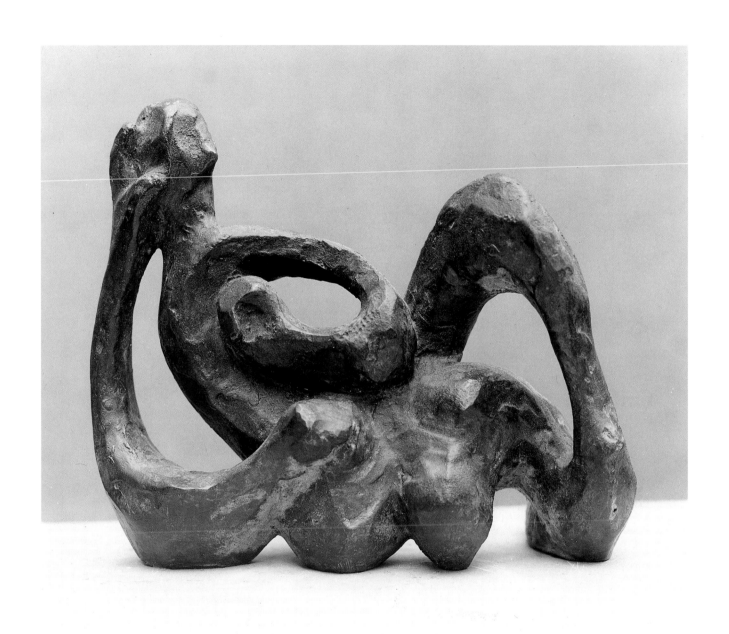

433 *Study for Hagar: Maquette No. 1,* 1948, Bronze, edition unknown, L. 8.5 in /21.6 cm

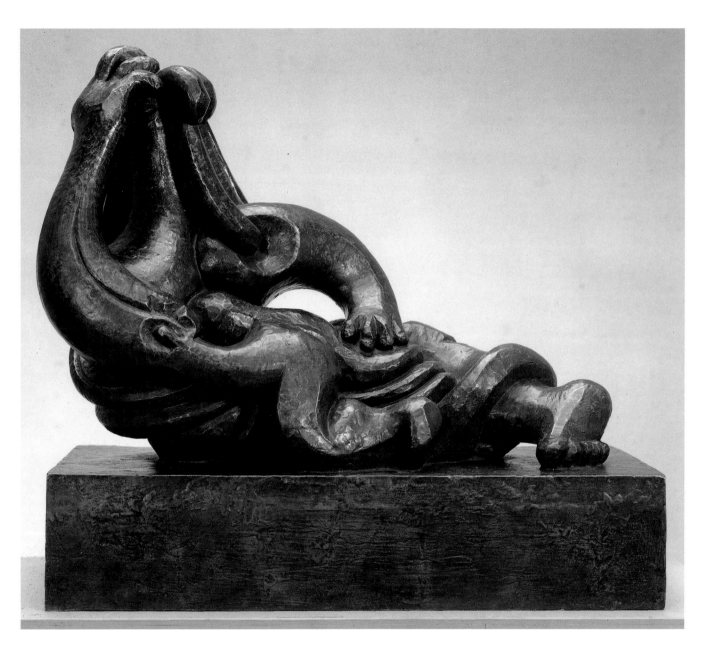

438 *Hagar I*, 1948, Bronze, L. 31.25 in /79.4 cm

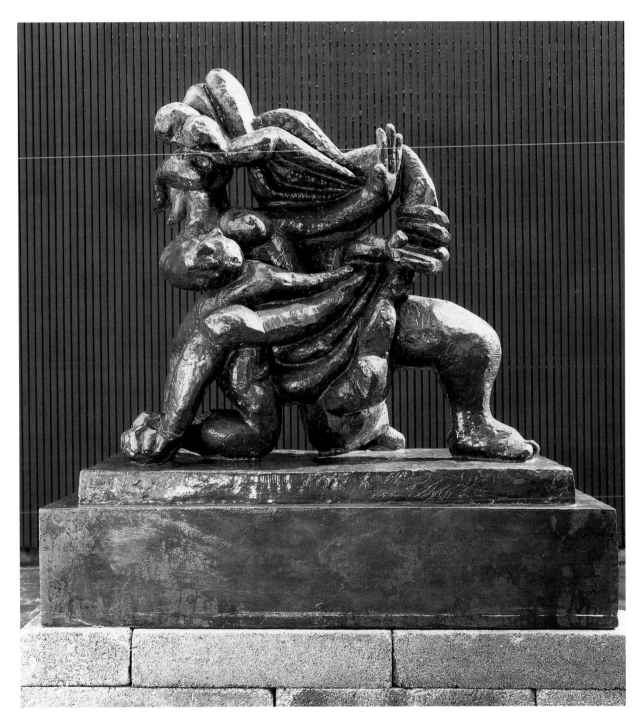

440 *Hagar in the Desert* (also known as *Hagar III*), 1949-57, Bronze, H. 39.5 in /100.4 cm

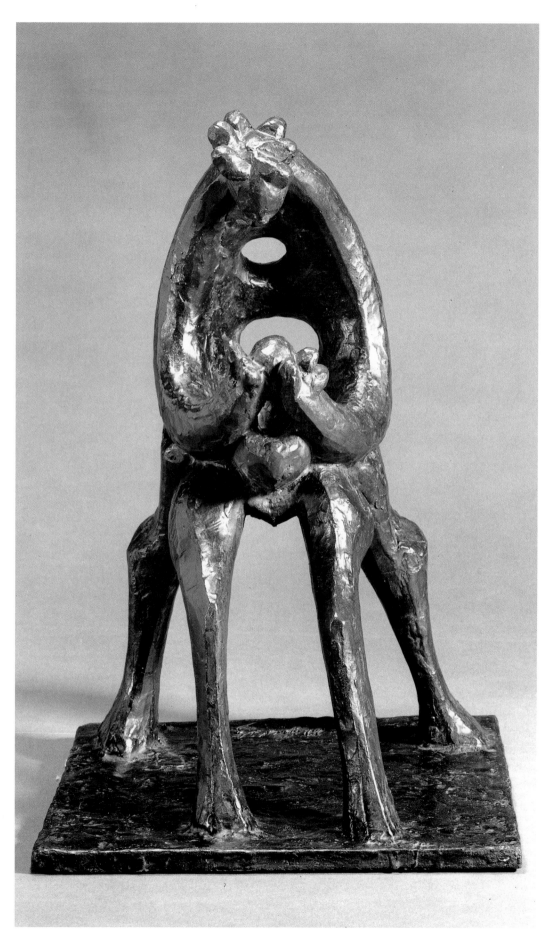

442 *Mother and Child II*, 1949, Bronze, H. 15.25 in /38.7 cm

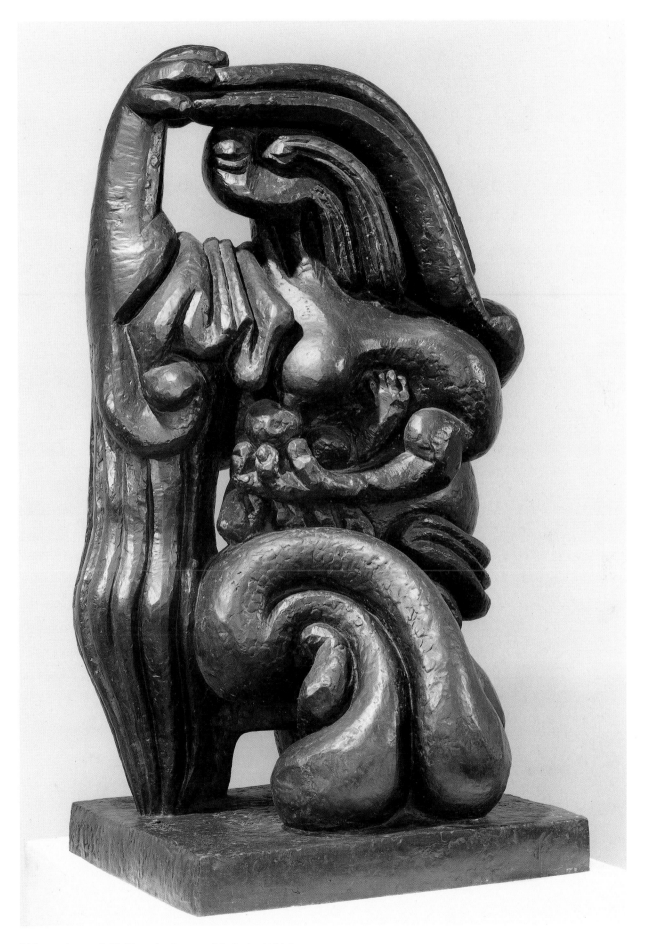

444 *Mother and Child,* 1949, Bronze, H. 57 in /144.8 cm

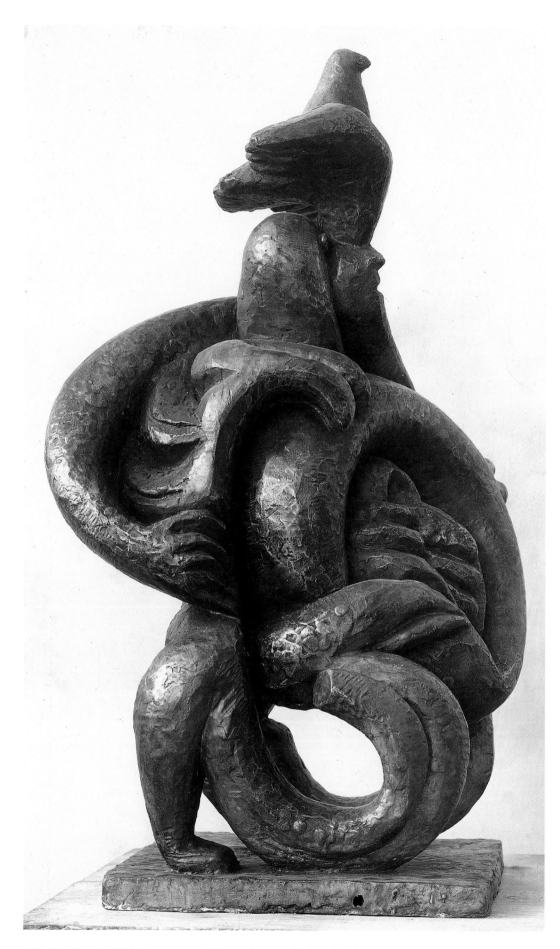

445 *The Cradle,* 1949-54, Bronze, edition unknown, H. 32.25 in /82 cm

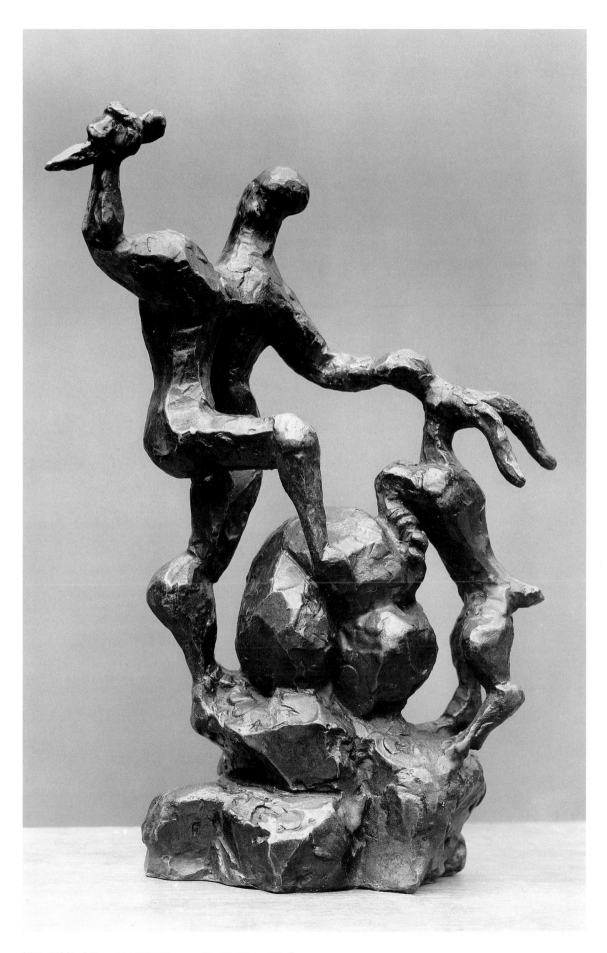

447 *Biblical Scene I,* 1950, Bronze, H. 12.37 in /31.4 cm

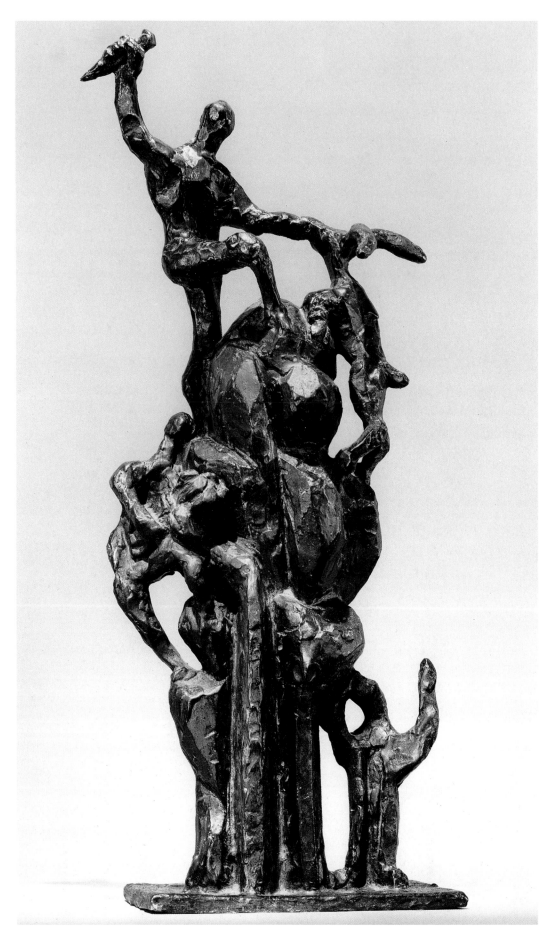

448 *Biblical Scene II*, 1950, Bronze, H. 20 in./50.8 cm

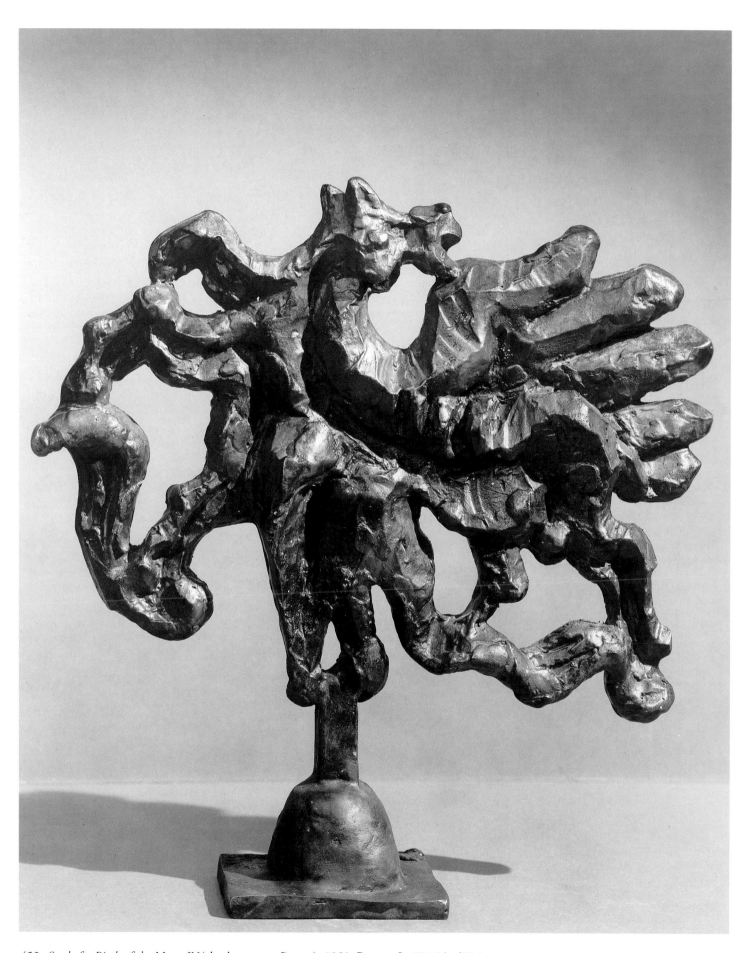

452 *Study for Birth of the Muses IV* (also known as *Pegasus*), 1950, Bronze, L. 10.12 in /25.5 cm

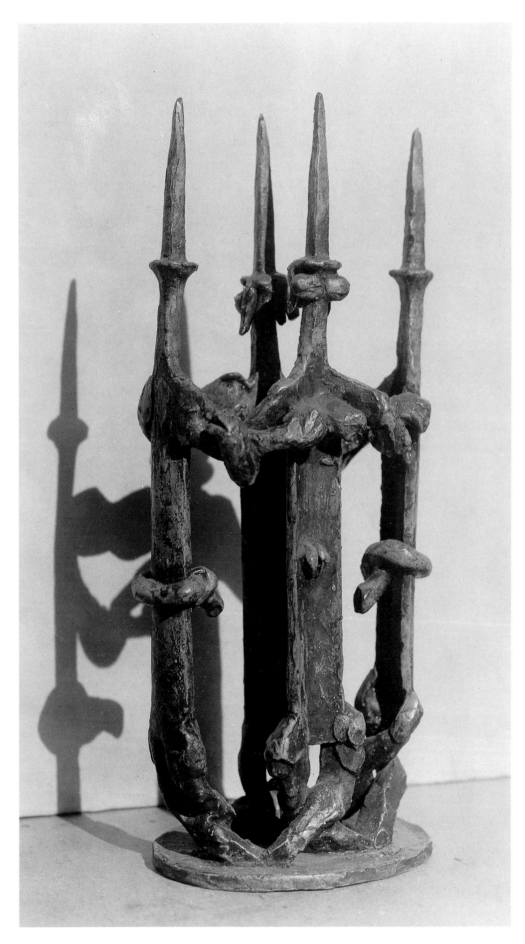

458 *Variation on a Chisel IV: Hebrew Object, The Dance,* 1951, Bronze (unique), H. approx. 9 in /22.9 cm

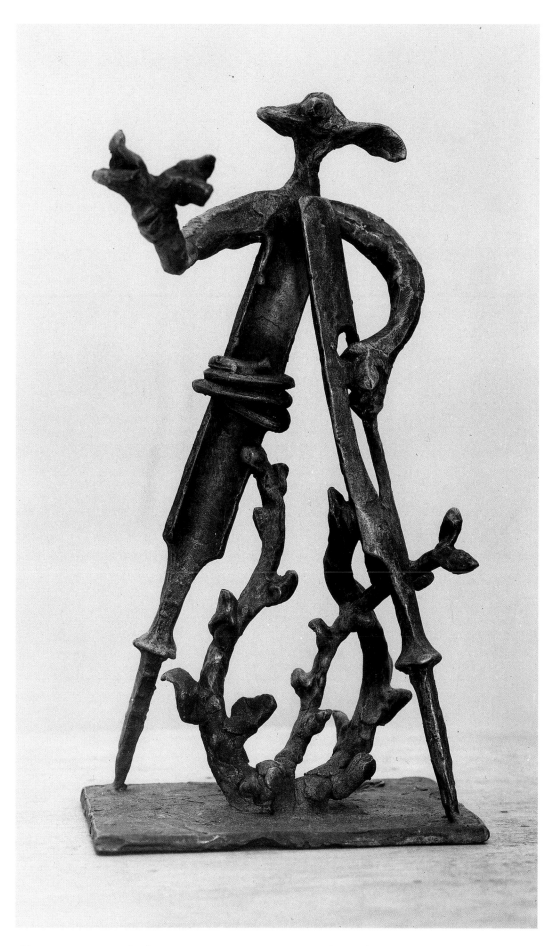

460 *Variation on a Chisel VI: Begging Poet*, 1951-52, Bronze (unique), H. 8.5 in /21.6 cm

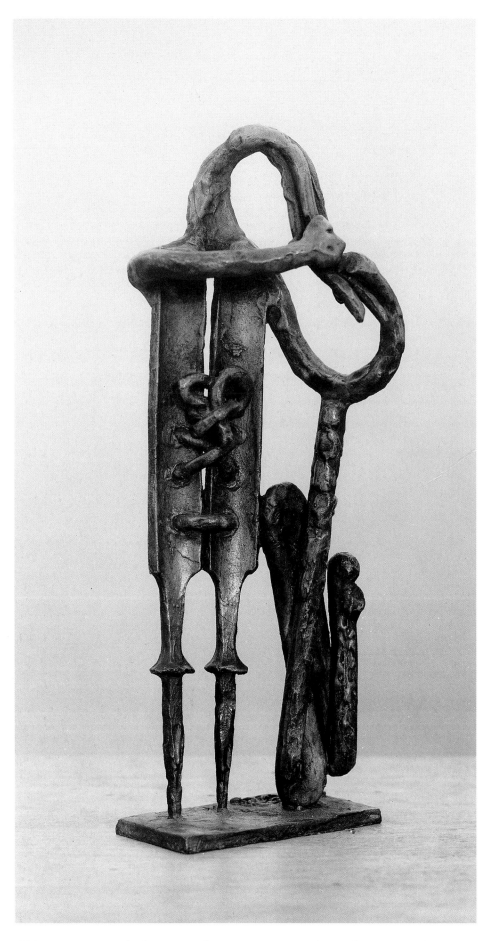

466 *Variation on a Chisel XII: La toilette,* 1951-52, Bronze (unique), H. 9.25 in /23.5 cm

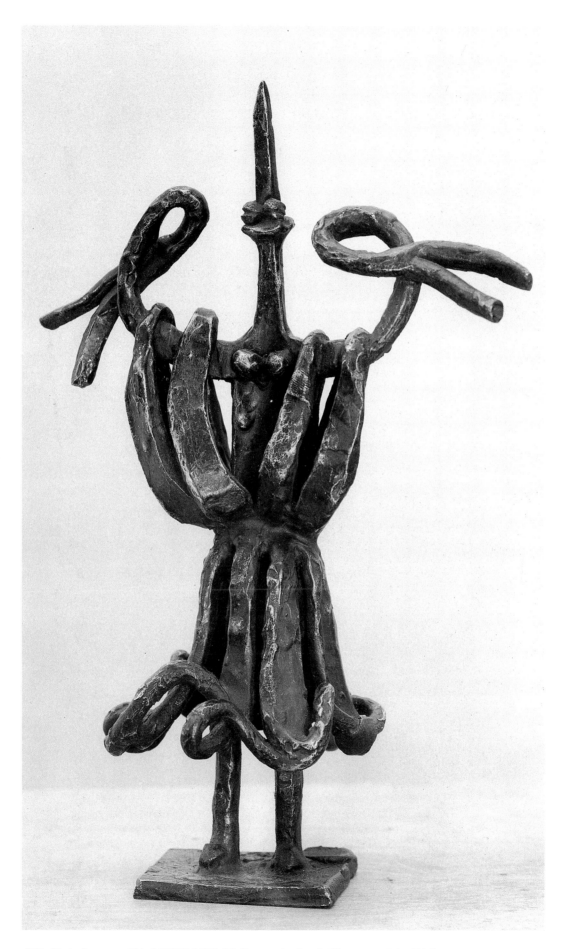

472 *Variation on a Chisel XVIII*, 1951-52, Bronze (unique), H. approx. 9 in /22.9 cm

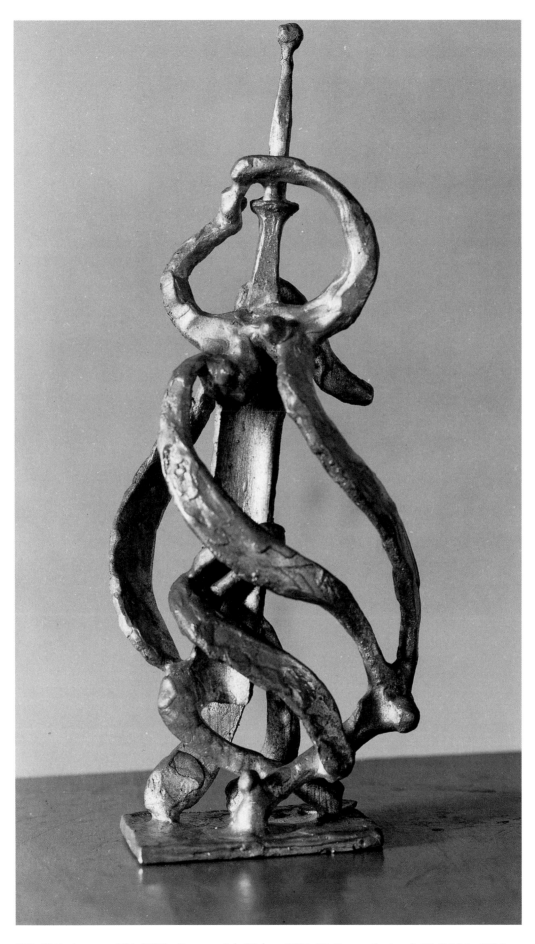

475 *Variation on a Chisel XXI: Danseuse à la Violette,* 1951-52, Bronze (unique), H. 9.12 in /23.2 cm

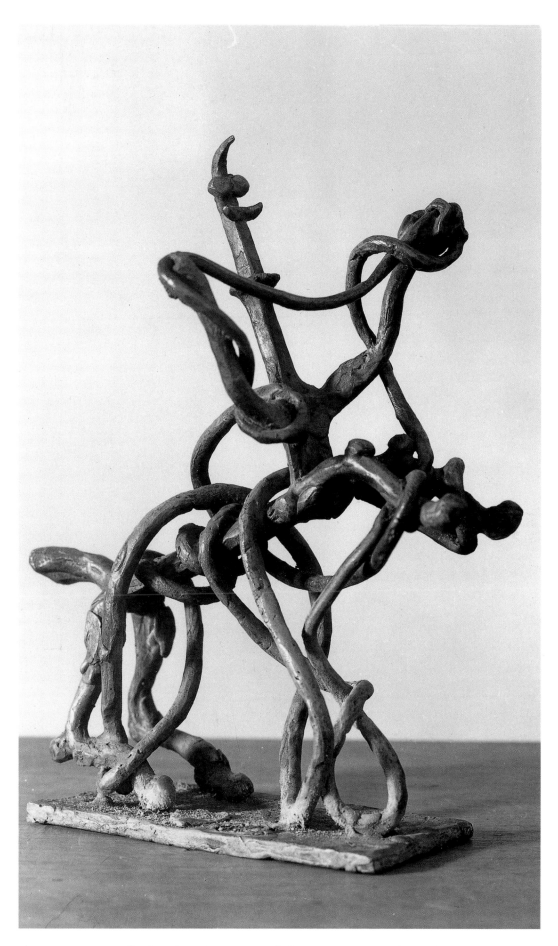

482 *Variation on a Chisel XXVIII: Centaur Enmeshed II,* 1951-52, Bronze (unique), H. 7.5 in /19.1 cm

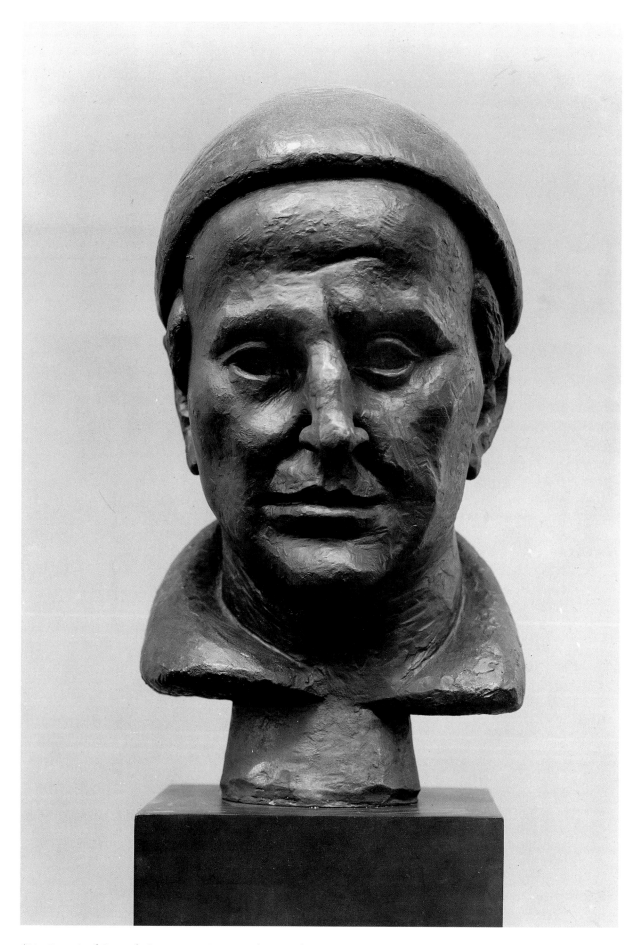

492 *Portrait of Gertrude Stein,* 1953, Bronze, edition unknown, H. 20 in /50.8 cm

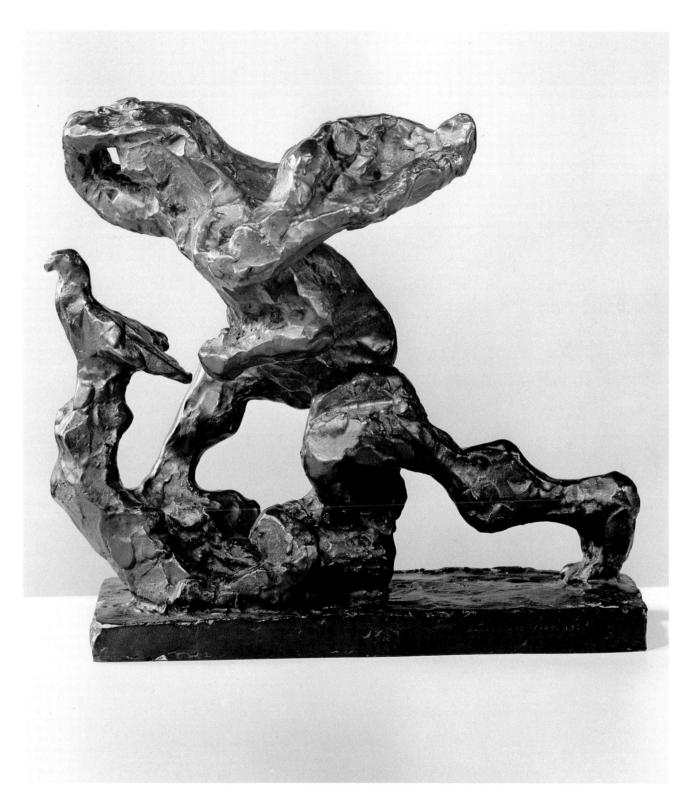

496 *Sketch for the Spirit of Enterprise IV,* 1953, Bronze, L. 12.12 in /30.8 cm

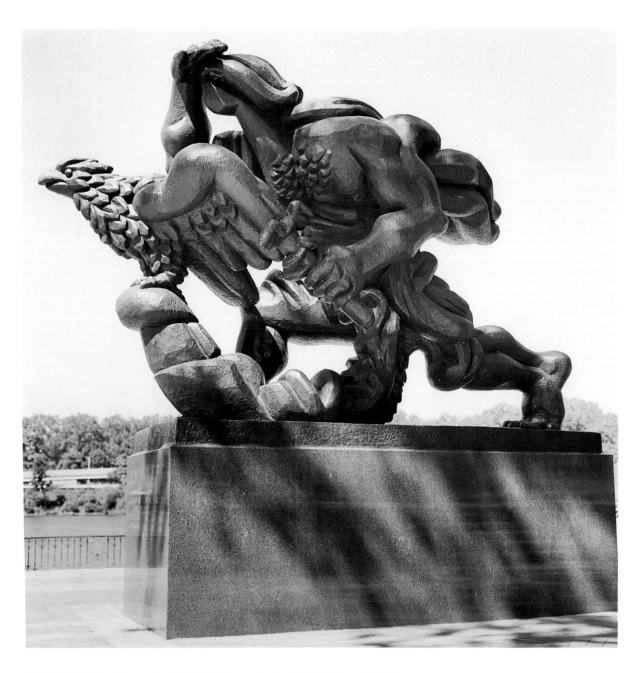

500 *The Spirit of Enterprise,* 1953-54, Bronze (unique), H. 137 in /347.98 cm

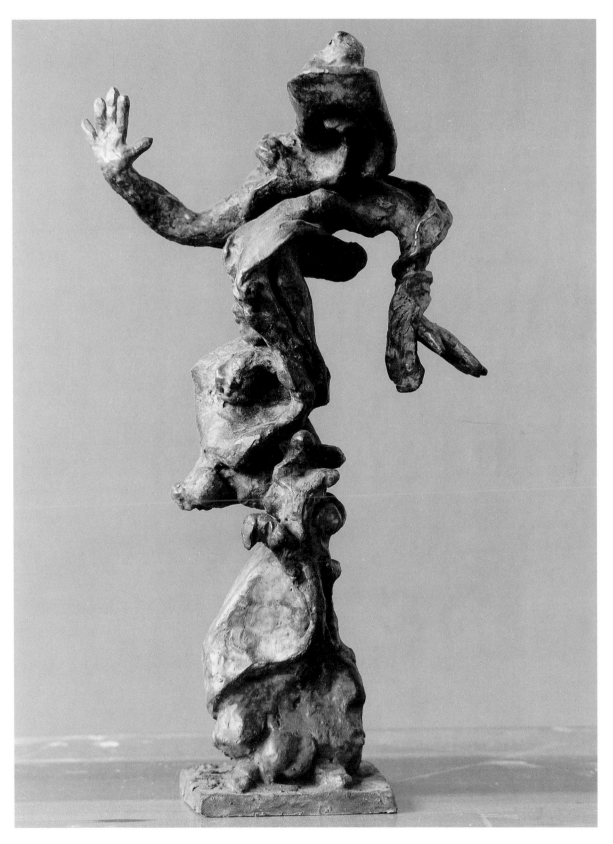

511 *Geisha*, 1955-56, Bronze (unique), H. 15.5 in /39.4 cm

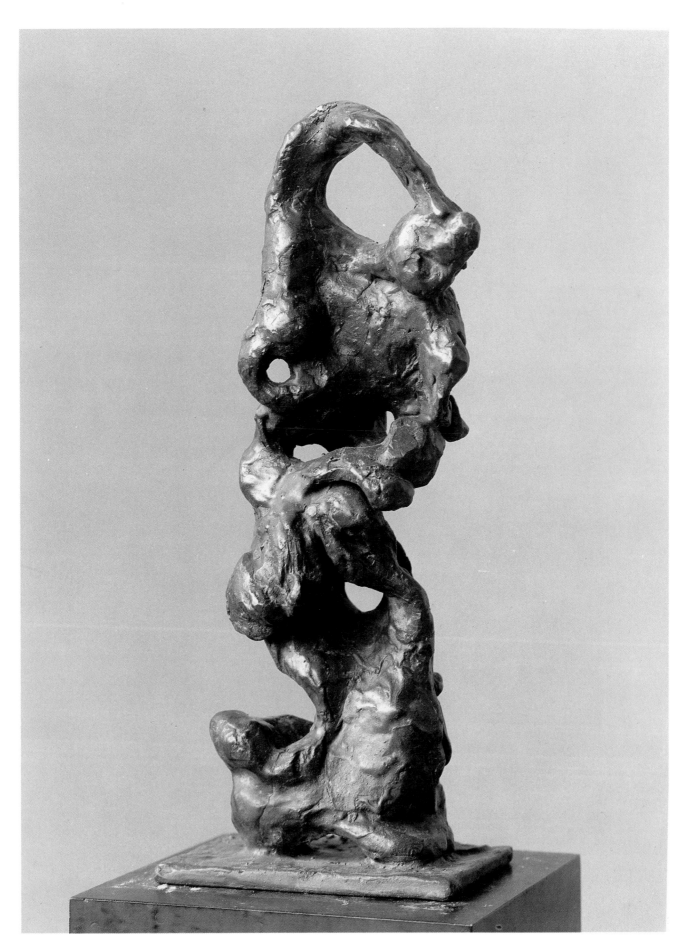

514 *Gypsy Dancer*, 1955-56, Bronze (unique), H. 11.25 in /28.6 cm

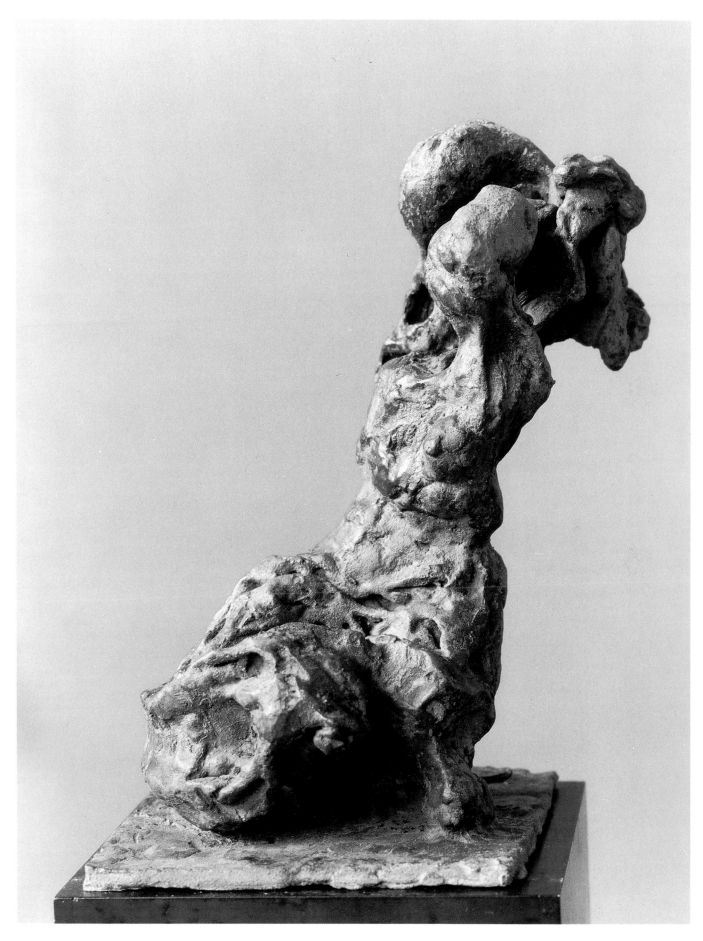

517 *Awakening,* 1955-56, Bronze (unique), H. 8.87 in /22.5 cm

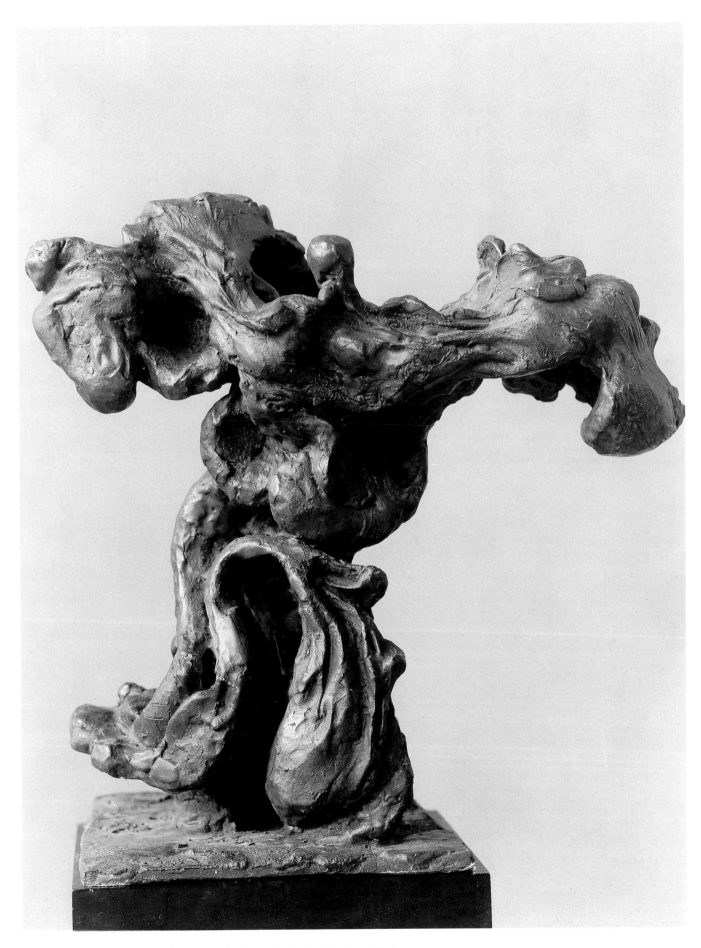

520 *Remembrance of Loie Fuller,* 1955-56, Bronze (unique), H. 10 in /25.4 cm

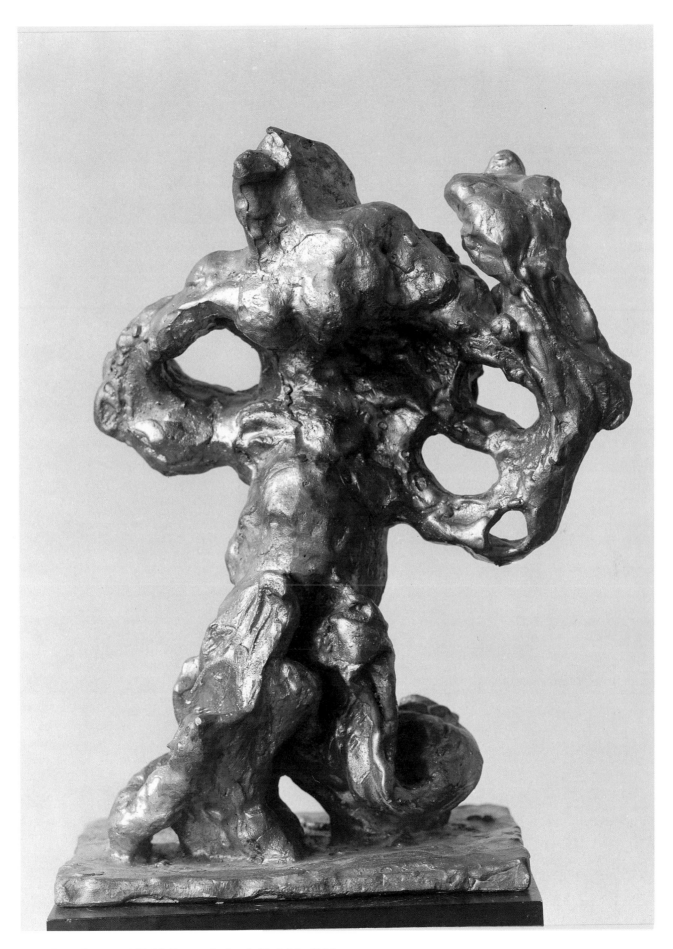

522 *Exotic Dancer,* 1955-56, Bronze (unique), H. 9.5 in /24.1 cm

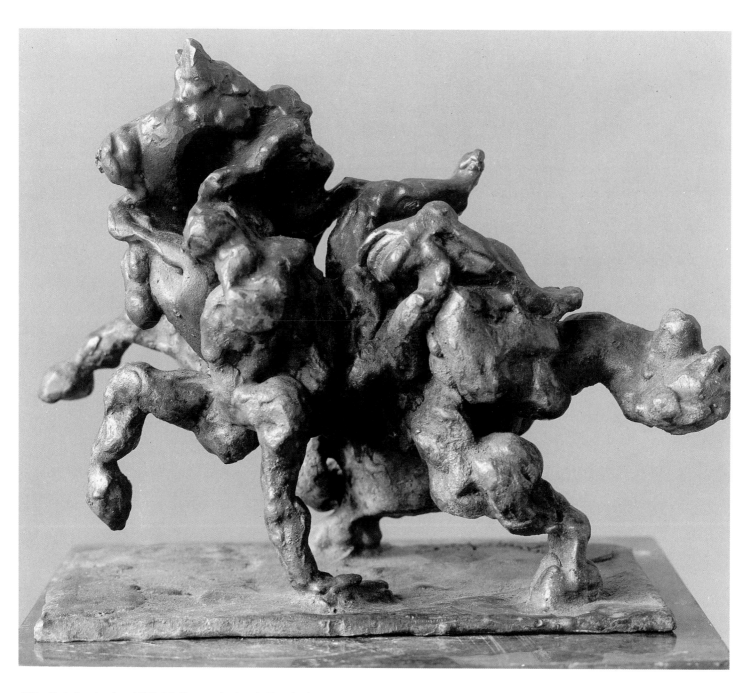

527 *Only Inspiration,* 1955-56, Bronze (unique), L. 9 in /22.9 cm

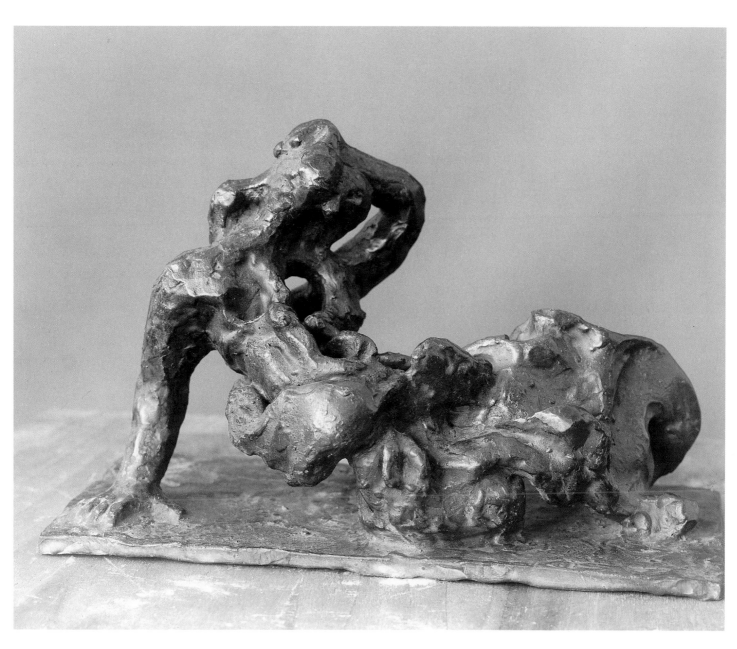

534 *Reclining Figure,* 1955-56, Bronze (unique), L. 11.25 in /28.6 cm H. 22 in /55.9 cm

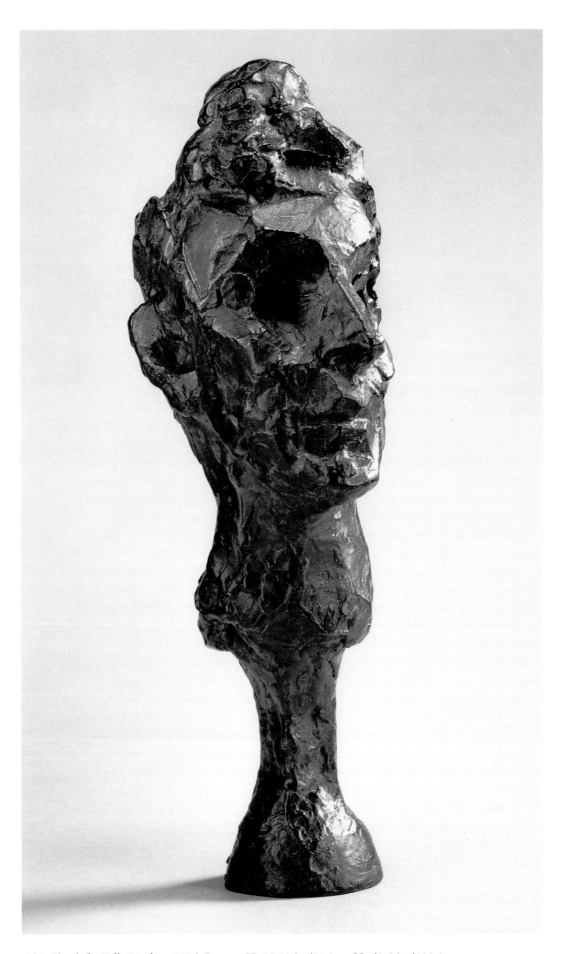

546 *Sketch for Yulla Lipchitz,* 1956, Bronze, H. 12.12 in /30.8 cmH. 42.5 in /108.0 cm

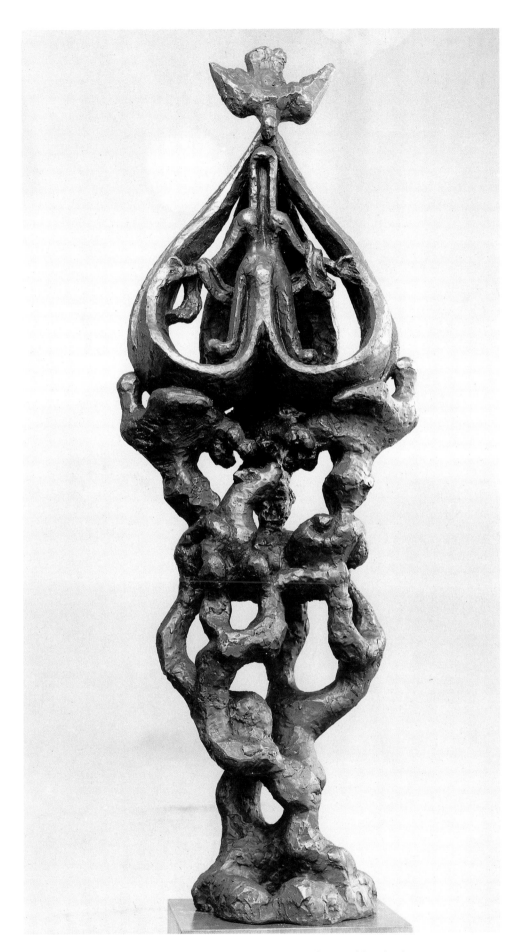

548 *Between Heaven and Earth I,* 1958, Bronze, edition of 3, H. 46 in /116.8 cm

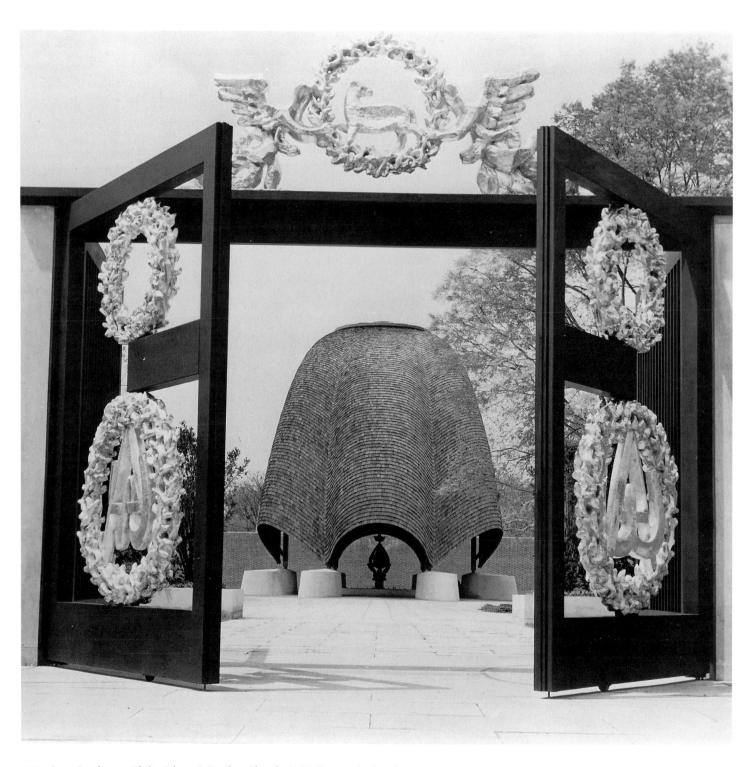

552 *Gates Leading to Philip Johnson's Roofless Church*, 1958, Bronze (unique)

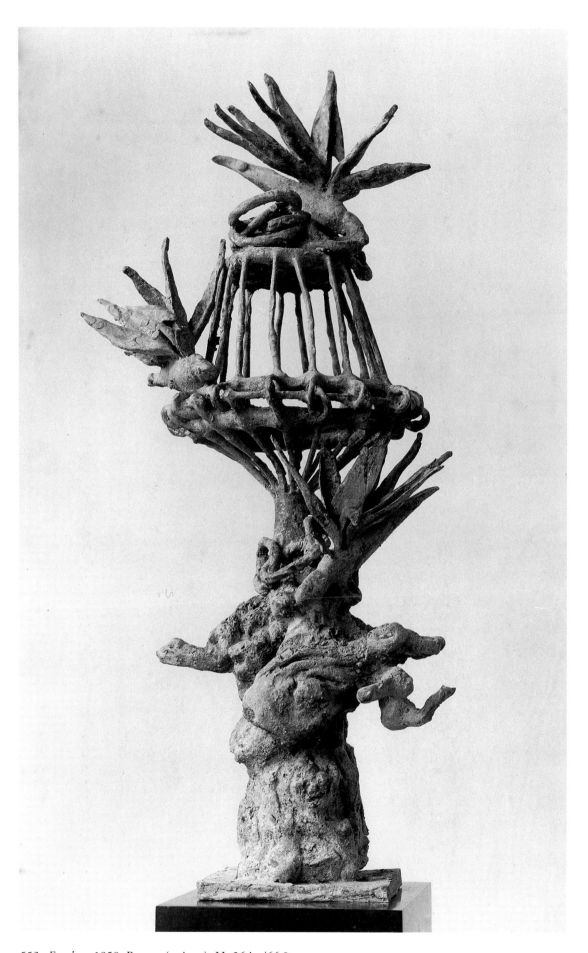

553 *Freedom,* 1958, Bronze (unique), H. 26 in /66.0 cm

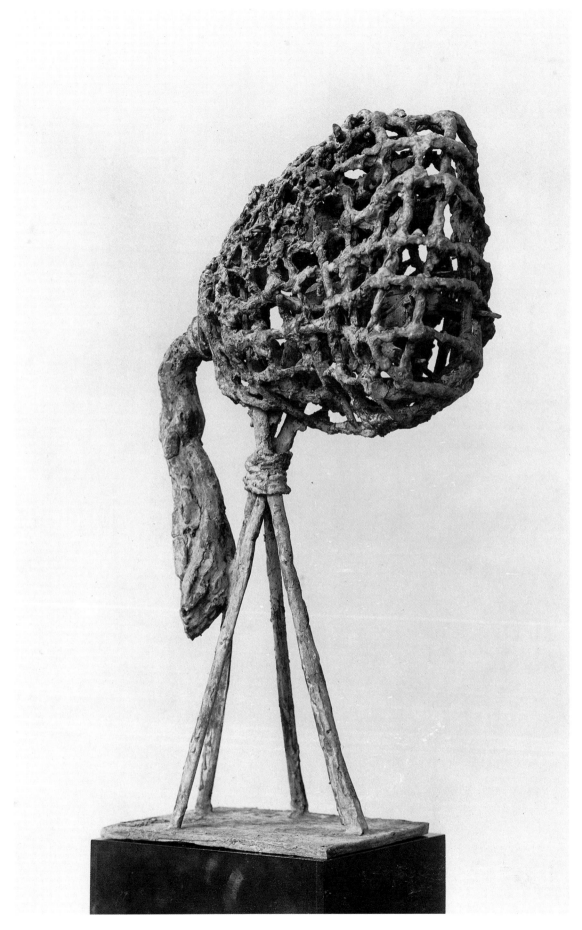

557 *Miraculous Catch,* 1958, Bronze (unique), H. 22 in /55.9

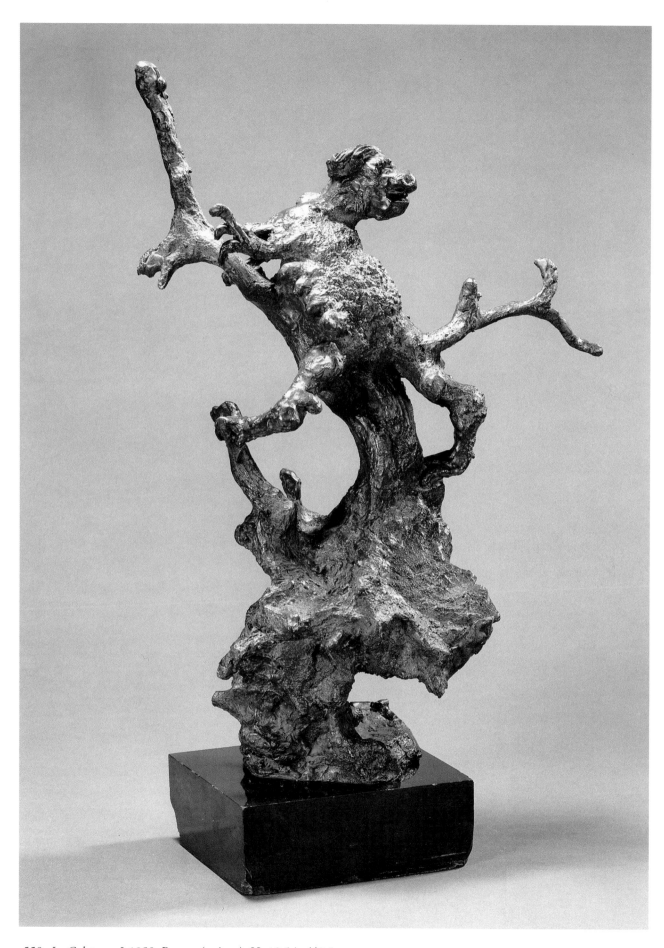

558 *La Galapagos I*, 1958, Bronze (unique), H. 19.5 in./49.5 cm

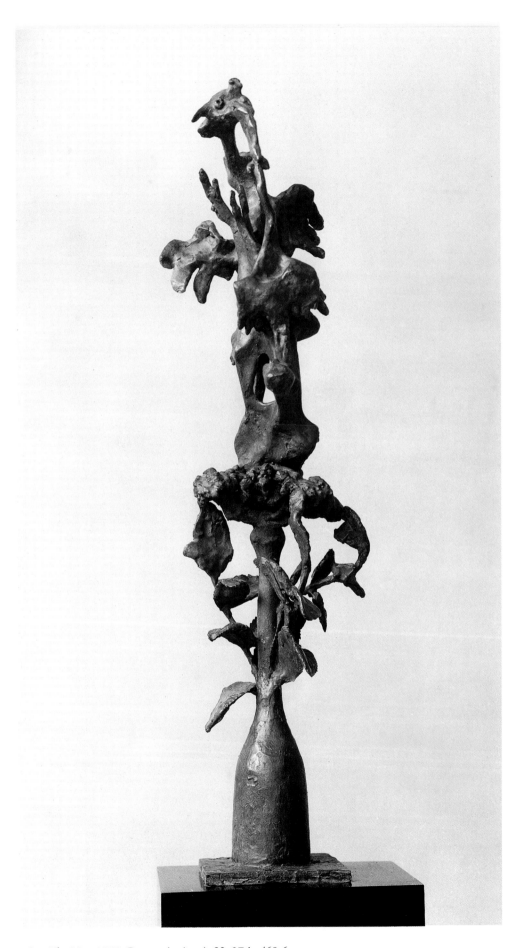

563 *The Nest,* 1958, Bronze (unique), H. 27 in /68.6 cm

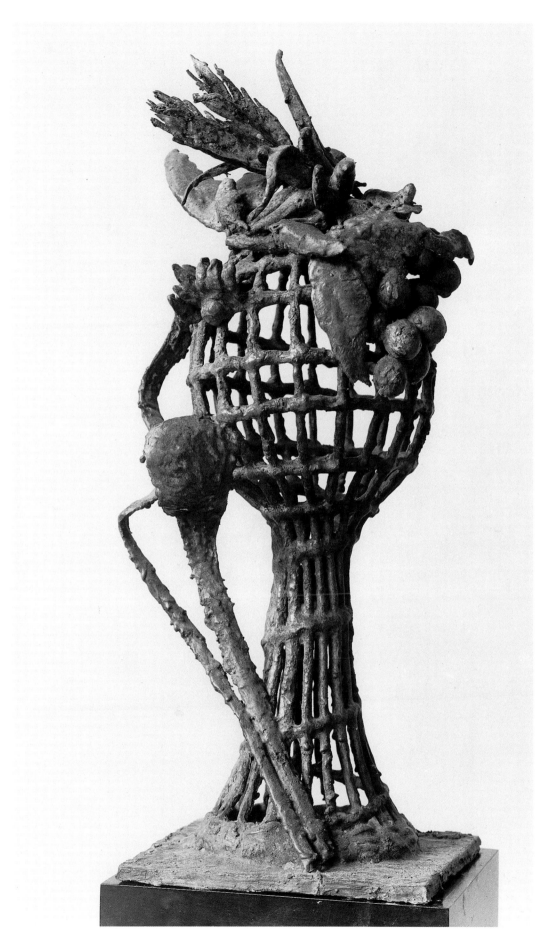

566 *Abundance*, 1959, Bronze (unique), H. 20.5 in /52.1 cm

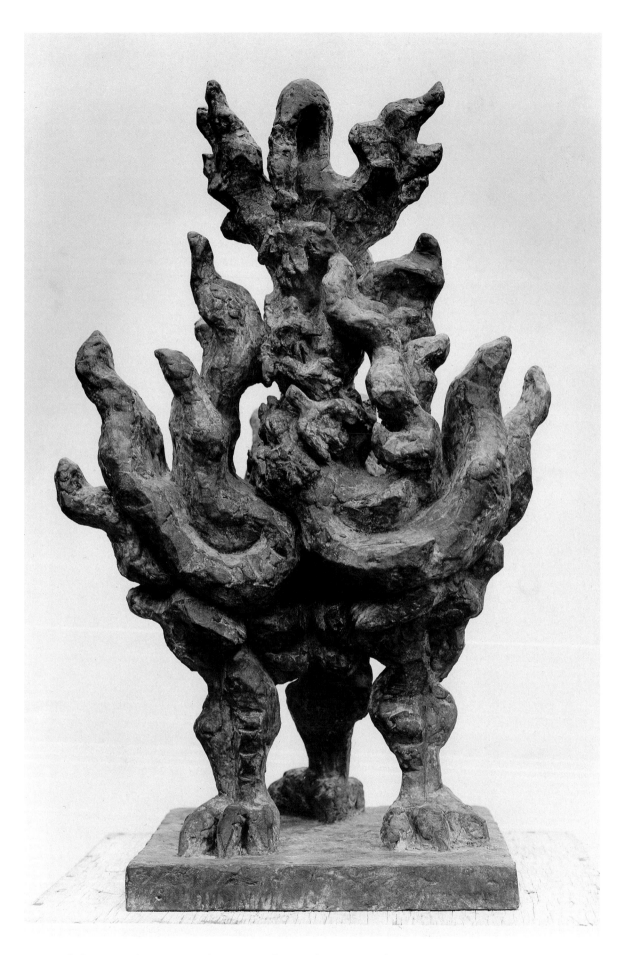

570 *Study for Lesson of a Disaster*, 1961, Bronze, edition unknown, H. 26.5 in /67.3 cm

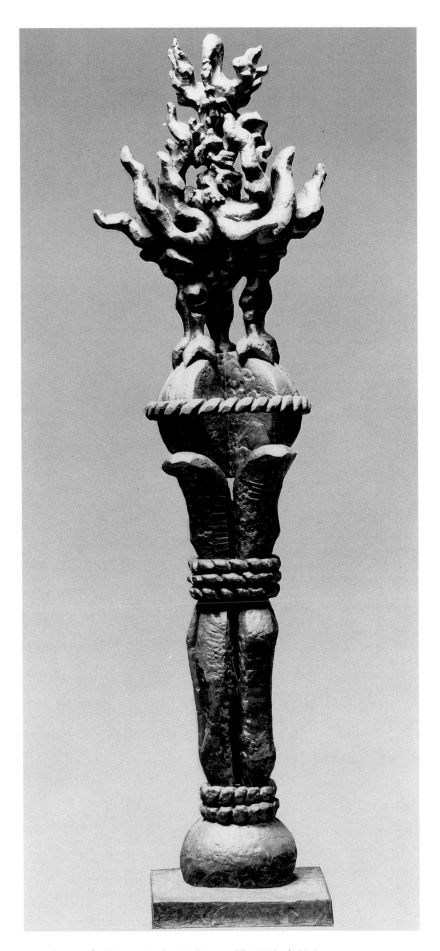

572 *Lesson of a Disaster*, 1961-70, Bronze, H. 139 in./353.3 cm

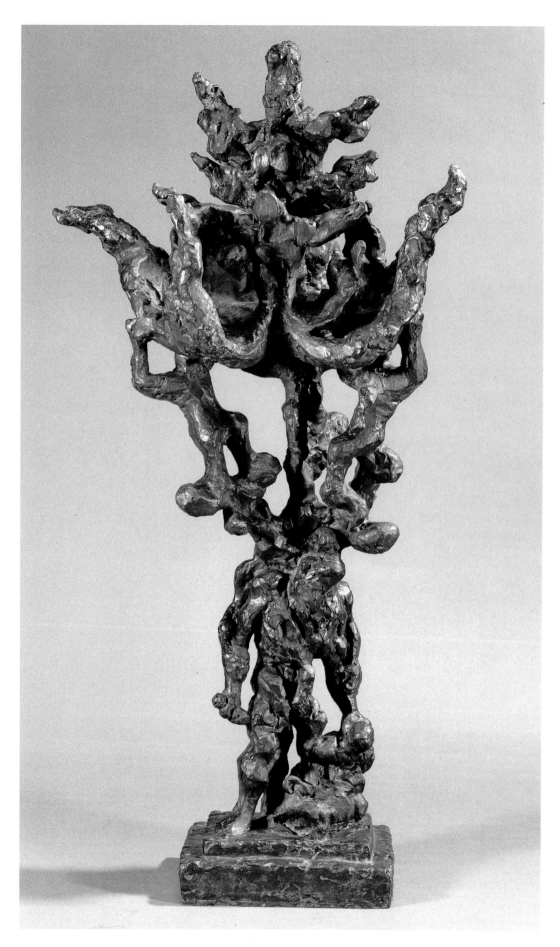

574 *Study for Our Tree of Life*, 1962, Bronze, H. 33.5 in /85.1 cm

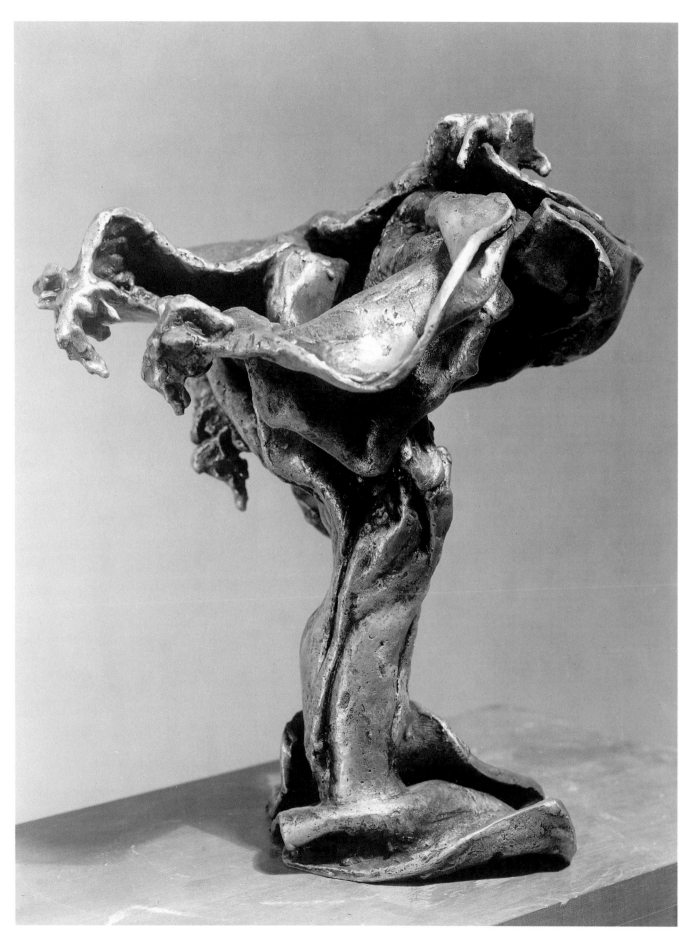

575 *The Cup of Atonement*, 1962, Bronze, edition of 7 + 1, H. 11.87 in /30.2 cm

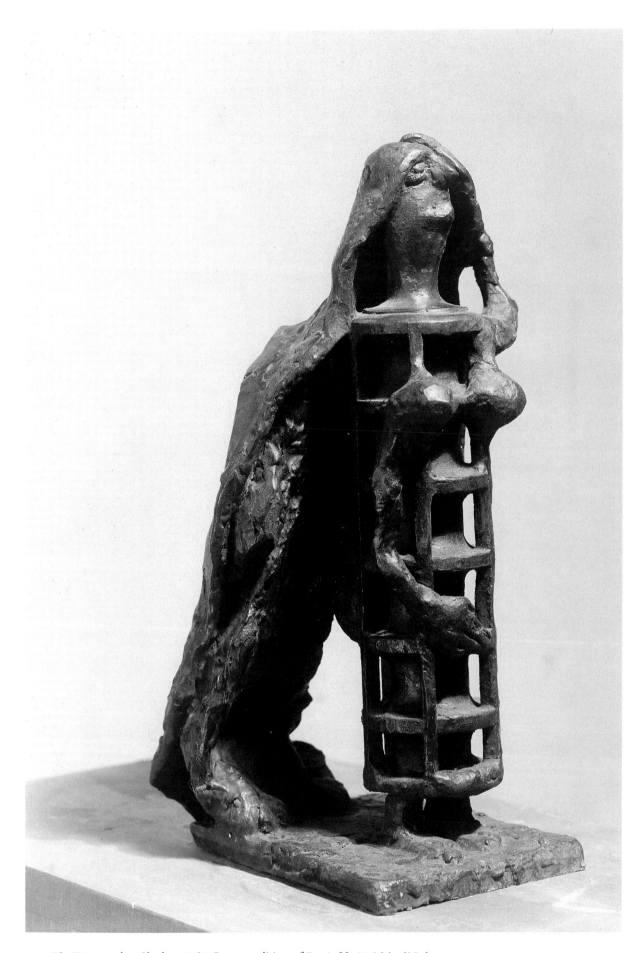

579 *The Tower and its Shadow,* 1962, Bronze, edition of 7 + 1, H. 11.25 in /28.6 cm

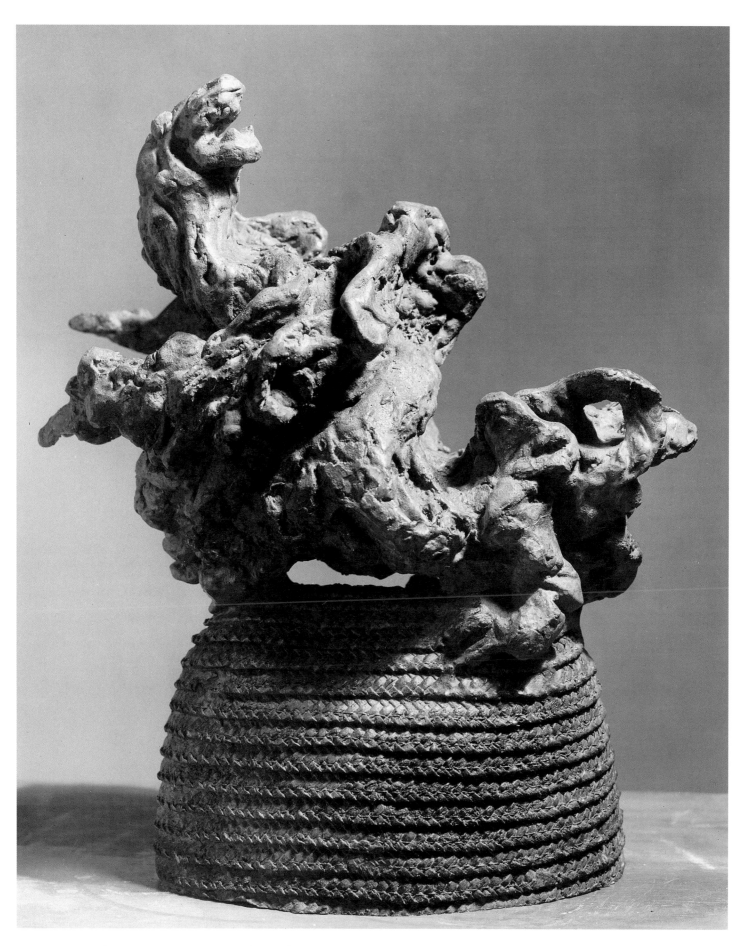

582 *Fountain of the Dragon,* 1962, Bronze, edition of 7 + 1, H. 10.75 in /27.3 cm

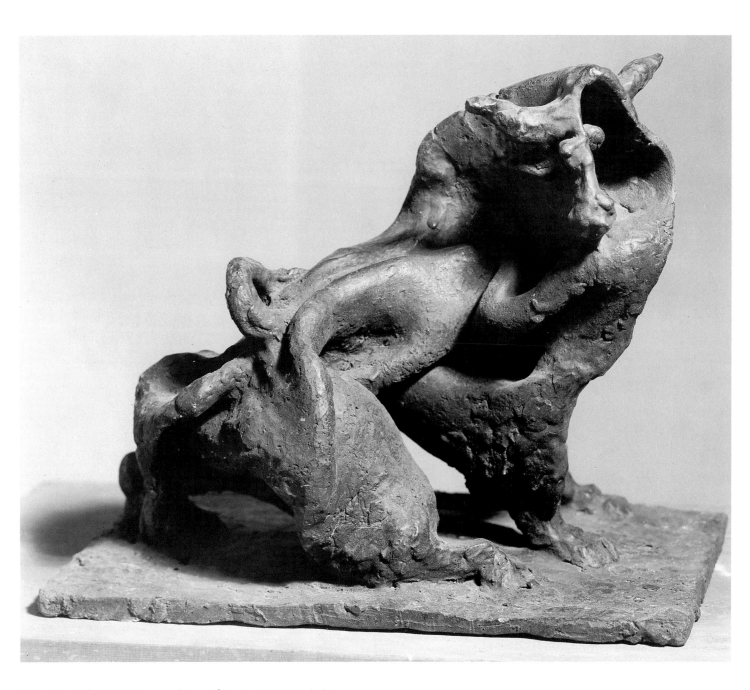

585 *The Bull,* 1962, Bronze, edition of 7 + 1, L. 9.75 in /24.8 cm

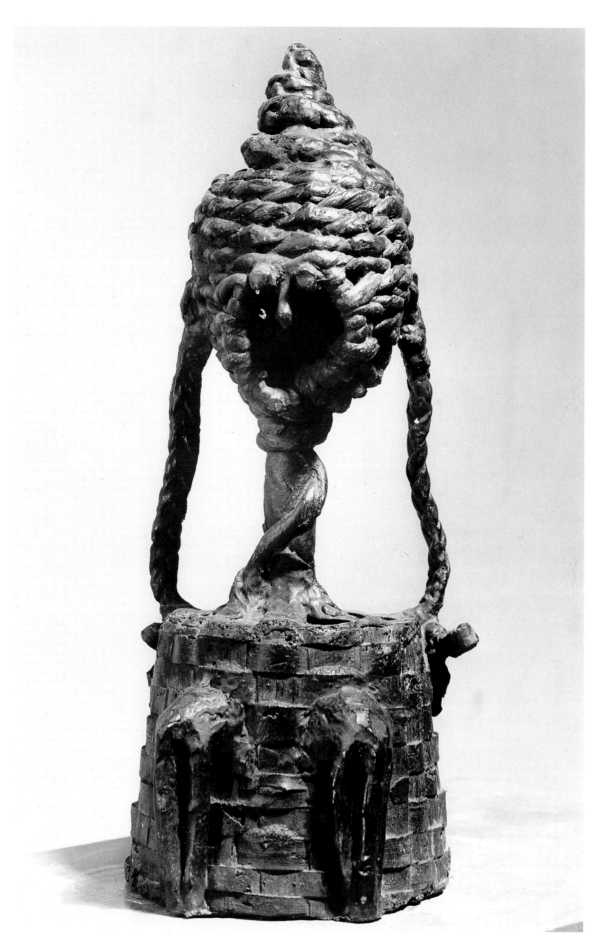

586 *The Beautiful One*, 1962, Bronze, edition of 7 + 1, H. 12.5 in /31.7 cm

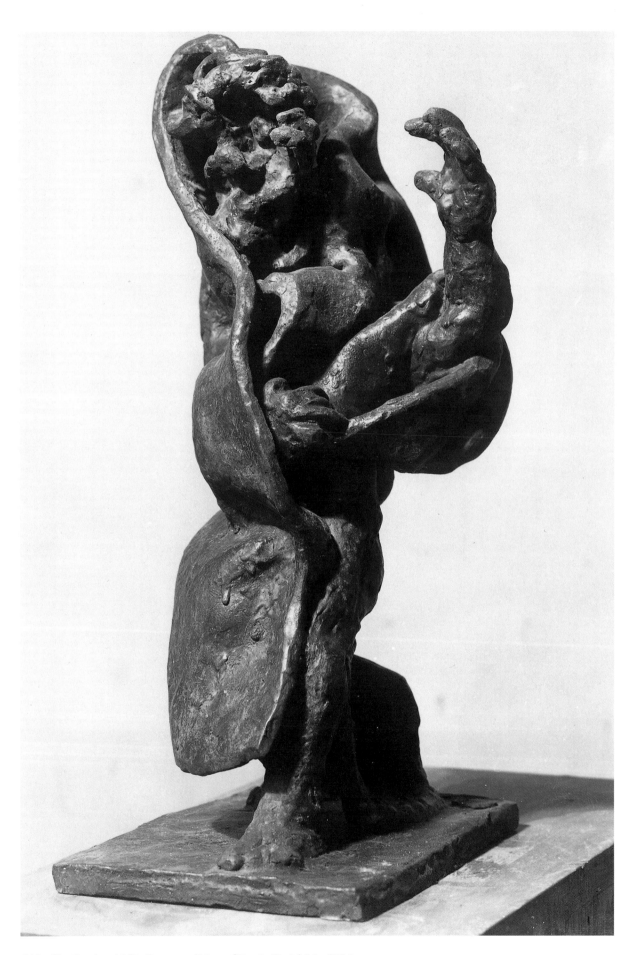

593 *The Prophet,* 1962, Bronze, edition of 7 + 1, H. 14.5 in /36.8 cm

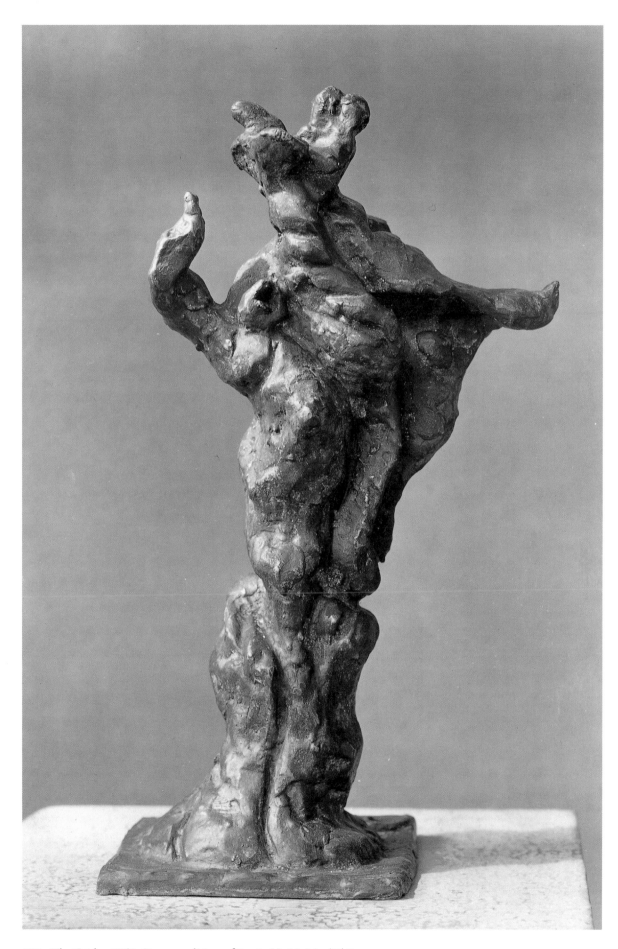

595 *The Geisha*, 1963, Bronze, edition of 7 + 1, H. 13.5 in /34.3 cm

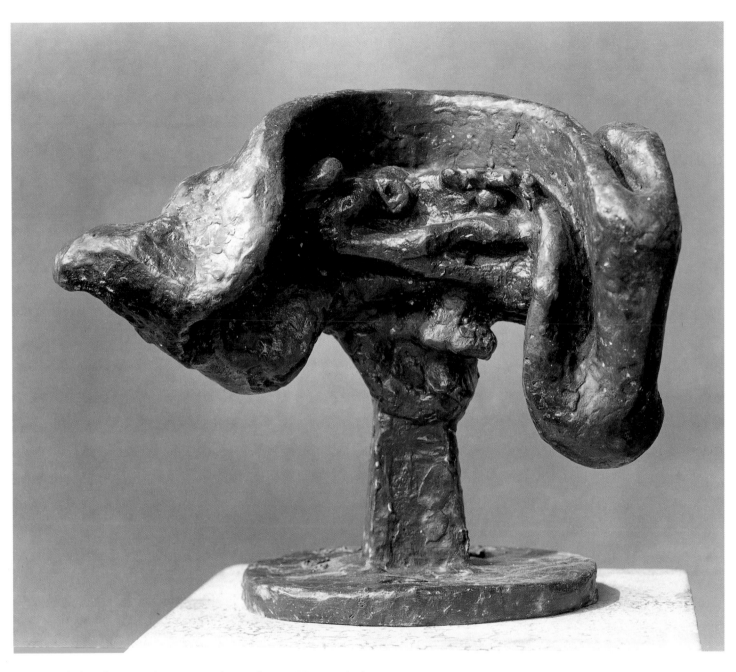

596 *Head of Harlequin,* 1963, Bronze, edition of 7 + 1, H. 10.75 in /27.3 cm

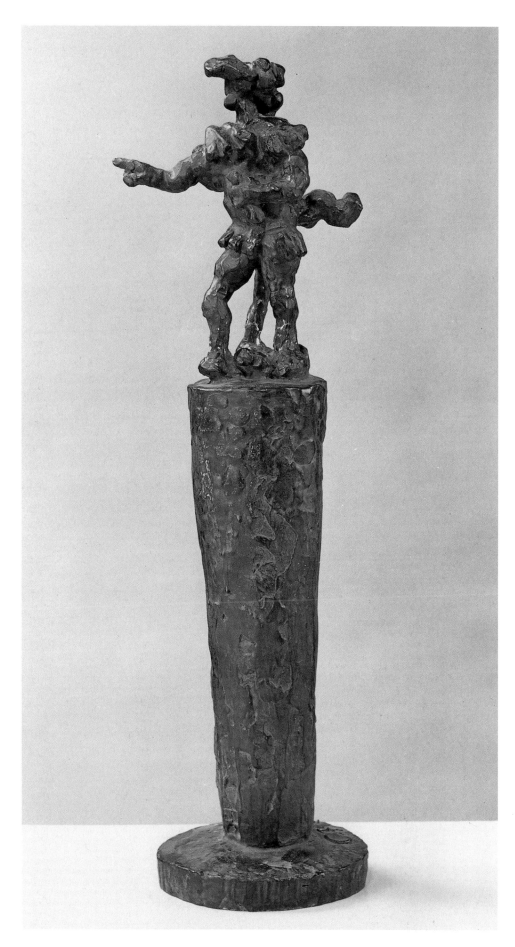

604 *Sketch for the Monument for du Luth II,* 1963, Bronze, H. 22.32 in /56.8 cm

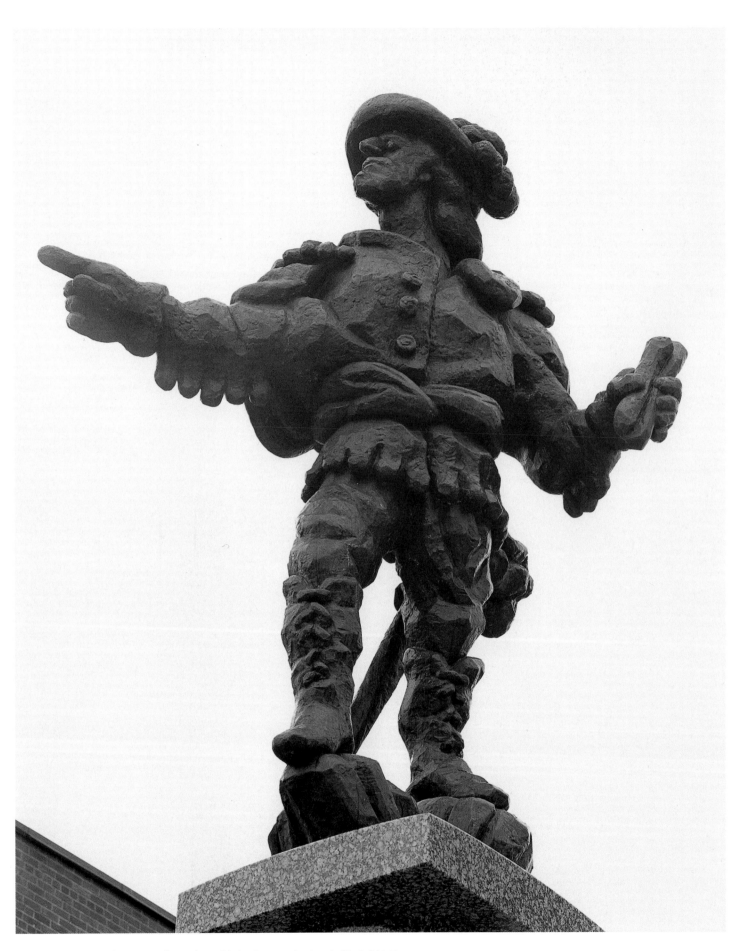

609 *Daniel Greysolon, Sieur du Luth,* 1964-65, Bronze (unique), H. 9 ft/2.7 m

610 *Sword of du Luth,* 1964, Bronze, H. 42.5 in /107.9 cm

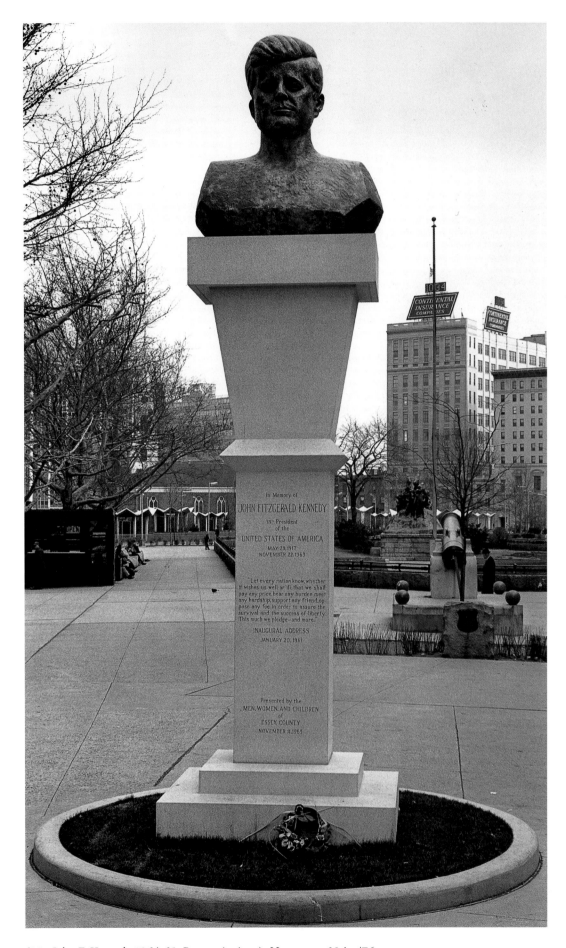

613 *John F. Kennedy,* 1964-65, Bronze (unique), H. approx. 30 in /76 cm

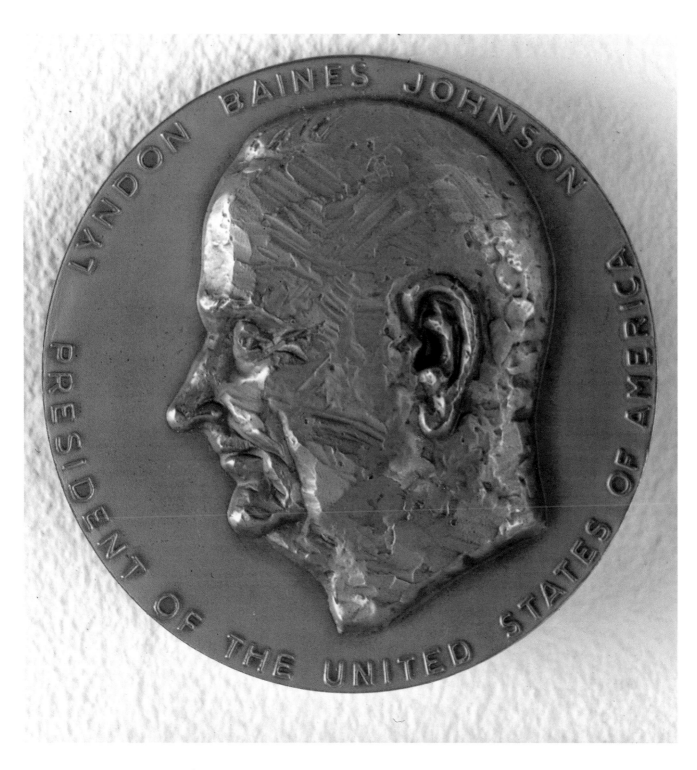

614 *President Lyndon Baines Johnson Award Medal,* c. 1964, Bronze , Diameter 3.5 in /8.8 cm

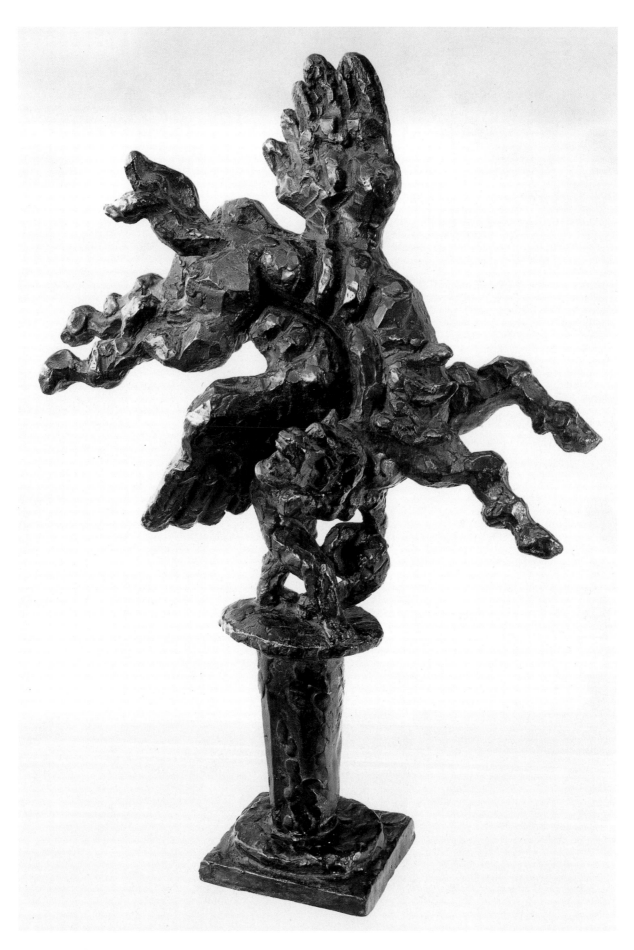

616 *Sketch for Bellerophon Taming Pegasus II*, 1964, Bronze, H. 20 in /50.8 cm

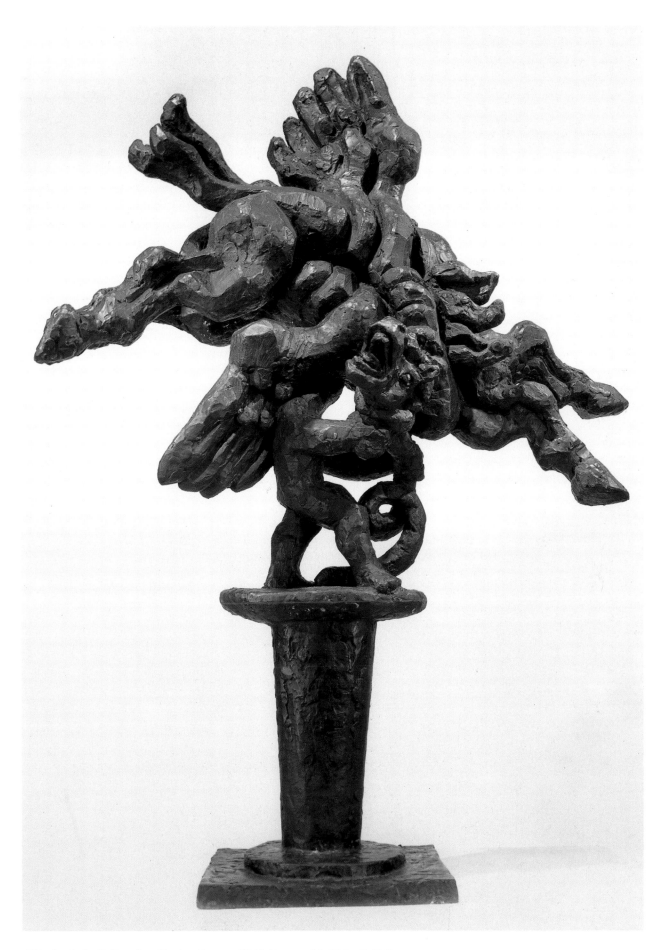

621 *Study for Bellerophon Taming Pegasus,* 1964, Bronze, H. 59 in /149.8 cm

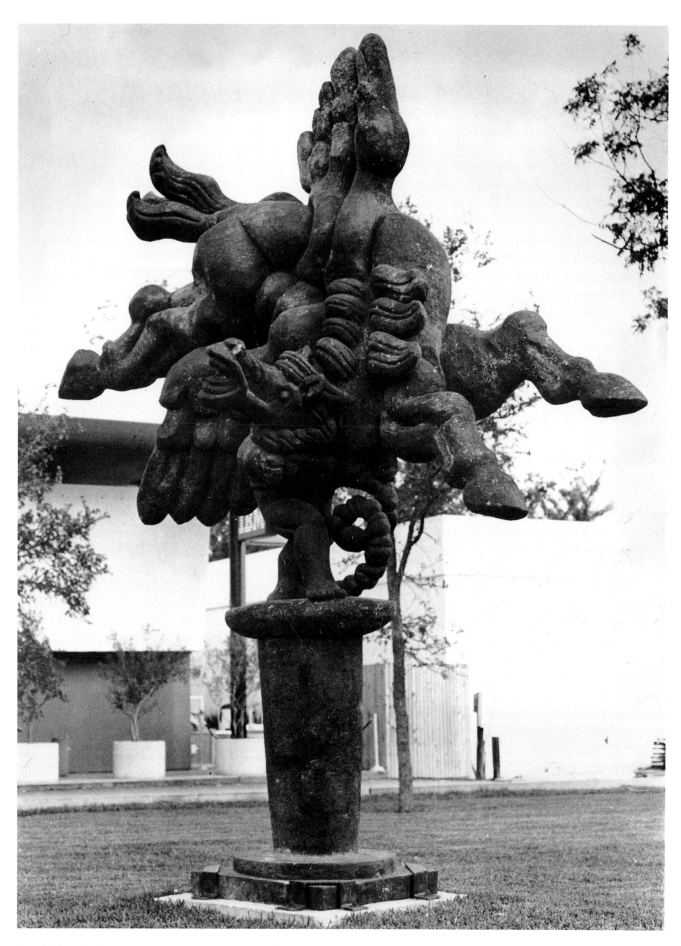

622 *Bellerophon Taming Pegasus: Large Version,* 1964, Bronze, edition of 2, H. approx. 12 ft /365.76 cm

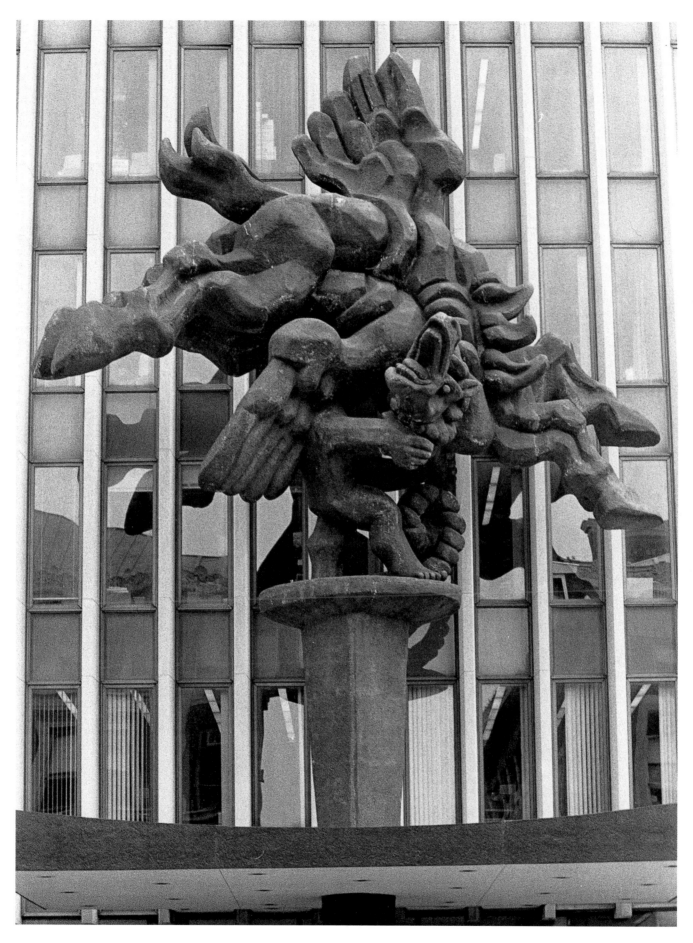

623 *Bellerophon Taming Pegasus,* 1964-73, Bronze (unique), H. approx. 38 ft/11.4 m

624 *Don Quixote,* 1966, Bronze, probably unique, H. 15.5 in /39.4 cm

625 *Portrait of Albert Skira,* 1966, Bronze, H. 16.12 in /41.0 cm

629 *Portrait of Freddy Hamburger,* n.d., Bronze, edition unknown, H. unknown

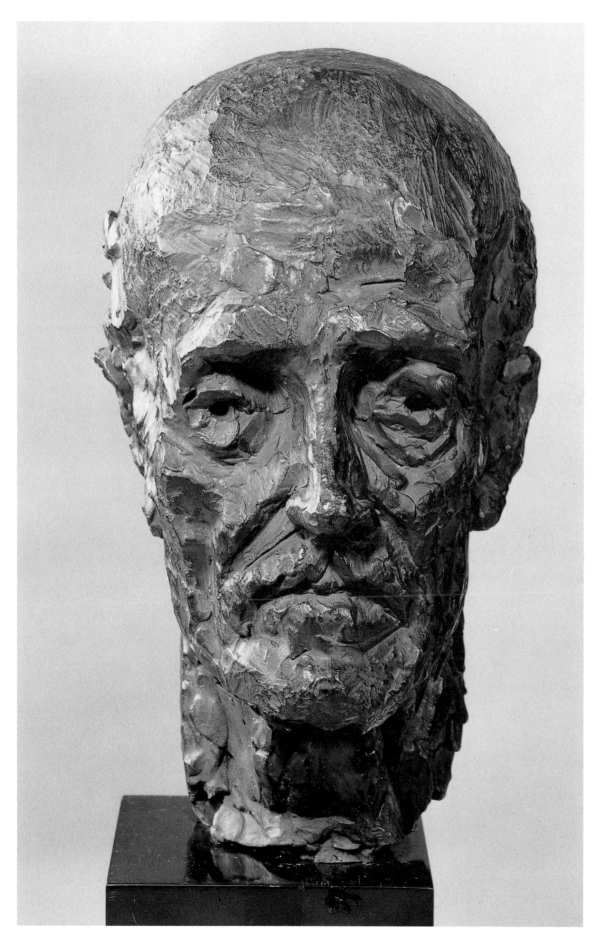

633 *Head of a Man IV*, n.d., Bronze, edition unknown, H. 13.62 in /34.6 cm

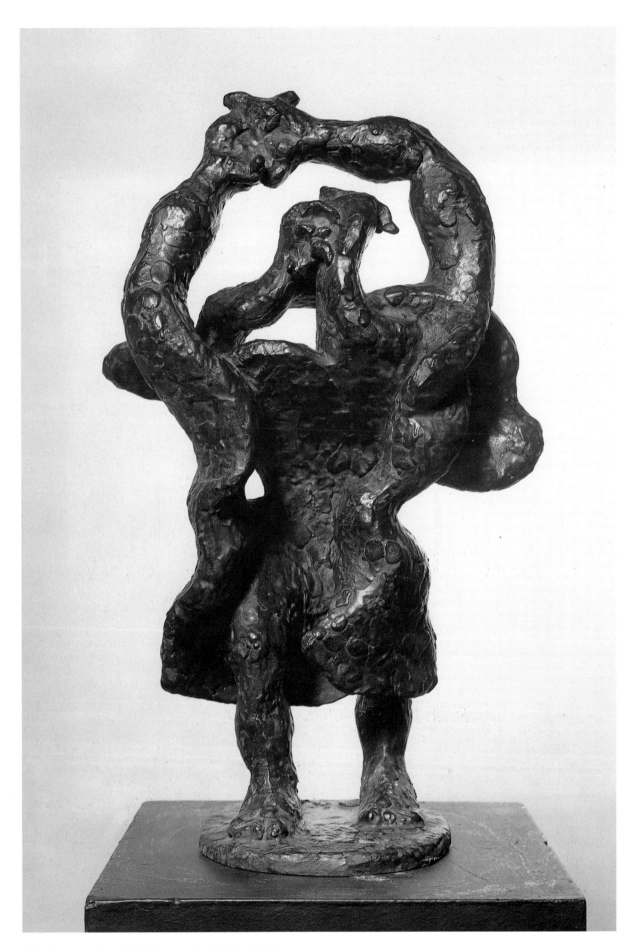

655 *Lamentation,* 1967, Bronze, H. 20.25 in /51.4 cm

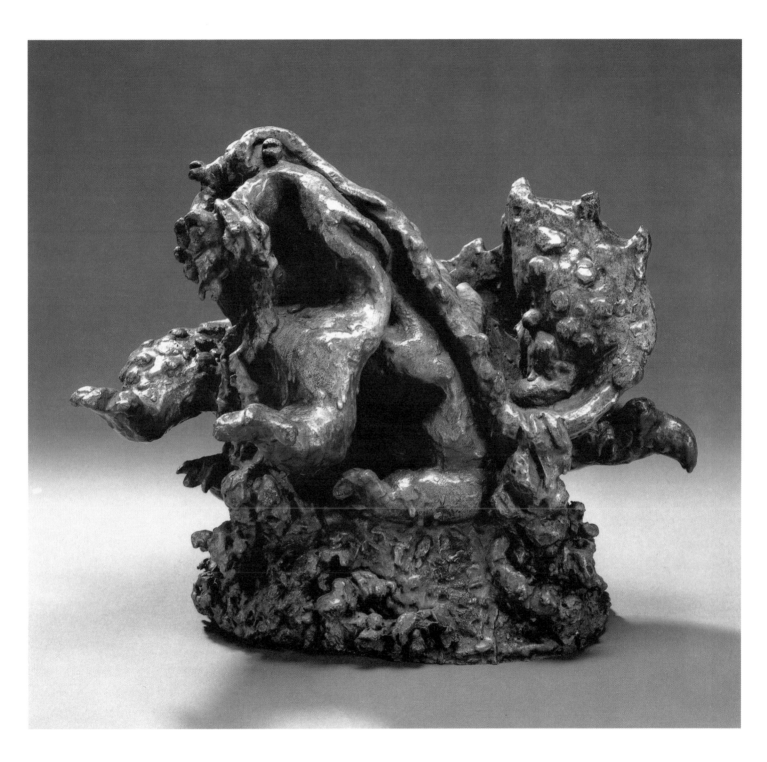

656 *L'Arno Furioso,* 1967, Bronze, H. 11 in /27.9 cm

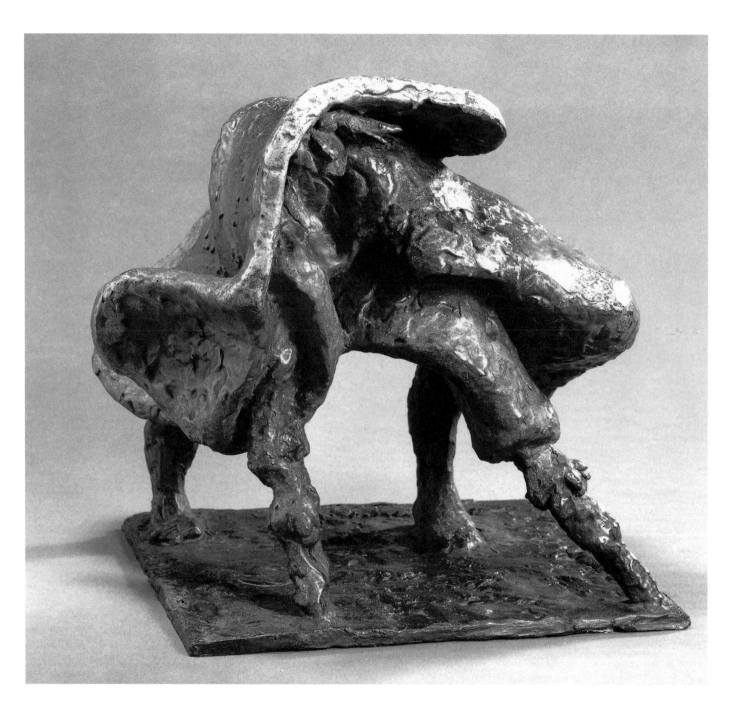

657 *Il Ponte Vecchio*, 1967, Bronze, H. 12 in /30.5 cm

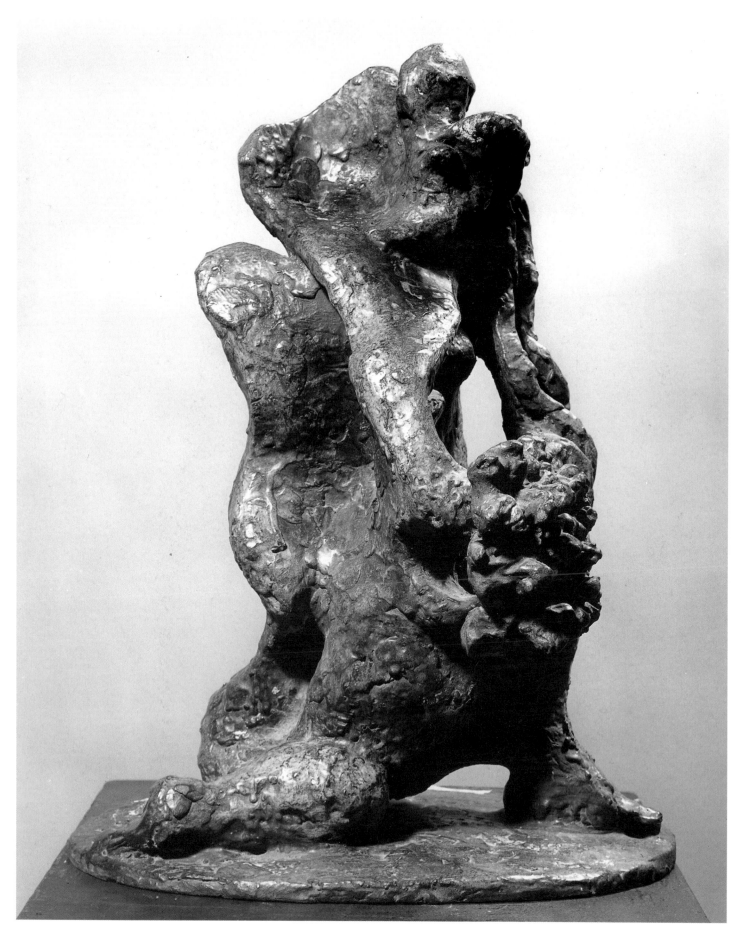

658 *Fleur pour Florence douloureuse,* 1967, Bronze, H. 16.25 in /41.3 cm

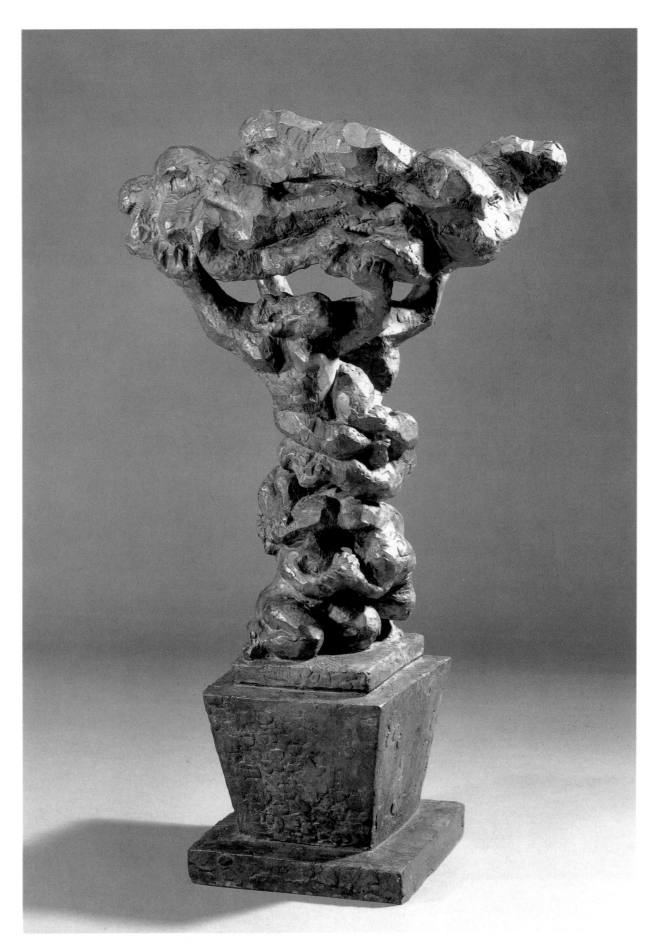

660 *Working Model for Government of the People,* 1967, Bronze, H. 48.5 in /123.2 cm

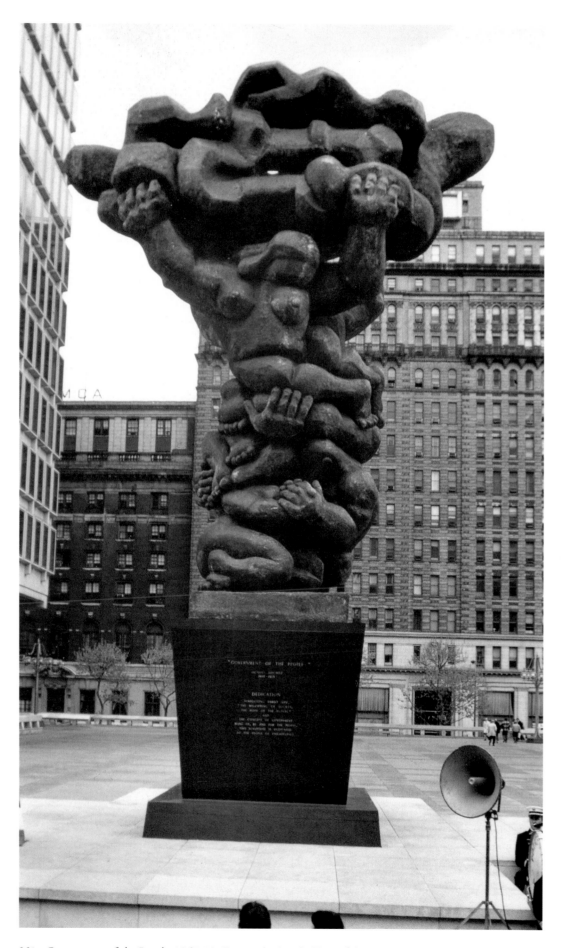

661 *Government of the People,* 1967-70, Bronze (unique), H. 35 ft/10.5 m

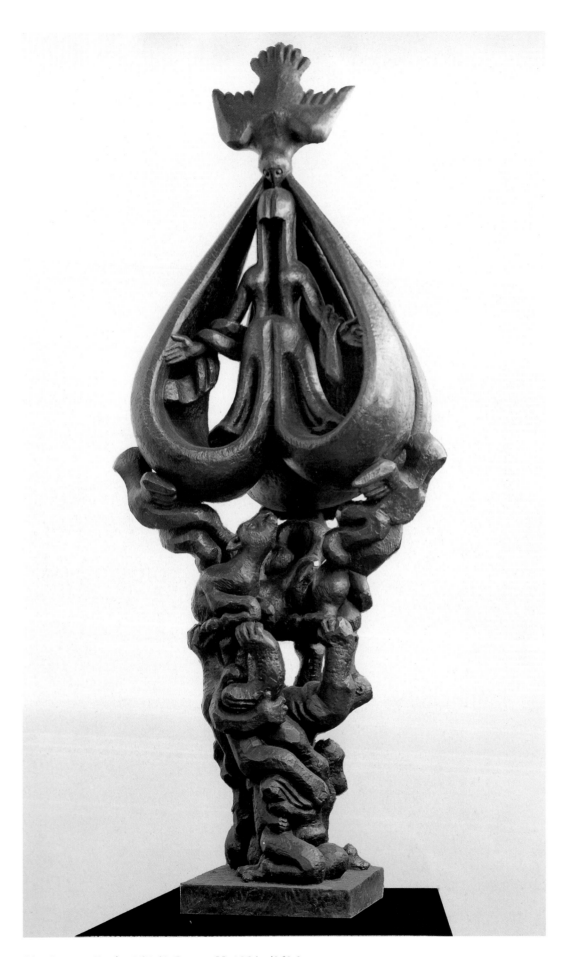

663 *Peace on Earth,* 1967-69, Bronze, H. 135 in /360.0 cm

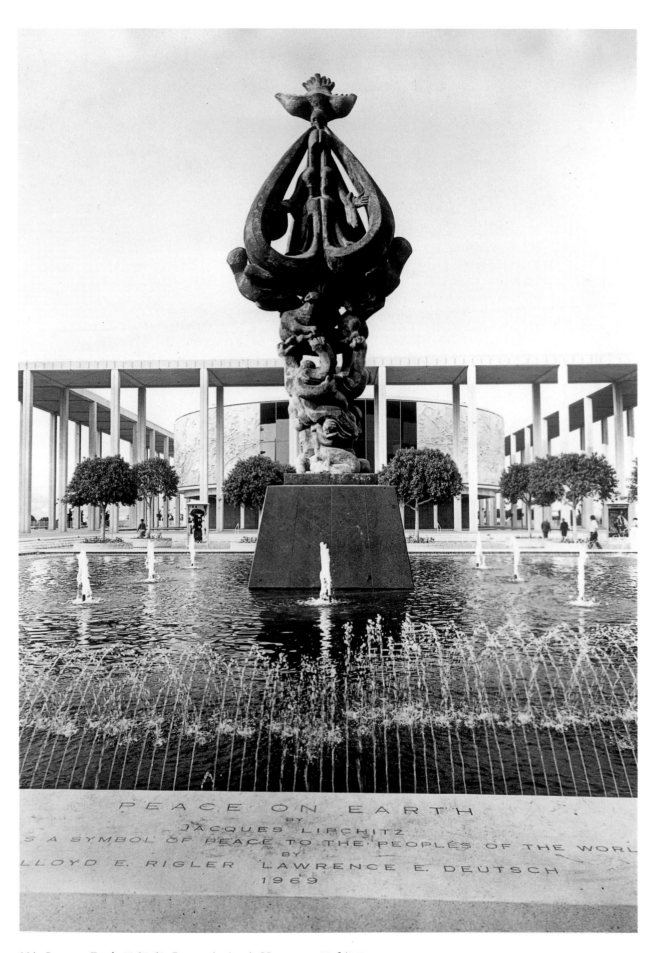

664 *Peace on Earth,* 1967-69, Bronze (unique), H. approx. 29 ft/8.7 m

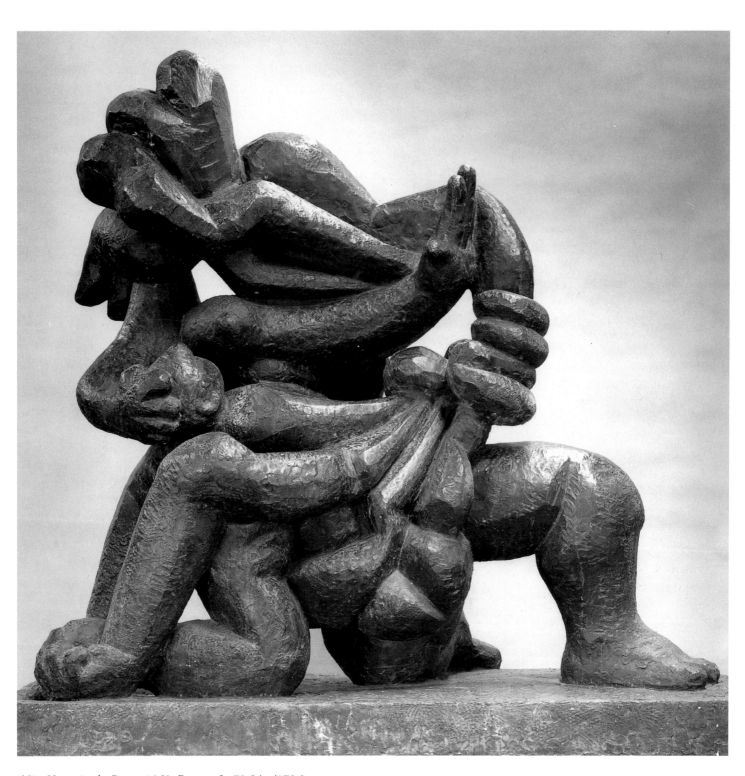

669 *Hagar in the Desert*, 1969, Bronze, L. 70.5 in /179.0 cm

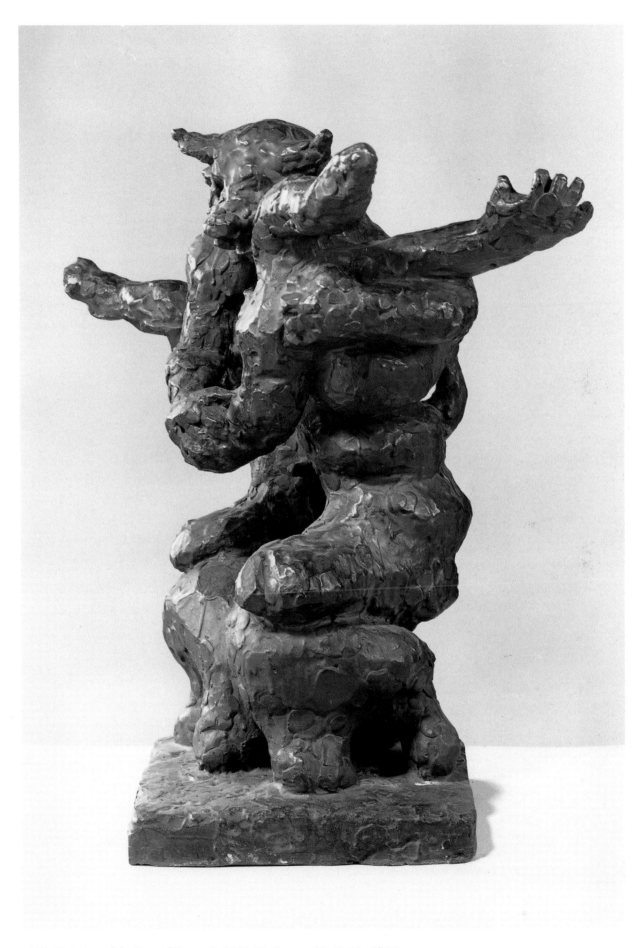

674 *Variation of the Rape of Europa E*, 1969-70, Bronze, H. 18.5 in /47.0 cm

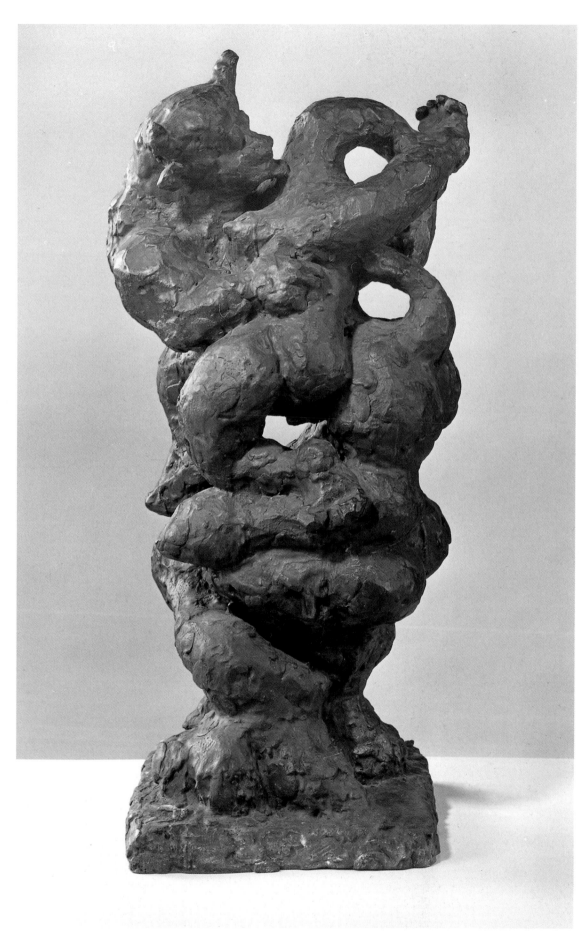

676 *Variation of the Rape of Europa G*, 1969-70, Bronze, H. 19.31 in /49.0 cm

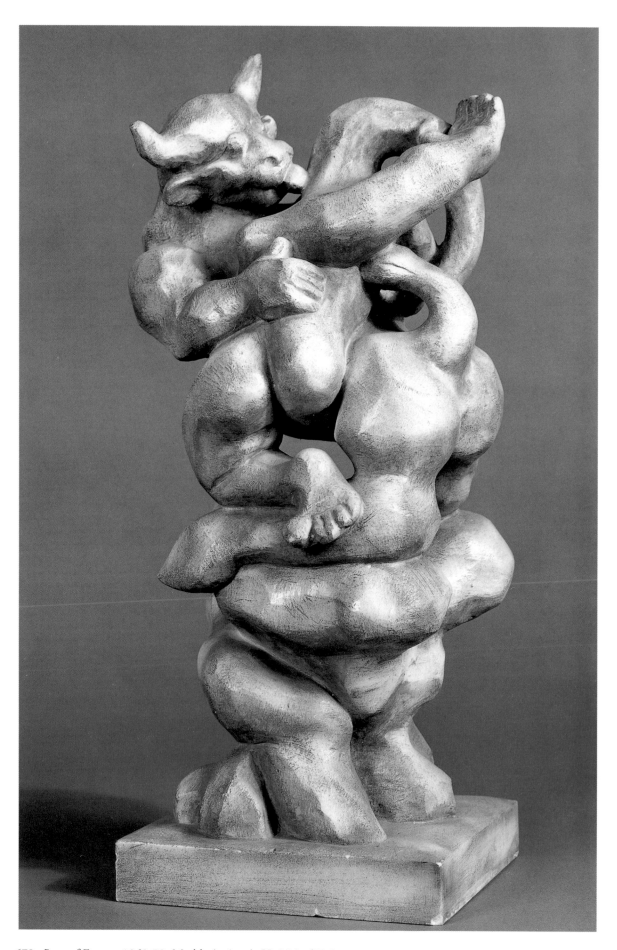

679 *Rape of Europa*, 1969-70, Marble (unique), H. 20 in /50.8 cm

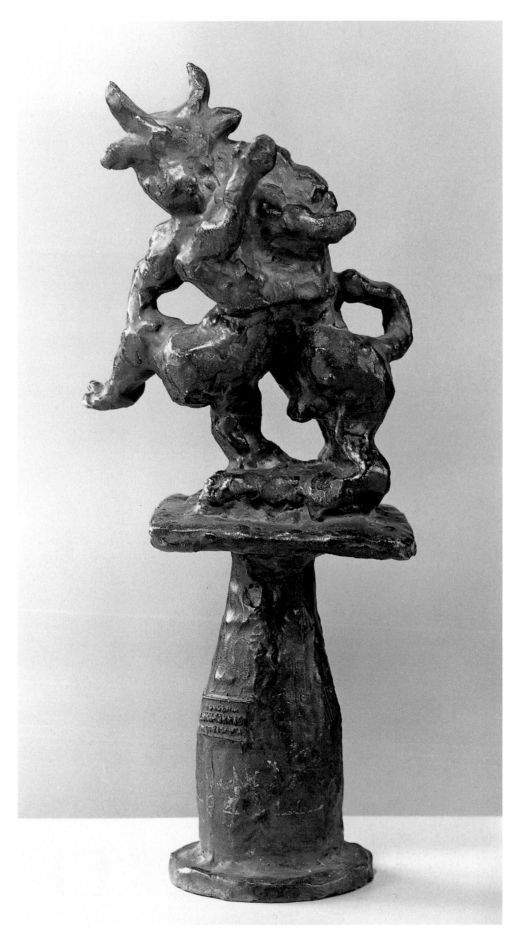

683 *Small Study for the Rape of Europa on Column II*, 1969-70, Bronze, H. 8.87 in /22.5 cm

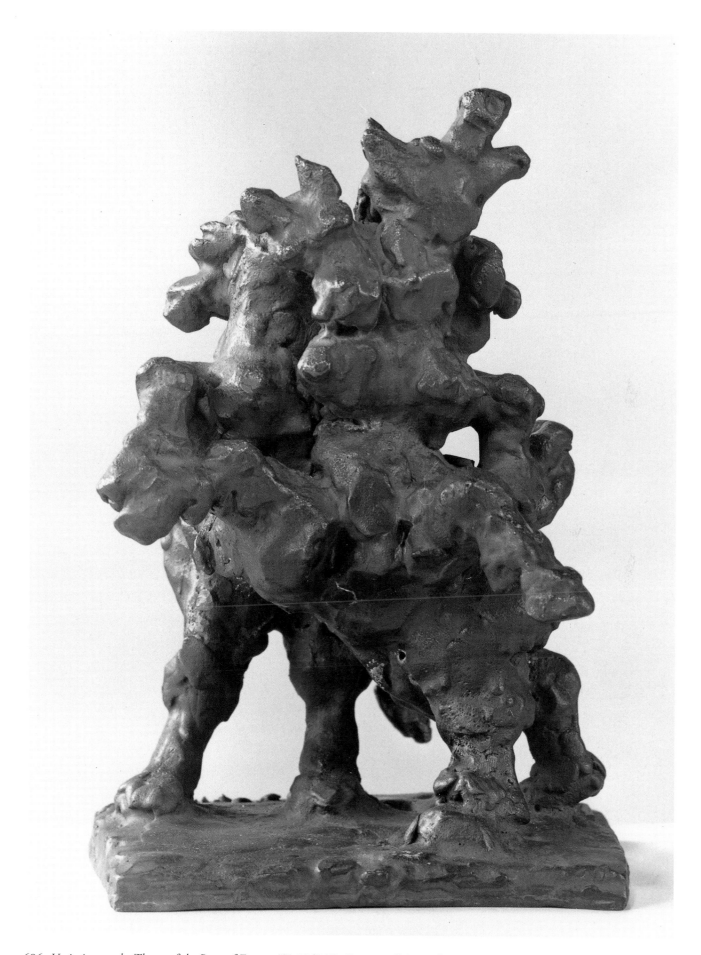

686 *Variation on the Theme of the Rape of Europa III*, 1969-72, Bronze, edition unknown, H. 7.5 in /19.0 cm

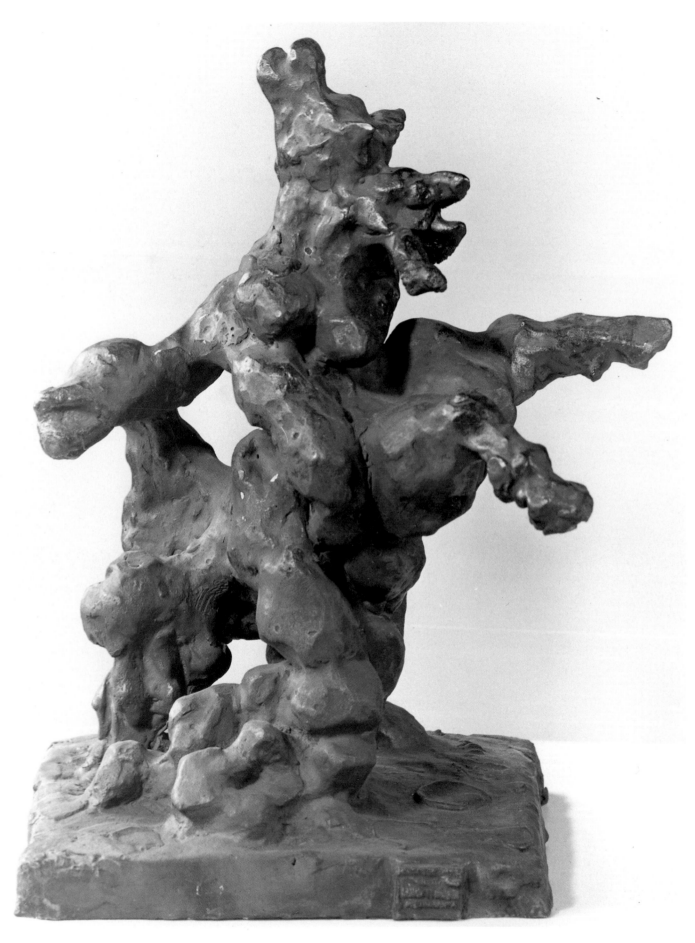

688 *Variation on the Theme of the Rape of Europa V,* 1969-72, Bronze, H. 8.93 in /22.7 cm

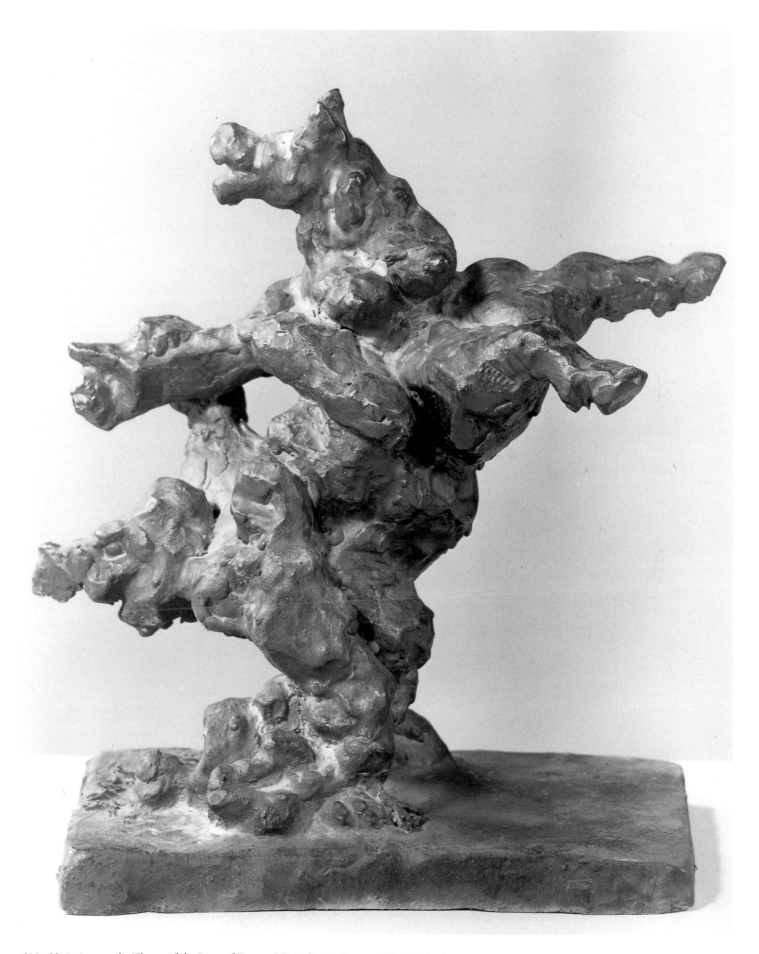

689 *Variation on the Theme of the Rape of Europa VI*, 1969-72, Bronze, H. 8.93 in /22.7 cm

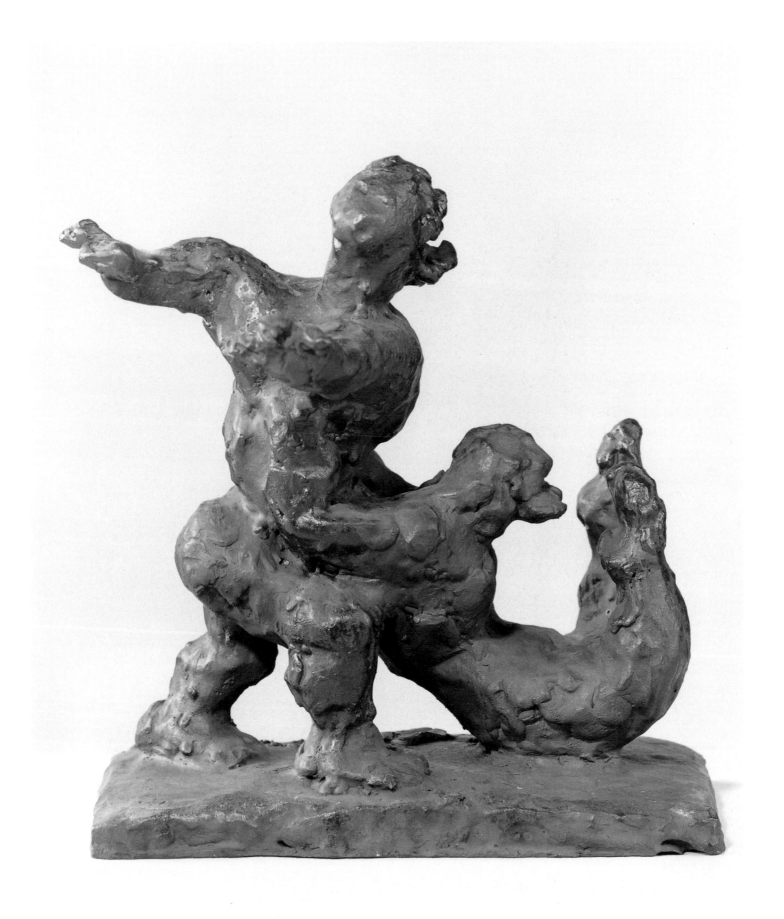

698 *Variation on the Theme of the Last Embrace III,* 1970-72, Bronze, L. 7.93 in /19.9 cm

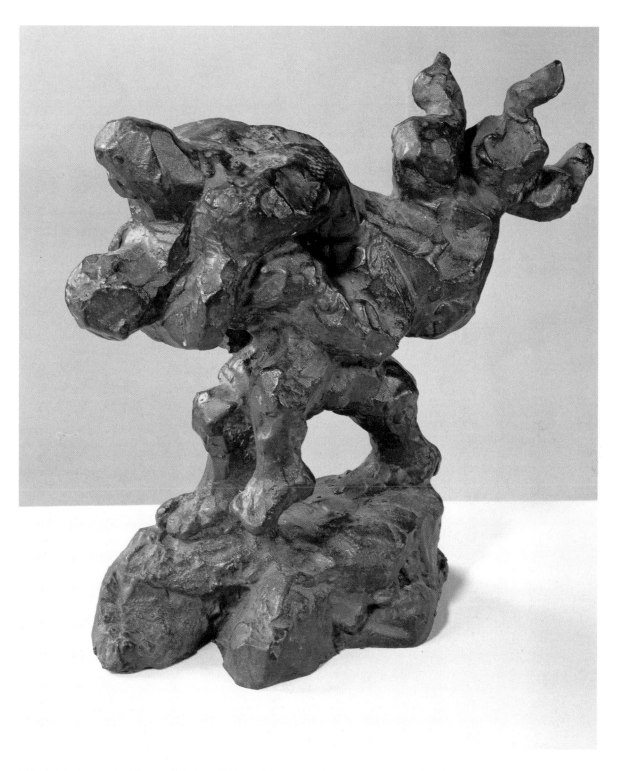

700 *Variation on the Theme of the Last Embrace V,* 1970-72, Bronze, L. 7.25 in /18.4 cm

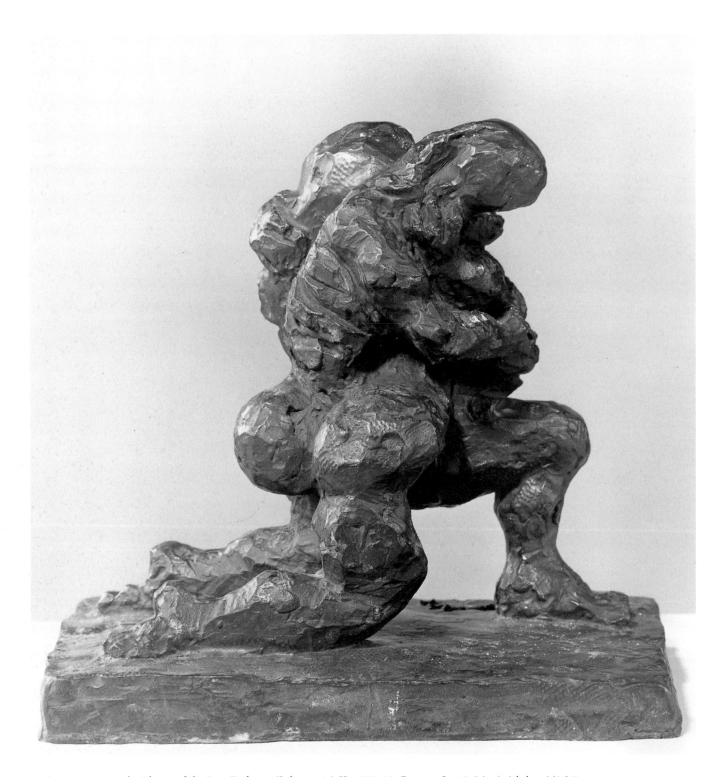

704 *Variation on the Theme of the Last Embrace (Salvataggio) II,* 1970-72, Bronze, L. 10.5 in (with base)/26.7 cm

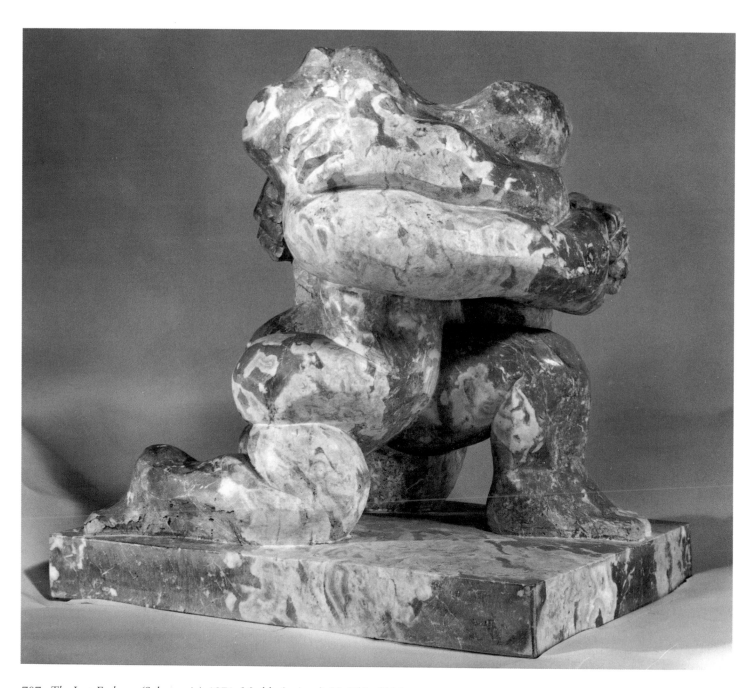

707 *The Last Embrace (Salvataggio),* 1971, Marble (unique), H. 26 in /66.0 cm

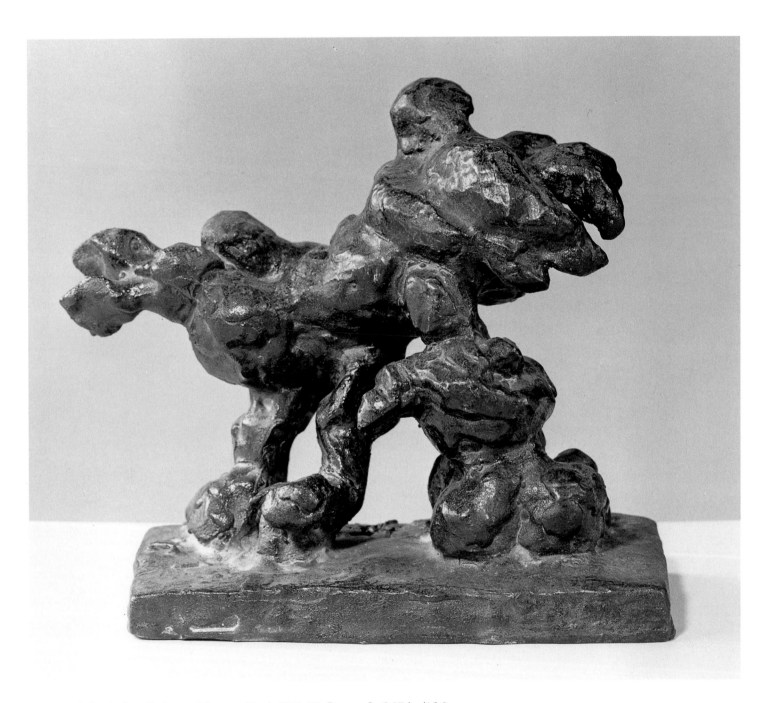

708 *Study for the Last Embrace: Maquette No. 1,* 1970-72, Bronze, L. 5.87 in /15.0 cm

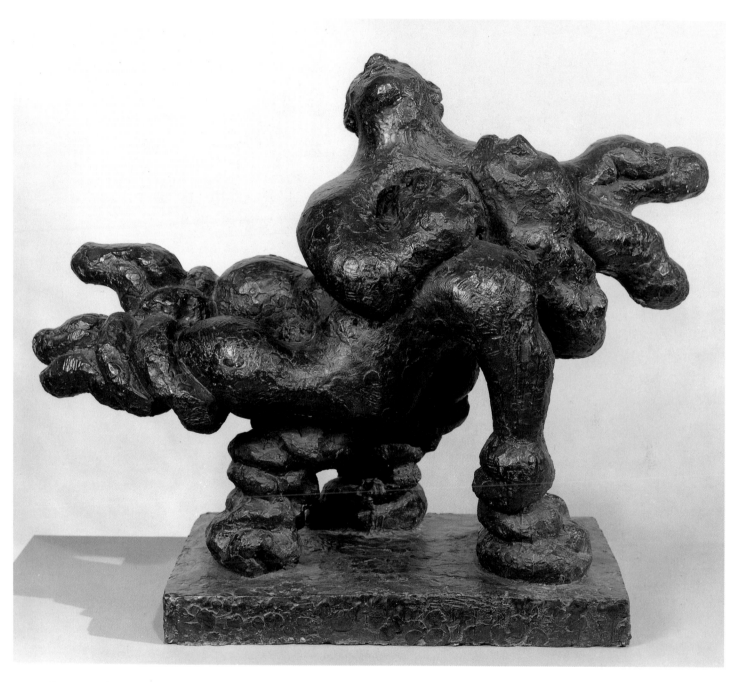

711 *The Last Embrace,* 1970-71, Bronze, L. 41 in /104.1 cm

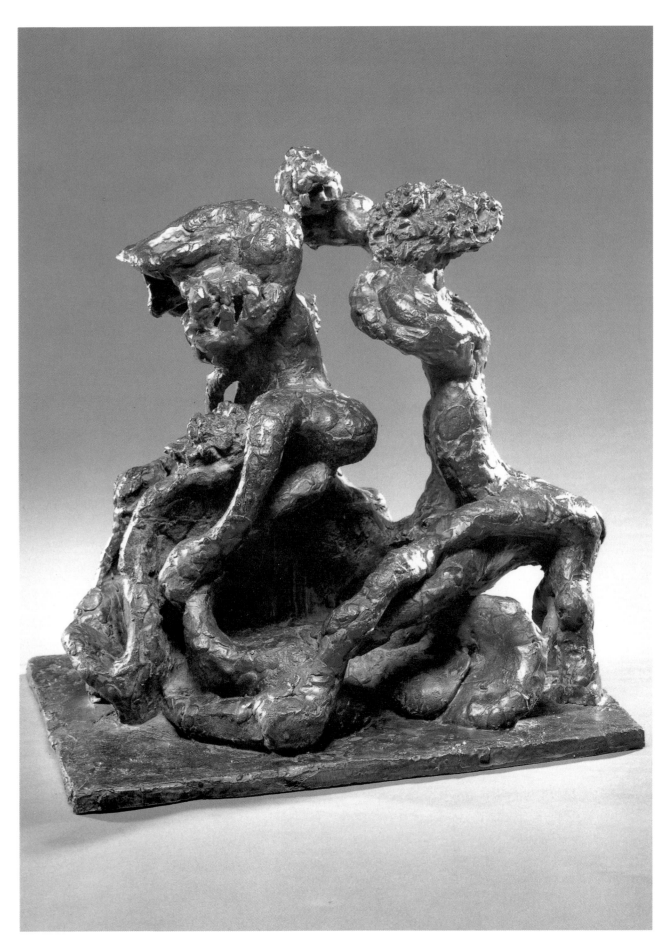

712 *Homage to Dürer*, 1970, Bronze, L. 16 in /40.6 cm

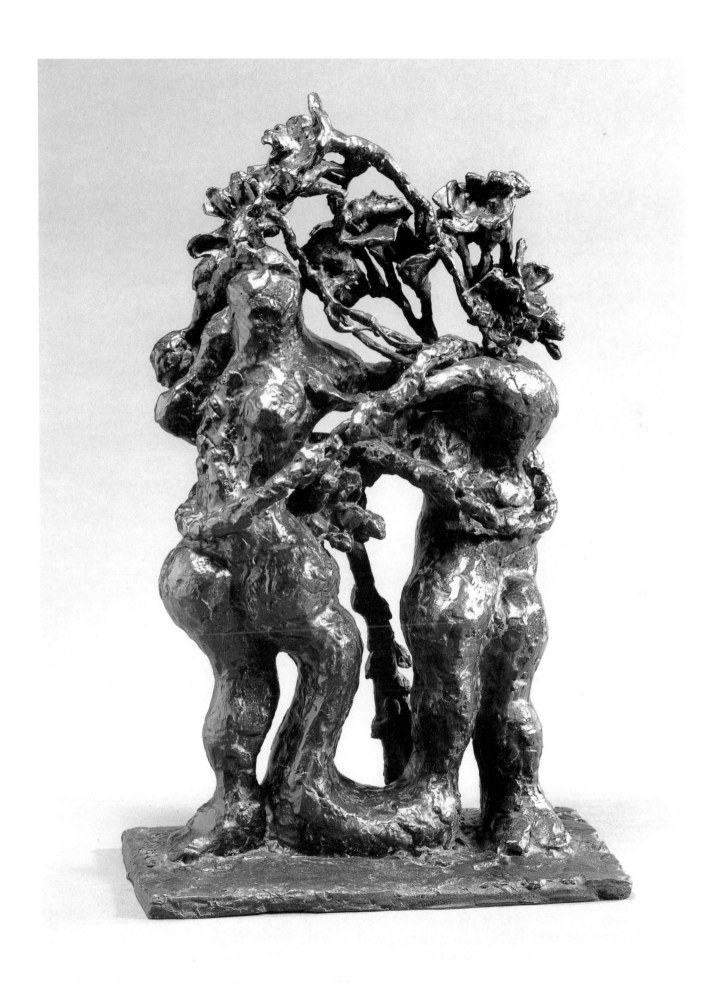

713 *La première rencontre,* 1970-71, Bronze, H. 17.5 in /44.5 cm

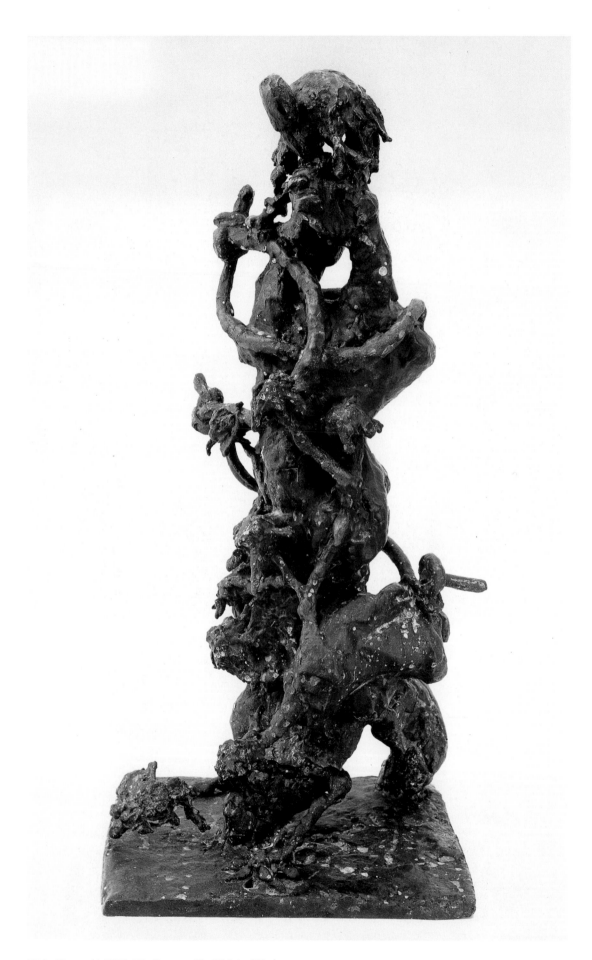

714 *L'emmelé*, 1970-71, Bronze, H. 15.5 in /39.4 cm

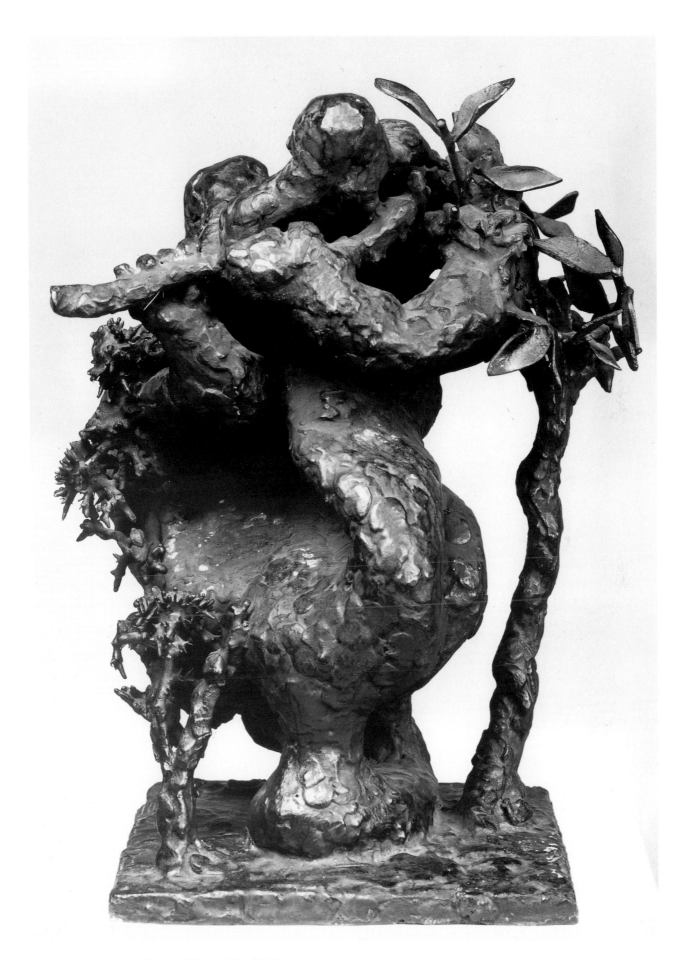

715 *Pierrot,* 1970-71, Bronze, H. 14.75 in /37.5 cm

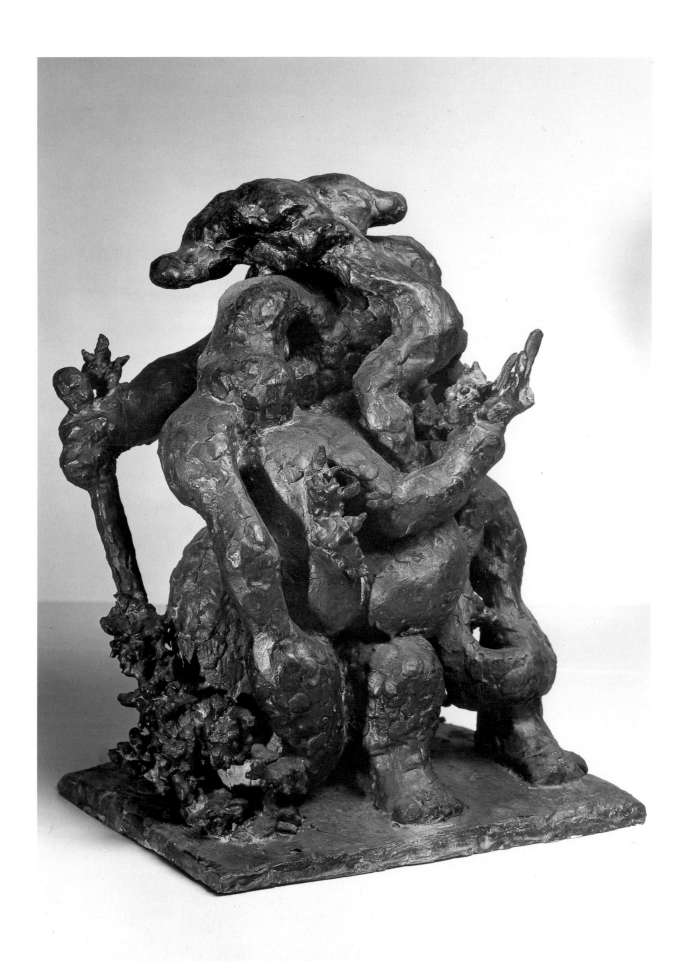

716 *La rencontre*, 1970-71, Bronze, H. 16.56 in /42.0 cm

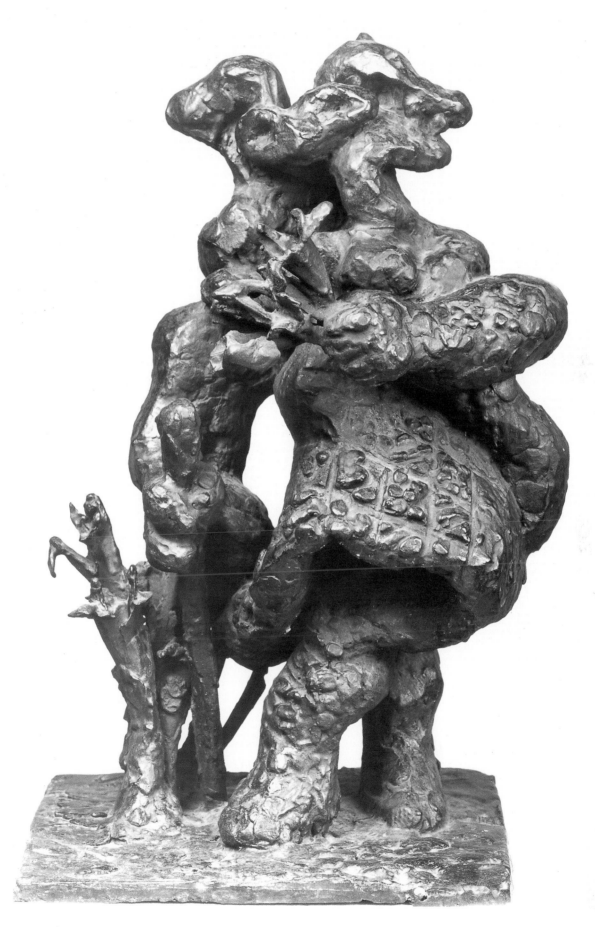

717 *Harlequin,* 1970-71, Bronze, H. 15.37 in /39.1 cm

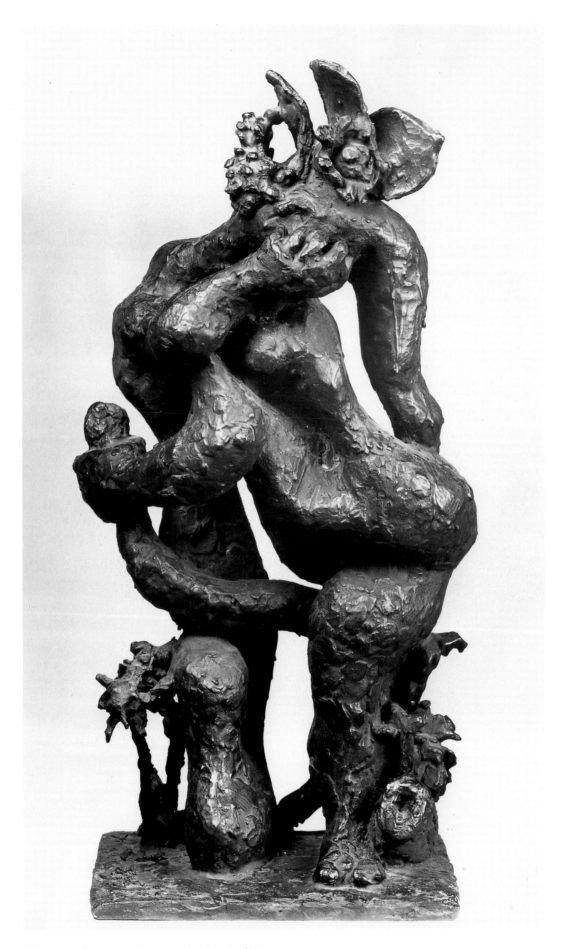

718 *Columbine,* 1971, Bronze, H. 20.37 in /51.8 cm

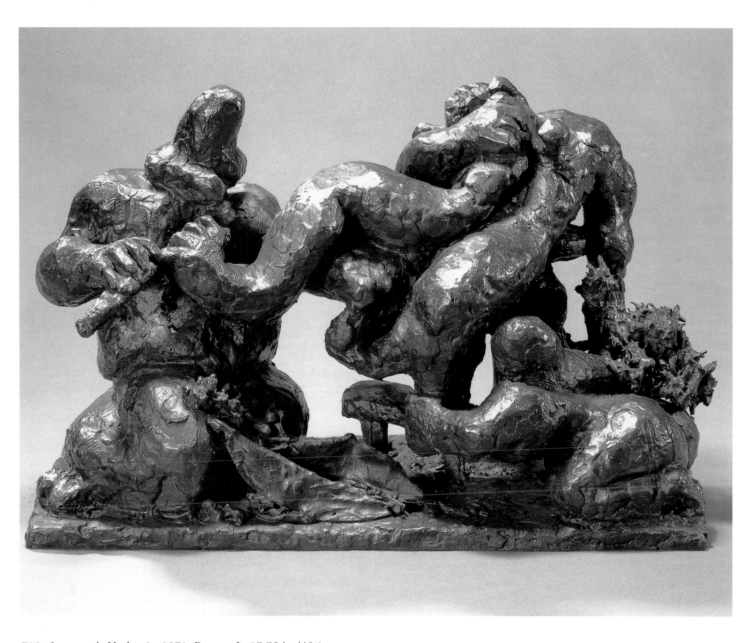

719 *La mort de Harlequin,* 1971, Bronze, L. 17.75 in /45.1 cm

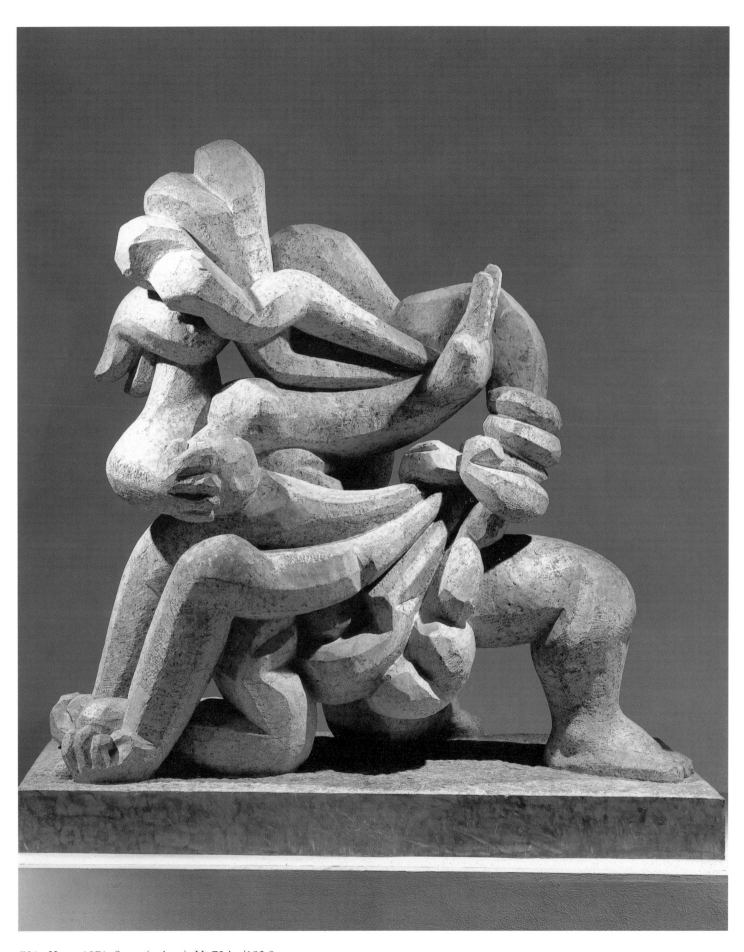

721 *Hagar,* 1971, Stone (unique), H. 72 in /182.9 cm

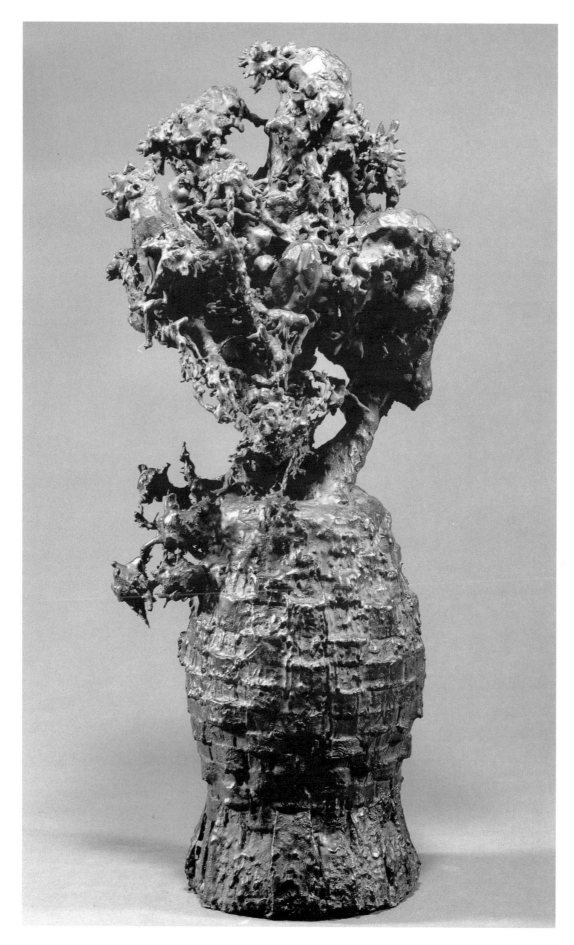

722 *Homage to Arcimboldo,* 1971, Bronze (unique), H. 21.5 in /54.6 cm

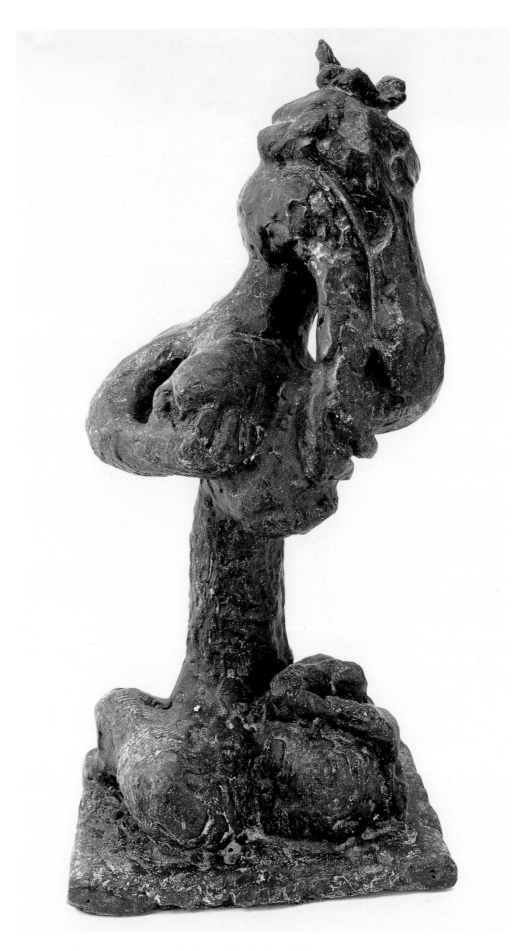

726 *La belle III*, 1971, Bronze (unique), H. 12.12 in /30.8 cm

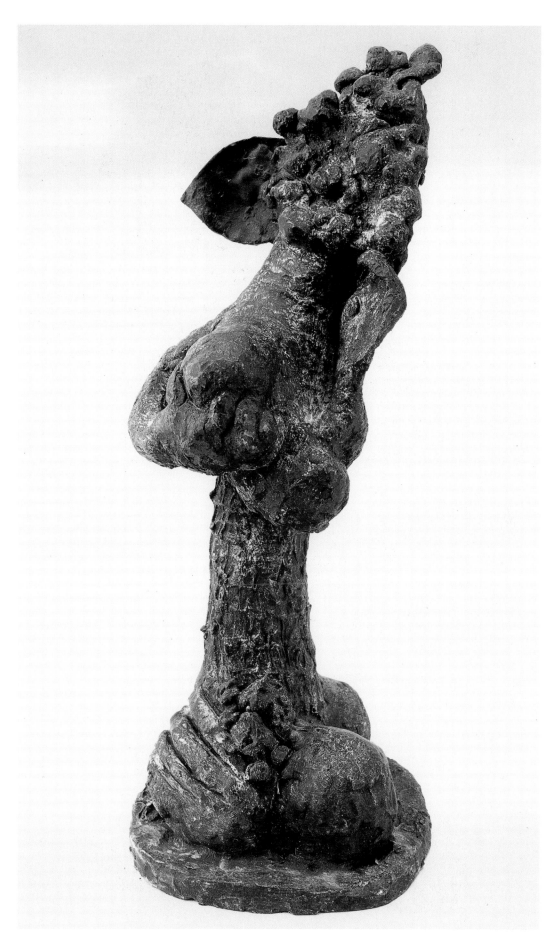

727 *La belle IV,* 1971, Bronze (unique), H. 11.62 in /29.5 cm

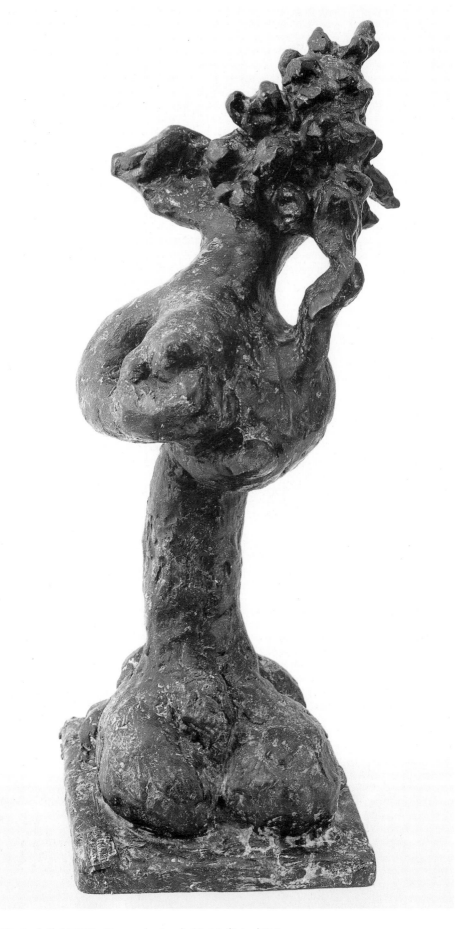

728 *La belle V,* 1971, Bronze (unique), H. 11.62 in /29.5 cm

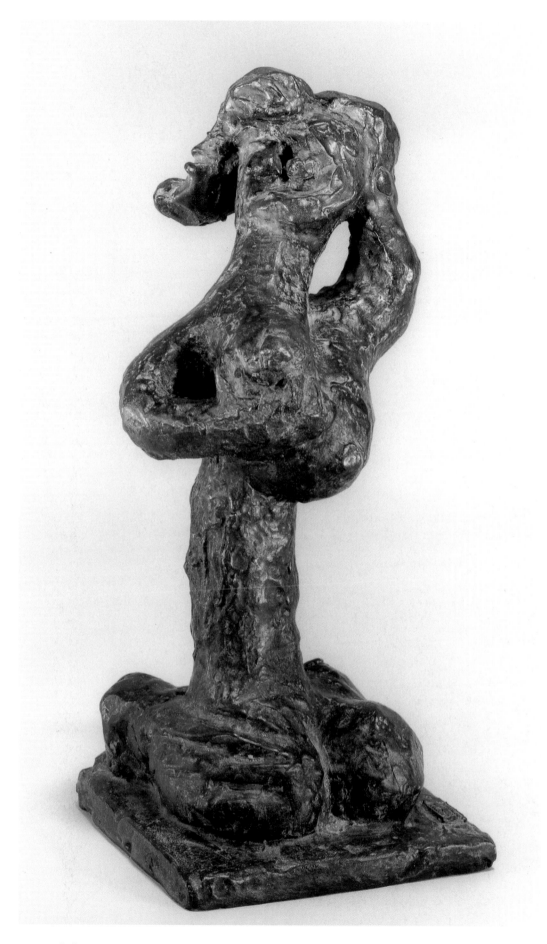

730 *La belle VII,* 1971, Bronze (unique), H. 11.5 in /29.2 cm

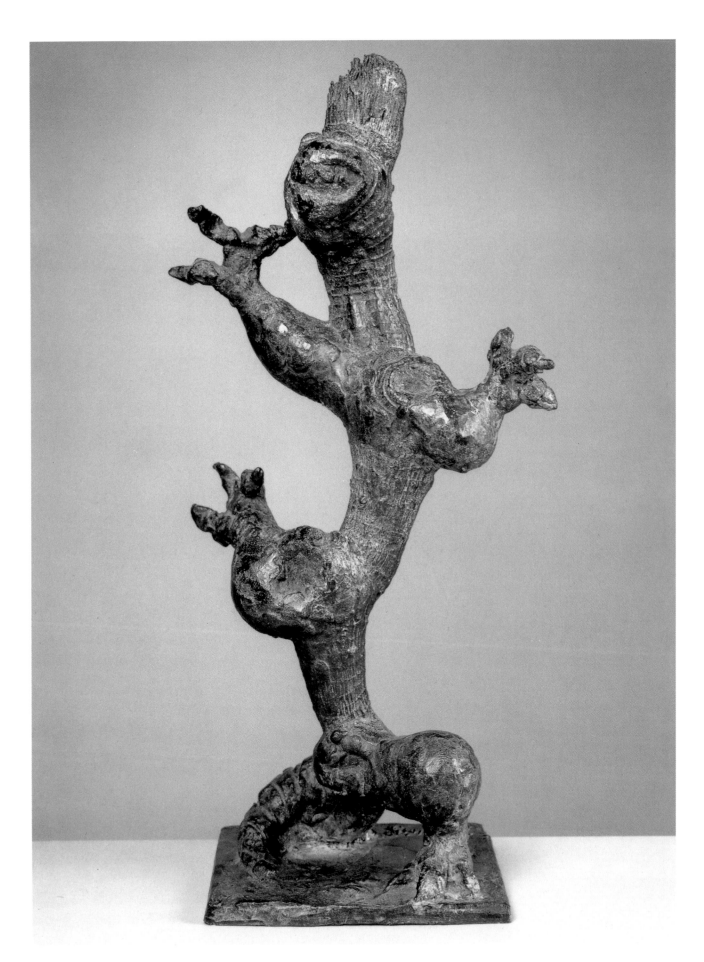

733 *La danse érotique,* 1971, Bronze (unique), H. 17.75 in /45.1 cm

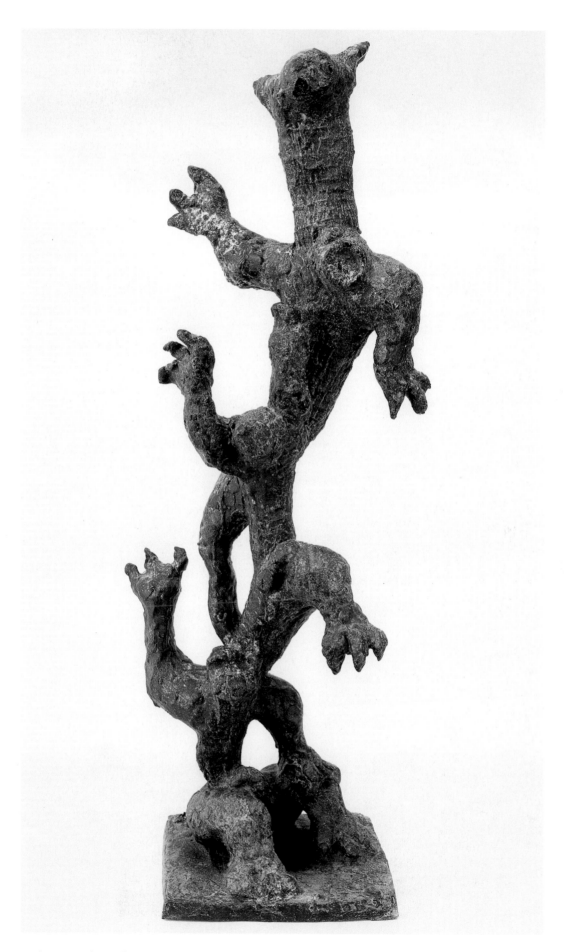

734 *Le grand tumulte*, 1971, Bronze (unique), H. 20.75 in /52.7 cm

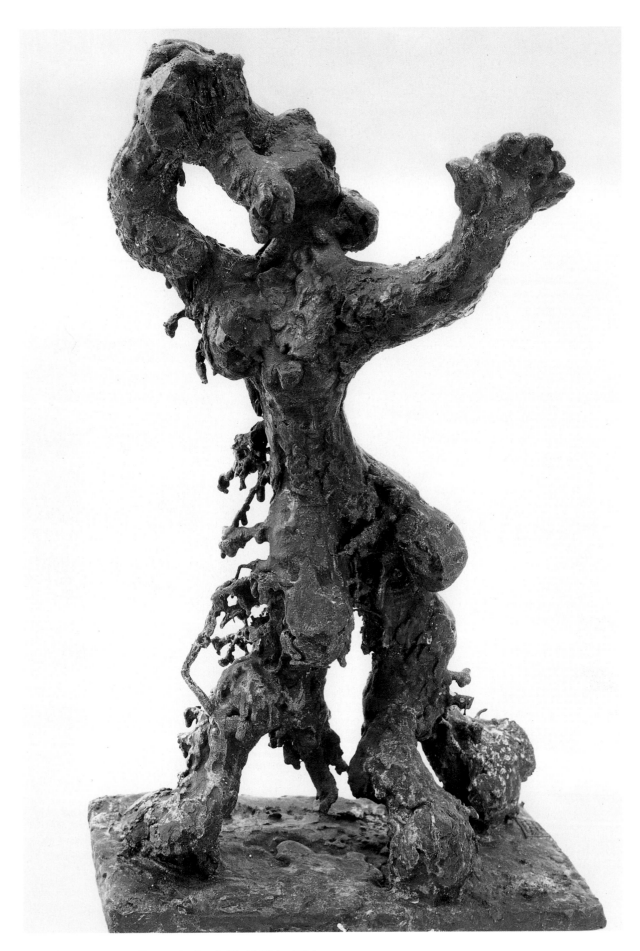

736 *L'Amazone*, 1971, Bronze (unique), H. 12.75 in /32.4 cm

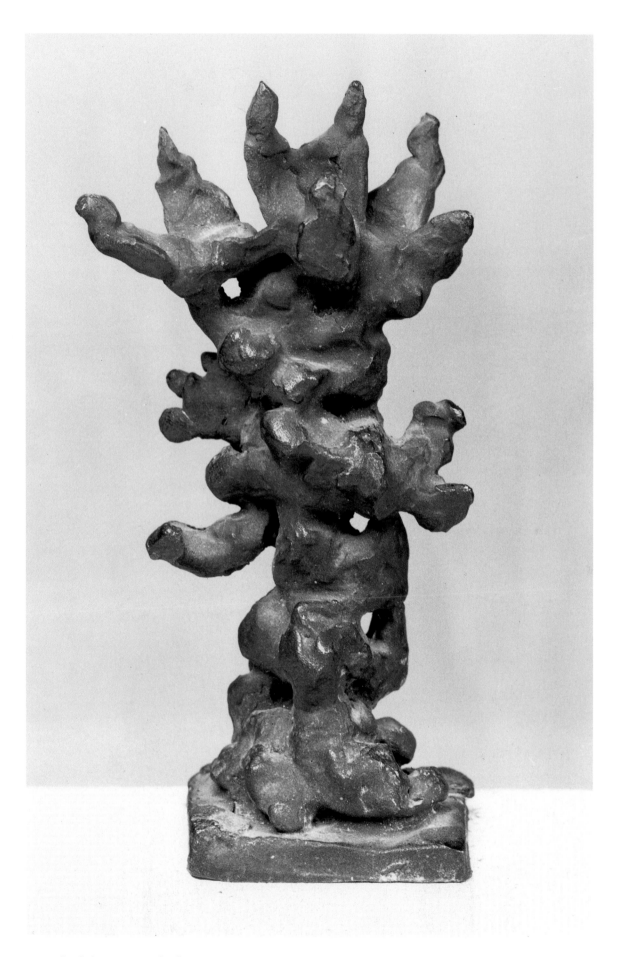

738 *Sketch for Our Tree of Life I*, 1971-72, H. 4.5 in /11.5 cm

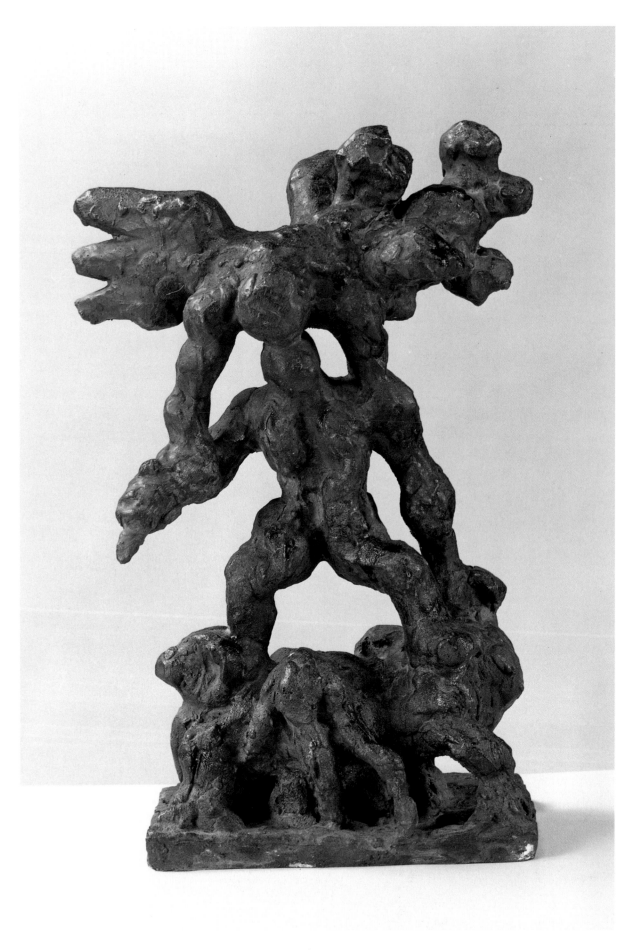

740 *Sketch for Our Tree of Life III*, 1971-72, H. 11.75 in /29.9 cm

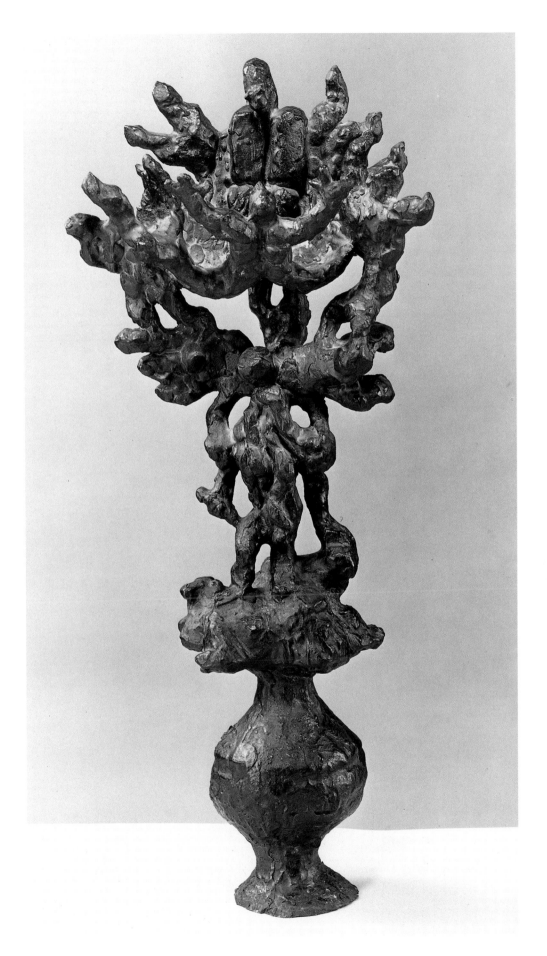

742 *Sketch for Our Tree of Life V*, 1971-72, H. 20.5 in /52.1 cm

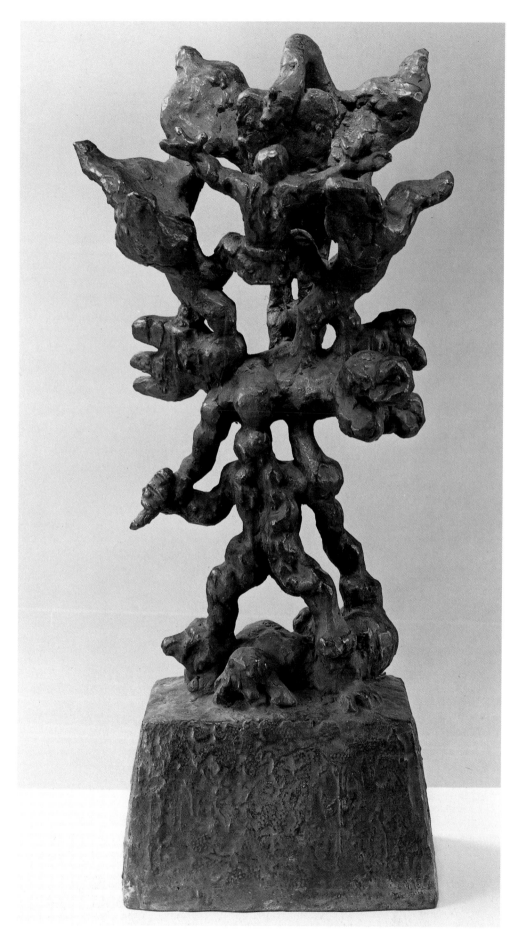

744 *Sketch for Our Tree of Life VII*, 1971-72, H. 21.37 in /54.3 cm

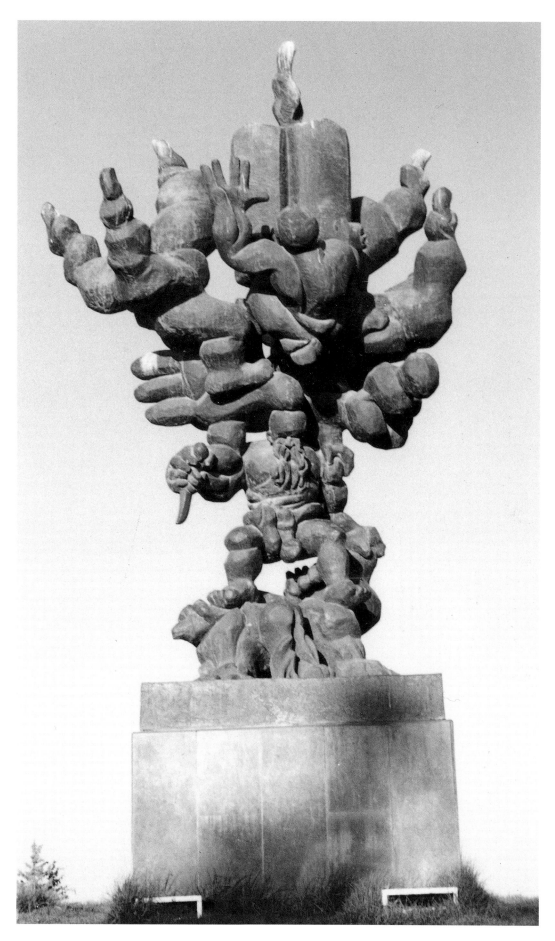

747 *Our Tree of Life,* 1973-78, Bronze (unique), H. 20 ft /6 m.

INDEX OF SCULPTURES

379
Prometheus Strangling the Vulture, 1943
Bronze, edition of 7
H. 37.5 in /95.3 cm
The Art Museum, Princeton University, Princeton,
New Jersey

380
Prometheus Strangling the Vulture, 1943
Bronze, edition of 7
H. 16 to 20 in /40.1 to 50.8 cm, depending on
height of pedestal.
Portland Art Museum, Portland, Oregon;
Worcester Art Museum, Worcester, Massachusetts;
Stedelijk Museum, Amsterdam

381
Prometheus Strangling the Vulture, 1944-53
Bronze, edition of 2
H. 7 ft 9 in /236.2 cm
Philadelphia Museum of Art; Walker Art Center,
Minneapolis, Minnesota

382
Birth of the Muses I, 1944
Bronze, edition of 7
H. 5 in /12.7 cm

383
Birth of the Muses II, 1944
Bronze, edition unknown
L. 7.12 in /18.1 cm
Stedelijk Museum, Amsterdam

384
Pegasus (also known as *Birth of the Muses*), 1944
Bronze, edition of 7
L. 20.56 in /53.3 cm
Cincinnati Art Museum; Israel Museum, Jerusalem

385
Birth of the Muses, 1944-50
Bronze, edition of 7
60.5 x 89 in /153.7 x 226.1 cm
Lincoln Center for the Performing Arts, New York;
MIT List Visual Art Center, Cambridge,
Massachusetts; Syracuse University Art Collection,
Syracuse, New York

386
Portrait of the Poet Leib Jaffe, 1944
Bronze, edition of 7
H. 15 in /38.1 cm
Tel Aviv Museum of Art, Israel

387
Portrait of W. Oertly, 1944
Terracotta (unique)
H. 12.5 in /31.8 cm
Photograph unavailable. Catalogue no. 9 with
small illustration in: *Jacques Lipchitz,* Buchholz
Gallery, New York, 1946.

388
Song of Songs: Maquette No. 1
(also known as *First Study for Song of Songs*), 1944
Bronze, edition unknown
L. 7 in /17.8 cm
Israel Museum, Jerusalem

389
Song of Songs: Maquette No. 2
(also known as *Sketch for Song of Songs*), 1945
Bronze, edition unknown
L. 7.87 in /20.0 cm
Stedelijk Museum, Amsterdam

390
Song of Songs, 1945
Bronze, edition of 7
L. 36 in /91.5 cm
Indiana University Art Museum, Bloomington,
Indiana; MIT List Visual Art Center, Cambridge,
Massachusetts

391
Mother and Child, 1945
Bronze, edition unknown
L. 11 in /27.9 cm
Israel Museum, Jerusalem

392
Sketch for Massacre: Maquette No. 1, 1945
Bronze, edition unknown
H. 5.75 in /14.6 cm

393
Sketch for Massacre: Maquette No. 2, 1945
Bronze, edition unknown
H. 5.75 in /14.6 cm
Photograph unavailable. Catalogue no. 15 in:
Jacques Lipchitz, Buchholz Gallery, New York,
1946.

394
The Rescue, 1945
Bronze, edition of 7
H. 15.75 in /40.0 cm

395
The Joy of Orpheus I, 1945
Bronze, edition of 7
H. 18.5 in /47.0 cm
Hirshhorn Museum and Sculpture Garden,
Smithsonian Institution, Washington, D.C.;
Washington University Gallery of Art, St. Louis,
Missouri; The Harvard University Art Museums,
Cambridge, Massachusetts

396
The Joy of Orpheus II, 1945-46
Bronze, edition of 7
H. 20 in /50.8 cm

397
Benediction, 1945
Bronze (unique)
H. 7 ft /213.4 cm

398
Trentina, 1946
Bronze (unique)
H. 20.56 in /52.2 cm
The Harvard University Art Museums, Cambridge,
Massachusetts

399
Aurelia, 1946
Bronze (unique)
H. 25.32 in /64.5 cm
Peggy Guggenheim Collection, Venice; The
Solomon R. Guggenheim Foundation, New York

400
Happiness (Study), 1947
Bronze, edition unknown
H. 9.75 in /24.8 cm

401
Happiness, 1947
Bronze, edition of 7
H. 19.25 in /48.9 cm
University of Michigan Museum of Art, Ann Arbor

402
Rescue II (Study): Maquette No. 1, 1947
Bronze, edition 1 or 2
H. 6 in /15.2 cm

403
Rescue II (Study): Maquette No. 2, 1947
Bronze, edition unknown
H. 8 in /20.3 cm

404
Rescue II, 1947
Bronze, edition of 7
H. 20 in /50.8 cm

405
Dancer with Hood (Study)
(also known as *Danseuse au Capuchon (Study)*),
1947
Bronze, edition unknown
H. 9 in /22.8 cm

406
Dancer with Hood
(also known as *Danseuse au Capuchon*), 1947
Bronze, edition of 7
H. 21.12 in /53.7 cm
Niigata City Art Museum, Japan

407
Dancer with Hood, 1947
Artificial stone
H. 20.87 in /53.0 cm
Tel Aviv Museum of Art, Israel

408
Dancer with Drapery
(also known as *Dancer*), 1947
Bronze, edition unknown
H. 8.25 in /21.0 cm

409
Dancer with Train
(also known as *Dancer with Veil,* and *Dancer*),
1947
Bronze, edition unknown
H. 9.12 in /23.2 cm
Israel Museum, Jerusalem

410
Couple I, 1947
Bronze, edition unknown
H. 5 in /12.7 cm
Israel Museum, Jerusalem

411
Couple II, 1947
Bronze, edition of 7
H. 8 in /20.3 cm

412
Miracle
(also known as *Miracle I*), 1947
Bronze, edition unknown
H. 14.25 in /36.2 cm

413
Miracle, 1947
Bronze, edition unknown
H. unknown
Photographed in Lipchitz's studio, Hastings-on-Hudson, New York

414
Exodus, 1947
Bronze, edition of 7
H. 22 in /55.9 cm

415
First Study for Sacrifice
(also known as *Sacrifice (Study)*), 1947
Bronze, edition of 7
H. 13.62 in /34.6 cm
Philadelphia Museum of Art

416
Second Study for Sacrifice
(also known as *Sacrifice 1*), 1947
Bronze, edition of 7
H. 19 in /48.3 cm
Herbert F. Johnson Museum of Art, Cornell University, Ithaca, New York; Portland Art Museum, Portland, Oregon; David and Alfred Smart Museum of Art, University of Chicago; University of Iowa Museum of Art, Iowa City, Iowa

417
Cradle I, 1947
Cast Stone (unique)
H. 12.25 in /31.1 cm

418
Cradle II, 1947
Cast stone (unique)
H. 15.25 in /38.7 cm

419
Study for Notre Dame de Liesse I, 1948
Bronze (unique)
H. 9.25 in /23.5 cm

420
Study for Notre Dame de Liesse II, 1948
Bronze (unique)
H. 8.75 in /22.2 cm

421
Study for Notre Dame de Liesse III, 1948
Bronze (unique)
H. 8.25 in /21.0 cm

422
Study for Notre Dame de Liesse IV, 1948
Bronze (unique)
H. 8.25 in /21.0 cm

423
Study for Notre Dame de Liesse V, 1948
Bronze (unique)
H. 10 in /25.4 cm

424
Study for Notre Dame de Liesse, 1948
Bronze, edition of 7
H. 33 in /83.8 cm
David and Alfred Smart Museum of Art, the University of Chicago

425
Notre Dame de Liesse, 1948-55
Bronze, edition of 3
H. 97 in /246.4 cm
The Abbey of Saint Columba, Iona, Argyll, Scotland; Notre Dame de Toute Grâce, Assy, Haute-Savoie; Roofless Church, New Harmony, Indiana

426
Dancer with Braids
(also known as *Study for Dancer with Braids*), 1948
Bronze, edition of 7
H. 13.25 in /33.7 cm
Baltimore Museum of Art

427
Dancer with Braids, 1948
Bronze, edition unknown
H. 14.25 in /36.2 cm

428
Dancer, 1948
Bronze, edition unknown
H. 13.75 in /35.0 cm

429
Miracle II, 1948
Bronze, edition of 7
H. 30 in /76.2 cm
The Harvard University Art Museums, Cambridge, Massachusetts; The Jewish Museum, New York

430
Miracle II, 1948
Bronze, edition of 7
H. 110 in./279.4 cm

431
Sacrifice, 1948
Bronze (unique)
H. 48.75 in /123.9 cm
Albright-Knox Art Gallery, Buffalo, New York

432
Sacrifice II, 1948-52
Bronze (unique)
H. 49.25 in /125.1 cm
Whitney Museum of American Art, New York

433
Study for Hagar: Maquette No. 1, 1948
Bronze, edition unknown
L. 8.5 in /21.6 cm
David and Alfred Smart Museum of Art, University of Chicago; Philadelphia Museum of Art

434
Study for Hagar: Maquette No. 2, 1948
Bronze, edition unknown
L. 8.75 in /22.2 cm
David and Alfred Smart Museum of Art, University of Chicago

435
Study for Hagar: Maquette No. 2, 1948
Plaster and iron filing, edition of 10
L. 9 in /22.8 cm

436
Study for Hagar: Maquette No. 3, 1948
Bronze, edition unknown
H. approx. 9.5 in /21.1 cm

437
Study for Hagar: Maquette No. 3, 1948
Plaster and iron filings, edition of 10
H. 9.5 in /24.1 cm
Rijksmuseum Kröller-Müller, Otterlo, The Netherlands; David and Alfred Smart Museum of Art, University of Chicago; Tate Gallery, London (Tate cast shown here)

438
Hagar I, 1948
Bronze, edition of 7
L. 31.25 in /79.4 cm
Art Gallery of Ontario, Toronto

439
Hagar II
(also known as *Hagar*), 1949
Bronze, edition unknown
H. 13 in /33.0 cm
Los Angeles County Museum of Art

440
Hagar in the Desert
(also known as *Hagar III*), 1949-57
Bronze, edition of 7
H. 39.5 in /100.4 cm
Von der Heydt-Museum Wuppertal, Germany
MIT List Visual Art Center, Cambridge, Massachusetts

441
Mother and Child I, 1949
Bronze, edition of 7
H. 17.5 in /44.4 cm
The Jewish Museum, New York

442
Mother and Child II, 1949
Bronze, edition of 7
H. 15.25 in /38.7 cm

443
Mother and Child, 1949
Bronze, edition of 7
H. 48.5 in /123.3 cm
Washington University Gallery of Art, St. Louis, Missouri; Wilhelm Lehmbruck Museum, Duisberg, Germany

444
Mother and Child, 1949
Bronze, edition of 7
H. 57 in /144.8 cm
Birmingham Museum of Art, Birmingham, Alabama; Hood Museum of Art, Dartmouth College, Hanover, New Hampshire

445
The Cradle, 1949-54
Bronze, edition unknown
H. 32.5 in /82.5 cm

446
Sacrifice III (also known as *Sacrifice*), 1949-57
Bronze, edition of 7
H. 49.25 in /125.1 cm
Jewish Museum, New York;
MIT List Visual Art Center, Cambridge,
Massachusetts; Fundacion Museo de Bellas Artes
de Caracas, Venezuela; Tel Aviv Museum of Art

447
Biblical Scene I, 1950
Bronze, edition of 7
H. 12.37 in /31.4 cm

448
Biblical Scene II, 1950
Bronze, edition of 7
H. 20 in /50.8 cm
Des Moines Art Center, Des Moines, Iowa

449
Study for Birth of the Muses I
(also known as *Sketch for Pegasus*), 1950
Bronze, edition unknown
11 x 12.25 in /28.0 x 31.1 cm
Israel Museum, Jerusalem

450
Study for Birth of the Muses II, 1950
Bronze, edition unknown
Dimensions unknown

451
Study for Birth of the Muses III, 1950
Bronze, edition unknown
L. 9.5 in /21.1 cm

452
Study for Birth of the Muses IV
(also known as *Pegasus*), 1950
Bronze, edition of 7
L. 10.12 in /25.5 cm
Israel Museum, Jerusalem

453
Study for Birth of the Muses V
(also known as *Pegasus*), 1950
Bronze, edition of 7
H. 12.75 in /32.4 cm

454
Study for a Monument (The Spirit of Enterprise), 1951
Bronze, edition of 7
H. 35.75 in /90.8 cm

455
Variation on a Chisel I:
Hebrew Object, Praying Man, 1951
Bronze (unique)
H. approx. 8.25 in /20.9 cm

456
Variation on a Chisel II:
Hebrew Object, Praying Man, 1951
Bronze (unique)
H. approx. 8.25 in /20.9 cm

457
Variation on a Chisel III:
Hebrew Object, 1951
Bronze (unique)
H. 8.75 in /22.2 cm

458
Variation on a Chisel IV:
Hebrew Object, The Dance, 1951
Bronze (unique)
H. approx. 9 in /22.9 cm

459
Variation on a Chisel V: Flower Vendor, 1951-52
Bronze (unique)
H. 9.5 in /24.1 cm

460
Variation on a Chisel VI: Begging Poet, 1951-52
Bronze (unique)
H. 8.5 in /21.6 cm

461
Variation on a Chisel VII:
Begging Poet (author's title), 1951-52
Bronze (unique)
H. approx. 9 in /22.9 cm

462
Variation on a Chisel VIII:
Begging Poet (author's title), 1951-52
Bronze (unique)
H. 8.87 in /22.5 cm

463
Variation on a Chisel IX:
Begging Poet (author's title), 1951-52
Bronze (unique)
H. 9 in /22.9 cm

464
Variation on a Chisel X: Poet on Crutches, 1951-52
Bronze (unique)
H. 8.5 in /21.6 cm

465
Variation on a Chisel XI, 1951-52
Bronze (unique)
H. 9.62 in /24.5 cm

466
Variation on a Chisel XII: La toilette, 1951-52
Bronze (unique)
H. 9.25 in /23.5 cm

467
Variation on a Chisel XIII, 1951-52
Bronze (unique)
H. 9.62 in /24.4 cm

468
Variation on a Chisel XIV, 1951-52
Bronze (unique)
H. 8.5 in /21.6 cm

469
Variation on a Chisel XV, 1951-52
Bronze (unique)
H. approx. 9 in /22.9 cm

470
Variation on a Chisel XVI, 1951-52
Bronze (unique)
H. approx. 9 in /22.9 cm

471
Variation on a Chisel XVII, 1951-52
Bronze (unique)
H. approx. 9 in /22.9 cm

472
Variation on a Chisel XVIII, 1951-52
Bronze (unique)
H. approx. 9 in /22.9 cm

473
Variation on a Chisel XIX:
Pas de Deux (author's title), 1951-52
Bronze (unique)
H. 8.75 in /22.2 cm

474
Variation on a Chisel XX: Dancer, 1951-52
Bronze (unique)
H. 8.5 in /21.6 cm

475
Variation on a Chisel XXI: Danseuse à la Violette,
1951-52
Bronze (unique)
H. 9.12 in /23.2 cm

476
Variation on a Chisel XXII:
Bird (author's title), 1951-52
Bronze (unique)
H. approx. 9 in /22.9 cm

477
Variation on a Chisel XXIII, 1951-52
Bronze (unique)
H. approx. 9 in /22.9 cm

478
Variation on a Chisel XXIV: Storks, 1951-52
Bronze (unique)
H. 8.75 in /22.2 cm

479
Variation on a Chisel XXV: Fight, 1951-52
Bronze (unique)
H. 10 in /25.4 cm

480
Variation on a Chisel XXVI: Centaur, 1951-52
Bronze (unique)
H. 7 in /17.8 cm

481
Variation on a Chisel XXVII:
Centaur Enmeshed I, 1951-52
Bronze (unique)
H. approx. 9 in /22.9 cm

482
Variation on a Chisel XXVIII:
Centaur Enmeshed II, 1951-52
Bronze (unique)
H. 7.5 in /19.1 cm

483
Variation on a Chisel XXIX: Menorah, 1951-52
Bronze (unique)
H. approx. 9 in /22.9 cm

484
Oriental Dancer, 1952
Bronze, edition unknown
H. 9 in /22.9 cm
Photograph unavailable. Listed in: Henry R.
Hope, *The Sculpture of Jacques Lipchitz,* The
Museum of Modern Art, New York, 1954.

485
Virgin in Flames I, 1952
Bronze (unique)
H. 13.5 in /34.3 cm

486
Virgin in Flames II, 1952
Bronze, edition unknown
H. 20 in /50.8 cm
Photograph unavailable. Listed in: Henry R.
Hope, *The Sculpture of Jacques Lipchitz,* The
Museum of Modern Art, New York, 1954.

487
Lesson of a Disaster, 1952 (1956?)
Bronze, edition of 7
H. 10.25 in /26.0 cm
Israel Museum, Jerusalem

488
Lesson of a Disaster, 1952
Bronze (unique)
H. 25.25 in /64.1 cm

489
Figure (author's title), c. 1952
Bronze, edition unknown
H. unknown
There is no information on the back of this photo-
graph.

490
Portrait of Otto Spaeth, 1952
Bronze, edition unknown
H. 14.5 in /36.8 cm

491
Portrait of Henry Pearlman, 1952
Bronze, edition unknown
H. 16.5 in /41.9 cm

492
Portrait of Gertrude Stein, 1953
Bronze, edition unknown
H. 20 in /50.8 cm

493
Sketch for the Spirit of Enterprise I, 1953
Bronze, edition of 7
H. 9.75 in /24.8 cm
Dallas Museum of Art

494
Sketch for the Spirit of Enterprise II, 1953
Bronze, edition of 7
H. 9.12 in /23.2 cm

495
Sketch for the Spirit of Enterprise III, 1953
Bronze, edition of 7
L. 10.25 in /26.0 cm
Israel Museum, Jerusalem

496
Sketch for the Spirit of Enterprise IV, 1953
Bronze, edition of 7
L. 12.12 in /30.8 cm

497
Sketch for the Spirit of Enterprise V, 1953
Bronze, edition of 7
L. 17.25 in /43.8 cm
Israel Museum, Jerusalem

498
Study for the Spirit of Enterprise, 1953
Bronze, edition of 7
H. 31.62 in /80.3 cm
Tate Gallery, London

499
Working Model for the Spirit of Enterprise, 1953
Bronze (unique)
H. 45 in /114.3 cm

500
The Spirit of Enterprise, 1953-54
Bronze (unique)
H. 137 in /347.98 cm
Fairmount Park Art Association, Philadelphia,
Pennsylvania

501
Inspiration, 1955
Bronze, edition of 7
H. 29.25 in /74.3 cm
Stedelijk Museum, Amsterdam

502
Reclining Figure, 1955-56
Bronze (unique)
L. 9.75 in /24.8 cm

503
The Prophet, 1955-56
Bronze (unique)
H. 10 in /25.4 cm

504
Mother and Child (Standing), 1955-56
Bronze (unique)
H. 11.5 in /29.2 cm

505
Mater Dolorosa, 1955-56
Bronze (unique)
H. 12.25 in /31.1 cm

506
Mother and Child, 1955-56
Bronze (unique)
H. 8 in /20.3 cm

507
Head of an Old Man, 1955-56
Bronze (unique)
H. 13.5 in /34.3 cm

508
Consolation, 1955-56
Bronze (unique)
H. 9 in /22.9 cm

509
Man with Rooster, 1955-56
Bronze (unique)
H. 13.5 in /34.3 cm

510
Imploration, 1955-56
Bronze (unique)
H. 18.5 in /47.0 cm

511
Geisha, 1955-56
Bronze (unique)
H. 15.5 in /39.4 cm

512
Bouquet, 1955-56
Bronze (unique)
H. 11.25 in /28.6 cm

513
Animal-Bird, 1955-56
Bronze (unique)
L. 12 in /30.5 cm

514
Gypsy Dancer, 1955-56
Bronze (unique)
H. 11.25 in /28.6 cm

515
Rêve de Valse, 1955-56
Bronze (unique)
H. 11 in /27.9 cm

516
Woman-Flower, 1955-56
Bronze (unique)
H. 11.12 in /28.3 cm

517
Awakening, 1955-56
Bronze (unique)
H. 8.87 in /22.5 cm

518
Precious Bundle, 1955-56
Bronze (unique)
H. 11.75 in /29.9 cm

519
Dancer, 1955-56
Bronze (unique)
H. 16.25 in /41.3 cm

520
Remembrance of Loie Fuller, 1955-56
Bronze (unique)
H. 10 in /25.4 cm

521
Two Sisters, 1955-56
Bronze (unique)
H. 9 in /22.9 cm

522
Exotic Dancer, 1955-56
Bronze (unique)
H. 9.5 in /24.1 cm

523
Mother and Child on Sofa, 1955-56
Bronze (unique)
L. 8.75 in /22.2 cm

524
The Lady with Camellias, 1955-56
Bronze (unique)
H. 13 in /33.0 cm

525
Dervish, 1955-56
Bronze (unique)
H. 16.75 in /42.6 cm

526
Hagar and the Angel, 1955-56
Bronze (unique)
H. 14.5 in /36.8 cm

527
Only Inspiration, 1955-56
Bronze (unique)
L. 9 in /22.9 cm

528
Beggar Selling Flowers, 1955-56
Bronze (unique)
H. 14.5 in /36.8 cm
Hirshhorn Museum and Sculpture Garden,
Smithsonian Institution, Washington, D.C.

529
Head of Harlequin, 1955-56
Bronze (unique)
H. 12 in /30.5 cm

530
Here are the Fruits and the Flowers, 1955-56
Bronze (unique)
H. 16.75 in /42.5 cm

531
Defense, 1955-56
Bronze (unique)
H. 13 in /33.0 cm

532
Mother and Child, 1955-56
Bronze (unique)
H. 11.75 in /29.9 cm

533
Mother and Child on Bench, 1955-56
Bronze (unique)
H. 10.75 in /27.3 cm

534
Reclining Figure, 1955-56
Bronze (unique)
L. 11.25 in /28.6 cm

535
The Prophet, c. 1955-56
Bronze (unique)
H. 12.5 in /31.8 cm

536
Woman with Swirling Robes (author's title), c. 1955-56
Bronze (unique)
H. 11 in /27.9 cm

537
Standing Figure (author's title), c. 1955-56
Bronze (unique)
unknown
There is no information on the back of this photograph.

538
Figure with Drapery (author's title), c. 1955-56
Bronze (unique)
H. unknown
There is no information on the back of this photograph.

539
Head (author's title), c. 1955-56
Bronze (unique)
H. unknown
There is no information on the back of this photograph.

540
Upright Form I (author's title), c. 1955-56
Bronze (probably unique)
H. 19.62 in /49.9 cm
There is no information on the back of this photograph. The author measured this bronze cast.

541
Upright Form II (author's title), c. 1955-56
Bronze (probably unique)
H. unknown
There is no information on the back of this photograph.

542
The Lock: Design for Yale Locksmiths, n.d.
Bronze, edition unknown
Dimensions unknown

543
Sketch of Mrs. John Cowles, 1956
Bronze, edition unknown
H. 13 in /33.0 cm

544
Head of Mrs. John Cowles, 1956
Bronze, edition of 5
H. 17 in /43.2 cm
Minneapolis Institute of Arts; Smith College
Museum of Art, Northampton, Massachusetts; Des
Moines Art Center, Des Moines, Iowa

545
Head of Mr. John Cowles, 1956
Bronze, edition of 5
H. 17 in /43.2 cm
Minneapolis Institute of Arts; Des Moines Art
Center, Des Moines, Iowa

546
Sketch for Yulla Lipchitz, 1956
Bronze, edition of 7
H. 12.12 in /30.8 cm

547
Portrait of Yulla Lipchitz, c. 1956
Bronze, edition unknown
H. 14.75 in /37.5 cm

548
Between Heaven and Earth I, 1958
Bronze, edition of 3
H. 46 in /116.8 cm

549
Between Heaven and Earth II, 1958
Bronze, edition of 3
H. 45 in /114.3 cm

550
Between Heaven and Earth III, 1958
Bronze, edition of 3
H. 46 in /116.8 cm

551
Sketch for the Gates of the Roofless Church, 1958
Bronze (unique)
17 x 20.75 in /43.2 x 52.7 cm

552
Gates Leading to Philip Johnson's Roofless Church, 1958
Bronze (unique)
New Harmony, Indiana

553
Freedom, 1958
Bronze (unique)
H. 26 in /66.0 cm

554
Japanese Basket, 1958
Bronze (unique)
H. 20 in /50.8 cm
Art Gallery of Ontario, Toronto

555
Carnival, 1958
Bronze (unique)
H. 17.75 in /45.1 cm

556
The Artichokes, 1958
Bronze (unique)
H. 19.5 in /49.5 cm

557
Miraculous Catch, 1958
Bronze (unique)
H. 22 in /55.9

558
Galapagos I, 1958
Bronze (unique)
H. 19.5 in./49.5 cm

559
Galapagos II, 1958
Bronze (unique)
H. 19.5 in /49.5 cm

560
Galapagos III, 1958
Bronze (unique)
H. 16.87 in /42.9 cm

561
Oceanide, 1958
Bronze (unique)
H. 25 in /63.5 cm

562
Marvelous Capture, 1958
Bronze (unique)
H. 18 in /45.7 cm

563
The Nest, 1958
Bronze (unique)
H. 27 in /68.6 cm

564
The Bone, 1958-59
Bronze (unique)
H. 26 in /66.0 cm

565
Enchanted Flute, 1959
Bronze (unique)
H. 35 in /88.9 cm

566
Abundance, 1959
Bronze (unique)
H. 20.5 in /52.1 cm

567
Portrait of Zalman Schocken, c. 1959
Bronze, edition unknown
H. 14.56 in /37.50 cm
Israel Museum, Jerusalem

568
Portrait of R. Sturgis Ingersoll, 1960
Bronze, edition unknown
H. 17 in /43.2 cm
Philadelphia Museum of Art

569
Memorial Bust of Senator Robert Alphonso Taft, c. 1961
Bronze (unique)
H. approx. 4 ft /121.9 cm
Cincinnati Art Museum, Lent by the Thomas M. Emery Memorial Foundation

570
Study for Lesson of a Disaster, 1961
Bronze, edition unknown
H. 26.5 in /67.3 cm

571
Working Model for Lesson of a Disaster, 1961-70
Bronze, edition of 7
H. 71 in /180.3 cm

572
Lesson of a Disaster, 1961-70
Bronze, edition of 7
H. 139 in./353.3 cm

573
Study for Our Tree of Life
(also known as *The Sacrifice of Abraham*), 1962
Bronze, edition of 7
H. 15.62 in /39.0 cm
Israel Museum, Jerusalem

574
Study for Our Tree of Life, 1962
Bronze, edition of 7
H. 33.5 in /85.1 cm

575
The Cup of Atonement, 1962
Bronze, edition of 7 + 1
H. 11.87 in /30.2 cm

576
The Day After Viareggio, 1962
Bronze, edition of 7 + 1
H. 6.87 in /17.5 cm

577
The Olive Branch, 1962
Bronze, edition of 7 + 1
H. 8.62 in /21.9 cm

578
Memory of Barga, 1962
Bronze, edition of 7 + 1
L. 8.75 in, included base/22.2 cm

579
The Tower and its Shadow, 1962
Bronze, edition of 7 + 1
H. 11.25 in /28.6 cm

580
Homage to Etruria, 1962
Bronze, edition of 7 + 1
Diameter 21 in /53.3 cm

581
Head, 1962
Bronze, edition of 7 + 1
H. 8.75 in /22.2 cm

582
Fountain of the Dragon, 1962
Bronze, edition of 7 + 1
H. 10.75 in /27.3 cm

583
Homage to the Renaissance, 1962
Bronze, edition of 7 + 1
H. 8.75 in /22.2 cm

584
Fountain, 1962
Bronze, edition of 7 + 1
H. 14.75 in /37.5 cm

585
The Bull, 1962
Bronze, edition of 7 + 1
L. 9.75 in /24.8 cm

586
The Beautiful One, 1962
Bronze, edition of 7 + 1
H. 12.5 in /31.7 cm

587
Head of an Old Man, 1962
Bronze, edition of 7 + 1
H. 9.5 in /24.1 cm

588
Chapel in the Mountain, 1962
Bronze, edition of 7 + 1
H. 9.25 in /23.5 cm

589
On the Beach, 1962
Bronze, edition of 7 + 1
L. 14.5 in./36.8 cm

590
The Flame, 1962
Bronze, edition of 7 + 1
H. 16.75 in /42.6 cm

591
Happy Birthday, 1962
Bronze, probably unique
H. 16 in /40.6 cm

592
The Schechoth, 1962
Bronze, edition of 7 + 1
H. 14.5 in /36.8 cm

593
The Prophet, 1962
Bronze, edition of 7 + 1
H. 14.5 in /36.8 cm

594
Memory of Rabat, 1963
Bronze, edition of 7 + 1
H. 14.5 in /36.8 cm

595
The Geisha, 1963
Bronze, edition of 7 + 1
H. 13.5 in /34.3 cm

596
Head of Harlequin, 1963
Bronze, edition of 7 + 1
H. 10.75 in /27.3 cm

597
Head of a Woman, 1963
Bronze, edition of 7 + 1
H. 17.75 in /45.1 cm

598
Woman with Comb, 1963
Bronze, edition of 7 + 1
H. 11.62 in /29.5 cm

599
Variation on the Schechoth, c. 1963
Bronze, edition unknown
H. 8.25 in /21.0 cm

600
Variation on the Beautiful One, c. 1963
Bronze, probably unique
H. 11 in /21.0 cm

601
Variation on Chapel in the Mountains, c. 1963
Bronze, edition of 7
H. 9.37 in./23.8 cm

602
Portrait of Jules Stein, 1963
Bronze, edition unknown
H. unknown

603
Sketch for the Monument for du Luth I, 1963
Bronze, edition of 7
H. 15.25 in /38.7 cm
Tweed Museum of Art, University of Minnesota,
Duluth

604
Sketch for the Monument for du Luth II, 1963
Bronze, edition of 7
H. 22.37 in /56.8 cm

605
Sketch for the Monument for du Luth III, 1963
Bronze, edition of 7
H. 22.67 in /57.5 cm

606
Sketch for the Monument for du Luth IV, 1963
Bronze
H. 22.62 in /57.5 cm

607
Sketch for the Monument for du Luth V (Giuliano),
1963
Bronze, edition of 7
H. 28.25 in /71.8 cm

608
Working Model for the Monument for du Luth, 1963
Bronze, edition of 7
H. 33 in /83.8 cm
Tweed Museum of Art, University of Minnesota,
Duluth

609
Daniel Greysolon, Sieur du Luth, 1964-65
Bronze (unique)
H. 9 ft/2.7 m
Tweed Museum of Art, University of Minnesota,
Duluth

610
Sword of du Luth, 1964
Bronze, edition of 7
H. 42.5 in /107.9 cm
Museo de Arte Contemporáneo de Caracas

611
Sketch for John F. Kennedy, 1964
Bronze, edition of 21
H. 17.75 in /45.1 cm

612
John F. Kennedy, 1964-65
Bronze (unique)
H. 31 in /78.8 cm
International Students House, London

613
John F. Kennedy, 1964-65
Bronze (unique)
H. approx. 30 in /76 cm
Military Park, Newark, New Jersey

614
President Lyndon Baines Johnson Award Medal,
c. 1964
Bronze
Diameter 3.5 in /8.8 cm

615
Sketch for Bellerophon Taming Pegasus I, 1964
Bronze, edition of 7
H. 19.5 in /49.5 cm

616
Sketch for Bellerophon Taming Pegasus II, 1964
Bronze, edition of 7
H. 20 in /50.8 cm

617
Sketch for Bellerophon Taming Pegasus III, 1964
Bronze, edition of 7
H. 19.75 in /50.2 cm

618
Sketch for Bellerophon Taming Pegasus IV, 1964
Bronze, edition of 7
H. 20.5 in /52.1 cm

619
Sketch for Bellerophon Taming Pegasus V, 1964
Bronze, edition of 7
H. 19.25 in /48.9 cm

620
Sketch for Bellerophon Taming Pegasus VI, 1964
Bronze, edition of 7
H. 19.25 in /48.9 cm

621
Study for Bellerophon Taming Pegasus, 1964
Bronze, edition of 7
H. 59 in /149.8 cm

622
Bellerophon Taming Pegasus: Large Version, 1964
Bronze, edition of 2
H. approx. 12 ft /365.76 cm

623
Bellerophon Taming Pegasus, 1964-73
Bronze (unique)
H. approx. 38 ft /11.4 m
Columbia University in the City of New York, Gift
of the Alumni to the Law School, 1977

624
Don Quixote, 1966
Bronze, probably unique
H. 15.5 in /39.4 cm

625
Portrait of Albert Skira, 1966
Bronze, edition of 7
H. 16.12 in /41.0 cm

626
Portrait of Samuel D. Leidesdorf, 1966
Bronze, edition unknown
H. 15 in /38.1 cm

627
Portrait of Dr. A. Courant, n.d.
Bronze, edition unknown
H. 14.5 in /36.8 cm

628
Portrait of J. Kaplan, n.d.
Bronze, edition unknown
H. unknown

629
Portrait of Freddy Hamburger, n.d.
Bronze, edition unknown
H. unknown

630
Head of a Man I, n.d.
Bronze, edition unknown
H. unknown

631
Head of a Man II, n.d.
Bronze, edition of 7
H. 15.25 in /38.7 cm

632
Head of a Man III, n.d.
Bronze, edition of 7
H. 14.25 in /36.2 cm

633
Head of a Man IV, n.d.
Bronze, edition unknown
H. 13.62 in /34.6 cm

634
Head of a Man V, n.d.
Bronze, edition unknown
H. 14.37 in /36.5 cm

635
Head of a Man VI, n.d.
Bronze, edition unknown
H. 18.5 in /47.0 cm

636
Head of a Man VII, n.d.
Bronze, edition unknown
H. 16.37 in /41.6 cm

637
Head of a Man VIII, n.d.
Bronze, edition unknown
H. 13 in /33.0 cm

638
Head of a Man IX, n.d.
Bronze, edition unknown
H. 12 in /30.5 cm

639
Head of a Man X, n.d.
Bronze, edition unknown
H. 11.25 in /28.6 cm

640
Head of a Man XI, n.d.
Bronze, edition of 2 (?)
H. 13.56 in /34.5 cm

641
Head of a Man XII, n.d.
Bronze, edition unknown
H. 18.5 in /47.0 cm

642
Head of a Man XIII, n.d.
Bronze, edition unknown
H. 12 in /30.5 cm

643
Head of a Man XIV, n.d.
Bronze, edition unknown
H. 12 in /30.5 cm

644
Negev Sponsor Pin, 1967
Metal with turquoise stone
2 x 2 in /5.1 x 5.1 cm
Jewish Museum, New York

645
Chai Sponsor Pin, 1967
Metal with diamond-like stone
2 x 2 in /5.1 x 5.1 cm
Jewish Museum, New York

646
Sponsor Pin, 1968
Metal
1.87 x 2 in /4.8 x 5.1 cm
Jewish Museum, New York

647
Negev Sponsor Pin, 1968
Metal with turquoise stone
1.87 x 2 in /4.8 x 5.1 cm
Jewish Museum, New York

648
20th Anniversary Sponsor Pin, 1968
Metal with diamond-like stone
1.87 x 2 in /4.8 x 5.1 cm
Jewish Museum, New York

649
Sponsor Pin, 1970
Metal
2.75 x 2.25 in /7.0 x 5.7 cm
Jewish Museum, New York

650
Jerusalem Sponsor Pin, 1970
Metal with diamond-like stone
2.75 x 2.25 in /7.0 x 5.7 cm
Jewish Museum, New York

651
Sponsor Pin, 1971
Metal
2.25 x 2 in /5.7 x 5.1 cm
Jewish Museum, New York

652
Jerusalem Sponsor Pin, 1971
Metal with diamond-like stone
2.25 x 2 in /5.7 x 5.1 cm
Jewish Museum, New York

653
Golden Sponsor Pin, 1971
Metal with three ruby-like stones
2.25 x 2 in /5.7 x 5.1 cm
Jewish Museum, New York

654
Jerusalem Foundation Award Medal, n.d.
Bronze
Diameter 3.5 in /8.8 cm
Jewish Museum, New York

655
Lamentation, 1967
Bronze, edition of 7
H. 20.25 in /51.4 cm

656
L'Arno Furioso, 1967
Bronze, edition of 7
H. 11 in /27.9 cm

657
Le Ponte Vecchio, 1967
Bronze, edition of 7
H. 12 in /30.5 cm

658
Fleur pour Florence douloureuse, 1967
Bronze, edition of 7
H. 16.25 in /41.3 cm

659
First Study for Government of the People, 1967
Bronze, edition of 7
H. 16.5 in /41.9 cm
Philadelphia Museum of Art

660
Working Model for Government of the People, 1967
Bronze, edition of 7
H. 48.5 in /123.2 cm

661
Government of the People, 1967-1970
Bronze (unique)
H. 35 ft /10.5 m
Municipal Plaza, Philadelphia

662
First Study for Peace on Earth, 1967
Bronze, edition of 15
H. 10.25 in /26.0 cm
Israel Museum, Jerusalem

663
Peace on Earth, 1967-69
Bronze, edition of 7
H. 135 in /360.0 cm
Hastings-on-Hudson, New York; Nelson-Atkins
Museum of Art, Kansas City, Missouri

664
Peace on Earth, 1967-69
Bronze (unique)
H. approx. 29 ft /8.7 m
The Music Center of Los Angeles County, Los
Angeles, California

665
Peace on Earth, 1969-70
Marble (unique)
H. 169.25 in /430.0 cm
Photograph unavailable. Galerie Nazionale d'Arte
Moderna e Contemporaneo di Roma.

666
Samson Fighting the Lion, 1968
Bronze, edition of 200 + 12 artist's
copies numbered in roman numerals
H. 8.5 in /21.6 cm

667
Remembrance Medal (Prayer for the Peace of Jerusalem), 1969
Bronze (unique)
20.87 x 16.5 in /53.0 x 42.0 cm

668
Hagar, 1969
Marble (unique)
H. 36.25 in /92.1 cm

669
Hagar in the Desert, 1969
Bronze, edition of 7
L. 70.5 in /179.0 cm
Jewish Museum San Francisco, California; Tel Aviv
Museum of Art

670
Variation of the Rape of Europa A, 1969-70
Bronze, edition of 7
H. 15.75 in /40.0 cm

671
Variation of the Rape of Europa B, 1969-70
Bronze, edition of 7
H. 20.68 in /52.5 cm

672
Variation of the Rape of Europa C, 1969-70
Bronze, edition of 7
H. 17.87 in /45.5 cm

673
Variation of the Rape of Europa D, 1969-70
Bronze, edition of 7
H. 13.62 in /34.5 cm

674
Variation of the Rape of Europa E, 1969-70
Bronze, edition of 7
H. 18.5 in /47.0 cm

675
Variation of the Rape of Europa F, 1969-70
Bronze, edition of 7
H. 18.5 in /47.0 cm

676
Variation of the Rape of Europa G, 1969-70
Bronze, edition of 7
H. 19.31 in /49.0 cm

677
Rape of Europa, 1969-70
Bronze, edition of 7
H. 38.75 in /98.4 cm

678
Rape of Europa, 1969-70
Marble (unique)
H. 41 in /104.1 cm

679
Rape of Europa, 1969-70
Marble (unique)
H. 20 in /50.8 cm

680
Small Study for the Rape of Europa, 1969-70
Bronze, edition of 7
L. 4.25 in /10.8 cm

681
Small Study for the Rape of Europa, 1969-70
Bronze, edition of 7
H. 4.87 in /12.4 cm

682
Small Study for the Rape of Europa on Column I,
1969-70
Bronze, edition of 7
H. 8.25 in /20.9 cm

683
Small Study for the Rape of Europa on Column II,
1969-70
Bronze, edition of 7
H. 8.87 in /22.5 cm

684
Variation on the Theme of the Rape of Europa I,
1969-72
Bronze, edition of 7
H. 4.31 in /11 cm

685
Variation on the Theme of the Rape of Europa II,
1969-72
Bronze, edition of 7
H. 6.5 in /16.5 cm

686
Variation on the Theme of the Rape of Europa III,
1969-72
Bronze, edition unknown
H. 7.5 in /19.0 cm

687
Variation on the Theme of the Rape of Europa IV,
1969-72
Bronze, edition of 7
H. 8.87 in /22.5 cm

688
Variation on the Theme of the Rape of Europa V,
1969-72
Bronze, edition of 7
H. 8.93 in /22.7 cm

689
Variation on the Theme of the Rape of Europa VI,
1969-72
Bronze, edition of 7
H. 8.93 in /22.7 cm

690
Variation on the Theme of the Rape of Europa VII,
1969-72
Bronze, edition of 7
H. 9.06 in /23.0 cm

691
Variation on the Theme of the Rape of Europa VIII,
1969-72
Bronze, edition of 7
H. 9.12 in /23.2 cm

692
Variation on the Theme of the Rape of Europa IX,
1969-72
Bronze, edition of 7
H. 9.31 in /23.7 cm

693
Variation on the Theme of the Rape of Europa X,
1969-72
Bronze, edition of 7
H. 9.43 in /24.0 cm

694
Variation on the Theme of the Rape of Europa XI,
1969-72
Bronze, edition of 7
H. 9.56 in /24.2 cm

695
Variation on the Theme of the Rape of Europa XII,
1969-72
Bronze, edition of 7
H. 10.06 in /25.5 cm

696
Variation on the Theme of the Last Embrace I, 1970-72
Bronze, edition of 7
L. 4.5 in /11.4 cm

697
Variation on the Theme of the Last Embrace II,
1970-72
Bronze, edition of 7
L. 6.68 in /17.0 cm

698
Variation on the Theme of the Last Embrace III,
1970-72
Bronze, edition of 7
L. 7.93 in /19.9 cm

699
Variation on the Theme of the Last Embrace IV,
1970-72
Bronze, edition of 7
L. 7.25 in /18.4 cm

700
Variation on the Theme of the Last Embrace V, 1970-72
Bronze, edition of 7
L. 7.25 in /18.4 cm

701
*Untitled (Variation on the Theme of the Last
Embrace?)*, c. 1970-72
Bronze, edition of 7
L. 6.37 in /16.2 cm

702
*Untitled (Variation on the Theme of the Last
Embrace?)*, c. 1970-72
Bronze, edition unknown
H. 8.43 in /21.5 cm

703
*Variation on the Theme of the Last Embrace
(Salvataggio) I*, 1970-72
Bronze, edition unknown
L. 9.87 in /25.0 cm

704
*Variation on the Theme of the Last Embrace
(Salvataggio) II*, 1970-72
Bronze, edition of 7
L. 10.5 in (with base)/26.7 cm

705
*Variation on the Theme of the Last Embrace
(Salvataggio) III*, 1970-72
Bronze, edition of 7
L. 11.81 in (with base)/30.0 cm

706
*Variation on the Theme of the Last Embrace
(Salvataggio) IV*, 1970-72
Bronze, edition of 7
L. 12 in (with base)/30.5 cm

707
The Last Embrace (Salvataggio), 1971
Marble (unique)
H. 26 in /66.0 cm

708
Study for the Last Embrace: Maquette No. 1, 1970-72
Bronze, edition of 7
L. 5.87 in /15.0 cm

709
Study for the Last Embrace: Maquette No. 2, 1970-72
Bronze, edition of 7
L. 8.25 in /21.0 cm

710
Study for the Last Embrace: Maquette No. 3, 1970-72
Bronze, edition of 7
L. 15.5 in /39.4 cm

711
The Last Embrace, 1970-71
Bronze, edition of 7
L. 41 in /104.1 cm

712
Homage to Dürer, 1970
Bronze, edition of 7
L. 16 in /40.6 cm

713
The First Meeting (La première rencontre), 1970-71
Bronze, edition of 7
H. 17.5 in /44.5 cm

714
L'emmelé, 1970-71
Bronze, edition of 7
H. 15.5 in /39.4 cm

715
Pierrot, 1970-71
Bronze, edition of 7
H. 14.75 in /37.5 cm

716
La rencontre, 1970-71
Bronze, edition of 7
H. 16.56 in /42.0 cm

717
Harlequin, 1970-71
Bronze, edition of 7
H. 15.37 in /39.1 cm

718
Columbine, 1971
Bronze, edition of 7
H. 20.37 in /51.8 cm

719
The Death of a Harlequin (Le Mort de Harlequin), 1971
Bronze, edition of 7
L. 17.75 in /45.1 cm

720
Untitled, c. 1970-71
Bronze, edition unknown
H. 24.5 in /62.2 cm

721
Hagar, 1971
Stone (unique)
H. 72 in /182.9 cm

722
Homage to Arcimboldo, 1971
Bronze (unique)
H. 21.5 in /54.6 cm

723
Fleure solitaire, 1971
Bronze (unique)
H. 11.87 in /30.2 cm

724
La belle I, 1971
Bronze (unique)
H. 12.25 in /31.1 cm

725
La belle II, 1971
Bronze (unique)
H. 12.5 in /31.8 cm

726
La belle III, 1971
Bronze (unique)
H. 12.12 in /30.8 cm

727
La belle IV, 1971
Bronze (unique)
H. 11.62 in /29.5 cm

728
La belle V, 1971
Bronze (unique)
H. 11.62 in /29.5 cm

729
La belle VI, 1971
Bronze (unique)
H. 10.5 in /26.7 cm

730
La belle VII, 1971
Bronze (unique)
H. 11.5 in /29.2 cm

731
La belle VIII, 1971
Bronze (unique)
H. 11.75 in /29.8 cm

732
La belle IX, 1971
Bronze (unique)
H. 12.25 in /31.1 cm

733
La danse érotique, 1971
Bronze (unique)
H. 17.75 in /45.1 cm

734
Le grand tumulte, 1971
Bronze (unique)
H. 20.75 in /52.7 cm

735
La sauvageonne, 1971
Bronze (unique)
H. 14.37 in /36.5 cm

736
L'Amazone, 1971
Bronze (unique)
H. 12.75 in /32.4 cm

737
Le bon pasteur, 1971
Bronze (unique)
H. 11.75 in /29.8 cm

738
Sketch for Our Tree of Life I, 1971-72
Bronze, edition of 7
H. 4.5 in /11.5 cm

739
Sketch for Our Tree of Life II, 1971-72
Bronze, edition of 7
H. 9.25 in /23.5 cm

740
Sketch for Our Tree of Life III, 1971-72
Bronze, edition of 7
H. 11.75 in /29.9 cm

741
Sketch for Our Tree of Life IV, 1971-72
Bronze, edition of 7
H. 18.5 in /47.0 cm

742
Sketch for Our Tree of Life V, 1971-72
Bronze, edition of 7
H. 20.5 in /52.1 cm

743
Sketch for Our Tree of Life VI, 1971-72
Bronze, edition of 7
H. 23 in /58.4 cm

744
Sketch for Our Tree of Life VII, 1971-72
Bronze, edition of 7
H. 21.37 in /54.3 cm

745
Sketch for Our Tree of Life VIII, 1971-72
Bronze, edition of 7
H. 25.87 in /65.7 cm

746
Sketch for Our Tree of Life IX, 1971-72
Bronze, edition of 7
H. 31.5 in /80.0 cm

747
Our Tree of Life, 1973-78
Bronze (unique)
H. 20 ft /6 m
Hadassah University Hospital, Mount Scopus, Jerusalem. Yulla Lipchitz, the sculptor's widow, enlarged this sculpture, based on the definitive plaster study for *Our Tree of Life*, which Lipchitz completed shortly before his death on May 27, 1973. The sculpture was installed on Mount Scopus in 1978.

CHRONOLOGY

Written and edited by Mary Morris, Marlborough Gallery, New York, revised by Alan G. Wilkinson.

1891 Chaim Jacob Lipchitz born on August 22, in Druskieniki, Lithuania. He is the first of six children to Abraham Lipchitz, a young building contractor, and Rachael Leah Krinsky.

1902-6 Draws and models in clay. Attends commercial school in Bialystok.

1906-9 Attends high school in Vilna.

1909 Determined to go to Paris, he arrives in October with the financial assistance of his mother but without his father's consent.

1909-10 Studies with Jean-Antoine Ingalbert at the École des Beaux-Arts as a "free pupil." Father reconciles with the artist and provides a generous allowance. He then transfers to the Académie Julian and attends sculpture classes of Raoul Verlet. Spends mornings drawing or modeling from the figure and in the afternoons visits the Louvre and other museums. Attends evening drawing classes at the Académie Calarossi. Begins collecting tribal sculpture and the art of other cultures.

1911 Settles and works in Montparnasse. Works in various sculptural media but concentrates primarily on modeling in clay for casting in bronze. After learning of his father's financial difficulties, he returns home to assist the family.

1912 He is drafted into the Russian military but is discharged owing to illness. On return to Paris, he accepts an opportunity to visit the Hermitage in St. Petersburg and is greatly inspired by the paintings and by the collection of Scythian art. He moves into a studio in Montparnasse, next door to Brancusi. The next few years are difficult as his father can no longer support him financially. Visits the Italian Futurist exhibitions in Paris.

1913 Receives praise for *Woman and Gazelles* exhibited at the Salon d'Automne. Meets Picasso and other Cubist painters through Diego Rivera. Creates his first proto-Cubist sculptures. Attends the infamous premiere of Igor Stravinsky's *The Rite of Spring*.

1914 Takes a trip to Spain with Diego Rivera and friends. At the Prado in Madrid, he is impressed by the work of Tintoretto, Rubens, El Greco, Goya and Velázquez. He goes to the island of Mallorca where he rests and recovers from previous health problems. Influenced by Mediterranean life, he creates the sculptures *Sailor with Guitar, Toreador,* and *Girl with Braid.* After the outbreak of the first World War, he returns to Paris in December. Introduces his friend Chaim Soutine to Amedeo Modigliani.

1915 Meets and lives with poet Berthe Kitrosser whom he later marries. Creates his first

mature Cubist work. He constructs a series of wood sculptures known as detachable figures.

1916 Amedeo Modigliani, a friend of the artist, paints a wedding portrait of Lipchitz and his wife Berthe, now in the Art Institute of Chicago. Signs a contract with the dealer Léonce Rosenberg who gives him a monthly stipend. Becomes a close friend of Juan Gris.

1918 Leaves Paris in the spring with Berthe and Josette and Juan Gris, when the city is threatened by German bombing. They stay in the Touraine village of Beaulieu-lès-Loches. Since materials for sculpture are not available, he spends his time making drawings and gouaches for a series of bas reliefs. Experiments with carved polychrome reliefs. Returns to Paris with his wife in the autumn.

1920 Executes portraits of Jean Cocteau, Raymond Radiguet, and Gertrude Stein. First one-man exhibition at Léonce Rosenberg's Galerie de l'Effort Moderne in Paris. He subsequently breaks his contract with Rosenberg to pursue a more independent style. With the help of his friends, he buys back his sculptures from Rosenberg. Maurice Raynal publishes the first monograph on the artist.

1921 Works on portraits of Coco Chanel and other commissions for her house and garden. The curvilinear forms of the andirons for her house were to have a pivotal influence on the direction of artist's work.

1922 Dr. Albert C. Barnes visits the artist in Paris and purchases several sculptures from the studio and commissions stone reliefs for the façade of his mansion at Merion, Pennsylvania (now the Barnes Foundation). Lipchitz introduces Dr. Barnes to Soutine and Modigliani.

1923 Continues to work on commissions for Dr. Barnes, as well as the monumental free-standing bronze *Bather* (1923-25).

1924 Becomes a French citizen.

1925 Moves to the Parisian suburb of Boulogne-sur-Seine, into a house designed by Le Corbusier. Begins to sculpt a series of works called "transparents," made of cardboard and wax, then cast in bronze. Through his work, he resolves technical difficulties of casting the pronounced negative space and delicate forms. His work anticipates the welded sculpture by Pablo Picasso and Julio Gonzáles of the late 1920s and 1930s.

1926 Joins the gallery of Jeanne Bucher. Spends the summer in Ploumanach, a resort on the Brittany coast, creating a new series of works influenced by the rock formations off the shore. Produces preparatory clay sketches for the sculpture *Figure* (1926-1930) which is enlarged at the request of Madame Tachard.

1927 Executes the sculpture *Joy of Life* for the garden of the Vicomte Charles de Noailles at Hyères near Toulon. The openness of the sculpture summarizes the artist's Cubist efforts of the last few years.

1928 Attends concerts in the Salle Pleyel in Paris. The experience is later seen in *The Harpists* (1930), a composite sculpture of the series of transparents. Reacting to the deaths of his father and sister, he begins *The Couple.* The title is later changed to *The Cry* as a result of the controversial subject of figures in the act of making love.

1930 First large retrospective exhibition of 100 works is held at Jean Bucher's Galerie de la Renaissance, Paris. The show is favorably received. Begins to explore biblical themes and the image of mother and child.

1931 Begins to explore for the first time the mythical character Prometheus. Becomes preoccupied with the biblical theme of Jacob struggling with the angel. Creates *Song of the Vowels* as a garden sculpture for Madame de Maudrot's home at Le Pradet, designed by Le Corbusier.

1934 Exhibits a large scale plaster of David and Goliath at the Salon des Indépendants, Paris. His mother dies.

1935 From August through October, he takes a trip to Russia to visit family. The artist has his first important exhibition in the United States, held at the Brummer Gallery, New York, but is unable to attend.

1936-37 The French government commissions him to create a monumental plaster sculpture *(Prometheus Strangling the Vulture)* for the entrance to the Science Pavilion at the Paris World's Fair, the same exposition where Picasso's *Guernica* and Gonzáles' *Monserrat* are shown in the Spanish Pavilion. A room is devoted to his sculptures at "Les Maîtres de L'Art Indépendant" in the Petit Palais at which he is awarded the Gold Medal. At the close of the Fair, the plaster sculpture of *Prometheus Strangling the Vulture* is destroyed.

1938 Renews acquaintance with Gertrude Stein and produces two bronze portraits. Makes two versions of the *Rape of Europa.*

1940 During the first year of the Second World War, he produces *The Flight* and many drawings. In May he flees with Berthe to Toulouse when the Germans occupy Paris.

1941 He seeks asylum in the United States and with the help of his American friends, he arrives in New York on June 13. Joseph Brummer, now exclusively dealing in antiques, introduces the artist to Curt Valentin of the Buchholz Gallery. Mr. Valentin, who becomes his New York dealer, immediately begins to sell his work. He rents a studio in New York City on Washington Square South.

1942 Begins to exhibit regularly at the Buchholz Gallery. He continues to live at Washington Square South but also rents a studio overlooking Madison Square at 2 East 23rd Street. Starts to cast with the Modern Art Foundry in Long Island City, New York.

1944 Completes a large plaster of *Prometheus Strangling the Vulture* for the Ministry of Health and Education, Rio de Janeiro. Meets sculptor Yulla Halberstadt.

1946 Returns to Paris in the spring for the first time since the beginning of the war. Exhibits at Galerie Maeght in Paris. He is made Chevalier de la Légion d'Honneur by the French government. Father Couturier commissions a baptismal font *(Notre Dame de Liesse)* for the Catholic Church of Notre Dame de Toute Grâce at Assy, Haute-Savoie, France. After seven months in France, Lipchitz decides to return permanently to the United States. Berthe remains in France, and they are divorced soon after.

1948 Marries Yulla Halberstadt. His only child, Lolya Rachel, is born.

1949 Moves his residence to Hastings-on-Hudson, New York. Begins a series of studies for the church of Notre Dame de Toute Grâce at Assy.

1950 Creates preliminary studies and large relief sculpture entitled *The Birth of the Muses* for the townhouse of Mrs. John D. Rockefeller III.

1951 An exhibition on the relief *The Birth of the Muses* (1950) is organized by The Museum of Modern Art, New York, and is then installed at the Rockfellers' house. An exhibition of 25 sculptures and 28 drawings is organized by the Portland Art Museum, Oregon, which later travels to the San Francisco Art Museum and the Cincinnati Art Museum.

1952 On January 5, a fire in his 23rd Street studio destroys many works, including the commission for Notre Dame de Toute Grâce and Fairmont Park. He works in a temporary studio at the Modern Art Foundry, Long Island City. Exhibits 22 sculptures at the XXVIth Venice Biennale in the French Pavilion. Receives George D. Widener Memorial Gold Medal award from Pennsylvania Academy of Arts, Philadelphia for *Prometheus Strangling the Vulture* (1944-53).

1953 Begins work in newly built studio within walking distance of his Hastings-on-Hudson home. Creates *Virgin in Flames*.

1954 In New York, a retrospective exhibition is held at The Museum of Modern Art in cooperation with the Walker Art Center, Minneapolis, and the Cleveland Museum of Art.

1955 *Notre Dame de Liesse* is completed for Notre Dame de Toute Grâce at Assy.

1956 Receives Alfred G.B. Steel Award from Pennsylvania Academy of Arts for *Mother and Child* (1949-54).

1957 In New York, he exhibits his new series of semi-automatic sculptures at Fine Arts Associates. The exhibition is a series of small ambimorphic bronzes spontaneously created in wax under water. He continues the inventive semi-automatic series *(A la Limite du possible / To the Limit of the Possible)* the following year, adding found objects to wax forms.

1958 Receives Creative Arts Award from Brandeis University. Designs ornamental gates for Philip Johnson's Roofless Church in New Harmony, Indiana, which houses a second cast of *Notre Dame de Liesse*. A large traveling exhibition is organized in Europe by the Stedelijk Museum, Amsterdam, which continues on to major museums in Otterlo, Basel, Dortmund, Brussels, and London. He becomes a citizen of the United States. A serious illness interrupts his work for several months.

1960 A retrospective exhibition of 42 sculptures and numerous drawings is shown at the Corcoran Gallery of Art, Washington, D.C., and the Baltimore Museum of Art.

1961-62 He begins to be represented by the Otto Gerson Gallery, New York (later the Marlborough-Gerson and presently the Marlborough Gallery, Inc.). A retrospective exhibition of 72 sculptures is shown at the Gerson Gallery which later travels to the White Museum of Art, Cornell University, Ithaca, New York. Receives a commission for a monument to Daniel Greysolon, Sieur du Luth, the 17th-century French explorer. The monumental sculpture is made possible by the bequest of Albert L. Ordeans in co-operation with the City of Duluth, Minnesota, and is placed in 1965 on the campus of the University of Minnesota, near the Tweed Museum of Art, Duluth. Visits Italy and begins working at the Tommasi Foundry, Pietrasanta, near Carrara. He spends subsequent summers in Italy. Begins the series of 24 sculptures entitled *Images of Italy*.

1963 Travels for the first time to Israel. Comprehensive retrospective exhibition selected by the artist tours throughout the United States, starting at the University of California at Los Angeles. The committee of the Los Angeles County Music Center commissions a monumental sculpture. The exhibition *157 Bronze Sketches, 1912-1962* opens at the Otto Gerson Gallery, and is then circulated by The Museum of Modern Art in the United States, and internationally to South America, Australia, and New Zealand.

1964 Exhibits *Between Heaven and Earth* (1958) at Documenta International, Kassel, and Carnegie International, Pittsburgh. A retrospective exhibition is shown at Boston University. The Phillips Collection, Washington, D.C., organizes an exhibition of Cubist sculptures and reliefs. President Johnson commissions him to design the medallion for the Presidential Scholar awards.

1965 Receives an award for cultural achievement from Boston University and is made an Honorary Doctor of Laws by the Jewish Theological Seminary in New York. In Military Park, Newark, New Jersey, he installs his portrait commission of John F. Kennedy. Additional bronzes are cast for the International Student's House, London, England, and for the Kennedy Memorial Library, Cambridge, Massachusetts.

1966 Marlborough-Gerson Gallery, New York, exhibits *Images from Italy*. Receives Gold Medal from the Academy of Arts and Letters, New York.

1967 A sculpture exhibition of the artist's biblical themes is presented at the Jewish Museum, New York. The artist presents the bronze sculpture *Between Heaven and Earth* (1958) to the village of Hastings-on-Hudson, New York.

1968 *Lipchitz: The Cubist Period, 1913-1930* is exhibited at Marlborough-Gerson Gallery, New York. He works on the casting of major sculptures in Pietrasanta, Italy, as well as at the Modern Art Foundry and Avnet Shaw Foundry, New York.

1969 Unveils the 45-foot high (13.7 m) bronze sculpture *Peace on Earth* at the Los Angeles County Music Center. Receives the Einstein Commemorative Award of Merit from the Medical Center of Yeshiva University, New York, and Medal of Achievement from American Institute of Architects.

1970 Retrospective exhibition is organized by the Neuer Berliner Kunstverein for the Nationalgalerie in Berlin, and then travels to Duisburg, Baden-Baden, and Vienna.

1971 The artist travels to Israel for the retrospective exhibit at the Tel Aviv Museum which inaugurates the new museum. The Israel Museum, Jerusalem, presents an exhibition in honor of the artist's 80th birthday and of the donation by his brother Rubin of 130 bronze sketches in memory of their parents. While Lipchitz is in Jerusalem, a site is chosen for *Our Tree of Life* on Mount Scopus. On his return from Israel, he begins work on the commissions for Columbia Law School *(Bellerophon Taming Pegasus)*, Municipal Plaza, Philadelphia *(Government of the People)* and Mount Scopus, Israel.

1972 Major exhibition is organized at the Metropolitan Museum of Art, New York, concurrent with the publication of his autobiography, *My Life in Sculpture*. The book is based on a series of taped interviews with Deborah Stott recorded between 1968 and 1970 in Italy.

1973 Completes the definitive maquette of *Our Tree of Life*. On May 27, the artist dies on the island of Capri and is later buried on Har Hamenuhot, Jerusalem. *A Tribute to Jacques Lipchitz in America 1941-73* is held at the Marlborough Gallery, New York, in November. As stipulated in his Will, none of the plaster or terracotta models is to be cast after his death, but instead they are to be given to the Jacques and Yulla Lipchitz Foundation for distribution to venerable institutions throughout the world.

1974 The first comprehensive exhibition of the sculptor's drawings opens at the Trisolini Gallery of Ohio University, Athens, Ohio, and travels to The Columbus Gallery of Fine Arts, Columbus, Ohio, and the Marlborough Gallery, New York.

1976-77 Cast before the artist's death, the bronzes of *Government of the People* and *Bellerophon Taming Pegasus* are installed by his widow.

1977 Marlborough Gallery, New York, presents *Sculpture and Drawings from the Cubist Epoch* which travels to Marlborough Fine Art, London, the following year.

1978 A retrospective collection of over 50 plaster and terracotta models are given by the Lipchitz Foundation to both the Centre Georges Pompidou, Paris, and the Kröller-Müller Museum, Otterlo. In fulfillment of the artist's dying wish and with the consent of the Hadassah University Hospital, Jerusalem, which commissioned the work, Yulla Lipchitz completes the enlargement of *Our Tree of Life* and supervises its installation on Mount Scopus.

1979 An exhibition of *Small Sculptures, Maquettes and Drawings, 1915-1972* is presented at the Marlborough Gallery, New York.

1981 Monumental sculpture exhibition is installed at the Marlborough Gallery, New York.

1982 After receiving a gift of plaster sculptures from the Lipchitz Foundation, the University of Arizona Museum of Art, Tucson, places the works on permanent display.

1985 An exhibition focusing on the artist as a sculptor and a collector of ancient and non-Western artifacts is presented at the List Visual Arts Center at Massachusetts Institute of Technology.

1986 The Tate Gallery, London, displays *The Lipchitz Gift,* an exhibition of 57 plaster and terracotta sculptures donated by the Lipchitz Foundation to the museum.

1989-91 A major retrospective exhibition is organized by Alan G. Wilkinson for the Art Gallery of Ontario, Toronto, Ontario, Canada, and travels to the Winnipeg Art Gallery, Manitoba, the Nelson-Atkins Museum of Art, Kansas City, Missouri, and the Jewish Museum, New York.

1991 Tel Aviv Museum of Art opens an exhibition of plaster models donated to the institution by the Lipchitz Foundation, coinciding with the anniversary of the artist's birth.

1993 Galería Marlborough, Madrid, presents the first exhibition of the artist's work in Spain followed by another exhibition at the Centro de Arte Palacio Almundi, Murcia.

1996 An exhibition of sculptures created during the Paris years, 1910-1940, is presented at the Marlborough Gallery, New York, March 13-April 13. Publication of *The Sculpture of Jacques Lipchitz - A Catalogue Raisonné, Volume One, The Paris Years 1910-1940,* London, Thames and Hudson, by Alan G. Wilkinson.

1997 Galería Marlborough, Madrid, presents an exhibition of sculptures from 1911-1971. *Lipchitz, un mundo sorprendido en el espacio,* opens at the Museo Nacional Centro de Arte Reina Sofía in Madrid in May. In September it travels to IVAM, Centro Julio González in Valencia.

1998 *Lipchitz dans les Jardins du Palais Royal* opens in Paris in May. The exhibition travels to Yorkshire Sculpture Park in September.

SELECTED EXHIBITIONS

1920 *Jacques Lipchitz,* Galerie de l'Effort Moderne (Léonce Rosenberg), Paris

1930 *Cent Sculptures par Jacques Lipchitz,* Galerie de la Renaissance (Jeanne Bucher), Paris, June 13-28

1935-36 *Jacques Lipchitz,* Brummer Gallery, New York, New York, December 2-January 31

1937 *Jacques Lipchitz,* at Les Maîtres de l'art indépendant, Paris World's Fair, Petit Palais, Paris

1942 *Jacques Lipchitz,* Buchholz Gallery (Curt Valentin), New York, New York, January 21-February 14

1943 *Jacques Lipchitz,* Buchholz Gallery (Curt Valentin), New York, New York, April 12-May 1

1944 *The Drawings of Jacques Lipchitz,* Buchholz Gallery (Curt Valentin), New York, New York

1946 *Jacques Lipchitz,* Buchholz Gallery (Curt Valentin), New York, New York, March 26-April 20

Jacques Lipchitz, Galerie Maeght, Paris, June 18

1948 *Jacques Lipchitz: Early Stone Carvings and Recent Bronzes,* Buchholz Gallery (Curt Valentin), New York, New York, March 23-April 17

1950 *Jacques Lipchitz,* Petite Galerie du Séminaire, Brussels

1950-51 *Lipchitz: Works 1914-1950,* Portland Art Museum, Portland, Oregon, October 24-December 3; traveled to The San Francisco Museum of Art, San Francisco, California, January 5-February 11, 1951; The Cincinnati Art Museum, Cincinnati, Ohio, March 9-April 8, 1951

1951 *Jacques Lipchitz,* Buchholz Gallery, New York, New York, May 1-26

Jacques Lipchitz: Birth of the Muses, The Museum of Modern Art, New York, New York, July 18-August 19

1952 *Sculptura: Jacques Lipchitz,* French Pavilion, XXVIth Biennale, Venice, Italy, June 14-October 19

Jacques Lipchitz, Frank Perls Gallery, Beverly Hills, California, and The Santa Barbara Museum of Art, Santa Barbara, California, February 12-March 9

1954-55 *The Sculpture of Jacques Lipchitz,* The Museum of Modern Art, New York, May 18-August 1, 1954; traveled to Walker Art Center, Minneapolis, Minnesota, October 1-

December 12, 1954; the Cleveland Museum of Art, Cleveland, Ohio, January 25-March 13, 1955.

1957 *Jacques Lipchitz: Thirty-Three Semi-Automatics 1955-56 and Earlier Works 1915-28,* Fine Arts Associates, New York, New York, March 5-30

Jacques Lipchitz, Frank Perls Gallery, Beverly Hills, California

Lipchitz: Small Sculptures, Cincinnati Art Museum, Cincinnati, Ohio, October 4-November 5

1958-59 *Jacques Lipchitz,* Stedelijk Museum, Amsterdam, March 14-May 5, 1958; traveled to Rijksmuseum Kröller-Müller, Otterlo, May 17-July 20, 1958; Kunsthalle, Basel, August 9-September 7, 1958; Museum am Ostwall, Dortmund, November 15-December 28, 1958; Palais des Beaux-Arts, Brussels, January 17-February 28, 1959

Jacques Lipchitz, École des Beaux-Arts, Montréal, Quebec, late 1958; traveled in Canada to Norman MacKenzie Art Gallery, Regina, Saskatchewan, January 8-February 1, 1959; Winnipeg Art Gallery, Winnipeg, Manitoba, February 8-March 8, 1959; and The Art Gallery of Ontario, Toronto, Ontario, April 24-May 24, 1959

Lipchitz, Städtische Galerie München, Munich, September 19-October 26

1959 *Jacques Lipchitz,* Musée National d'Art Moderne, Paris, May 20-June 28

Jacques Lipchitz: Fourteen Recent Works 1958-1959 and Earlier Works 1949-1959 Fine Arts Associates, New York, New York, November 10-December 5

Sculpture by Jacques Lipchitz, The Tate Gallery, London, England, November 14-December 16

1960 *Juan Gris, Jacques Lipchitz: A Friendship,* M. Knoedler & Co., New York, New York, January 11-February 6

Jacques Lipchitz: A Retrospective Exhibition of Sculpture and Drawings, The Corcoran Gallery, Washington, D.C., March 12-April 10; traveled to Baltimore Museum of Art, Baltimore, Maryland, April 26-May 29

1961-62 *Fifty Years of Lipchitz Sculpture,* Otto Gerson Gallery, New York, New York, November 7-December 9, 1961; traveled to Andrew Dickson White Museum of Art, Cornell University, Ithaca, New York, January 8-February 11, 1962

1962 *Jacques Lipchitz: Recent Sculpture,* Otto Gerson Gallery, New York, New York, October 2-20

1963-64 *Jacques Lipchitz: A Retrospective Selected by the Artist,* UCLA Art Galleries, University of California Art Council, Los Angeles, California, March 4-April 14, 1963; traveled to San Francisco Museum of Art, San Francisco, California, April 23-June 2, 1963; Denver Art Museum, Denver, Colorado, June 30-August 25, 1963; Fort Worth Art Center, Fort Worth, Texas, September-October; Walker Art Center, Minneapolis, Minnesota, November 26, 1963-January 19, 1964; Des Moines Art Center, Des Moines, Iowa, February 1-March 8, 1964; Philadelphia Museum of Art, Philadelphia, Pennsylvania, April 23-June 7, 1963

1963-65 *Jacques Lipchitz: 157 Bronze Sketches 1912-1962,* Otto Gerson Gallery, New York, New York, April 16-May 11, 1963; circulated by The Museum of Modern Art and traveled to Currier Gallery of Art, Manchester, New Hampshire, July 3-August 15, 1963; Albright-Knox Art Gallery, Buffalo, New York, September 23-October 16, 1963; Atlanta Art Association, Atlanta, Georgia, January 2-30, 1964; Joslyn Art Museum, Omaha, Nebraska, February 23-March 22, 1964; Tweed Gallery, University of Minnesota, Minneapolis, Minnesota, April 1-29, 1964; Arts Club of Chicago, Illinois, May 16-June 15, 1964; Detroit Institute of Art, Detroit, Michigan, June 27-July 25, 1964; Instituto Torcerato de Tella, Buenos Aires, September 12-30, 1964; Museo de Arte Contemporaneo, University of Chile, Santiago, November 4-December 15, 1964; Museo de Bellas Artes, Caracas, February 7-22, 1965; Casa de Retiro, Instituto de Arte Contemporaneo, Lima, June 16-July 6, 1965; National Gallery of Victoria, Melbourne, November 8-January 9, 1965; Auckland City Art Gallery, Arts Council of New Zealand, February 11-March 4, 1965; National Gallery, Wellington, March 15-31, 1965

1964 *Jacques Lipchitz: Retrospective,* Boston University School of Fine and Applied Arts, Boston, Massachusetts, March 15-April 16

Jacques Lipchitz, Marlborough-Gerson Gallery, New York, New York, August 6-October 3

The Cubist Period of Jacques Lipchitz, The Phillips Collection, Washington, D.C., October 3-November 17

Jacques Lipchitz, J.L. Hudson Gallery, Detroit, Michigan, October 21-November 28

1964-65 *Between Heaven and Earth,* Documenta International, Kassel, June 27-October 5, and Carnegie International, Pittsburgh, Pennsylvania, October 30-January 10

1965 *Jacques Lipchitz & Marc Chagall,* Israel Museum, Jerusalem, May 11-July 28

Jacques Lipchitz, Newark Museum of Art, Newark, New Jersey, November 11-December 12

1966 *Lipchitz: Drawings and Bronzes,* Makler Gallery, Philadelphia, Pennsylvania, February 1-26

Jacques Lipchitz: Images of Italy, Marlborough-Gerson Gallery, New York, New York, April 19-May 7

Jacques Lipchitz: Images of Italy, Felix Landau Gallery, Los Angeles, California, May 23-June 20

1967 *Jacques Lipchitz: Sculptures on Biblical Themes,* The Jewish Museum, New York, New York, January-May

Jacques Lipchitz: Images of Italy, Dunkelman Gallery, Toronto, April-May

1968 *Lipchitz: The Cubist Period 1913-1930,* Marlborough-Gerson Gallery, New York, New York, March 12-30

Jacques Lipchitz, Slosberg Art Gallery, Brandeis University, Waltham, Massachusetts, June 1-15

1969 *The Sculpture of Jacques Lipchitz,* University of Wisconsin Art History Galleries, Milwaukee, Wisconsin, April 1-30; traveled to Herron Museum of Art, Indianapolis, Indiana, June 8-29

Jacques Lipchitz, Katonah Gallery, Katonah, New York, July 27-September 2

1970-71 *Jacques Lipchitz: Skulpturen und Zeichnugen 1911-1969,* Neue Nationalgalerie, Berlin, September 18-November 9, 1970; traveled to Staatliche Kunsthalle, Baden-Baden, November 30, 1970-January 10, 1971; Wilhelm-Lehmbruck-Museum, Duisburg, January 16-March 7, 1971; Museum des 20 Jahrhunderts, Vienna

1971 *Jacques Lipchitz: Sculptures and Drawings 1911-1970,* Tel Aviv Museum, Tel Aviv, April 19-July 10

Jacques Lipchitz: Bronze Sketches, Israel Museum, Jerusalem, continuous exhibition opened August 3

1972 *Jacques Lipchitz: His Life in Sculpture,* The Metropolitan Museum of Art, New York, New York, June 6-September 12

Jacques Lipchitz: Sculpture, Watercolors, and Drawings, Makler Gallery, Philadelphia, Pennsylvania, November 3-30

Jacques Lipchitz, Marlborough-Godard, Toronto, Ontario, Canada, September 8-30

1973 *Jacques Lipchitz: Sculptures and Drawings,* Marlborough Fine Art, London, May 10-June 8; traveled as *Jacques Lipchitz: Skulpturen und Zeichnungen* to Marlborough Galerie, Zurich, September-October
A Tribute to Jacques Lipchitz: Lipchitz in

America, 1941-1973, Marlborough Gallery, New York, New York, November 9-December 1

1974 *Sculptures by Jacques Lipchitz*, Brooks Memorial Art Gallery, Memphis, Tennessee, October 10-November 30

Jacques Lipchitz: Sculptures, Prints, and Drawings, Baltimore Museum of Art, Baltimore, Maryland, May 19-July 14

1974-75 *Selected Master Drawings of Jacques Lipchitz: 1910 - 1958*, Trisolini Gallery of Ohio University, Athens, Ohio, November 7-25, 1974; The Columbus Gallery of Fine Arts, December 12, 1974-January 12, 1975; Marlborough Gallery, New York, New York, February 8-March 1, 1975; Marlborough Godard, Toronto, June 1975

1977 *Jacques Lipchitz: Sculptures and Drawings from the Cubist Epoch*, Marlborough Gallery, New York, New York, February 12-March 12

1978 *Jacques Lipchitz*, Galerie Brusberg, Hannover, Germany, June 2-August 18

Jacques Lipchitz: Kubistische Skulpturen und Zeichnungen, Marlborough Galerie, Zurich, Switzerland, June 7-July 31

Jacques Lipchitz: Sculpture and Drawings from the Cubist Epoch, Marlborough Fine Art, London, England, October-November

1979 *Jacques Lipchitz: Small Sculptures, Maquettes and Drawings, 1915-1972*, Marlborough Gallery, New York, New York, March 3-27

1981-82 *Jacques Lipchitz: Selected Sculpture in Large Scale 1927-1971*, Marlborough Gallery, New York, New York, November 19, 1981-February 19, 1982

1982 *Jacques Lipchitz: Sculptures (Biblical Themes) 1930-1972*, Aberbach Fine Art, New York, New York, March-May

1983 *Jacques Lipchitz: Mother and Child*, Norman Mackenzie Art Gallery, University of Regina, Saskatchewan, October 7-November 13

1985 *Jacques Lipchitz: Sculptor and Collector*, Albert and Vera List Visual Arts Center, Massachusetts Institute of Technology, Cambridge, Massachusetts, March 1-June 9

Jacques Lipchitz: A Survey 1911-1973, Marlborough Fine Arts, Tokyo, Japan, October 16-December 7

Jacques Lipchitz: Selected Sculpture, Reliefs & Drawings 1911-1972, Marlborough Gallery, New York, New York, November 7-December 3

1986-87 *The Lipchitz Gift: Models for Sculpture*, The Tate Gallery, London, England, November 12, 1986-February 15, 1987

1987 *Jacques Lipchitz: The Cubist Period (1913-1930)*, Marlborough Gallery, New York, New York, October 15-November 14

Jacques Lipchitz: Esculturas, Galería Fernando Quintana, Bogota, October - November

1988 *Jacques Lipchitz: Esculturas en Bronce*, Galería Freites, Caracas, January - February

Hommage à Lipchitz: œuvres de 1914 à 1963, Galerie Marwan Hoss, Paris, F.I.A.C. '88, Grand Palais, October 2-30

1989-90 *Jacques Lipchitz: A Life in Sculpture*, Art Gallery of Ontario, Toronto, December 15 - March 11, 1990; traveled to Winnipeg Art Gallery, Winnipeg, Manitoba, May 13-August 12, 1990; The Nelson-Atkins Museum of Art, Kansas City, Missouri, October 7-November 25, 1990; The Jewish Museum, New York, January 16-April 15, 1991

1991-92 *Jacques Lipchitz: From Sketch to Sculpture*, Tel Aviv Museum of Art, Tel Aviv, December 10, 1991-February 29, 1992

1993 *Jacques Lipchitz: Esculturas, 1913-1972*, Galería Marlborough, Madrid, Spain, March 17-April 30

Jacques Lipchitz (1891-1973), Centro de Arte Palacio Almudi, Murcia, April 2 -May 18

1996 *Jacques Lipchitz: Sculpture 1910-1940, The Paris Years*, Marlborough Gallery, New York, New York, March 13-April 13

Jacques Lipchitz, Galerie Gmurzynska, Marienburg, November

1997 *Jacques Lipchitz, Escultura 1911-1971*, Marlborough Gallery, Madrid, Spain, May 20-June 20

Lipchitz, un mundo sorprendido en el espacio, Museo Nacional Centro de Arte Reina Sofía, Madrid, May 20-September 2; traveled to IVAM, Centro Julio Gonzáles, Valencia, September 18-November 30

1998 *Lipchitz dans les Jardins du Palais Royal*, Les Jardins du Palais Royal, Paris, May 20-August 31, 1998; traveled to Yorkshire Sculpture Park, Wakefield, September 1998-March 1999

SELECTED COMMISSIONS

1921 *Portrait of Mlle Coco Chanel and Reclining Woman (Andirons)*, Coco Chanel, Paris

1922-23 *Five stone reliefs*, Dr. Albert C. Barnes, Merion, Pennsylvania (now The Barnes Foundation)

1926-30 *Figure*, Madame Tachard, France

1927 *Joy of Life*, Vicomte Charles de Noailles, Hyères

1931 *Song of the Vowels*, Madame de Maudrot, Le Pradet, France

1936-37 *Prometheus Strangling the Vulture*, the government of France, Paris World's Fair (destroyed)

1943-44 *Prometheus Strangling the Vulture*, The Ministry of Health and Education, Rio de Janeiro

1948-55 *Notre Dame de Liesse*, Notre Dame de Toute Grâce Catholic Church, Assy, Haute-Savoie, France

1950 *Birth of the Muses*, Mrs. John D. Rockefeller III, New York

1953-54 *Spirit of Enterprise*, Fairmont Park Association, Philadelphia, Pennsylvania

1958 Ornamental gates for Philip Johnson's Roofless Church, New Harmony, Indiana and a second cast of *Notre Dame de Liesse*

1963-65 *Daniel Greysolon, Sieur du Luth*, by the bequest of Albert L. Ordean and the City of Duluth, Minnesota

1967-69 *Peace on Earth*, Los Angeles County Music Center, California

1964 Medallion portrait of President Johnson for the Presidential Scholar awards

1964-65 Portrait commissions of John F. Kennedy for the City of Newark, Military Park, New Jersey, International Students House, London, England, and at the Kennedy Memorial Library, Cambridge, Massachusetts

1967 Commemoration medal on the unification of Jerusalem commissioned by Mayor Teddy Kollek and given "gratis" to the state of Israel

1967-70 *Government of the People*, Municipal Plaza, Philadelphia, Pennsylvania

1964-73 *Bellerophon Taming Pegasus*, Columbia University Law School, New York

1971-73 *Our Tree of Life*, Mount Scopus, Jerusalem, Israel

1909 First prize for sculpture, Académie Julian, Paris

1936-37 Gold Medal at the Paris World's Fair for *Prometheus Strangling the Vulture*

1946 Awarded Chevalier de la Légion d'Honneur, Paris

1952 George D. Widener Memorial Gold Medal award from Pennsylvania Academy of Arts, Philadelphia, for *Prometheus Strangling the Vulture*

1958 Brandeis Creative Arts Award for notable achievement in the arts from Brandeis University, Waltham, Massachusetts

1965 Award for cultural achievement from Boston University, Boston, Massachusetts and made Honorary Doctor of Laws by the Jewish Theological Seminary, New York, New York

1966 Gold Medal of the National Institute of Arts and Letters, New York

1969 Award of Merit from the Einstein Medical Center of Yeshiva University and Medal of Achievement from the American Institute of Architects

SELECTED PUBLIC AND MUSEUM COLLECTIONS
that hold works by Lipchitz

Albright-Knox Art Gallery, Buffalo, New York, USA
Art Gallery of Ontario, Toronto, Ontario, Canada
Art Institute of Chicago, Chicago, Illinois, USA
Art Museum, Princeton University, Princeton, New Jersey, USA
Baltimore Museum of Art, Baltimore, Maryland, USA
Barnes Foundation, Merion, Pennsylvania, USA
Birmingham Museum of Art, Birmingham, Alabama, USA
Broadgate, Broadgate Square, London, England
Bunkamura Museum of Art, Tokyo, Japan
Centre National d'Art et de Culture George Pompidou, Paris, France
Centro Museo de Arte Reina Sofía, Madrid, Spain
Chrysler Museum, Norfolk, Virginia, USA
Cleveland Museum of Art, Cleveland, Ohio, USA
Contemporary Arts Museum, Houston, Texas, USA
Currier Gallery of Art, Manchester, New Hampshire, USA
Dallas Museum of Art, Dallas, Texas, USA
The David and Alfred Smart Museum of Art, University of Chicago, Illinois, USA
Davis Museum and Cultural Center, Wellesley College, Wellesley, Massachusetts, USA
Denver Art Museum, Denver, Colorado, USA
Des Moines Art Center, Des Moines, Iowa, USA
Detroit Institute of Arts, Detroit, Michigan, USA
Fogg Art Museum, Harvard University, Cambridge, Massachusetts, USA
Franklin D. Murphy Sculpture Garden, University of California, Los Angeles, California, USA
Galleria Nazionale d'Arte Moderna, Rome, Italy
Haags Gemeentemuseum, The Hague, Netherlands
Hakone Open-Air Museum, Hakone-machi, Japan
Hamburger Kunsthalle, Hamburg, Germany
Hirshhorn Museum and Sculpture Garden, Smithsonian Institution, Washington, D.C., USA
Honolulu Academy of Arts, Honolulu, Hawaii, USA
Hood Museum of Art, Dartmouth College, Hanover, New Hampshire, USA
Indiana University Art Museum, Bloomington, Indiana, USA
Israel Museum and Billy Rose Art Garden, Jerusalem, Israel
Jewish Museum, New York, New York, USA
Jewish Museum, San Francisco, California, USA
Kröller-Müller Museum, Otterlo, The Netherlands
Kunsthaus Zürich, Zurich, Switzerland
Kunstmuseum Basel, Basel, Switzerland
Kunstmuseum Bern, Bern, Switzerland
Los Angeles County Museum of Art, Los Angeles, California, USA
M.I.T.-List Visual Arts Center, Massachusetts Institute of Technology, Cambridge, Massachusetts, USA
Meadows Museum, Southern Methodist University, Dallas, Texas, USA
Metropolitan Museum of Art, New York, New York, USA

Milwaukee Art Museum, Milwaukee, Wisconsin, USA
Minneapolis Institute of Arts, Minneapolis, Minnesota, USA
Minnesota Museum of American Art, St. Paul, Minnesota, USA
Miriam and Ira D. Wallach Art Gallery, Columbia University, New York, New York, USA
Montréal Museum of Fine Arts, Montréal, Québec, Canada
Munson-Williams-Proctor Institute, Museum of Art, Utica, New York, USA
Musée des Beaux-Arts, Nancy, France
Musée des Beaux-Arts et de la Céramique, Rouen, France
Musée d'Art et d'Histoire du Judaïsme, Paris, France
Musée d'Art Moderne de la Ville de Paris, Paris, France
Museo de Bellas Artes de Caracas, Caracas, Venezuela
Museum Boymans-van Beuningen, Rotterdam, The Netherlands
Museum Folkwang, Essen, Germany
Museum of Fine Arts, Houston, Texas, USA
Museum of Modern Art, New York, New York, USA
National Gallery of Art, Washington, D.C., USA
National Gallery of Canada, Ottawa, Ontario, Canada
Nelson-Atkins Museum of Art, Kansas City, Missouri, USA
New Orleans Museum of Art, New Orleans, Louisiana, USA
Norton Museum of Art, West Palm Beach, Florida, USA
Norton Simon Museum, Pasadena, California, USA
Olin Library, Cornell University, Ithaca, New York, USA
Openluchtmuseum voor Beeldhouwkunst, Middelheimpark, Antwerp, Belgium
Peggy Guggenheim Collection, Solomon R. Guggenheim Foundation (New York), Venice, Italy
PepsiCo Sculpture Gardens, Purchase, New York, USA
Philadelphia Museum of Art, Philadelphia, Pennsylvania, USA
Phillips Collection, Washington, D.C., USA
Portland Art Museum, Portland, Oregon, USA
Queensland Art Gallery, Brisbane, Australia
Saarland Museum, Saarbrücken, Germany
St. Louis Art Museum, Saint Louis, Missouri, USA
San Francisco Museum of Modern Art, San Francisco, California, USA
Scottish National Gallery of Modern Art, Edinburgh, Scotland
Scottsdale Center for the Arts, Scottsdale, Arizona, USA
Sheldon Memorial Art Gallery and Sculpture Garden, University of Nebraska, Lincoln, Nebraska, USA
Shizuoka Prefectural Museum of Art, Shizuoka, Japan
Skirball Museum, Hebrew Union College, Los Angeles, California, USA
Smith College Museum of Art, Northhampton, Massachusetts, USA
Solomon R. Guggenheim Museum, New York, New York, USA

Sprengel Museum, Hannover, Germany
Staatliche Kunsthalle, Karlsruhe, Germany
Staatsgalerie Stuttgart, Stuttgart, Germany
Städtische Kunsthalle Mannheim, Mannheim, Germany
Stanford University Museum of Art, Stanford, California, USA
Stedelijk Museum, Amsterdam, The Netherlands
Stedelijk Van Abbe Museum, Eindhoven, The Netherlands
Syracuse University Art Collection, Syracuse, New York, USA
Tate Gallery, London, England
Tel Aviv Museum of Art, Tel Aviv, Israel
Tokushima Modern Art Museum, Tokushima, Japan
Tweed Museum of Art, University of Minnesota Duluth, Duluth, Minnesota, USA
University of Arizona Museum of Art, Tucson, Arizona, USA
University of Iowa Museum of Art, Iowa City, Iowa, USA
University of Michigan Museum of Art, Ann Arbor, Michigan, USA
Virginia Museum of Fine Arts, Richmond, Virginia, USA
Walker Art Center, Minneapolis, Minnesota, USA
Washington University Gallery of Art, St. Louis, Missouri, USA
Whitney Museum of American Art, New York, New York, USA
Wilhelm Lehmbruck Museum, Duisburg, Germany
Worcester Art Museum, Worcester, Massachusetts, USA
Yale University Art Gallery, New Haven, Connecticut, USA

BIBLIOGRAPHY

WRITINGS AND STATEMENTS BY JACQUES LIPCHITZ
(arranged chronologically)

Valori Plastici, Rome, Vol.1, Nos. 2-3, February-March 1919, p. 3.

Answer to a questionnaire, *Little Review,* New York, Vol. 12, May 1929, pp. 47-48. Reprinted in Hammacher, *Jacques Lipchitz: His Sculpture.* New York: Abrams, 1961, pp. 70-71.

Omaggio a Modigliani, Milan, 1930.

"Réponse à une enquête sur l'art d'aujourd'hui." *Cahiers d'Art,* Paris, Vol. 10, 1935, p. 68.

"The Story of My Prometheus." *Art in Australia,* Sydney, Ser. 4, No. 6, June-August 1942, pp. 29-35. Foreword in *Bronzes by Degas, Matisse, Renoir,* Buchholz Gallery, New York, 1943.

Foreword in *Juan Gris,* Buchholz Gallery, New York, 1944.

Interview with J.J. Sweenry, *Partisan Review,* Winter 1945.

Brief statement in a *Symposium on Guernica (Picasso),* Museum of Modern Art, New York, November 25, 1947. Typescript in Museum of Modern Art Library, New York.

"I Remember Modigliani," as told to Dorothy Seckler, *Art News,* Vol. 49, February 1951, pp. 26-29, 64-65.

Statement in "Fourteen Eyes in a Museum Storeroom." *University Museum Bulletin,* University of Pennsylvania, Philadelphia, February 1952, pp. 12-17.

Amedeo Modigliani, (Library of Great Painters, Portfolio Edition) New York: Abrams, 1952.

"What in the World? Identification of Archaeological Objects: A Television Broadcast." *Archaeology,* Cambridge, Massachusetts, Vol. 6, March 1953, pp. 18-23.

Introduction "About Rodin" in exhibition catalogue for *Auguste Rodin,* New York: Curt Valentin Gallery, May 1954.

"I call them semi-automatics…Hastings-on-Hudson, 1957." *Jacques Lipchitz: Thirty-three Semi-automatics, 1955-56, and Earlier Works, 1915-28.* New York: Fine Arts Associates, 1957.

Statement in "Jacques Lipchitz montre sa collection." *L'Oeil,* No. 66, June 1960, pp. 46-53.

Interview with Selden Rodman. "Lipchitz." *Conversation with Artists,* New York, 1961.

"Introductory Statement" in A.M. Hammacher, *Jacques Lipchitz: His Sculpture.* New York: Abrams, 1961, pp. 9-10.

Interview with Katherine Kuh, "Conclusions from an old Cubist," *Art News,* Vol. 60, November 1961, pp. 48-49.

Interview with Frederick S. Wight "A Talk with Jacques Lipchitz." *Jacques Lipchitz Retrospective,* Los Angeles: U.C.L.A. Art Council, 1963.

Introduction in *Art in Architecture,* with Louis G. Redstone, New York: McGraw-Hill, 1968.

Foreword in *Jacques Lipchitz,* with Harvard H. Arnason, New York: Praeger Publishers, 1969, p. 4.

Interview with Linda Arking. "A Visit with Jacques Lipchitz." *Atlantic Monthly,* March 1971, pp. 68-77.

Jacques Lipchitz with Harvard H. Arnason. "Jacques Lipchitz: His Life in Sculpture." *Metropolitan Museum of Art Bulletin,* Vol. 30, No. 6, June-July 1972, pp. 284-88.

Jacques Lipchitz with Harvard H. Arnason. *My Life in Sculpture,* New York: Viking Press, 1972; Canada: Macmillan Company, 1972.

D.W. Lippold, J. Thalacker, and Jacques Lipchitz. *Art in Architecture.* Rochester, Michigan: Meadowbrook Gallery, Oakland University, 1977.

AUDIO/VISUAL DOCUMENTATION
(arranged chronologically)

NBC TV Series. *Wisdom,* 1952. Interview with Lipchitz by Cranston Jones. TV Archives, Museum of Modern Art.

_____. *Wisdom,* 1958. "Conversations with the Elder Wise Men of Our Day." Interview with Jacques Lipchitz by Cranston Jones. Text printed in James Nelson, ed., *Wisdom: Conversations with the Elder Wise Men of Our Day,* New York, 1958, pp. 74-75.

ABC TV Series. *Directions '62,* 1962. Interview with Lipchitz by Eli Wallach. TV Archives, Museum of Modern Art.

CBS TV Series. *Chronicle,* 1964. "The Best is Yet to Be." Interview with Lipchitz (among others) by Charles Collingwood. TV Archives, Museum of Modern Art.

"Conversations with Lipchitz." Taped interviews with Deborah A. Stott, Jacques Lipchitz Art Foundation, New York, 1968-70.

Jacques Lipchitz. Directed and produced by Bruce Bassett, New York, and Jacques Lipchitz Art Foundation, 1971, 16mm film. Re-released in video, *Jacques Lipchitz,* Bruce W. Bassett Productions, 1989.

Masters of Modern Sculpture Series. Part 1: The Pioneers, produced and directed by Michael Blackwood, Michael Blackwood Productions Inc., 1979, 16mm film and video.

Lipchitz au Palais Royal, On Line Productions, 1998, video.

Lipchitz Dans Les Jardins du Palais Royal, 1998, video.

MONOGRAPHS AND EXHIBITION CATALOGUES

Amishai-Maisels, Ziva. *Jacques Lipchitz at Eighty (Sculptures and Drawings 1911-1971).* Jerusalem, Israel: Israel Museum, 1971.

Arnason, Harvard H. *Jacques Lipchitz: Sketches in Bronze.* New York: Praeger; London: Pall Mall,1969.

_____. *Sculptures by Jacques Lipchitz.* Memphis, Tennessee: Brooks Memorial Art Gallery, 1974.

Barbier, Nicole, Cachin Françoise and George Pierre. *Lipchitz: 100 oeuvres nouvelles 1974-76.* Paris: Musée National d'Art Moderne, Centre National d'Art et de Culture Georges Pompidou, 1977.

Barrio-Garay, J.L. "Master Drawings of Jacques Lipchitz." *Selected Master Drawings of Jacques Lipchitz: 1910-1958.* Athens, Ohio: Trisolini Gallery of Ohio University, 1974.

Breeskin, A. D., Jacques Lipchitz, and H.W. Williams. *Jacques Lipchitz: A Retrospective Exhibition of Sculpture and Drawings.* Washington, D.C.: Corcoran Gallery, 1960.

Cassou, Jean, Camille Soula, and Jacques Kober. *Jacques Lipchitz.* Paris: Galerie Maeght, 1946.

Cent Sculptures par Jacques Lipchitz. Paris: Galerie de la Renaissance, 1930.

Cubist Period of Jacques Lipchitz. Washington, D.C.: Phillips Collection and H.K. Press, 1964.

Dorival, Bernard. *Sculpture by Jacques Lipchitz.* London: Arts Council of Great Britain & Tate Gallery, 1959.

Eckhardt, Ferdinand. *Jacques Lipchitz.* Montréal: Winnipeg Art Gallery and École des Beaux-Arts, 1958.

Faure, Elie. *Jacques Lipchitz.* English translation by Allan Ross MacDougall, New York: Brummer Gallery, New York, 1935.

Goldwater, Robert. *Lipchitz.* Cologne and Berlin: Kiepenheuer & Witsch, 1954.

_____. *Jacques Lipchitz.* Amsterdam: Allert de Lange; London: Zwemmer; New York: Universe Books, 1958.

Hammacher, A.M. *Jacques Lipchitz: His Sculpture.* New York: Abrams, 1961; London: Thames & Hudson, n.d.

_____. *Tribute to Jacques Lipchitz.* Translation by James Brockway. New York: Marlborough Gallery, 1973.

_____. *Lipchitz in Otterlo.* Otterlo, Netherlands: Rijksmuseum Kröller-Müller, 1977.

_____, Klaus Herding, and Jörn Merkert. *Jacques Lipchitz: Skulpturen und Zeichnungen, 1911-1969.* Berlin: Neue Nationalgalerie, 1970.

Hommage à Lipchitz: Oeuvres de 1914 à 1963. Paris: Galerie Marwan Hoss, 1988.

Hope, Henry R. *The Sculpture of Jacques Lipchitz.* New York: Museum of Modern Art, 1954.

Jacques Lipchitz. Paris: Jeanne Bucher, 1947.

Jacques Lipchitz: Thirty-Three Semi-automatics 1955-1956 and Earlier Works 1915-1928. New York: Fine Arts Associates, 1957.

Jacques Lipchitz. Munich: Städische Galerie München, 1958.

Jacques Lipchitz: Fourteen Recent Works 1958-1959 and Earlier Works 1949-1959. New York: Fine Arts Associates, 1959. Text by Lipchitz: "À la Limite du possible."

Jacques Lipchitz: Recent Sculpture. New York: Otto Gerson Gallery, 1962.

Jacques Lipchitz. 157 Small Bronze Sketches, 1914-1962. New York: Otto Gerson Gallery, 1963.

Jacques Lipchitz: Esbozos de Bronce 1912-62. Buenos Aires: Instituto Torcuato di Tella Buenos Aires, 1964.

Jacques Lipchitz: Retrospective Sculpture and Drawing. Boston: Boston University Press, 1965

Jacques Lipchitz: Bocetos en Bronce, 1912-62. Caracas: Museo de Bellas Artes, 1965.

Jacques Lipchitz Images of Italy. Toronto: Dunkelman Gallery, 1966.

Jacques Lipchitz: Sculpture and Drawings, 1911-1970. Tel Aviv, Israel: Tel Aviv Museum of Art, 1971.

Jacques Lipchitz: Sculpture, Watercolors, and Drawings. Philadelphia: Makler Gallery, 1972.

Jacques Lipchitz: Sculpture and Drawings from the Cubist Epoch. London: Marlborough Fine Art, 1978.

Jacques Lipchitz: Selected Sculpture in Large Scale 1927-1971. New York: Marlborough Gallery, 1981.

Jacques Lipchitz. New York: Aberbach Fine Art, 1982.

Jacques Lipchitz: Models and Sketches. Phoenix, Arizona: University of Arizona Press, 1982.

Jacques Lipchitz: Selected Sculpture, Reliefs & Drawings 1911-1972. New York: Marlborough Gallery, 1985.

Jacques Lipchitz: A Survey 1911-1973. Tokyo, Japan: Marlborough Fine Art, 1985.

Jacques Lipchitz: Esculturas. Bogota, Colombia: Galería Fernando Quintana, 1987.

Jacques Lipchitz: Sculpture 1910-1940, The Paris Years. New York, New York: Marlborough Gallery, 1996.

Jacques Lipchitz: Escultura 1911-1971, Madrid: Galería Marlborough, 1997.

Jacques Lipchitz: Un mundo sorprendido en el espacio. Madrid: Museo Nacional Centro de Arte Reina Sofía; Valencia: IVAM, Centro Julio González, 1997.

Jenkins, D.F. and D. Pullen. *The Lipchitz Gift: Models for Sculpture.* London: Tate Gallery, 1987.

Leal, Paloma Esteban, and Carmen Fernández Aparicio. *Donación Lipchitz,* Madrid: Museo Nacional Centro de Arte Reina Sofía, 1997.

Lipchitz. Munich: Städtische Galerie München, 1958.

Lipchitz: Sculpture, Drawings, Gouaches. Syracuse: Syracuse University Press, 1959.

Parke-Taylor, Michael. *Jacques Lipchitz: Mother and Child.* Saskatchewan, Canada: University of Regina, 1983.

Patai, Irene. *Encounters: The Life of Jacques Lipchitz.* New York: Funk & Wagnalls Co., 1961.

Raynal, Maurice. *Lipchitz.* Paris: Action, 1920; second edition 1927.

Ritchie, Andrew C. *Lipchitz: Works 1914-1950.* Portland, Oregon: Portland Art Museum, 1950.

Sandberg, Willem. *Fifty Years of Lipchitz Sculpture.* New York: Otto Gerson Gallery, 1961.

Schwartzberg, Miriam B. *"The Sculpture of Jacques Lipchitz."* Unpublished master's thesis for New York University, 1941. Typescript in Museum of Modern Art Library.

The Sculpture of Jacques Lipchitz. Milwaukee, University of Wisconsin; Indianapolis: Herron Museum of Art, 1969.

Stott, Deborah A. *"Jacques Lipchitz and Cubism."* Unpublished Ph.D. dissertation, Columbia University, 1975.

_____. *Jacques Lipchitz and Cubism.* New York: Garland Publishing, 1978.

Swope, John. *Jacques Lipchitz: Sculptor and Collector.* Los Angeles, California: U.C.L.A. Art Council, 1967. A photographic study.

Valentin, Curt. *Twelve Bronzes by Jacques Lipchitz.* New York: Buchholz Gallery, 1943; special edition of 35, numbered and signed, and each contained one original etching.

Van Bork, Bert. *Jacques Lipchitz: The Artist at Work.* New York: Crown Publishers, 1966.

Vitrac, Roger. *Jacques Lipchitz.* Paris: Gallimard, 1929.

Wadley, Nicholas. *Jacques Lipchitz.* London: Marlborough Fine Art; Zurich: Galerie Marlborough, 1973.

Werner, Alfred. *Lipchitz: The Cubist Period, 1913-1930.* New York: Marlborough-Gerson Gallery, 1968.

Weyl, Martin and Willem Sandberg. *Jacques Lipchitz: Bronze Sketches.* Jerusalem: Israel Museum, 1971.

Wight, Frederick S. *Jacques Lipchitz.* Los Angeles, California: U.C.L.A. Art Council, 1963.

Wilkinson, Alan G. *Jacques Lipchitz: A Life in Sculpture.* Toronto: Art Gallery of Ontario, 1989.

_____. *Jacques Lipchitz: The Cubist Period (1913-1930).* New York: Marlborough Gallery, 1987.

_____. *Jacques Lipchitz: Esculturas 1913 - 1972.* Madrid, Spain: Galería Marlborough, 1993.

_____. *Jacques Lipchitz (1891-1973).* Murcia, Spain: Centro de Arte Palacio Almundi de Murcia, 1993.

_____. *The Sculpture of Jacques Lipchitz - A Catalogue Raisonné, Volume One - The Paris Years 1910-1940.* London and New York: Thames and Hudson, 1996.

_____. *Lipchitz dans les Jardins du Palais Royal,* Paris, France: Les Jardins du Palais Royal, 1998.

Yifat, Dorit. *Jacques Lipchitz from Sketch to Sculpture.* Tel Aviv: Tel Aviv Museum of Art, 1991.

Yvars, J.F., and Lucía Ybarra. *Cartas a Lipchitz y algunos inéditos del artista.* Madrid: Museo Nacional Centro de Arte Reina Sofia, 1997.

ARTICLES

"African Art in the collection of Jacques Lipchitz." *African Arts,* Los Angeles, Summer 1970, pp. 48-51.

Amishai-Maisels, Ziva. "Lipchitz and Picasso: Thematic Interpretations." *Journal of Jewish Art,* Vol. 1, 1974, pp. 80-92.

"Around with Lipchitz." *Newsweek,* Vol. 43, May 24, 1954, p. 63.

"Art and Religion." *Art Digest,* Vol. 28, December 1953, p. 9.

Ashton, D. "Visual Nourishment; exhibition at the Museum of Modern Art." *Art Digest,* Vol. 28, June 1954, p.16.

Baker, Kenneth. "A Fearless Sculptor's Lifelong Evolution." *San Francisco Chronicle,* San Francisco, January 14, 1990.

Barrio-Garay, José L. "La escultura de Jacques Lipchitz." *Goya,* Madrid, No. 96, May 1970, pp. 350-57.

Baudot, François. "Sculptures de Lipchitz - Le Palais Royal Revisité." *Elle,* Paris, August 3-9, 1998.

Benson, Emanuel M. "Seven Sculptors: Calder, Gargallo, Lehmbruck, Lipchitz, Manolo, Moore, Wolff." *American Magazine of Art,* Washington, D.C., Vol. 28, August 1935, pp. 455-59.

Bissiere. "Lipchitz." *Action,* Paris, No. 4, 1920, pp. 39-42.

Blakeston, O. "Jacques Lipchitz." *Art Review,* Vol. 30, October 27, 1978, p. 575.

Bowness, A. "Lipchitz Retrospective at the Tate Gallery." *Arts Magazine,* Vol. 34, January 1960, p. 17.

Brenson, Michael. "The Reach and Grasp of Jacques Lipchitz." *New York Times,* Vol. 140, January 18, 1991, p. 32.

Buckley, C.E. "Three Twentieth Century European Acquisitions." *St. Louis Art Museum Bulletin,* Vol. 10, No. 3, May-June 1974, pp. 42-46.

Carter, M.N. "The Lipchitz Imbroglio." *Art News,* Vol. 78, No. 4, April 1979, pp. 50-54.

_____. "The Lipchitz 'Tree of Life' Controversy, Continued." *Art News,* Vol. 78, No. 7, September 1979, pp. 105-6.

Cassou, Jean. "Contemporary Sculptors: V-Lipchitz." *Horizon,* London, December 1946, pp. 377-80.

Cavaliere, B. "Exhibition Review." *Arts Magazine,* Vol. 51, No. 8, April 1977, pp. 26-28.

Coates, R.M. "Art Galleries: Retrospective at Museum of Modern Art." *New Yorker,* Vol. 30, May 29, 1954, pp. 74-76.

Cocteau, Jean. "Jacques Lipchitz and My Portrait Bust." *Broom,* Rome, Vol. 2, 1922, pp. 207-9.

_____. "The Technique of Jacques Lipchitz." *Broom,* Rome, Vol. 2, 1922, pp. 216-19.

Couturier, Elisabeth. "Au Palais-Royal Lipchitz fait un pied de bronze à Buren." *Match de Paris,* Paris, July 2, 1998.

Craig, Martin. "Jacques Lipchitz." *Art Front,* New York, Vol. 2, January 1936, pp. 10-11.

Davidson, A. "Jacques Lipchitz: The Artist at Work, by Bert Van Bork, with a Critical Evaluation by Alfred Werner." *Art Quarterly,* Vol. 30, No. 3-4, Fall-Winter 1967, p. 296.

Dermée, Paul. "Lipchitz." *L'Esprit Nouveau,* No. 2, 1920, pp. 169-182.

Dreishpoon, Douglas. "Jacques Lipchitz, the Jewish Museum New York." *Sculpture,* Vol. 10, No. 4, 1991, pp. 57-58.

Duault, Nicole. "Au Palais-Royal - Jacques Lipchtiz ouvre le bal, dans ce nouveau temple de la sculpture." *Sommaire,* Paris, June 6-12, 1998.

Eagle, J. "Artist as Collector." *Art in America,* Vol. 55, May 1967, pp. 54-55.

Eisendrath, William N. " 'Bather' by Jacques Lipchitz." *St. Louis Museum Bulletin,* Vol. 42, No. 4, 1957, pp. 45-46.

"El Reina Sofía recibe una donación de 21 obras de Lipchitz." *La Cultura, El País,* Madrid, Wednesday, November 26, 1997, p. 40.

Elsen, Albert. "Duets of the Line and Shadow." *Art News,* Vol. 77, No. 3, March 1978, pp. 64-66.

_____. "The Humanism of Rodin and Lipchitz." *College Art Journal,* Vol. 17, No. 3, Spring 1958, pp. 247-65.

Faure, Elie. " Jacques Lipchitz et le Cubisme." *Les Arts Plastiques,* Brussels, No. 2, 1950, pp. 117-122. (Written in 1932-33).

Feaver, William. "Hear, hear, O'Israel." *Sunday Observer,* London, October 14, 1990, p. 59.

"Fire (in Lipchitz's studio)." *Art Digest,* New York, February 1, 1952, p. 14.

"Forty Years of Lipchitz; Retrospective at the Museum of Modern Art." *Interiors,* Vol. 113, June 1954, p.10

"Französische plastik des 20 Jahrhunderts in Dortmund." *Kunstwerk,* Vol. 13, July 1959, p. 28.

Fremantle, C.E. "New York Commentary: Retrospective Exhibition at the Museum of Modern Art." *Studio,* Vol. 148, October 1954, pp. 124-25.

"Frequent Phoenix." *Time,* Vol. 63, June 7, 1954, pp. 89-90.

Frost, Rosamund J. "Lipchitz Makes a Sculpture." *Art News,* New York, April 1950, pp. 36-39, 63-64.

Fulford, Toronto R., "Kandinsky-Lipchitz Dual Exhibition." *Canadian Art,* Vol. 16, August 1959, p. 204.

Garnier, Isabelle. "L'Art est au jardin." *Madame Fogaro,* Paris, June 6, 1998, pp. 42-43.

Gaz. "Musée d'Israël de Jerusalem: exposition." *Beaux Arts,* France, Vol. 79, March 1972.

George, Waldemar. "Jacques Lipchitz." *L'Amour de l'art,* Paris, Vol. 2, August 1921, pp. 255-58.

_____. "Jacques Lipchitz, père légitime des transparents." *Art et Industrie,* Paris, Vol. 27, No. 24, 1952, pp. 28-29.

Greenberg, Clement. "Sculpture of Jacques Lipchitz." *Commentary,* New York, Vol. 18, September 1954, pp. 257-59.

"Gris Drawings and Lipchitz Sculptures at Knoedler's." *Art News,* Vol. 58, February 1960, p.12.

Grossman, Emery. "A Return Visit with Jacques Lipchitz." *Temple Israel Light,* Great Neck, New York, October 1962, pp. 4-5.

Gueguen, Paul, "Jacques Lipchitz, ou l'histoire naturelle magique," *Cahiers d'Art,* Paris, Vol. 7, 1932, pp. 252-58.

Gueguen, Pierre. "Le nouveau colloque avec Lipchitz." *XXe Siècle,* Paris, No. 13, 1959, pp. 76- 80.

_____. "Le nouveau colloque avec Lipchitz"(with English summary). *XXe Siecle,* No. 21, December 1959, supplement pp. 27-31.

Hammacher, A..M. "La Rétrospective Lipchitz à Berlin." *XXe Siècle,* No. 36 , June 1971, pp. 85-91.

Hampel, Claude. "L'œuvre sculpté de Jacques Lipchitz: une statuaire de thèmes et d'idées." *Cahiers Bernard Lazare,* Paris, July 1998, pp. 16-17.

Harvard-Franceschi, Natacha. "Première grande exposition de Lipchitz à Paris - Un musée dans les jardins du Palais-Royal." *Gala,* Paris, June 4, 1998.

Hess, Thomas B. "Lipchitz: Space for Modern Sculpture." *Art News,* June 1954, pp. 34-37, 61-62.

Hope, Henry R. "La scultura di Jacques Lipchitz." *La Biennale di Venezia,* No. 10, September 1952, pp. 8-11.

_____, "Drawing by Lipchitz: The Arrival." *John Heron Institute Bulletin,* Vol. 44, April 1957, pp. 5-7.
_____. "Un sculpteur d'hier et d'aujourd'hui." *L'Oeil,* No. 53, May 1959, pp. 30-37.

"Jacques Lipchitz montre sa collection." *L'Oeil,* No. 66, June 1960, pp. 46-53.

"Instantané - Le Retour de Prométhée." *Le Monde,* Paris, Tuesday, June 30, 1998.

"Jacques Lipchitz's Harlequin with Clarinet acquired by Museum Folkwang, Essen." *Burlington Magazine,* Vol. 107, June 1965, p. 341.

Judd, Donald. "Sculpture at the Marlborough-Gerson Gallery." *Arts Magazine,* Vol. 39, October 1964, pp. 60-62.

Kelleher, P. J. "Sacrifice: Bronze acquired by the Museum." *Albright Gallery Notes,* Buffalo, Vol. 16, May 1952, pp. 2-3.

_____. "Another Phoenix." *Art Digest,* New York, Vol. 26, February 15, 1952, p. 14.

Kingsbury, A.M. "Lipchitz Sculpture at Cornell." *Art Journal,* New York, No. 2, 1963-64, p. 140.

Koskas, Pierre. "Baroque et Lyrique Lipchitz." *Tribune Juive,* Paris, July 23, 1998.

Kramer, Hilton. "Cubist Epoch." *Art in America,* Vol. 59, March 1971, p. 56.

_____. Review of "Thirty-Three Semi-Automatics." *Arts Magazine,* New York, March 1957, pp. 46-47.

_____. "Lipchitz Show at the Jewish Museum: Effort to Revise Artist's Reputation." *New York Observer,* New York, January 24, 1991, p. 1.

_____. "Small was Generally Better after Lipchitz Found Fame." *New York Observer,* New York, Vol. 5, No. 4, January 28, 1991.

Kuh, Katherine. "Conclusions from an Old Cubist." *Art News,* November 1961, pp. 48-49, 73-74.

Kuspit, Donald. "Jacques Lipchitz: The Jewish Museum." *Artforum,* New York, Vol. 29, No. 9, May 1991, pp. 141.

Lanes, Jerrold. "Work from the Cubist Period at Marlborough-Gerson Gallery." *Burlington Magazine,* London, May 1968, pp. 295-96.

Langsner, J. "Retrospective Sponsored by the U.C.L.A. Arts Council." *Art News,* May 1963, p. 48.

Larrea, Juan. "An Open Letter to Jacques Lipchitz." *College Art Journal,* Vol. 13, No. 4, Summer 1954, pp. 250-88.

Lerner, Abram. "A Recollection." *Archives of American Art Journal,* Vol. 33, No. 4, 1993, pp. 8-10.

Levinson, Andre. "Sculpteurs de ce temps." *L'Amour de l'art,* Paris, Vol. 5, 1924, pp. 377-91.

"Lipchitz au Palais-Royal." *Le Journal du Dimanche,* Paris, Wednesday, June 14, 1998.

Lozowick, Louis. "Jacques Lipchitz." *Menorah Journal,* Vol. 16, New York, 1929, pp. 46-48.

Marescaux, Laure. "Les Sculptures de Jacques Lipchitz s'affichent en ville." *VSD Sommaire,* Paris, June 18-24, 1998.

Mastai, M. L. D. "Lipchitz Retrospective at the Otto Gerson Gallery of New York." *Apollo,* London, November 1961, p. 150.

Melville, R. "Exhibition of Bronzes in London." *Architectural Review,* Vol. 127, February 1960, pp. 135-6

_____. "Philadelphia Lipchitz." *Architectural Review,* Vol. 142, July 1967, p. 48.

Munro, E. C. "Sculptor in the Foundry: Lipchitz at Work." *Art News,* March 1957, pp. 28-30, 61-62.

Nordland, Gerald. "Lipchitz: Lively Legend." *Artforum,* San Francisco, June 1963, pp. 38-40.

Pach, Walter. "Lipchitz and the Modern Movement." *Magazine of Art,* Washington, D.C., December 1946, pp. 354-59.

Packer, William. "Jewish Experience." *Financial Times,* London, October 16, 1990.

Parkes, Kineton. "The Constructional Sculpture of Jacques Lipchitz." *Architect,* London, September 18, 1925, pp. 202-4.

Patai, Irene. "A Chapter in the Life of Jacques Lipchitz." *Chicago Perspective,* Vol. 13, No. 5, May 1964, pp. 30-35.

Payne, E.H. "Four Faces of Cubism." *Detroit Institute Bulletin,* Autumn 1991.

Perl, Jed. "The Neo-Baroque: Lipchitz and De Chirico." *New Criterion,* New York, Vol. 9, No. 7, March 1991.

Perruche, Céline. "Au Palais-Royal, Lipchitz saute de la plastique africaine à la politique." *La Croix,* Paris, August 18, 1998.

Pinte, Jean-Louis. "Jacques Lipchitz - Le lyrisme des corps." *Figaro Scope,* Paris, June 3, 1998.

Posèq, Avigdor W. G. "Childhood Fantasy into Archetype Icons in Jacques Lipchitz." *Konsthistorisk Tidskrift,* Vol. 60, No.1, 1991, pp. 42-55.

_____. "Jacques Lipchitz's 'David and Goliath'." *Source: Notes in the History of Art,* Vol. 8, No. 2, Spring 1989, pp. 22-31.

_____. "The 'David-Orpheus' Motif in Jacques Lipchitz." *Jewish Art,* Israel, Vol. 19-20, 1993-94, pp. 212-23.

Quantrill, M. "London Letter." *Art International,* Vol. 22, No. 9, February 1979, pp. 38-45.

Raynal, Maurice. "La sculpture de Jacques Lipchitz." *Arts de France,* Paris, No. 6, 1946, pp. 43-50.

Raynor, Vivien. "Exhibition at Gerson Gallery." *Arts Magazine,* Vol. 37, September 1963, p. 55.

_____. "Wrestling With the Ever-Changing Forces of Modernism." *The New York Times, Westchester Review,* October 17, 1993, p. 24.

Review, "Exhibition of Jacques Lipchitz." *Cleveland Museum Bulletin,* Vol. 42, No. 23, February 1955.

_____, *Art News,* March 1957, pp. 28-30.

_____, "Artist as Collector." *Art in America,* Vol. 46, No. 2, Summer 1958, p. 24

_____, "Ausstellung seines Gesamtwerkes in der Kunsthalle, Basel." *Werk,* Vol. 45, October 1958, supplement pp. 205-206.

_____, "Lipchitz Exhibition in Canada." *Canadian Art,* Vol. 16, May 1959, p. 132.

_____, "Exhibition at Fine Arts Gallery." *Art News,* Vol. 58, November 1959, p.15.

_____, "Exhibition at Fine Arts Associates Gallery" *Arts Magazine,* Vol. 34, December 1959, p. 54.

_____, "Exhibition at the Tate." *Burlington Magazine,* Vol. 19, December 1959, p. 470.

_____, "Exhibition at Knoedler Gallery." *Arts Magazine,* Vol. 34, February 1960, p. 56.

_____, "Retrospective Exhibition at the Tate." *Studio,* Vol. 159, February 1960, p. 58.

_____, "Exhibition at the Otto Gerson Gallery." *Progressive Architecture,* Vol. 42, December 1961, p. 71.

_____, "Lipchitz: 1911-1962." *Art News,* March 1963, p. 28.

_____, "Exhibition at Gerson Gallery." *Art News,* Vol. 62, Summer 1963, p. 15.

_____, "Exhibition at Gerson Gallery." *Art News,* Vol. 63, October 1964, p. 14.

_____, "Exhibition at Marlborough-Gerson Gallery." *Art News,* Vol. 65, Summer 1966, p. 12.

_____, "Exhibition at Marlborough-Gerson Gallery." *Arts Magazine,* Vol. 43, April 1968, p. 63.

_____, "Exhibition at Marlborough-Gerson Gallery." *Art News,* Vol. 67, May 1968, p. 18.

_____, *Art,* Vol. 10, No. 2, Winter 1991, pp. 32-40.

Rewald, John. "Jacques Lipchitz's Struggle." *Museum of Modern Art Bulletin,* New York, November 1944, pp. 43-50.

Rouve, Pierre. "Lipchitz." *Arts Review,* Vol. 25, No.10, May 19, 1973, pp. 326-327.

_____. "The Two Faces of Lipchitz." *Arts Review,* London, April 8-22, 1961, p. 16.

Salmon, Andre. "La sculpture vivante." *L'Art Vivant,* Paris, Vol. 2, May 1926, pp. 208-211, 258-260, 334-335, 742-744.

Salmon, Andre. "Nouvelles sculptures de Lipchitz." *Cahiers d'Arts,* Vol. 3, No. 10, Paris, 1926, pp. 21-23.

Sawin, Martica. "Gonzalez and Lipchitz." *Arts Magazine,* Vol. 36, February 1962, pp. 14-19.

Schneider, Pierre. "Lipchitz: Cubism, The School for Baroque." *Art News,* Vol. 58, October 1959, p. 46.

"Sculptors' Jewelry." *Art in America,* Summer 1962, p. 77.

"Sculptures en balade." *L'Express - Paris Spectacles,* Paris, July 2-8, 1998.

Sierra, Rafael. "El Reina Sofía engrosa su colección." *Cultura, El Mundo,* Madrid, Wednesday, November 26, 1997, p. 55.

Slusser, Jean P. "Sculptures by Arp and Lipchitz." *Bulletin of the Museum of Art,* University of Michigan Press, Ann Arbor, Vol. 1, No. 1, May 1950, pp. 9-12.

Stein, Gertrude. "Lipchitz." *Ray,* London, No. 2, 1927, p. 1.

Swann, Ron Robertson. "Jacques Lipchitz: Musical Instruments." *Art and Australia,* Vol. 25, No. 2, Summer 1987, pp. 220-221.

Sweeney, James Johnson. "Eleven Europeans in America." *Museum of Modern Art Bulletin,* New York, September 1946, pp. 24-27, 38.

_____. "Two Sculptors: Lipchitz and Arp." *Theatre Arts,* New York, Vol. 33, April 1949, pp. 52-56.

Talphir, Gabriel. "Jacques Lipchitz." *Gazith,* Tel Aviv, No. 213-214, 1961, pp. 1-2.

Tasset, Jean-Marie. "Jardins du Palais-Royal - Lipchitz en magesté." *Le Figaro - La Vie Des Arts,* Paris, Tuesday, May 19, 1998, p. 29.

Tériade, E. "A propos de la récente exposition de Jacques Lipchitz." *Cahiers d'Art,* Paris, Vol. 5, 1930, pp. 259-265.

Trier, E. "Ikonographische Traditionen im Werk von Jacques Lipchitz." *Das Münster,* Vol. 25, Pt. 5-6, September-December 1972, pp. 381-388.

de Villiers, Jean Pierre. "Jacques Lipchitz: une vie de sculpture." *Vie des Arts,* No. 140, Vol. 35, September 1990, pp. 22-25.

Weller, Paul. "Jacques Lipchitz: A Portfolio of Photographs." *Interiors,* New York, Vol. 109, May 1950, pp. 88-95.

Werner, Alfred. "The Dramatic World of Jacques Lipchitz." *The Progressive,* August 1954.

_____. "Lipchitz: Thinking Hand." *Midstream,* New York, Fall 1959.

_____. "Protean Jacques Lipchitz." *The Painter and Sculptor,* London, Vol. 2, No. 4, Winter 1959-60, pp. 11-17.

_____. "Jacques Lipchitz: His Sculpture, by A.M. Hammacher; (review)" *Arts,* Vol. 35, April 1961, p. 15.

Weyl, M. "Jacques Lipchitz in Jerusalem." *Ariel,* No. 41, 1976, pp. 53-59.

Wilkinson, Alan G. "Paris and London: Modigliani, Lipchitz, Epstein, and Gaudier-Brzeska." *"Primitivism" in 20th Century Art: Affinity of the Tribal and the Modern.* Edited by William Rubin. The Museum of Modern Art, New York, 1984, Vol. II, pp. 417-50.

Wolfzahn, Karolina. "Jacques Lipchitz au Palais-Royal." *L'Arche,* Paris, June 1998.

Photo Credits

Albright-Knox Art Gallery, Buffalo, NY, 431
Art Gallery of Ontario, Toronto, Canada, 346, 347, 349, 350, 356, 369, 379, 380, 390, 395, 426, 438, 442, 498, 546, 550, 551, 558, 571, 574, 610, 611, 656, 657, 660, 712, 713, 719, 722, 724, 733
Robert Lee Blaffer Trust, New Harmony, IN, 425
Cincinnati Art Museum, Cincinnati, OH/Thomas M. Emery Foundation, 569
Columbia University Law School, New York, 623
Fairmount Park Art Association, Philadelphia, PA, 500
Peggy Guggenheim Collection, Venice, Solomon R. Guggenheim Foundation, New York, 399
Solomon R. Guggenheim Foundation, New York, 348
The Harvard University Art Museums, Cambridge, MA, 370, 398, 429
Israel Museum, Jerusalem, 388, 391, 409, 449, 453, 487, 495, 497, 567
Jewish Museum, New York, 644, 645, 646, 647, 648, 649, 650, 651, 652, 653, 654
The Estate of Jacques Lipchitz, title page, 10a, 104a, 170a, 190a, 190b, 211a, 216a, 244a, 260a, 279a, 279b, 359, 375, 397, 400, 402, 403, 405, 408, 410, 411, 412, 413, 414, 416, 418, 427, 428, 433, 434, 436, 439, 441, 447, 450, 459, 460, 461, 462, 463, 464, 465, 466, 467, 468, 469, 470, 471, 472, 473, 474, 475, 476, 477, 478, 479, 480, 481, 482, 483, 513, 530, 575, 576, 577, 578, 579, 580, 582, 583, 584, 586, 587, 588, 589, 590, 592, 614, 626, 662, 678, 707
Marlborough Gallery, Inc., New York, frontispiece, castings and signatures, 65a, 352, 353, 355, 357, 358, 360, 361, 362, 363, 364, 365, 366, 367, 368, 372, 373, 378, 381, 382, 383, 384, 385, 386, 392, 394, 396, 401, 404, 406, 415, 419, 420, 421, 422, 423, 424, 430, 440, 443, 444, 445, 446, 448, 451, 452, 454, 455, 456, 457, 458, 485, 489, 490, 491, 492, 493, 499, 501, 502, 503, 504, 505, 506, 507, 508, 509, 510, 511, 512, 514, 515, 516, 517, 518, 519, 520, 521, 522, 523, 524, 525, 526, 527, 528, 529, 531, 532, 533, 534, 535, 536, 537, 538, 539, 540, 541, 542, 543, 547, 548, 549, 552, 553, 554, 555, 556, 557, 559, 560, 561, 562, 563, 564, 565, 566, 568, 570, 572, 573, 581, 585, 591, 593, 594, 595, 596, 597, 598, 599, 602, 613, 615, 616, 617, 618, 621, 622, 624, 627, 628, 629, 630, 655, 658, 661, 663, 664, 668, 669, 676, 677, 679, 711, 714, 715, 716, 720, 723, 725, 726, 727, 728, 729, 730, 731, 732, 734, 735, 736, 737
Herbert Michel, 496, 604, 605, 606, 631, 632, 633, 634, 635, 636, 637, 638, 639, 640, 670, 671, 672, 673, 674, 675, 680, 681, 682, 683, 684, 685, 686, 687, 688, 689, 690, 691, 692, 693, 694, 695, 696, 697, 698, 699, 700, 701, 702, 703, 704, 705, 706, 708, 709, 710, 740, 741, 742, 743, 744, 745, 746
Minneapolis Institute of Arts, Minneapolis, MN, 544, 545
Museum of Modern Art, New York, 354, 371
Philadelphia Museum of Art, Philadelphia, PA, 377, 659
Prudence Cuming Associates Ltd, London, 612
Horace Richter, New York, 376
David and Alfred Smart Museum of Art, The University of Chicago, Chicago, IL, 57a
Tate Gallery, London, 437
Tate Gallery Archive, London, T.G.A. 897: 11a, 37a, 212a, 337a, 344a, 344d, 344e, 344f, 344g, 344h, 344i
Tel Aviv Museum of Art, Israel, 407
Tweed Museum of Art, University of Minnesota, Duluth, MN, 603, 609
Segy Gallery, New York, 666
Sotheby's, New York, 417
Stedelijk Museum, Amsterdam, Netherlands, 389
Virginia Museum of Fine Arts, Richmond, VA, 351
Whitney Museum of American Art, New York, 432
Alan G. Wilkinson, 488, 600, 601, 625, 641, 642, 643, 747